PENGUIN BOOKS

THE DINNER PARTY

JUDY CHICAGO is an artist and writer whose work has had an international impact on art and culture. She is best known for *The Dinner Party*, a collaborative, multimedia installation that presents a symbolic history of women in Western Civilization through a series of thirty-nine place settings, set on a triangular banquet table forty-eight feet per side. *The Dinner Party* has traveled extensively throughout the United States and to five other countries, where it has been seen by approximately one million viewers during its fourteen showings. Its continuing influence is to be examined in a commemorative exhibition at the UCLA Armand Hammer Museum in Los Angeles, scheduled to open in April, 1996.

In the 1980s Chicago worked on the *Birth Project*, another collaborative effort. This series of needle-worked images celebrating birth and creation was exhibited in nearly one hundred venues around the United States. She then created *Powerplay*, a series of monumental works exploring the gender construct of masculinity. In 1985 she took up an inquiry into the subject of the Holocaust. Eight years of study, travel, and artmaking resulted in the *Holocaust Project: From Darkness into Light*, a traveling exhibition and accompanying book.

Other books by Chicago include *Through the Flower*, *Embroidering Our Heritage*, *Birth Project*, *Holocaust Project*, and *Beyond the Flower*. There have been numerous films made about the artist's work, and she has lectured widely to diverse audiences all over the world. She lives in New Mexico with her husband, photographer Donald Woodman.

DONALD WOODMAN holds an MFA in photography from the University of Houston. He worked as an architectural photographer with Ezra Stoller in New York and was Minor White's assistant at the Massachusetts Institute of Technology. Mr. Woodman's work can be found in numerous museum collections, and it has appeared in such magazines and newspapers as *Vanity Fair*, *Art in America*, and *New York Newsday*. He collaborated with Judy Chicago on the *Holocaust Project*.

THE DINNER PARTY

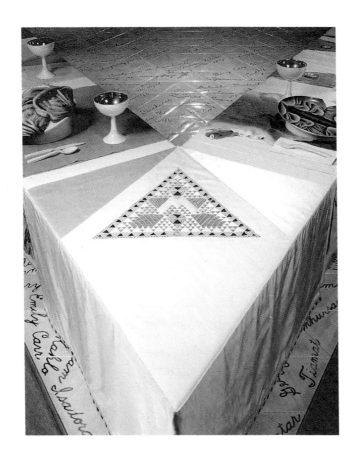

JUDY CHICAGO

with photography coordinated by Donald Woodman

PENGUIN BOOKS

PENGUIN BOOKS
Published by the Penguin Group
Penguin Books USA Inc., 375 Hudson Street, New York, New York 10014, U.S.A.
Penguin Books Ltd, 27 Wrights Lane, London W8 5TZ, England
Penguin Books Australia Ltd, Ringwood, Victoria, Australia
Penguin Books Canada Ltd, 10 Alcorn Avenue, Toronto, Ontario, Canada M4V 3B2
Penguin Books (N.Z.) Ltd, 182–190 Wairau Road, Auckland 10, New Zealand

Penguin Books Ltd, Registered Offices: Harmondsworth, Middlesex, England

This edition first published in simultaneous hardcover and paperback editions
by Viking Penguin and Penguin Books 1996

1 3 5 7 9 10 8 6 4 2

Portions of this work first appeared in different form in the author's
The Dinner Party (1979 edition) and *Embroidering Our Heritage* (1980).

Drawings on page 225 by Yasi Vafai reproduced by permission of Narduli/Grinstein.
Photographs by Donald Woodman, copyright © Donald Woodman, 1996.
All other images reproduced by arrangement with Through the Flower.

LIBRARY OF CONGRESS CATALOGING IN PUBLICATION DATA
Chicago, Judy, 1939–
The dinner party / Judy Chicago.
p. cm.
Includes index.
ISBN 0-670-85957-5 (hc.)
ISBN 0 14 02.4437 9 (pbk.)
1. Chicago, Judy, 1939– Dinner party. 2. China painting—United
States. 3. Needlework—United States. 4. Women in art.
5. Feminism and art—United States. I. Title.
NK4605.5.U63C482 1996
709′.2—dc20 94–49428

Printed in the United States of America
Set in Garamond No. 3
Designed by Kate Nichols

CONTENTS

THIS BOOK—LIKE THE WORK OF ART THAT IT DESCRIBES—

IS DEDICATED TO THE MEMORY OF THESE 1,038 WOMEN WHO SYMBOLIZE

THE MANY THOUSANDS OF HEROIC WOMEN ALL OVER THE WORLD

WHO HAVE STRUGGLED FOR FREEDOM AND DIGNITY.

PART ONE

Introduction

*L*ucky are you, reader, if you happen not to be of that sex to whom it is forbidden all good things; to whom liberty is denied; to whom almost all virtues are denied; lucky are you if you are one of those who can be wise without its being a crime.*

I included this quote from the sixteenth-century writer and feminist Marie le Jars de Gournay, in the first of two volumes about *The Dinner Party*. These were published in 1979 and 1980, at the time that the exhibition began what was to be a ten-year worldwide tour. While preparing for this new edition, which accompanies the 1996 commemorative showing of *The Dinner Party* at the UCLA Armand Hammer Museum in Los Angeles, I discovered that I responded quite differently to de Gournay's words than I did when I first encountered them. Originally, though struck by the poignancy of her remarks, I felt distant from the sentiments expressed, as if the profound longing that pervaded her tone was applicable only to the distant past. Now I hear her words ringing out across the centuries.

Today, when most Western women have access to education and are protected by legal rights unimaginable in de Gournay's day, the "good things" to which she referred do not necessarily take the same form that they did in earlier centuries. Nevertheless, I have come to understand that there are still many "good things" that are "forbidden"—among them the assurance that the achievements of twentieth-century women will not prove to be as ephemeral as were those of our predecessors, many of whom are represented in *The Dinner Party*. The goal of this symbolic history of women in Western civilization was and is twofold: to teach women's history through a work of art that can convey the long struggle for freedom and justice that women have waged since the advent of male-dominated societies, and to break the cycle of history that *The Dinner Party* describes.

The Dinner Party is a work of art, triangular in configuration, that employs numerous media, including ceramics, china-painting, and needlework, to honor women's achievements. An immense open table covered with fine white cloths is set with thirty-nine place settings, thirteen on a side, each commemorating a goddess, historic personage, or important woman. Though most are largely unknown, their names should, in my estimation, be as familiar to us as the male heroes whose exploits we absorb from childhood through art, myth, literature, history, and popular entertainment. *The Dinner Party* suggests that these female heroes are equally worthy of commemoration, as are those hundreds of others whose names are inscribed upon the *Heritage Floor.* This lustred porcelain surface serves as the foundation for *The Dinner Party* table and the many important human accomplishments it symbolizes.

The Dinner Party visually describes the historic struggle of women to participate in all aspects of society; its aim is to end the ongoing cycle of omission in which women's hard-earned achievements are repeatedly written out of the historic record, sometimes within years of their attainments. This process results in generation after generation of women struggling for insights and freedoms that, even when fiercely won, are too often quickly forgotten or erased once again.

My idea for *The Dinner Party* grew out of the research into women's history that I had begun at the end of the 1960s. I had undertaken this study in an effort to discover whether women before me had faced and recorded their efforts to surmount obstacles similar to those I was encountering as a woman artist. When I started my investigation, there were no women's studies courses, and the prevailing attitudes toward women's history can best be summed up by the following story. While an undergraduate at UCLA, I took a course titled the Intellectual History of Europe. The professor, a respected historian, promised that at the last class he would discuss women's contributions to Western thought. I waited eagerly all semester, and at the final meeting, the instructor strode in and announced: "Women's contributions to European intellectual history? They made none."

I was devastated by his judgment, and when my later studies demonstrated that my professor's assessment did not stand

*From "Grief des Dames," as quoted by Elise Boulding in *The Underside of History* (Boulder, CO: Westview Press, 1976).

up to intellectual scrutiny, I became convinced that the idea that women had no history—and the companion belief that there had never been any great women artists—was simply prejudice elevated to intellectual dogma. I suspected that many people accepted these notions primarily because they had never been exposed to a different perspective.

As I began to uncover what turned out to be a treasure trove of information about women's history, I became both empowered and inspired. My intense interest in sharing these discoveries through my art led me to wonder whether visual images might play a role in changing the prevailing views regarding women and women's history. I had always been attracted to medieval art, which taught history, myth, and values to the populace through easily understandable visual symbols. Though contrary to the tenets of modern art, which promote a visual language that is far from accessible to most people, this earlier model appeared particularly appealing, primarily because it suggested a way of reaching a broad audience, an objective that seemed essential if I were to contribute to any meaningful transformation of consciousness. This ideal appeared eminently possible in the climate of the early 1970s, when the women's movement was at its height, a time when no dream—even one so vast as influencing the world through art—seemed impossible.

My concept for *The Dinner Party* evolved slowly. I began the first drawings in the spring of 1974 and worked on the art until 1979, finally finishing the second of two books about the piece in 1980. In the years since then, I have had difficulty separating myself from *The Dinner Party* in the way most artists do once they've completed a work. The reasons for this are that I still believe the information embodied by the piece is precious and, more significant, my original goals for the project have not yet been achieved.

The 1996 exhibition of *The Dinner Party*, curated by Dr. Amelia Jones and intended as a reappraisal of both the art and its influence, allowed me the possibility of doing another book about the work. In this volume, I intend to emphasize what has always been most important to me about *The Dinner Party*, which is the art and the way in which it reflects the (to me) crucially important historical information about the women represented. This new publication has also afforded me the opportunity to review my original intentions in undertaking such a mammoth work.

In addition to describing *The Dinner Party*, I intend to briefly chronicle what happened to it after its 1979 premiere at the San Francisco Museum of Modern Art. I will discuss the ways in which, ironically, the ongoing vicissitudes of the work seem to have expanded upon the painful historical story that it conveys, which is something that I never expected. Finally, I shall reflect upon the meaning of some of the controversy that *The Dinner Party* has stimulated in the hopes that my analysis might be useful to others who wish to see an end to the time when "good things" are prohibited to anyone because of gender and, by implication, race, religion, sexual preference, or ethnicity.

The Dinner Party was created in my studio in Santa Monica, California. All of the images were designed and, in some cases, executed entirely by me. I began by working by myself, struggling to formulate what was to become an overwhelming task and one that I could never have completed alone: I intended to create a work of art that could symbolize the immense amount of material about women's history that I was discovering (later amplified by a team of researchers).

In the early 1970s I did a series of paintings titled *The Great Ladies*, which were abstract portraits of women whose lives were particularly instructive to me. In these images, I attempted to make symbolic, abstract portraits of women in history. But I was dissatisfied with the lack of specificity in these paintings, and I felt the need for a media other than sprayed acrylic, which is how they were executed. Then, quite by accident, I saw a china-painted porcelain plate in an antique shop and became intrigued by its unique fusion of color and surface, something I had always tried to achieve in my paintings. In 1972 I took up the study of china-painting, which for the first time brought me into contact with women's traditional arts. Needless to say, these had been entirely scorned at the art schools I'd attended. I learned a great deal from the women with whom I trained, not only about china-painting but about how arbitrary the traditional distinctions between art and craft can be.

Discovering the visual beauty, aesthetic potential, and rich history of china-painting—and the way in which it had been dis-

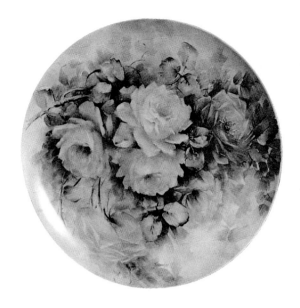

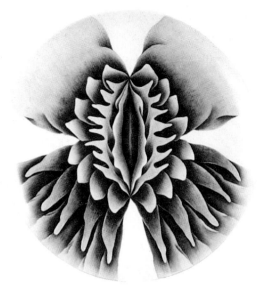

FAR LEFT: Traditional rose plate; painted by Rosemarie Radmaker

LEFT: Untitled test plate; © Judy Chicago, 1975; China-paint on porcelain, 14" diameter

regarded as a "woman's craft"—led me to decide to use this technique for another series of abstract portraits of women which would be presented on plates. But before I could implement this plan, I had to invest two years in mastering the art of painting on porcelain, which proved to be quite challenging. Between 1972 and 1974 I studied china-painting, then executed a series of ceramic pieces that allowed me to apply my gradually-developing technical expertise to a slowly-evolving imagery.

In 1975 I began working on the first series of plates. Sometime later I decided to make some of the images dimensional and, as I then had rather limited ceramic skills, sought help in the person of Leonard Skuro, a graduate student in ceramics at UCLA, who became my assistant. His job, which proved quite formidable, was to design a system for making plates that could be reliefed, then painted in a complex a process that required multiple firings. Moreover, the finished surfaces had to match the fine quality of the Japanese porcelain upon which I had painted the early images.

The imagery on the plates incorporates both vulval and butterfly motifs, the latter chosen in part because the butterfly is an ancient symbol of liberation. The butterfly forms undergo a metamorphosis as the painted and sculpted abstract portraits become increasingly dimensional, a metaphor for women's intensifying struggle for freedom. This form is occasionally submerged in other designs that I deemed more appropriate for a particular woman because of her life experience or because I discovered particularly fitting symbols.

The organic iconography of the plates evolved out of a long struggle to find my own forms as an artist. When I first got out of graduate school in 1964, I locked myself in my studio for a month and tried to create comparable images of an active vulval and phallic form. Art generally develops in relation to the art that precedes it, and many people never think about the fact that art objects are ultimately the most significant transmitters of a culture's values. Dating back to the earliest cave paintings, it is visual art that informs us about what human beings did, thought, and revered. Those experiences that are not imaged exist only in the sphere of the personal in my opinion, thereby preventing them from being either socially validated or seen in their larger, universal dimensions.

I firmly believe that the absence of visual images from a female perspective attests to a more significant absence, one that impacts heavily upon women's sense of self. Whereas for men there is *presence* in the public arena, for women there is primarily *absence*: an *absence* of political leaders on the highest level of world governments; an *absence* of public monuments honoring women heroes and leaders; and, mirroring this, an *absence* in our museums of images that extend our personal experiences into the cultural dialogue and, most important, convey our sense of ourselves as subjects rather than as objects. I felt this absence

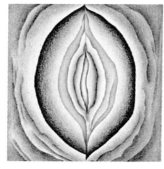

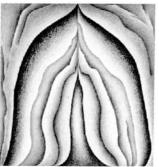

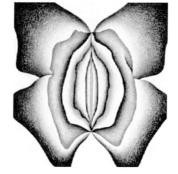

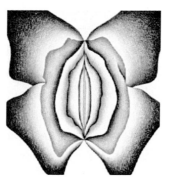

RIGHT: Detail, *Rejection Quintet #5*; © Judy Chicago, 1974; Prismacolor on rag paper; overall drawing 29" x 23"; Collection: San Francisco Museum of Modern Art

FAR RIGHT, TOP: With Diane Gelon in Santa Monica studio, 1976

FAR RIGHT, BOTTOM: Susan Hill at ecclesiastical embroidery class, 1976

keenly when I tried to create an active vaginal or vulval form to represent my sense of my own identity and sexuality.

It took me years to create images that could convey the idea that the female body experience is as active and as central to what it means to be human as is that of the male and, in fact, can be explored aesthetically as one pathway to an understanding of the universal. Long before I began *The Dinner Party*, I had been struggling to anthropomorphize the vulval form, transforming it into numerous motifs suggesting flower, cave, flesh, or landscape. When fused with the butterfly formation, this image became a metaphor for an assertive female identity as well as the visual base for many of the transmuting forms on the plates.

The incorporation of vulval iconography was certainly in-

tended to challenge the pervasive definitions of women and of female sexuality as passive. But, more significant, in the context of this work of art, it implies that the various women represented—though separated by culture, time, geography, experience, and individual choices (not to mention that some are mythical, others real)—are unified primarily by their gender, which in my opinion, is the main reason that so many were and are unknown.

After seeing a hand-painted set of dishes on an elegant table, I decided to present the plates in the context of a table setting rather than hanging them on a wall, which had been my original intention. Then I began to think about traditional paintings of meals, most notably renditions of the Last Supper, which of course included only men. It was at this time that I

titled the work *The Dinner Party* and began referring to it humorously as a reinterpretation of the Last Supper from the point of view of those who've done the cooking throughout history.

I had determined that the table should rest upon a porcelain floor covered with the names of other women who had "made a mark on history" and was trying to assemble a large file of information about women for this *Heritage Floor*. During these years I kept running into a young feminist activist and art-history student named Diane Gelon (whom I have always called Gelon). One day I asked her what she was doing with herself. When she replied "Not much," I inquired whether she might be interested in helping me with some of the research for the names on the floor, which was becoming increasingly time-consuming. She agreed and eventually became the administrator of what would slowly become an increasingly complex project.

Shortly after Gelon began working with me, I received a letter from a woman named Susan Hill, who had read and been inspired by my first book *Through the Flower*. She also wished to assist me, though she had no idea that she would end up becoming the needlework supervisor of an enormous project, coordinating dozens of stitchers working in the studio loft in which I had originally worked in solitude. It was she who introduced me to ecclesiastical embroidery, which opened up another new visual language for me. Even though I could barely sew, I was soon to discover that I had an unexpected ability to design for the needle and textile arts.

Susan took me to an exhibit by the ecclesiastical embroidery class in which she had enrolled in an effort to broaden her needlework skills, largely because I wanted to use stitching to identify the various women represented at the table. My lack of knowledge about needlework was matched only by my ignorance of Christian rituals and vestments, but perhaps it was precisely this innocence that helped shape my intense response. The room was full of church vestments and altar cloths, all beautifully embroidered by the women who were proudly standing by or demonstrating their needle techniques. They seemed altogether oblivious to the fact that their talents were being used to aggrandize a church that, like so many organized religions, had deprived women of equality for many centuries.

Moreover and most unsettling was the fact that the women received absolutely no tangible credit for their needlework; they were not even allowed to stitch their names onto the pieces they had spent months, sometimes years, creating. It was as if I were seeing women's larger historical condition illustrated in that room, which is part of what prompted me to undertake a systematic study of the history of needlework. I soon discovered that it was possible to perceive the various and often disquieting changes in women's circumstances throughout history mirrored in the needle and textile arts, a discovery I decided to incorporate into *The Dinner Party*.

Susan pointed out the richly embellished altar cloths that were on display at the show, suggesting that we might do individual runners for each of the plates, which could drop over the fronts and backs of the table. In addition to cleverly solving the problem of identifying the various women (their names could be embroidered onto the runner fronts), this format would provide a visual space in which I could use needlework to tell another layer of women's history. Moreover, it struck me that the difficulty of seeing the runner backs across the expanse of the table might be an apt metaphor for the difficulty of perceiving the richness of women's heritage through the filter of the dominant view of history.

Susan, Gelon, and Leonard became my basic studio team, which was rapidly amplified over the next few months, in particular by a young industrial designer named Ken Gilliam, who devised all of the ingenious systems that were to provide the structural and mechanical underpinnings for *The Dinner Party* installation. As my concept for *The Dinner Party* developed, many dozens of people came forward to help with what seemed like ever-expanding work, some for only a few days, others for several years. Slowly, teams evolved, not only in ceramics and needlework but also in research, graphics, photography, and fabrication.

Many studio members were eager for opportunities for leadership (opportunities that are still too often unavailable to women), and each team soon had a supervisor. These were chosen on the basis of skill, along with the willingness to make a significant time commitment and also assume leadership. The studio gradually became a structure of self-sufficient groups, working under my guidance while also building teamwork through shared responsibility and honest dialogue. Almost

everyone, including myself, worked as a volunteer, except for a few members of the primary team. We tried to raise enough money to pay those individuals small salaries so that they could be free to work full time on the project.

At the beginning I provided all of the funds from my own earnings, which came primarily from art sales, book royalties, and lectures. Gradually Gelon took on most of the fundraising, supplementing my personal funds by selling my preparatory drawings to supportive collectors, obtaining a few rather modest grants, and finally through soliciting many donations, both large and small. Some of these came from *Dinner Party* workers and their friends, who became increasingly committed to seeing that the piece be completed. At the end, a generous woman named Joan Palevsky co-signed a crucial loan, which Gelon and I later repaid from exhibition revenues. But we were always close to running out of money, which caused increasing anxiety as the years went by, since we would all have been devastated had we not been able to finish.

Early on, Gelon and I instituted the group process techniques that I had used in my earlier feminist art programs, which involved applying what has come to be called consciousness-raising principles to our weekly group meetings. Every Thursday night we held potluck dinner discussions. As we went around the table after supper, everyone was encouraged to speak openly about studio and other problems or—if we were having an intellectual dialogue or a guest speaker—to engage in the conversation, something some women, at least at first, were hesitant about doing.

Most of the studio work was done by women, but there were always men involved in addition to the two in pivotal roles. At one point there began to be some degree of conflict between the women and the men around issues of gender and authority. These were confronted—though never fully resolved—at several contentious Thursday-night discussions, after which I asked the men if they might like a separate group. I was quite surprised when they said they wished to be treated just like the women and remain a part of the group.

Thursday evenings were sometimes very difficult for me because, in addition to my long hours of studio work, I had to assume the role of facilitator. These sessions were often emotionally draining, but I recognized their importance in the building

of a team spirit. In addition, it seemed necessary to address and try to resolve the myriad of human conflicts that are inevitable in creative environments. But it was only during these Thursday-night discussions that I made myself available for questions, confrontations, or casual conversation.

The rest of the time, because the studio was organized around work, we established strict rules to protect the quiet and uninterrupted, concentrated focus essential to the creative process.

Thursday-night potluck and discussion

8

It was Gelon's job to keep all but work-related talk in the studio at a minimum and to discourage "hanging out" or long conversations about personal problems. Although this might have been troublesome for some, those who stayed soon learned that real achievement usually depends upon taking one's work seriously.

Over the years, as I encountered many statements and read a good deal of writing about *The Dinner Party*, I have been struck by some of the misconceptions that seem to have developed, particularly about the nature of the work process. Although there was certainly considerable collaboration in the studio, it took place within the framework of my leadership, both aesthetic and philosophical. I always encouraged people to bring their own ideas and skills into the artmaking process, but I retained both aesthetic control and final decision-making authority because, ultimately, it was my piece.

It is extremely difficult, however, to convey to people who weren't there—or whose cynicism blinds them to the gratification that can come from working with others in the service of a higher purpose—how utterly thrilling it was to participate in the task of representing women's history at a time when such history was largely unknown. Many of us felt that it was a great privilege to be involved with such significant subject matter, no matter how difficult or financially unrewarding the work might have been. Our belief in the crucial importance of our mission bonded us, forging a connection that has remained strong among a number of us even after so many years.

After considerable thought about both the final number of plates and the configuration of the table, I had finally settled on thirty-nine settings, thirteen on each side of what would be three wings of an open triangular table. The number thirteen refers to both the number of men present at the Last Supper and the number of women in a witches' coven. I found it an odd coincidence that the same number connoted male holiness and feminine evil, and I wanted to call those associations into question, inverting them to assert the sanctity of the feminine spirit.

The runners provided a perfect format for the identification of each goddess or woman, whose name is embroidered in gold thread edged with metallic gold floss. (This same embroidery also borders the long tablecloths.) The capital letter of each woman's

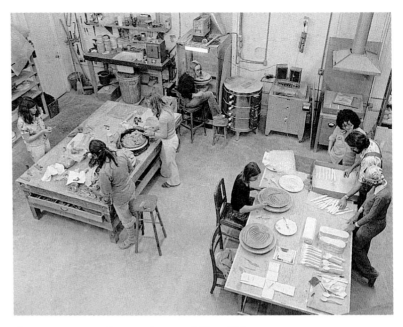

Ceramics team working with me and Ken Gilliam

first (and sometimes only) name is illuminated and elaborately stitched. Although each plate and runner is distinct—to reflect the many differences among the women represented—all of the place settings are exactly the same. Each includes lustred ceramic flatware, a similarly lustred ceramic goblet or chalice with a gold interior, and a napkin whose stitched gold edge repeats the embroidery on the names and the borders of the tablecloths. These table settings are intended as a dual metaphor, both domestic and religious, expressing the "containment" imposed by female role expectations while also calling attention to the indispensable though unacknowledged value of "women's work". Thus the place settings vigorously protest women's oppression, while at the same time honoring their many achievements.

The runners which are executed in a variety of needle and textile techniques incorporate decorative styles and motifs typical of the period with which each woman or goddess was associated while acting as a visual context for the plate. In addition to expressing aspects of each woman's life, they also symbolize something of the historical circumstances she faced. In some cases, the imagery on the plates overwhelms the runner design, implying that particular woman's courageous transcendence of oppressive conditions; in others, the runner design encroaches on the plate,

9

suggesting a historical atmosphere inhospitable to her aspirations. Sometimes there is a near-total congruence between the imagery on the plate and runner to suggest a similar consonance between the woman's ambition and prevailing social attitudes toward women. Then again, occasionally there is an intense visual tension between the plate and the runner, a symbol of that woman's rebellion against the constraints of her particular circumstances.

While doing needlework research at a museum one day, I was shown an elaborately embroidered and jewel-encrusted bishop's glove. The curator allowed me to try it on, and as I donned it, I remember being struck by the sense of importance it seemed to impart, partly the result of the many hours of human labor that had been lavished upon it. I wondered what it would mean to use such exquisite stitching in relation to women's—rather than men's—achievements. It was then that I decided to adapt some of the finest ecclesiastical embroidery techniques to the runners, particularly the triangular altar cloths that grace the three corners of the table.

Called "Millennium runners" and signified by the letter *M*—which is incorporated into the elaborate whitework designs—these three cloths symbolize the Millennium, which could be thought of as a time when women and men will become equal everywhere on the Earth. The shape of these corner runners repeats the configuration of *The Dinner Party* table, whose triangular form connotes an ancient symbol for both women and the Goddess. As I suggested, the sacramental or religious nature of *The Dinner Party* is a deliberate part of its imagery, intended—like the bishop's glove—to convey eminence and even sacred meaning to women's accomplishments, in part through the rich detail of the place settings.

In addition to representing either a goddess, a mythological figure, or a woman of achievement, each place setting also stands for a historical period, which is traditionally symbolized by the achievements of men. For example, fifth-century Greek thought is frequently discussed through the ideas of Plato or Socrates. In contrast, in *The Dinner Party* it is the scholar and philosopher Aspasia whose life and contributions represent this period. *The Dinner Party* might be thought of as a symbolic history of Western civilization as experienced and exemplified by women.

One of my objectives was to display a wide representation of women's experiences and achievements on the table. If I had already depicted a woman scientist, therefore, I tried to select someone of a different profession for later periods, even those in which there might have been more outstanding women in science. Each abstract portrait was intended to convey both a particular woman and women's larger relationship to various occupations. For example, Elizabeth Blackwell might not have been the greatest of all women doctors, but her story served to illustrate the many difficulties encountered by women trying to enter the medical profession.

On occasion I did not select a woman because I felt that I could not adequately symbolize her, a result of the limits on the available information or because something about her life prevented me from considering her. Ultimately, I had to make my decisions about inclusion based upon whether I could transform the historical information into cogent visual images.

It was while working on my research for the women to be represented on the plates that I had begun to realize how many women had struggled into prominence or been able to make their ideas known—sometimes in the face of overwhelming obstacles—only (like the women on the table) to have their hard-earned achievements marginalized. This discovery contributed to what I earlier described as a decision to position *The Dinner Party* table on a large triangular surface. This *Heritage Floor* would be comprised of 2,300 handcast white porcelain tiles and inscribed with the names of 999 other women of achievement, whose names become like a sea that ebbs in and out of view as one walks around the table, visually embodying the ephemeral nature of women's achievements.

The names on the floor were grouped together based upon some commonality of experience, contribution, historic period, and/or geography, then placed in relation to particular place settings in order to emphasize the fact that the achievements of the women represented on the table need to be seen in this larger context. The groupings, which form streams emanating from beneath each of the place settings, create a pattern that transforms history into a perceptible form. This *Heritage Floor* thus becomes symbolically, as well as literally, the foundation for *The Dinner Party* table.

up, then hand-written onto the tiles with gold lustre. Repeated applications and firings of an iridescent rainbow lustre not only helped to accomplish the desired visual metaphor but also produced colored shadows on the runner backs. These contribute greatly to the magical quality of *The Dinner Party*, which was literally "pieced together" from a myriad of fragments to form a symbolic picture of women's rich heritage.

It required over two years and a team of more than twenty researchers to complete the information about the women represented on the *Heritage Floor*. The research team, headed by Gelon and artist Ann Isolde, had to "read through" the biased way in which women are usually presented in historical materials. These dedicated researchers painstakingly ferreted out what we considered to be important about each woman—that is, what she had attained as an individual. This information was often buried in descriptions of her physical attributes or the achievements of the male members of her family, tribe, or clan.

The sometimes few facts about the woman were then typed onto index cards and cross-filed alphabetically—by country, century, and occupation—an arduous process that continued until we had compiled a card file chronicling the accomplishments of almost three thousand women. We then did something that women have rarely had the opportunity to do: that is define and shape the historical record, making choices for inclusion on the *Heritage Floor* according to three criteria that *we* established.

First, did the woman make a worthwhile contribution to society? This was sometimes difficult to determine because categories of achievement have been established primarily in relation to what men do and what men have deemed significant. Thus, although many women were responsible for the establishment of hospitals, schools, and social organizations, there was no such category as "founder of first hospital" and hence the often pioneering efforts of such women—though seemingly important—would be ignored by most historians. We therefore had to first expand the categories themselves before we could begin to make our assessments.

Second, had a woman attempted to improve conditions for women? We were to discover that choosing to work on behalf of other women usually resulted in that woman's activities being labeled insignificant or even being altogether excluded from the

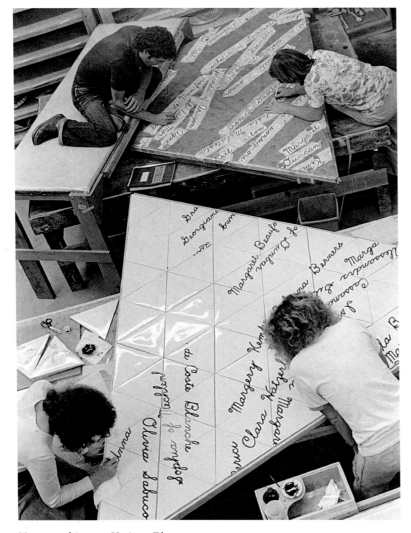

Team working on *Heritage Floor*

In addition to acknowledging that there were more women worthy of commemoration than I could undertake to honor, the relationship between the table and the *Heritage Floor* also challenges the idea that any woman can "pull herself up by her bootstraps." Actually, history demonstrates that singular women's accomplishments generally took place within an atmosphere of support, provided by a progressive family environment or a self-selected group of emancipated women; against a background of expanded opportunities for women; or as a result of widespread political or social agitation for equal rights.

The 999 names on the *Heritage Floor* were carefully gridded in the Palmer method of writing popular when I was growing

mainstream historical record. Even today, if a woman artist lists all-female exhibitions in her curriculum vitae, these are often dismissed as unimportant professional experience when her career is being evaluated. Needless to say, a comparable disregard for a male artist's list of shows composed exclusively of men would be unthinkable.

Our last criterion focused on whether the woman's life or work illuminated a significant aspect of women's history or provided a role model for a more egalitarian society. This last category was, to my mind, one of the most important because it seems to me that there is a great deal of meaningful human information embedded in women's experience that remains unapplied, largely because of sexism. As a result, the human race is frequently unable to benefit from the perspective and wisdom of half of its members.

The 999 women we eventually selected to honor on the porcelain floor are all identified in the *Heritage* panels, a series of hand-colored photo murals that list each of these women in relation to the place setting with which her name is grouped. Although I am not a devotee of numerology, I was determined that all of the numbers associated with *The Dinner Party* should possess some symbolic significance; thus the number 999, which has definite biblical connotations. Moreover, it also refers back to the number of wings on the table in that it is a multiple of three, which is, of course, also associated with the Trinity.

By the time *The Dinner Party* was completed, it was probably better described as a project rather than a work of art. Because the historical information that the piece embodies proved to be so vast, I kept expanding my concept, adding multiple layers to express the many aspects of women's history that were being uncovered. The plates, the runner designs and needlework techniques, the narrative information on the runner backs, the illuminated capital letters, the *Heritage Floor* and accompanying photo panels all convey various features of this rich and engrossing story.

The inclusion of women's crafts, like china-painting and needlework, was intended to pay homage to women's too-often unacknowledged creative contributions while calling into question some of the distinctions between "high" and "low" art. However, it is important to remember that the physical structure of *The Dinner Party* depends upon a fusion of these "womanly" arts with what are often considered more "manly" techniques. This suggests that there are numerous arbitrary categories, often based on gender, that serve only to stifle the imagination, as well as the human spirit.

During my years of research for *The Dinner Party*, I became acutely aware that the women whose stories I was finding were primarily from the ruling or privileged classes. This is, of course, because history has been written mainly from the point of view of those in power. To achieve a truly universal history, we would need a record that included all of humankind, in its full diversity. Until that time comes, I hope that people will accept the idea that, by implication, a symbol can be inclusive.

Certainly, one of my aims was to call into question the way in which history has been written. I wished to suggest that if the historic record has so excluded women (because it has been either written or controlled by men or a male perspective), it would be possible for women—or in fact any excluded or marginalized people—to present a similarly exclusive history, thereby demonstrating how incomplete the dominant historical picture actually is. However, I wish to emphasize that *The Dinner Party* does not attempt to be a precise or objective history but, rather, an imagined chronicle based upon historical fact.

Even though the women represented at *The Dinner Party* were not literally those who did the cooking or serving (had they been, their lives and activities would probably not have been recorded at all), they have nonetheless been obscured or at the very least, denied their full place in history. The women I chose to represent tried desperately to make their voices heard; they struggled valiantly to gain or retain some degree of influence; they attempted in innumerable ways to implement or extend the power that was theirs; and they courageously endeavored to do what they wished or deemed best during periods when women were too often expected to follow the lead of men or otherwise subvert their ambitions.

In my "Last Supper," these women are the honored guests and featured heroes. However, instead of being seated at the dinner table, their symbolic portraits are presented *on plates* as a metaphor for the fact that their accomplishments—rather than being appropriately commemorated and memorialized—have

been "consumed" by a historical process that far too often has left us out.

The Dinner Party installation is introduced by a series of woven tapestries, executed in the Aubusson technique typical of Renaissance pictorial weavings. These banners include a series of short phrases suggesting that women, women's history, and women's perspective must be entirely recognized—and more integrated into all aspects of human civilization. Until that time, a time that will surely come, women will remain locked into a cycle of "cruel repetitiousness," poignantly described by Gerda Lerner in *The Creation of Feminist Consciousness*:

> Men develop ideas and systems of explanation by absorbing past knowledge and critiquing and superseding it. Women, ignorant of their own history, [do] not know what women before them had thought and taught. So generation after generation, they [struggle] for insights others had already had before them . . . [resulting in] the constant reinventing of the wheel.

I do not know whether I was always entirely conscious of the degree to which *The Dinner Party* demonstrated this cycle, but I was certainly convinced that women's ongoing oppression was directly linked to the annihilation of our history. One of my primary goals was that this arduously pieced-together symbol of women's heritage would become an ineradicable part of our cultural history. Even before *The Dinner Party* was finished, I began to make plans for a porcelain room whose form would extend the imagery of the piece. Although this is not the only shape such an installation could take, permanently housing *The Dinner Party* was and is my ultimate goal; its loss would be yet another tragic example of the "cruel repetitiousness" cited by Lerner.

In March 1979, *The Dinner Party* opened at the San Francisco Museum of Modern Art, brought there by then-director Henry Hopkins. He had been committed to the project for a number of years, and his long-term support had been crucial in numerous ways. At one point he insisted that we start our own nonprofit arts organization to handle the many small donations that were helping to fund the completion of the piece. A newly established lawyer named Susan Grode volunteered to charter Through the Flower (named after the initial volume of my autobiography). Certainly, I for one could never have imagined how important the corporation would become to *The Dinner Party*'s future and my work. All I knew was that I and all my co-workers would have done whatever was necessary in order to finish the project. However, once we had been incorporated—stimulated in part by the intense enthusiasm that was being generated by the imminent premiere of the project—we began to discuss the idea of turning the loosely structured studio into a more formal institute. We hoped to offer classes and workshops and also provide support for other artists whose goals, like mine, were education, empowerment, and social change. But most of all, we fervently hoped that *The Dinner Party* would be a tremendous success.

The opening of the exhibition was one of the highlights of my life. Five thousand people attended, many standing in line for hours to see the art. Throughout the evening, I was presented with gifts, covered with flowers and congratulated. All of *The Dinner Party* workers were there in their party best, most of them ecstatic at having achieved the fulfillment of so many years of effort. During the three months that the work was on exhibit, there were long lines almost every day and a total audience of 100,000 viewers.

Another one of my goals in undertaking such a monumental work of art was to test the art system, to find out whether a woman artist, working at a level of aspiration not that unusual for men, would be rewarded and celebrated. For some months I believed that the answer was "Yes." I had conceived *The Dinner Party* to travel, several venues were lined up, and I thought that the ongoing positive audience response, the financial benefit to the museum through ticket and product sales, and the extensive and largely positive media coverage would assure a successful exhibition tour. Instead and somewhat inexplicably, the other institutions cancelled and no other bookings materialized.

At the end of its first exhibition, *The Dinner Party* went into storage and I went into shock. But that is a story that will have to wait until the conclusion of this book to recount. Now I would like to introduce you to the work of art and the rich history that it symbolizes.

PART TWO

The Creation of
The Dinner Party

In the first of the two original books about *The Dinner Party*, a long, handwritten narrative graced the top of the book pages. This narrative—created from the many fragments of women's history that I uncovered in the long years of research for *The Dinner Party*—presented a historical story far different from the one widely accepted as the official history of Western civilization. Although it may not be literally exact, I believe it to be symbolically true, and it is symbolic truth that *The Dinner Party* conveys.

This mythical narrative provided the historical, philosophical, and imaginative underpinnings for the imagery in *The Dinner Party*. Newly edited, this chronicle recounts women's ongoing resistance to the gradual development of patriarchal societies, which by now have come to be seen as both universal and the norm. Though it is difficult for many people to imagine a world in which male dominance is not all-pervasive, *The Dinner Party* suggests that there was once such a time and, by implication, that there can be such a time again.

IN THE BEGINNING,

the feminine principle was seen as the fundamental cosmic force. Many ancient peoples believed that the world was created by a female deity who brought the universe into being either alone or in conjunction with a male consort, usually her son, whom the Goddess created parthenogenetically. Perhaps it was because procreation was not understood to be connected with coitus that some thought that women—like the Goddess—brought forth life alone and unaided. Awe of the universal Goddess was expressed as reverence for women, and the female body was repeatedly represented as a powerful symbol of birth and rebirth.

Woman's creative power was embodied in a multitude of female figurines that emphasized breasts, belly, hips, and vulva. These statues have been discovered beneath the remains of civilizations all over the world, signifying a time when women were revered, a veneration that translated into social and political authority. Archaeological evidence suggests that these gynecratic agricultural societies—which were egalitarian, democratic, and peaceful—gradually gave way to male-dominated political states in which occupational specialization, commerce, social stratification, and militarism developed.

As men gained control of civilization, the power of the Goddess was diminished or altogether destroyed. For the first time, the idea arose that life originated entirely from a male—rather than a female—source, a dramatic change in thinking that is possible to trace in myths, legends, and

images of the Goddess. Her original primacy gave way to gradual subordination to male gods. In some cases, the sex of the female deity was simply altered and her attributes transferred. Then the rituals and temples of the various goddesses were taken over by religions dedicated to male gods. Soon the originally benevolent power of the remaining goddesses began to be viewed as negative, destructive, or evil. Finally the Judeo-Christian tradition absorbed all deities into a single male godhead.

At first the Jews, like many early peoples, worshiped both God and Goddess. It required six centuries for Yahweh to replace Astoreth as the primary Jewish deity, though for a long time their temples stood side by side. After the Jewish patriarchs finally succeeded in destroying Goddess worship, women's former status gradually diminished.

*T*his same story is repeated in culture after culture. As a result of successive Greek invasions, the matriarchal culture of Crete was overthrown and Cretan deities incorporated into Greek myths. Although the Greeks were already patriarchal by this time, Goddess worship continued there, as it would in Rome. But Greco-Roman goddesses paled beside their historic antecedents, and the position of Greek women was summed up in this famous remark by an Athenian philosopher: "That woman is best who is least spoken of among men, whether for good or evil."

The destruction of the Goddess reflected the gradual erosion of women's political, social, and religious authority. However, women did not passively accept this loss of power, as is evidenced in legends, literature, and images about the Amazons and various warrior queendoms. It is unknown whether women warred among themselves during the thousands of years of gynocracy, but myths suggest that some of these societies engaged in warfare against the emerging male-dominated societies in a vain effort to turn the tide.

While Roman women were in a similar legal position to that of their Greek predecessors, in actuality they were far less oppressed. Although women were considered "perpetual minors" and subject to the jurisdiction of their fathers and husbands, public sentiment was at odds with the laws. As a result of protests organized by Roman women, these laws were improved, though the gains were short lived.

*W*hen Christianity first developed, there were a number of early religious communities in which men and women enjoyed equal rights, partly as a result of their commitment to the idea that "in Christ there is neither male or female." Throughout the early Middle Ages, the Church offered women refuge from the invasions and violence that made them subject to capture, rape, and forcible marriage. Many girls went to convents to be educated, sometimes making religious houses their

permanent homes or returning to them in later life. Those who wished to devote themselves to scholarship and the arts gathered in the convents with or without taking vows.

During these years, upper-class women began to lose more and more of their property rights. In an effort to retain their lands, countless noblewomen established and ruled religious houses as abbesses, a process encouraged by the Church. As many abbesses were members of the royal families, they were allowed the rights and privileges of feudal barons and often acted as representatives of the king during his absence. These women frequently administered vast lands, managed convents, abbeys, and double monasteries, provided their own troops during wartime, enjoyed the right to coinage, and were consulted in political and religious affairs.

*I*n the later Middle Ages, the family emerged as the most stable social force of the secular world. Because women were generally central to the family, some played major roles in their communities. Wealthy women were able to own and administer property, and when their husbands were away, they often managed the estates, presided over the courts, signed treaties, made laws, and sometimes even commanded troops. In their courts, royal women supported troubadours who traveled around singing songs venerating both women and the Virgin Mary. It was during this period that worship of Mary increased among all classes of women.

As Christianity spread, it absorbed many indigenous religious practices, including the ongoing worship of the Goddess, maintained particularly by peoples far away from the centers of power. In an effort to obtain converts, the Church had allowed this worship to be transferred to the figure of Mary, whose image was derived from the ancient Goddess with her son/lover on her lap. Mary worship became so common that it was often said that "in the thirteenth century God changed sex." But by the end of the Middle Ages, the Church was well established and increasingly unwilling to tolerate a female deity.

At this point in history, Church leaders no longer needed help from women in the spreading of Christian doctrine, as they had in earlier centuries. This made them more willing to attack the last vestiges of Goddess worship and to restrict women's remaining power even further. In some cases, Goddess worship was tied to the practice of witchcraft, which the Church had permitted for centuries. But Church leaders—all of whom were men—felt more and more threatened by the prominent position women occupied in the witches' covens. In addition, a number of heretical sects had developed in which women were allowed to preach, a practice that incensed the Church.

The Church joined hands with the emerging nation-states of Europe to build the social and political institutions that were to become the foundation of modern society. Using the Inquisition to eliminate all those who resisted their authority, Church leaders targeted witches, heretics, lay healers (who practiced medicine despite the objections of male physicians), political dissenters, and

peasant leaders (many of whom were women), as well as anyone who protested the power of the Church and the consequent destruction of what was left of female authority.

*W*itch hunts were prevalent from the thirteenth century through the seventeenth. According to male scholars, no more than three hundred thousand people were murdered, but contemporary feminist scholars speculate that there were many more. Eighty-five percent of those accused and executed as witches were women, and the terror induced by the witch hunts, combined with the decline of feudalism and the steady contraction of women's position, virtually eliminated women's independent power. By the late Renaissance, the economic and political base that had supported their medieval predecessors had disappeared; women were barred from the newly formed universities, craft guilds, and developing professions.

Women's property and inheritance rights, slowly eroded over the centuries, were totally eliminated. Marriage became the only acceptable option for women, and when the convents were dissolved by the Reformation, female education—formerly available through the Catholic Church—became increasingly difficult to obtain. To the Reformers, any intellectual aspirations by women were considered not only absurd but perilous. They never tired of repeating that a woman's learning should be restricted to reading and writing for the purpose of teaching the Bible to her children.

*R*eformation leaders insisted that a woman's sole duty was silent obedience to her husband, though within the family, women were accorded some degree of respect. Because work was centered in the home, women's lives were busy and productive, as the activities of all the family members were crucial to economic survival. The Reformation supported some education for women though only for purposes related to the family. However, having access to at least some modicum of education gradually contributed to women's advancement, however slow.

But when the Industrial Revolution took work out of the house, the consequent separation between work and home had a profound effect on women's condition. Women's household work ceased to have importance as far as the world's values were concerned. Middle- and upper-class white women were expected to be only the leisured helpmates of men, while lower-class women of all races were economically exploited. This, coupled with the development of the Victorian ideal of a passive and dependent wife, made most women's lives doubly burdened, with so few options that there is little wonder that a women's revolution began.

In 1792 Mary Wollstonecraft wrote her Vindication of the Rights of Woman, *a book that provided a cornerstone of feminist theory and the subsequent revolution. She argued that if women failed to become men's equals, the progress of human knowledge and virtue would be halted*

and that the tyranny of men had to be broken both politically and socially if women were to become free. Her writings fueled action around the world.

In 1848 a group of American women met in Seneca Falls, New York, and addressed themselves to eighteen grievances. They demanded the right to vote, to be educated, to enter any occupation, to have control over their own bodies, to sign legal papers, to manage their earnings, and to own and administer property. At first the outcry was enormous and women were ordered back to their "place," but the women persisted, eventually changing many of the laws that had restricted women's lives. Moreover, they built a movement that became international in scale.

All over the Western world, women began agitating for their rights, and it seemed that no force could stop them and that full equality was in sight. But the initial thrust of the women's revolution was met by an overwhelming force that began to push women back into the confines of the home.

It was not only the legal system that oppressed women but, more important, guilt and ignorance. Women were repeatedly told that the fight for women's rights had been won and that their experiences to the contrary were not relevant. They were made to feel guilty for their aspirations and were told that their desire for equality was threatening to men. Most of all, women were systematically deprived of any knowledge of their foremothers' efforts. The women's revolution, like women's entire heritage, was obscured. Women were prevented from discovering the heroic efforts made by their predecessors in the previous centuries. They also had no way of knowing that women had been fighting for freedom and dignity from the moment that they first lost their Goddess and their power.

The Dinner Party presents a symbolic history of this obscured yet heroic past, pieced together from small fragments to form a visual image of women's long struggle for liberation throughout the history of Western civilization. The women represented are either historical or mythological figures, brought together—invited to dinner, so to speak—in order that what they have to say might be heard and the range and beauty of women's heritage become known and appreciated. Sadly, most of the 1,038 women honored in The Dinner Party are still unfamiliar, their lives and achievements unknown to most people.

To make people feel worthless, society robs them of their pride; this has happened to women. All of the institutions of our culture tell women in words and deeds—or, even worse, through omission—that women are insignificant. But one's heritage is one's power; women can know themselves and their full capacities by seeing that other women have been courageous and strong. To reclaim this heritage and insist that it become a part of human history is the task that lies before all human beings.

For the future requires that men accept women as full partners in shaping the world's destiny.

THE DINNER PARTY PRESENTS a mythological visual narrative, one that is woven from fact and fancy to express an imaginative picture of women's long struggle for freedom and dignity. The place settings and groupings of names on the *Heritage Floor* represent women's history until the end of World War II. I chose this historical moment as the termination point for my visual chronicle because I believe that by then women had begun to gain those intellectual and aesthetic tools essential to the expression of our full creative powers. This pivotal moment is marked by the place settings for Virginia Woolf and Georgia O'Keeffe. The imagery on the plates honoring these two great female creators hearkens back to the early Goddess plates, the final dimensional forms of the Woolf and O'Keeffe plates echoing and expanding upon the fecund images representing the ancient goddesses. This repetition is intended to link past and present in a visual metaphor suggesting the contemporary reemergence of female creative power.

In this book, the thirty-nine place settings are grouped by wing, with brief descriptions of each of the women represented, along with selected black-and-white photographs of place settings, plates, runner details, and capital letters. Immediately following each of these illustrated descriptions is a listing of those names from the *Heritage Floor* that are grouped around the place setting. By positioning them in this way, I hoped to amplify the tradition of achievement that each place setting symbolizes.

I spent many hours carefully editing the 999 entries that comprise the *Heritage Floor*, frequently marveling at the youthful audacity that impelled me to take up a job seemingly more fit for a devoted academic than an impassioned artist. But at the same time, I could vividly recall how frustrated I felt while in the midst of the original research. It seemed as if no trained historians were willing to help transform this twentieth-century woman artist's desperate search for her heritage into a historical log whose excellence could not be faulted. Even today, when women's studies courses abound, I remain dismayed by how few people have been able to replace the traditional male-centered view of history with a fuller picture of the past. Therefore, and despite my limitations, I continue to feel obligated to the history that *The Dinner Party* embodies.

While preparing these listings for this new publication, I tried to strike out some of the assumptions that now appear more a product of feminist anger than solid scholarship and also to limit the information about each of the 999 women to that which seems both most important and verifiable. Although some of the women cited on the *Heritage Floor* have died since *The Dinner Party* premiered, I have left their dates as they originally appeared.

I hope that the reader will be forgiving of this somewhat imperfect historical record and realize that it is its symbolic meaning that is most significant—and also most saddening. The story conveyed by *The Dinner Party* attests to the fact that, throughout history, while women have struggled to participate in the making and remaking of civilization, their efforts have not been sufficiently remembered or acknowledged. Moreover, in addition to the women included here, there are certainly countless others no less worthy of commemoration whose lives and contributions were beyond my ability to research.

Even if the history symbolized by *The Dinner Party* is found to suffer from inaccuracies of fact or detail, its greater importance rests in its reminder that women have a rich heritage. We have contributed in countless ways to the social and political changes, the intellectual currents, and the aesthetic strivings of the great human dramas of history. My profound hope is that, unlike Christine de Pisan's *Book of the City of Ladies*, a fifteenth-century precursor to *The Dinner Party*, this contemporary listing will be more than just a fleeting recitation of hundreds of women's names but, instead, a foundation for a different future, one in which both women and men will be raised with an understanding of the full history of the human race.

WING ONE

From Prehistory to Classical Rome

THE FIRST WING OF THE TABLE BEGINS with prehistory, which is presented in the first seven place settings. The eighth plate, which depicts Hatshepsut, one of the four female pharaohs of Egypt, is intended to straddle the mythological and real worlds, as pharaohs were thought to incarnate the power of the deities. Her plate is the first to include a slightly reliefed surface, a visual metaphor for the struggle for liberation that is developed in the later plate images.

The initial place settings present a series of Goddess figures. These are intended to represent prepatriarchal society, which was typified by the widespread worship of the Goddess. The early runners incorporate simple textile techniques and various motifs that emphasize the importance of the Goddess in the development of needlework, attested to by a variety of ancient myths and legends. The invention of weaving and spinning was often attributed to a number of female deities, who are described as having both taught these skills to women and sanctified their work.

The next sequence of place settings chronicle the development of Judaism, early Greek societies, and then the emergence of Rome as the center of the so-called civilized world. The decline of the Roman empire, while marking the end of the classical world, also brought significant alterations in women's circumstances. The earlier periods that featured some measure of social and political power gave way to increasing disenfranchisement, legal restrictions, and in some cultures, the sequestering of women. These changes are reflected in the runner designs on the first wing of the table and epitomized by the last image, that of Hypatia. Her place setting, and particularly the runner back, symbolize the terrible punishment inflicted upon some of those women who attempted to maintain the ancient tradition of reverence for both women and the Goddess.

FACING PAGE: *Millennium Triangle I* embroidery, cutwork and petitpoint; executed by a team of needleworkers

Primordial Goddess

(MYTHIC)

Primitive female creative energy is embodied in the first plate on the table, that of the Primordial Goddess, who symbolizes the original feminine power from which all life emerged. Her center is dark and molten; she is the primal vagina, the sacred vessel, the gateway to existence, and the doorway to the abyss. In the beginning, life and death, inseparable parts of the endless process of rejuvenation and decay, were merged in her body. There was a time when there was no distinction between this Primordial Goddess, the Earth, and the Earth's daughter, Woman; all were considered one, part of the mysterious female universe. As human beings watched plants grow from the body of the Earth and life spring from the body of Woman, they were awed by this nameless force and could only venerate the magical power possessed by the feminine spirit.

The image on the plate that symbolizes this early goddess figure is an undeveloped butterfly form, whose wings are not yet evolved from the flesh/rock substance comprising her shape. Originally named Gaea, after the Greek goddess who embodied the idea of this universal female principle, I changed the name upon realizing that the image depicts a concept that existed before written language. Studying early pictographs to see how this Primordial Goddess was represented, I discovered that only primitive markings or holes in rocks and sacred stones conveyed her power, which was so immense that it could barely be symbolized.

The Primordial Goddess plate rests on a runner with an illuminated letter in the shape of a spiral or coiled form, a reference to some of the earliest shapes fashioned by female hands. This was the basic shape of a pot

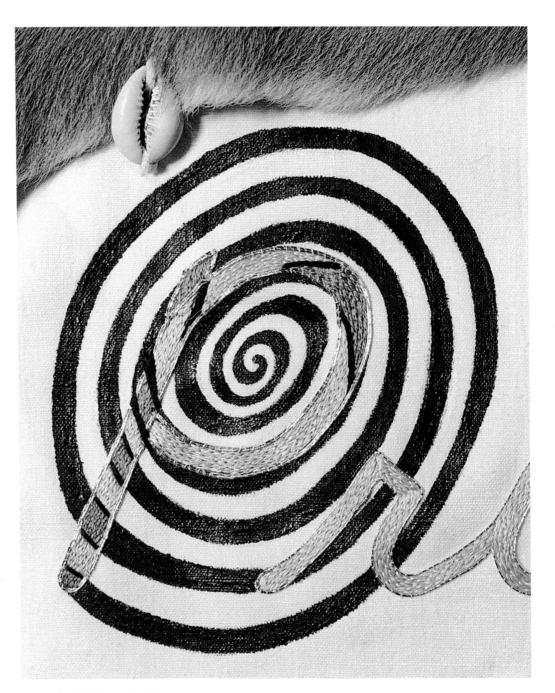

Primordial Goddess capital letter

or a basket, the object that allowed our foremothers to store precious water and to carry their possessions out of the cave and into the beginnings of civilization. Stretched over the surface of the runner and surrounding the plate are animal skins, referring to the earliest forms of clothing. These are stitched to the linen with cowry shells, which were an ancient symbol for women and the earliest form of money.

Grouped around the place setting for the Primordial Goddess are the names of other goddesses, beginning with those who were seen as the sole creators of the universe.

AJYSYT *(Mythic, Siberia)*: Ajysyt, whose name means "birth giver" or "procreator," was the Siberian goddess of birth. She was referred to in many prayers as the "Milk Lake Mother," a reference to the divine lake that supposedly exists beside the Tree of Life in the center of the Earth.

ARURU *(Mythic, Babylonia)*: When the god Marduk created the Earth, it is said that he called on the goddess Aruru to help him fashion the human race out of clay. In a fragmentary myth, Aruru is described as forming these first humans herself by mixing clay with the blood and flesh of another deity killed in a great battle.

ATIRA *(Mythic, North America)*: Atira, "Mother Earth and Universal Mother," was held in deep veneration by the Plains Indians. It was she who had brought forth life and it was into her body that all life would return at the end of its appointed time. Her symbol was the ear of corn, to represent the idea that, as the kernel is planted in Mother Earth (Atira) and she brings forth the ear of corn, so the child is begotten and born of woman.

EURYNOME *(Mythic, Greece)*: Eurynome—the "goddess of all things"—was a virgin goddess of creation who rose naked out of chaos. After dividing the sea from the sky, she began to dance on the waters and, through her wild and ecstatic motions, created the North Wind. By grabbing the wind and rubbing it between her hands, she produced the great serpent Ophion, who coupled with her. Assuming the form of a dove above the waters, the goddess then laid the universal egg and commanded Ophion to coil around the egg seven times until it hatched and split in two. Out of this egg came the Sun, Moon, planets, stars, and the Earth with all its vegetation and living creatures.

GAEA *(Mythic, Greece)*: Gaea, described in one myth as sending up fruits from the soil to nourish the human race, was the principle behind the life-to-death cycle and the goddess to whom all creatures eventually returned. According to ancient creation myths, Gaea, who originally emerged from chaos, gave birth to her husband, Uranus (or Heaven), the mountains, and the sea.

GEBJON *(Mythic, Sweden)*: A fertility goddess, Gebjon was identified as the "Giver," who gave the king of Sweden so much pleasure through her knowledge of magical arts that he offered her as much land as she could mark out with a plowshare in a day and a night. It is said that she dug the plow so deeply that it tore away the entire crust of the Earth, which was later filled in to become a lake; the soil removed from the crust became the island of Seeland.

ILMATAR *(Mythic, Finland)*: Considered the virgin daughter of the air, Ilmatar was a primary goddess thought to be responsible for all of creation. Myths say that because she became tired of floating alone in space, Ilmatar flew down to the bottom of the ocean, where she remained for seven hundred years, creating Heaven and Earth from the seven eggs of a wild duck. At the end of this time, she was said to have given birth to a son parthenogenetically.

NAMMU *(Mythic, Sumeria)*: Nammu was also described as "She Who Gives Birth to Heaven and Earth" and the "Mother of the Deities." Thought to have been conceived from the union of the goddesses of water, air, and earth, Nammu gave birth to other gods and goddesses and, with their help, created human beings from the clay that hung over the abyss.

NEITH *(Mythic, Egypt)*: Neith, described as a virgin goddess who was self-created and self-sustaining, personified the female principle from very early times. Neith was also called the "Great Weaver," said to weave the world on her loom as a woman weaves cloth. She was sometimes represented as a goddess of hunting and was worshiped in the form of a fetish made of two crossed arrows on an animal-skin shield. Later, Neith was depicted as a woman with a bow and arrows in her hand, also appearing as a cow goddess with the head of a lioness.

NINHURSAGA *(Mythic, Sumeria)*: The ancient Earth goddess of Sumeria was originally called "Mother of the Land." Her life-giving powers were symbolized by twigs sprouting from a "horn-crown" (ears of corn over her shoulders) or a cluster of dates from the Tree of Life in her hand. Ninhur-saga was considered the fertile soil that gave birth to all vegetation and, with her son/lover, to have produced all plant and animal life on Earth.

NUT *(Mythic, Egypt)*: Nut, the goddess of the sky, was represented as a woman with an elongated, arching body that vaulted the Earth with her fingertips and toes. Sometimes described as the woman along whose body the Sun traveled, her star-studded belly was depicted as holding all the constellations and forming the curved dome of Heaven. It was believed that she gave birth each morning to the Sun and every evening to the stars.

OMECIUATL *(Mythic, Meso-America)*: Omeciuatl, the "Lady of Our Subsistence," was originally considered the direct creator of the spirit of human life and the source of all nourishment. The most ancient Mexican creation myth states that the goddess gave birth to a sacrificial knife made of obsidian. This knife was thought to have fallen upon the northern plains, giving birth as it fell to sixteen hundred goddesses and gods.

SIVA *(Mythic, Russia)*: Siva was usually represented with an ornamental headdress suggestive of the sun's rays. In her left hand Siva held a sheaf of wheat and, in her right, a pomegranate, both symbols of the fertility of the female Earth.

TEFNUT *(Mythic, Egypt)*: According to one myth, Tefnut came into being when Re-Atum, the Sun god, united with his shadow; according to another account, this occurred when he coupled with the cow goddess, Hathor. As a result of one of these acts, Tefnut, the wet atmosphere, and her brother/husband Shu, the dry atmosphere, were born. She and her brother symbolized the two opposite forces that, according to Egyptian beliefs, had to unite to produce life. Together, they created the Heaven and the Earth.

TIAMAT *(Mythic, Babylonia)*: Tiamat personified the primordial sea, representing the blind forces of primitive chaos against which the male gods struggled. She was described as having been killed by one of her descendants, the god Marduk, who used her body in the creation process. According to the myth, Marduk broke Tiamat's body as if it were a reed, using one half to make a covering for the sky and the other half for the construction of the Earth.

Fertile Goddess

(MYTHIC)

From a generalized concept of the universe as an amorphous, feminine being with all living creatures merged into one force, distinctions began to arise. Human beings were gradually able to recognize themselves as separate from the animals, from the plants, and from the Earth itself. But people did not yet understand the biological process of reproduction. It seemed as if all that sustained human life emanated from women, who appeared supremely powerful. The essential parts of the female body were endowed with the miraculous power of procreation, and woman's body was worshiped as a symbol of birth and rebirth, as well as a source of nourishment, protection, and warmth.

Images with female body parts have been discovered underneath the remains of numerous civilizations. Sometimes called fertility goddesses, these are actually female deities who have little to do with sexuality. Rather, they embody the mystery of birth and death and the renewal of life. Manifestations of ancient Goddess worship can be found throughout the world, and figures like the famous Venus of Willendorf—with its pendulous breasts, large belly, and rounded buttocks—were the source for this image, the Fertile Goddess.

The plate sits on a roughly woven and stitched runner meant to evoke the early stages of human civilization, while also commemorating the development of weaving and pottery, which were probably invented by women. Clay goddess figures resembling effigies from prehistoric times adorn the runner, along with shells, starfish, and simple coiled shapes that hearken back to the many symbols by which the Goddess was depicted.

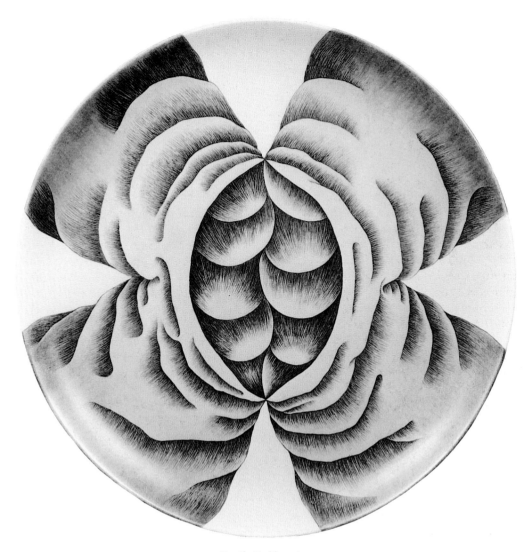

Fertile Goddess plate

The goddesses grouped around the place setting for the Fertile Goddess represent the worship of women's generative power and procreative function, which were often projected into the magical properties of goddesses.

BONA DEA *(Mythic, Rome)*: Bona Dea was an agricultural divinity representing the maternal, procreative principle in nature. A festival to ensure prosperity and well-being was held in her honor every December. A goddess of the feminine power of healing, Bona Dea was associated with health and longevity. In the temple devoted to her worship, there was a cave filled with sacred snakes and herbs to cure sterility and the diseases of women.

BRIGID *(Mythic, Celtic Ireland)*: Brigid was an ancient Irish fertility goddess whose mythology was later incorporated into the figure of St. Bridget. Frequently represented as a triple goddess and thought of as the goddess of plenty, she was associated with the fruits of the earth as well as with the fire and the hearth. As St. Bridget, she was later considered the patron saint of culture, skills, and learning.

CARDEA *(Mythic, Rome)*: Originally considered the goddess of the four winds, Cardea ruled over the "celestial hinge" at the back of the North wind, where the universe was said to revolve. As "Queen of the Circling Universe," she was described as living at the axle of the cosmos and holding the keys to the Underworld. She was also associated with the bean plant. Because it grows in an upward spiral, the bean suggested resurrection to ancient peoples, who believed that ghosts tried to be reborn by entering into these beans, which were to be eaten only by women. In primitive times only priestesses could plant and cook these beans, while in classical times they were used as a charm against witches and as an offering to the souls of the dead. Also personified as an Earth goddess, Cardea was connected with wooded groves and the Moon. Messages from the goddess were thought to come through the wind, and inspirational trances were believed to be induced by listening to the wind in the trees of a sacred grove. Legend says that Cardea was captured by the ancient Latin god Janus (an early form of Jupiter) and forced to become his mistress. After marrying the goddess, Jupiter put her under his total control, then gradually assumed her characteristics. Cardea was eventually transposed into a figure with the menial job of keeping witches away from the nursery door, then relegated to an entirely subordinate position in which she was portrayed as a demon that she herself had to guard against.

DANU *(Mythic, Celtic Ireland)*: Danu, the goddess of plenty, was originally considered the universal mother who represented the Earth and was also associated with the Moon. Thought to watch over crops and cattle, she was described as giving birth to the Irish deities who presided over the Tuatha de Danaan, a confederacy of tribes in which kingship descended through matrilinear succession. Later, the gender of the goddess was changed, along with her name, which became *Don*. In Roman records, *Don* turned into *Donnus*, the divine father of a sacred king.

FREYA *(Mythic, Norway)*: Freya, said to be the daughter of the Earth Mother Nerthus, was the goddess of love, marriage, and fecundity and the Scandinavian mythological counterpart of Venus and Aphrodite. In Norway Nerthus was replaced by the god Nord, who came to be considered the sole creator of Nerthus's children, Freya and her brother, Frey. Freya later became identified with the goddess Frig, who, as the wife of the sky god, Odin, was described as the goddess of the atmosphere and clouds.

FRIJA *(Mythic, Germany)*: Although goddesses did not play as important a role in Teutonic mythology as they did in many other cultures, Frija is one goddess who seems to have been revered by all the German tribes. Described as the goddess of marriage, love, and the home, everything was said to be known to her, and nature was considered to be under her control.

HERA *(Mythic, Greece)*: Hera, the Greek goddess who presided over all phases of feminine existence, was originally thought of as the queen of the sky and the celestial virgin. After her marriage to Zeus, however, she lost her cosmic attributes and was described primarily in relation to marriage and maternity. Although myths describe her as the chief feminine deity of Olympus, sitting on a golden throne next to her husband and with him receiving the honor of all the other deities, her power was significantly restricted by Zeus. In classical Rome, where she was known as Juno, she was seen only as an ideal woman and wife.

JUNO *(Mythic, Rome)*: Juno was venerated by the Etruscan, Sabine, and Umbrian tribes as a Moon goddess and the feminine principle of celestial light. With time, she became associated with childbirth and, as a symbol of the matron, was honored in Roman rituals celebrated exclusively by women. She was worshiped until after the time of Christ.

MACHA *(Mythic, Celtic Ireland)*: Macha, a fertility goddess and the patron of the capital city of Ulster (then known as Emain Macha), was thought to look after the fertility of the earth, animals, and humankind. Also a fearful warrior queen, she was sometimes associated with two other goddesses, who together formed a triad of warrior goddesses. They were said to preside over battles with their supernatural powers and shifting identities. Macha was forced to race against a team of horses. Despite the difficulty of this feat and the fact that she was pregnant, she won. But soon after giving birth to twins, she died, imposing a curse on the warriors of Ulster that was intended to incapacitate them for nine generations. Whenever they entered battle, they were to be stricken with the pains of childbirth, which would make them experience the same agony Macha had suffered before her death.

MADDERAKKA *(Mythic, Lapland)*: It was said of Madderakka, a birth deity, that through the creation of the body of her own child, she had rendered both women and cattle fruitful. Originally regarded as the mother of all deities, her power was gradually diminished.

NERTHUS *(Mythic, England)*: Worship of the Earth Mother Nerthus was brought from the Near East and the eastern Mediterranean to ancient England, southern Denmark, and northern Germany. Her cult, which was extremely popular, originally included specifically feminine rites, and she was usually represented on cauldrons as a woman with a gold collar around her neck, flanked by two oxen. This image referred to an annual ritual in which an image of Nerthus was taken around the countryside in a wagon pulled by oxen. The icon was stopped for prayers and feasting, as this was thought to ensure good crops. In the patriarchal society of Norway, Nerthus was transformed into the god Niord, and some of her fertility attributes were taken on by his son, Frey.

NINTI *(Mythic, Sumeria)*: According to legend, the goddess Ninhursaga allowed eight lovely plants to sprout in Paradise. Though it was forbidden to eat these, Enki, the water god, did so, thereby enraging Ninhursaga. After she condemned him to death, he fell ill, his strength failed him, and eight of his organs were afflicted. Ninhursaga finally took pity upon him, creating eight special healing deities, one for each of his sick organs; Ninti was created to cure his rib. This myth was later incorporated into the Bible, as the healing of Enki's rib by Ninti was transformed into the story of Eve's birth from Adam's rib.

TELLUS MATER *(Mythic, Rome)*: In ancient times, Tellus Mater was a goddess of fecundity similar to the Greek Gaea. She was seen as Mother Earth, presiding over the common grave of all living things and representing the parallel between the fruitfulness of woman and of the soil, a common theme in early religions. She eventually became associated with Jupiter, the principal male deity of the Roman state.

Ishtar

(MYTHIC)

The great Goddess Ishtar was worshiped for thousands of years in Mesopotamia as the supreme giver and taker of life. Some of the societies that worshiped Ishtar as the life-giving, protective, and nourishing female principle were highly developed, possessing written languages, legal codes, and knowledge of mathematics, canal building, and astronomy. As these civilizations perfected the art of weaponry, the identity of the Goddess began to undergo a change, and she increasingly came to be viewed as responsible for bringing victory in battle to the ruling warrior-king .

This newfound association was a dubious one; the emerging warlike image of the Goddess reflected a profound shift in the social structure. Women's power was on the wane and women's position was becoming circumscribed. It is the earlier, entirely positive aspect of Ishtar that is represented on her plate at *The Dinner Party*, where she is depicted as the fecund giver of life, the splendid and majestic female creator. Her inclusion on the table represents the apogee of female's power in the ancient world. Worshiped by men and women alike, Ishtar was the symbol of an ancient religion that continued to extol the feminine, even after women had begun to lose their former mythical and social stature.

The iconography of the plate is based upon depictions of the Goddess as many-breasted and omnipotent. While I was applying the multiple layers of gold and rainbow lustres to the image, I remembered a chant I had made up as a child. I would incant it before performing the plays that I wrote, directed, and put on with the neighborhood children: "Tomorrow at sunrise, Ishtar will rise." I cannot explain how it happened that I composed this phrase that reached back to such an ancient time.

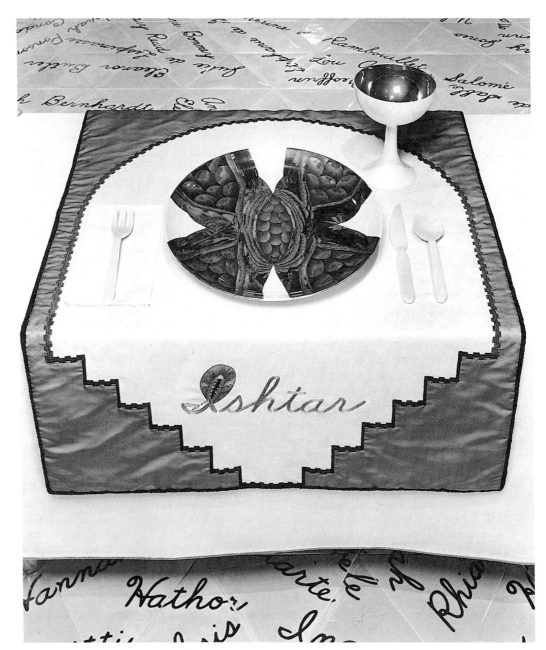

Ishtar place setting

The Ishtar plate rests on an appliqued and embroidered runner, whose motifs are derived from the famous Ishtar Gate and the ziggurat of Ur, a distinctive, terraced pyramid form closely identified with Babylonian culture. The capital letter incorporates Italian shading to repeat the visual quality of the penwork in the plate, while the use of gold reiterates the lustre of the plate image in order to emphasize the grandeur of the Goddess. The green in the stitched edge of the runner form and the intricate embroidery of the letter refers to the sacred color of this munificent goddess.

In addition to commemorating other deities whose power was comparable to that of Ishtar, the names that appear in relation to her place setting reflect the many ways that the concept of the Goddess was changing. A number of historical figures are also included, many of whom served as priestesses or remained devoted to Goddess worship.

AMAT-MAMU *(fl. 1750 B.C., Babylonia)*: Amat-Mamu was an official scribe in the convent community that housed 140 priestesses at Sippar. She was named repeatedly in documents.

ANAHITA *(Mythic, Persia)*: Anahita, goddess of sacred waters, was closely identified with Ishtar in that she had a fearful as well as a beneficent aspect. She was sometimes associated with the planet Venus and described as the goddess of springs and rivers, whose life-giving waters were thought to ensure fertility. Anahita was often depicted as richly arrayed, with a crown of gold adorned with stars, earrings, bracelets, a gold collar and shoes, and an otter-skin cloak embroidered in gold. Iranian texts from as late as the fourth century A.D. state that she was in charge of the universe.

ANATH *(Mythic, Canaan)*: Anath, a goddess of fertility and love as well as of war, was said to have shared her position with Asherah, goddess of sexuality and procreation. Both goddesses played important roles in the mythic struggles of the rain god Baal against his adversary, Mot, the god of sterility and drought. Anath's influence was described in approximately 1400 B.C., in an account of two major battles between Baal and Mot. After Baal had lost the first battle, Anath found his dead body and killed Mot in revenge. That night she had a dream in which she saw Baal alive, whereupon he joined Anath in the sacred marriage rite. Baal finally won a second battle with Mot, who had also reappeared. Although Anath was prominent in this myth—which symbolized the resurrection of the life force—the glorification of Baal was its central theme.

APHRODITE *(Mythic, Phoenicia/Greece)*: Aphrodite, the Greek goddess of love and beauty, was of Phoenician derivation. She was originally a complex goddess who was thought to rule over all of nature, but in later myths her identity became fragmented. In Greek legend the goddess Aphrodite gave birth to Adonis, then placed him in a chest and gave him to the goddess of the Underworld to protect. This goddess became so enamored of Adonis that she refused to give him up, until Zeus decreed that Adonis would spend half the year on Earth and half in the Underworld, a resurrection ritual that was celebrated in a festival every year. The Greek figure of Aphrodite seems a ratherfigure; the once holistic view of her power became divided into two aspects—one spiritual, the other earthly. As Aphrodite Urania, the goddess came to represent what was then considered the "highest" form of love—i.e., wedded love and fruitfulness; as Aphrodite Paudemus, she became a goddess of lust and the patron saint of courtesans.

ARINITTI *(Mythic, Anatolia)*: After Indo-European tribes had established the Hittite empire about 1900 B.C., the goddess Arinitti came to be seen as their principal deity. She was referred to in an early document as the "Queen of the land of Hatti, Heaven and Earth, Mistress of the Kings and Queens of the land of Hatti, directing the government of the King and Queen of Hatti." The center of her cult was only 125 miles south of Catal Huyuk, in Turkey, the site of a matriarchal, agricultural society and home to the earliest Goddess-worshiping people uncovered to date (ca. seventh millennium B.C.). Arinitti, who may have been related to or derived from that culture, was worshiped along with her two daughters and granddaughters.

ASHERAH *(Mythic, Canaan)*: Asherah, goddess of sexuality and procreation, was, with Anath, one of the two principal Earth goddesses described in the ancient myths of Canaan. When the Hebrew tribes invaded that area around 1250 B.C., they borrowed the worship of Asherah, renaming her Ashtoreth. Asherah, who was described as the mother of the deities, was said to rule jointly with her male consort, El. The power of their son, the weather god Baal, gradually increased until it eclipsed that of his father. According to later myths, Asherah tried to retain her own position, attempting to become Baal's consort. But it was Anath—sometimes considered an aspect of Asherah and at other times her daughter—who became Baal's lover. Although the worship of Asherah was eventually forbidden, she continued to be venerated as late as the sixth century B.C.

ASHTORETH *(Mythic, Hebrew)*: The Hebrew counterpart of Ishtar and Astarte, Ashtoreth was considered the goddess of fertility and reproduction. Her widespread worship—for some six hundred years after about 1150 B.C.—is attested to by both archaeological and literary evidence. For many centuries a number of temples to both Yahweh, the Hebrew God, and Ashtoreth stood side by side. This goddess was venerated in the royal household of Solomon and actually became part of temple worship during the time of Jezebel. Because of this, Jezebel was greatly maligned by the Levite prophets in the Bible, who denounced the worship of the Goddess as part of their patriarchal, monotheistic beliefs. They also attacked what they described as "temple prostitution," a reference to the ongoing ritual of sacred marriage, in which priestesses representing the Goddess coupled with men, often to confer kingship.

ASTARTE *(Mythic, Phoenicia)*: Astarte, the Phoenician version of Ishtar, was associated with

Photo of reconstructed Ishtar gate

the planet Venus. Considered the goddess of fertility, she was often represented standing naked on a lion. The sacred marriage ceremony was practiced extensively in connection with the worship of Astarte, who was one of the three goddesses mentioned in the Ugaritic texts of Canaan. They may have represented three aspects of womanhood: i.e., Asherah, mother and protector; Astarte, mistress and lover; and Anath, virgin and warrior. Astarte is often associated with Adonis, an agricultural divinity who replaced the vegetation gods Baal and Mot (closely related to Asherah and Anath in the Ugaritic poems). The young Adonis, Astarte's lover, died in a hunting accident in a forest grotto, and his death and resurrection were celebrated by the Phoenicians every year at a natural woodland sanctuary dedicated to Astarte.

BARANAMTARRA (*fl. 2500 B.C., Sumeria*): Baranamtarra, who ruled the city of Lagash with her husband, was called by the honorific title "the Woman." Lagash and other important cities such as Ur and Mari were temple and palace communities that evolved during the early dynasties in Sumeria. Baranamtarra had her own court, which was called the "House of the Woman." It was entirely separate from the "House of the Man," which was occupied by her husband (a *patesi,* or high priest). As one of the earliest recorded woman philanthropists, Baranamtarra is said to have donated money to religious groups that worshiped the Goddess.

BLODEUWEDD (*Mythic, Wales*): Blodeuwedd, goddess of the white flower, was often imagined as a "fragrant, seductive blossom which is pollinated by the bee." A Moon and love goddess, she was part of a transmuting trinity of goddesses. These included Blodeuwedd, Cerridwen, and the Underworld goddess, Arianhrod, who is said to have conceived the Sun god, Llew Llaw Gyffes. According to legend, Arianhrod adopted the form of Blodeuwedd, persuading Llew Llaw Gyffes to be her partner in a sacred marriage. After consummating this marriage, the male god was sacrificed in honor of the summer harvest, after which his soul took the form of an eagle and he was restored to life. Arianhrod then assumed her original identity and a new child developed in her dark womb. In this classic resurrection

myth, the son issues from the Goddess, unites with her, reaches maturity, and dies, only to be reborn.

CERRIDWEN (*Mythic, Wales*): Cerridwen was a barley and Moon goddess who represented the continuous cycle of life and death in the progression of the seasons. She was called the "white sow," presumably because pigs having crescent-moon-shaped tusks were associated with the goddess and were frequently sacrificed in her honor. Cerridwen, sister deity to both Arianrhod and Blodeuwedd, was thought to possess a magic liquid that gave the gift of inspiration to anyone who drank it. In one of the myths about this goddess, a servant boy mistakenly drank from her magic cauldron. Enraged, Cerridwen pursued him, both of them going through shape-shifting transformations in imitation of the seasonal cycles. The boy ultimately turned into a kernel of grain, which Cerridwen, taking the form of a hen, swallowed. The seed impregnated her and she gave birth to a son. In this myth there is a parallel between the Goddess using her servant/lover as an instrument of fertility, then resurrecting him from her own womb, and the way in which she was thought to nourish and bring forth grain from her own body.

CYBELE (*Mythic, Phrygia*): Cybele, who was called the "Mountain Mother," was thought to personify the Earth in its primitive state. She was worshiped on the tops of mountains, often depicted in a turreted crown and seated on a throne flanked by lions. As a Nature goddess, she was associated with such fertility symbols as the pine trees, the pine cone, the pomegranate, and the bee. Around 1000 B.C. veneration of Cybele and her son/consort, Attis, began to predominate. Religious practices included a vegetation-resurrection festival that somehow became associated with a group of eunuch priests. They considered themselves impersonators of Attis, and their goal was to attain immortality through mystical identification with the goddess. This was supposedly accomplished through ecstatic dancing to the wild music of flutes, drums, and cymbals. It was said that their rituals sometimes led to voluntary castration. If this is true, it would have been a bizarre perversion of the traditions of Goddess worship.

ENCHEDUANNA (*fl. 2050 B.C., Sumeria*): The earliest recorded poet, Encheduanna, a priestess and a member of the ruling class, wrote hymns to the Goddess. Although none of these are extant, the special poetry written by such priestesses for the sacred marriage ceremony is suggested by this excerpt from a later text:

> *Bridegroom, let me caress you,*
> *My precious caress is more savory than honey.*
> *In the bedchamber honey-filled,*
> *Let me enjoy your beauty.*

HANNAHANNA (*Mythic, Hittite empire*): Known as the "Grandmother," Hannahanna played an important role in one of the vegetation rituals of the people of Hatti, whose legends were incorporated into Hittite mythology. Hannahanna's role in guarding and protecting the fertility of the Earth and ensuring the perpetuation of the human race was reflected in this myth. A young fertility god became angry with the queen and stormed off, causing the crops to die and the life process to stop. Hannahanna sent a bee to recover him and, upon his return, used magic spells to soothe him until he was reconciled with the queen, whereupon life became regenerated.

HATHOR (*Mythic, Egypt*): As a primary Egyptian goddess, Hathor was considered the mother of the Sun god, Re. In his human incarnation as the pharaoh, he was suckled and protected by Hathor as her son, and the right of kingship was thereby passed to him. Hathor, one of the oldest deities of Egypt, was worshiped as a cow, an animal with great fertility significance dating back to prehistoric times. Often depicted as a celestial cow whose body was covered with stars, Hathor was also honored as a sky goddess, the mistress of the stars and the goddess of love, music, and sacred dance. Seen as the nourisher of the living, Hathor also came to be regarded as a protector of the dead, supposedly giving sustenance to whomever appealed to her for a happy life in the hereafter.

ILTANI (*fl. 1685 B.C., Babylonia*): Itani, a wealthy priestess from the royal family, enjoyed an influential position during the First Dynasty of Babylon. Her vast estates included eleven hundred head of cattle, which were administered by

her own officials. She belonged to a special class of priestess called *nadiatum,* most of whom did not marry. Many were connected with a convent community such as the one at Sippar, where the scribe Amat-Mamu had lived.

*I*NANNA *(Mythic, Sumeria)*: Described as the queen of Heaven in the Sumerian pantheon, Inanna was an earlier version of the Babylonian Ishtar. As goddess of love and fertility, she represented the life-producing mother who extended her enormous reproductive power to all plants and animals on the Earth. This goddess was thought to play the dominant role in the life process, while her son/consort was of secondary importance. Only after he proved himself in her bed would the goddess allow him to become king. As late as 2040 B.C., kingship continued to be bestowed by the priestesses of Inanna through the sacred marriage: "When he [the consort] has made love to me on the bed, then I in turn will show my love for the lord. I shall make him a shepherd of the land."

*I*SIS *(Mythic, Egypt)*: In early Egypt the royal family's lineage was matrilineal, meaning that daughters, rather than sons, inherited the ruler's titles at birth; there was also a preference for property to pass through the female line. As a result, the pharaoh usually gained his title on coronation day through marriage to his sister, who was identified with Isis. Because Isis, whose name meant "the throne," personified the sacred coronation stool (which represented the power of kingship), she was often depicted as wearing a throne on her head. The extent of her power was so great that she was thought to rule Heaven, Earth, the Sea, and the Underworld; she was known as the "Mother of Heaven and Queen of All Gods and Goddesses." Isis was one of the most widely worshiped deities of Egypt, and the earthly queen, as the representative of Isis, symbolized the continuing female vitality inherent in the throne. According to legend, Isis exerted great influence in the development of civilization, teaching women the arts of grinding corn and weaving cloth. She was associated with magical charms, was thought able to bestow the knowledge of healing, and was seen as the dispenser of wisdom and justice. When her brother/husband, the god Osiris, was away, she acted as regent (as did her earthly counterpart, the queen, in the pharaoh's absence). Because Isis was regarded as the goddess who "gives birth to gods and men, suckles kings, and bestows life and fecundity on the Earth," she was often represented with her son, Horus (the resurrected image of Osiris) seated in her lap. In this maternal aspect, Isis became identified with the cow goddess (Hathor or Neith), and her worship became widespread, eventually being introduced to western Asia, Greece, and Rome.

*K*UBABA *(fl. 2573 B.C., Sumeria)*: Originally an innkeeper and beer seller, Kubaba rose to power during a volatile political period, somehow attaining the throne. She founded the Third Dynasty of the city-state of Kish, becoming one of the few independently reigning queens in the ancient Near East. Because her dynasty retained power for nearly one hundred years, she became a legendary figure in Sumerian history.

*S*HIBTU *(fl. 1700 B.C., Babylonia)*: The official correspondence of Shibtu, queen of the kingdom of Mari, demonstrates that she played a significant administrative role in the affairs of state, staying informed about political and military matters through the high officials of her court. Queen Shibtu is known to have secured the release of a number of women from debtors' prison, and when the king was away on military campaigns or inspection tours, she conducted the royal business affairs and diplomatic relations herself.

*S*HUB-*A*D OF *U*R *(fl. 2500 B.C., Sumeria)*: Queen Shub-Ad lived during the first dynasty of Ur, and the extent of her influence was revealed by the discovery of her royal tomb, which contained staggering wealth. It is altogether probable that this wealth belonged to Shub-Ad personally, because her tomb bears an identifying inscription while her consort/king's has none. Although men were gradually establishing control over the temples, this woman seems to have played the traditional triple role of queen, priestess, and musician. She and the other priestesses carried out numerous religious ceremonies that incorporated elaborate music and incantations based on the wail, the most basic form of women's music.

*T*ANITH *(Mythic, Carthage)*: Tanith, a winged goddess of Heaven, was the primary goddess worshiped at the Phoenician colony of Carthage, in Africa. Depicted on numerous stelae, she was frequently represented as standing beneath the vault of Heaven and the zodiac. Tanith, who was associated with the fertility god Ba'al-Hammon, was generally referred to as the "face of Ba'al." Because the word *Ba'al* meant "god" or "lord," it is possible that Tanith was actually regarded as a god, a term for which the word "goddess" is not an altogether adequate parallel.

Kali

(MYTHIC)

My reasons for choosing Kali for the table are complicated. Although *The Dinner Party* is intended to symbolize the history of women in Western civilization, Kali, an ancient East Indian goddess, seemed to provide the most dramatic embodiment of what has been considered the destructive aspect of the Goddess. I felt compelled to deal with such a figure because the idea that powerful women are harmful remains deeply ingrained in present-day society. I wanted to explore and transform this archetypal symbol of the female as devourer/destroyer, and I chose Kali for this purpose because there really is no comparable image in Western mythology.

Kali began to be worshiped by practitioners of the Hindu religion during the first millennium B.C., at a time when women throughout the world were losing their former status and power. Her place setting in *The Dinner Party* represents the way in which women's power—as reflected in the widespread veneration of the Goddess—was being assaulted. Women were slowly being placed under the control of men, losing their freedom along with their right to worship a positive and life-affirming female deity.

In most ancient myths, female power was considered awesome but essentially positive. Although the Goddess was frequently thought to possess the power of death, life and death were considered indivisible and hence part of the life process. But gradually, the "death" aspect of the Goddess ceased to be part of a unified and venerated concept and became, instead, a separate and terrifying entity, which is demonstrated by the legendary figure of Kali.

This goddess is frequently depicted as fierce, cruel, and bloodthirsty, as in this typical mantra: "Hail Kali, three-eyed goddess of horrid

Detail from *Kali* runner; needlework by Connie von Briesen

form, around whose neck hangs a string of human skulls, a pendant.... Salutation to thee with this blood." Kali is often represented as a hideous creature who loves strife and rejoices in drinking the blood of those she destroys.

The treatment of the place setting is intended to transform this fearsome image. The dark, lustred plate includes armlike forms that extend outward from an open and fecund core. (In Indian art, Kali is often represented as a many-armed figure.) The plate rests on a runner created with overlays of transparent materials, extending the subtle colors and lustre of the plate into an image suggesting the awesome beauty of this goddess's power. In both the plate and the runner, the gaping maw and dancing fingers usually associated with Kali become a compelling, rather than a frightening, presence.

Grouped around the place setting for Kali are other goddesses and female figures who have been depicted as harmful, as guarding the doorway to death, or who have exemplified a so-called devouring female energy.

ALUKAH (*Mythic, Canaan*): Alukah represented the darker side of the Goddess in Canaanite culture, which flourished between the Jordan, the Dead Sea, and the Mediterranean around 1400 B.C. Alukah was depicted as a succubus or vampire, and her two daughters were said to be Sheve and the Womb, or Death and Life.

ARIANHROD (*Mythic, Wales*): Arianhrod was described as the death goddess who turned the wheel of Heaven. She was also seen as the destructive aspect of the Moon goddess and Earth Mother, Cerridwen, as well as another form of the mythic Blodeuwedd. Symbolized by a curved sliver of both the new and the waning Moon, it was said that she ruled over the double spiral in the tomb beneath Cerridwen's castle-fortress. This double spiral, which represented the continuous cycle of death and rebirth, had at its center the head of a second spiral coiling in a reverse direction, to allow an exit from the confusing maze. Because Arianhrod was also characterized as a virgin goddess who was able to continually give birth to new life as the great wheel of Heaven revolved, the dead went to Arianhrod's castle with hopes of resurrection.

COATLICUE (*Mythic, Meso-America*): Coatlicue, the Aztec Earth goddess, was often depicted with a death's head and dressed in a serpent-woven skirt, her hands raised in an awe-inspiring gesture.

ERESHKIGAL (*Mythic, Sumeria*): According to Sumerian myths, Ereshkigal, the goddess of death, was the ruler of the subterranean world, which no one except her sister Inanna was allowed to leave. After Nergal, the god of war and hunting, failed to properly honor Ereshkigal at a banquet of the deities, she demanded his death. In response, Nergal invaded her domain with fourteen demons, dragging Ereshkigal from her throne by her hair and threatening to cut off her head. In order to save her life and in an effort to achieve peace, she offered to share her throne with him. This story was gradually transformed into the Greek myth that installed the male god Hades as the ruler of the Netherworld.

THE FURIES (*Mythic, Greece*): The Furies (Erynines) were described as winged women with snakes entwining their bodies who, when angered, had the power to inflict sterility, crop failure, and disease. In their more benevolent Underworld aspect, they were considered the forces that worked to generate life and send it upward; while in death, everything was thought to return to them. They figured prominently in the myth of Orestes, who murdered his mother, Clytemnestra, in vengeance for her murder of his father, Agamemnon. The Furies did not consider Clytemnestra's act a crime because her husband was not a blood relative, while the action of Orestes was seen as unforgivable. Orestes was pursued by the Furies, and when he was acquitted by Athene, they became so enraged that they decided to hide in the Underworld in order to destroy the fertility of the Earth.

HECATE (*Mythic, Greece*): Hecate, known as the invincible queen of the Underworld and personified by the three phrases of the new, full, and waning Moon, was regarded as the triple-headed goddess of the Moon, who ruled the infernal regions along with Persephone and Hades. Her three heads represented the three phases of a woman's life: young girl, mature woman, and old hag. Images of the three-headed Hecate were customarily placed at crossroads, and offerings were made to her when the moon was full, the moon being sacred to most Goddess-worshiping religions.

HEL (*Mythic, Norway*): Hel was the name applied to both the territory of the Underworld and its presiding goddess, who was thought of as a vague and shadowy figure. She was frequently represented by a face that was half human and half obscured by darkness, or the black void. She was said to possess a vast palace, in which she received the heroes and deities who descended to the Netherworld.

IRKALLA (*Mythic, Babylonia*): Irkalla, the Babylonian goddess of the Underworld, was considered the death-related aspect of Ishtar and was sometimes described as Ishtar's sister. She supposedly possessed the head of a lioness (Ishtar's sacred animal) and the body of a woman. It was said that she grasped a serpent in her hands and that the dead existed in her dark realm by eating dust and mud. Her kingdom was known as the Land of No Return, and Ishtar and Irkalla were thought of as connecting links between life and death. Ishtar was thought to possess power over both death and life, while the darker side of female potency was embodied in her sister.

MORRIGAN (*Mythic, Celtic Ireland*): Morrigan, also known as the great queen, was actually a trinity of three warrior goddesses who shared one name. Celtic warriors were expected to evoke this triple goddess by blowing on war horns before each battle. The goddess had three names: Macha, who took the form of a raven; Badb Catha, "the cauldron"; and the old hag Anu. Accompanied by her prophetic raven of death, Anu, who watched over a boiling kettle in which the ever-changing faces of life and death supposedly bubbled, constituted the supernatural power of Morrigan.

NEPHTHYS (*Mythic, Egypt*): The sister and companion of Isis, Nephthys was considered the goddess of the dead and was one of the nine deities of the divine pantheon of Egypt. As the daughter of the Earth and the sky, she represented the twilight and, like Isis, was said to occupy a place in the boat of the sun at the time of creation. According to legend, she and Isis performed ministrations to the dead. Although she was a death goddess, Nephthys was not thought of as an entirely negative deity, probably because the Egyptians did not fear death itself, only decay.

THE NORNS (*Mythic, Norway*): The Norns—Urda, Verdandi, and Skuld—were the three goddesses of fate. They were thought of as female giants who represented the past, present, and future. Their job was to sew the web of fate and to water the sacred ash, whose roots reached down into the subterranean depths of the Earth. Urda and Verdandi were kind, but Skuld was cruel; she supposedly tore up her sisters' work as they sewed. The Norns were also considered the guardians of the third root of the ash tree, which was described as being gnawed by a serpent demon. Because of the efforts of Urda and Verdandi, the tree was able to sprout green leaves and maintain the indestructible strength of its trunk at the center of the Earth. The three Norns together balanced the forces of life and death, which were considered to be constantly at work in the weaving of destiny.

RHIANNON (*Mythic, Britain*): Rhiannon, called the great queen, ruled the Underworld jointly with her husband, the god Pwyll. Depicted as a mare-headed goddess who fed on raw flesh, her horselike and demonic appearance represented a terrifying aspect of the Great Goddess, who was sometimes symbolized by a horse.

TUCHULCHA (*Mythic, Etruria*): Transposed from Etruscan mythology, Tuchulcha was considered the principal female demon of the Roman Underworld. She was depicted with ferocious eyes, a beak instead of a mouth, the ears of a donkey, two serpents wound around her head, and another snake around her arm.

THE VALKYRIES (*Mythic, Germany*): The Valkyries were thirteen armored Amazon maidens who were seen as the dispensers of destiny. They were thought to watch the progress of battles and to choose the winners. In their benevolent function, they led the souls of dead war heroes back to the kingdom of Valhalla.

Snake Goddess

(MYTHIC)

Small female figurines with snakes coiled around their arms have been found in shrines or buried with the dead of the goddess-worshiping culture of Crete. The place setting honoring the Snake Goddess incorporates the colors, motifs, and symbols of these ancient statues. The relationship between the snake and the female had its origin in the Goddess religions of earliest history, and the snake was connected to a succession of goddesses for thousands of years, even into Greek times. The snake was considered the embodiment of psychic vision and oracular divination, both of which were traditionally considered to be part of women's magical powers.

In Crete, where the beautiful remains of a great matriarchal civilization have been unearthed, the snake aspect of the Goddess religion reached its highest development. The snake, which represented the wisdom of the Goddess, was associated with life, death, and regeneration. Snakes were venerated as protectors of the household, and special rooms equipped with snake tubes (which enabled them to travel through the house) were found in many Cretan homes.

Some priestesses served as advisors and counselors to the society, often entering trance states in order to solve the many problems that were brought to them. They achieved these states through fasting, snake bites, or through the administration of snake venom. While in a state of altered consciousness, the priestesses were considered to be in direct communication with the Goddess.

The Snake Goddess place setting at *The Dinner Party* mimics Cretan iconography: Outstretched arms of pale yellow extend from the center form of the plate, the egglike shapes representing the generative force of the God-

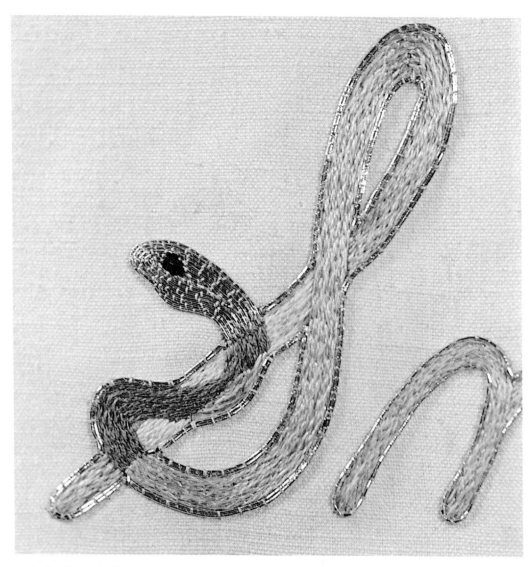

Snake Goddess capital letter

dess. The runner, like the plate, is done primarily in yellow, browns, and golds, colors reminiscent of the ancient goddess figurines. The snake motif is incorporated into the illuminated letter and repeated on the runner back, which features two shimmering and entwined embroidered gold snakes. The runner is bordered by inkle-loom woven strips in a pattern based upon motifs from garments of the period. The ruffled fabric on the front and back of the runner refers to the costumes of the early snake goddesses, who wore tiered skirts.

Surrounding the place setting honoring the Snake Goddess are names of other Cretan goddesses, along with mythological figures thought to possess a snake aspect.

ARIADNE (*Mythic, Crete*): Ancient legends describe the cult of Ariadne as an orgiastic one, which practiced the ritual sacrifice of the young king as part of its fertility and vegetation rites. In an effort to avert this ritual and prolong his rule, one young king, Minos, was said to have regularly brought men and women over from the

Greek mainland—the men to be sacrificed in Minos's place and the women to act as priestesses in the cult of Ariadne. The Greek Theseus volunteered to go to Crete and participate in this ritual sacrifice as a ruse; his real purpose was to overthrow the king. After the Cretan woman Ariadne helped Theseus accomplish his goal, they were married. Theseus wanted Ariadne to leave Crete with him but she refused, hoping that, by staying, she would be able to establish peace between Crete and the Greek mainland. Instead, Theseus abandoned her on an island near her homeland, thereby breaking Crete's matrilineal tradition and weakening the government, which paved the way for the final destruction of traditional Cretan culture. The Dorians eventually invaded Crete, whereupon Zeus was established as the supreme deity and the traditional Goddess religions were overthrown.

*A*RTEMIS *(Mythic, Greece)*: The alteration of the figure of the Goddess from Cretan to Greek to Roman culture can be traced through Artemis, who took numerous forms. The earliest of these was the famous Artemis of Ephesus at the temple in Ionia, in the western part of Anatolia. Artemis was originally a goddess whose fertility cult followed in the Ishtar tradition. Her worship may have been transported to Ionia during the establishment of the Hittite empire, when many Goddess-worshiping people fled westward. By the time Artemis appeared in the Greek pantheon of Olympus, she was viewed merely as an agricultural deity and a Moon goddess connected with the chase and the forests. The Greek Artemis watched over the forest and its inhabitants, but instead of being the vital symbol of all Nature, as she had been before, she was now described as a cool, chaste huntress. Artemis then became identified with the Roman goddess Diana and shared certain attributes: Both were connected with the Moon and the hunt and seen as protective figures. The goddess Diana was eventually incorporated into the Roman figure of Vesta, whose role as a virgin priestess was a trivialized reflection of her earlier powerful predecessor.

*A*THENE *(Mythic, Greece)*: It is possible that the figure of Athene was derived from the Egyptian goddess Neith, whose attributes were somewhat similar. Athene was described as a virgin goddess

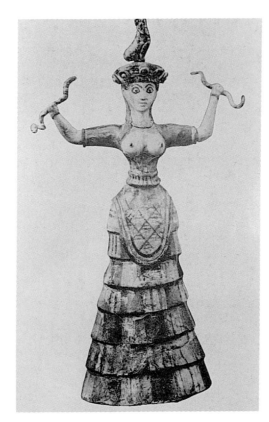

Cretan Snake Goddess:
Museo Archeologico, Florence

who was both a warrior and a patron of culture; she was also a deity of architects, artists, and weavers, the protector of Athens, and the goddess of wisdom and healing. She was traditionally associated with the snake—probably in connection with her role as goddess of wisdom—and numerous images of her include serpents. By the time Athene became part of the Greek pantheon, she had been transformed into the daughter of Zeus and described as having sprung full grown from his head. When Athene acquitted Orestes in Aeschylus's play *The Eumenides*, she decided against the whole tradition of mother's rights and the centuries-old taboo against matricide. Her action symbolically announced that the old matriarchal order had been replaced by the law and moral authority of the patriarchy.

*B*RITOMARTIS *(Mythic, Crete)*: According to later Greek legends, Britomartis, often depicted as a huntress, was one of Crete's most ancient goddesses. She was associated with the Moon,

which in gynocracies was said to control planting, harvesting, festivals, and religious rituals.

*B*UTO *(Mythic, Egypt)*: Buto, the great serpent, was a snake goddess usually represented in the form of a cobra, sometimes with the head of a woman. She was often associated with Nekhebet, the vulture goddess of the south, and Neolithic cultures of Egypt venerated these two goddesses as supreme deities. Around 3000 B.C., with the beginning of the Egyptian dynasties, the Cobra goddess and the vulture goddess both lost their prominence. Their previous power survived only to the extent that their symbols were worn in the center of the pharaoh's crown and appeared on official documents.

CHICOMECOATL *(Mythic, Meso-America)*: Chicomecoatl, also known as "Seven Snake," was symbolized by the double ear of corn. She was an ancient and indigenous maize goddess, the agricultural personification of the Earth mother who was related to the fruitful and fallow cycles of vegetation, symbolizing the complex rhythm of life, growth, and death in nature.

*D*EMETER *(Mythic, Greece)*: Demeter, who was thought to be the daughter of Rhea, the ancient Cretan goddess, symbolized fecundity, fruitfulness, and rebirth. As the goddess of agriculture, she was responsible for the cultivation of the soil. In her primitive form, she was associated with snakes and also represented the Underground, where the seeds were planted. This subterranean aspect was later transferred to her daughter Persephone, and in the Eleusinian mystery rites—which occurred at harvest time—Demeter and Persephone were symbolically reunited, thereby ensuring the continued fruitfulness of the Earth.

*E*UROPA *(Mythic, Crete)*: The myth of Europa is somewhat unclear. She might have been originally a real Cretan queen who, in a sacred marriage, was joined with the Mycenean king at the beginning of the dynasty of Minos. According to legend, after Europa was raped by Zeus, she gave birth to Minos, the legendary founder of the Minoan dynasty. This mythical rape may reflect the brutal way in which the Myceneans overtook Cretan culture, with the myth aimed at legitimizing the origins of King Minos.

FORTUNA *(Mythic, Rome)*: Fortuna, the goddess of the turning wheel, hearkened back to the early concept of the sacred oracular wheel of divination. Representing fate with all its unknown factors, the Roman Fortuna was a far cry from earlier omnipotent goddesses. Fortuna was known under many names, each connected with various functions. Eventually she became merely a good-luck charm, and small statues of her were placed in the emperor's bedroom to protect him from misfortune.

KORE *(Mythic, Greece)*: Persephone, the daughter of Demeter, was originally known as Kore in a Babylonian myth in which Ishtar descended into the Underworld in pursuit of her consort. In a later Greek adaptation, Demeter went to retrieve her daughter after she was kidnapped. One legend stated that Kore was abducted by Zeus's brother Hades, while another suggested that Kore was raped by Zeus (who was her father), rape having become a prominent theme in myths by then. After Kore disappeared, Demeter is said to have searched for her for nine days, finally returning to her temple and threatening to make the Earth barren if her daughter were not given back to her. Kore was allowed to return to Demeter, but only for two-thirds of the year; for the other third of each year she had to live with the god Hades, whom she had been tricked into marrying by Zeus's messenger. This myth can be thought of as reflecting the changed status of women, while also embodying ancient ideas about seasonal change. For when Kore was with Hades in the Underworld during the winter, the Earth was described as sleeping in sadness and mourning. The flowering of spring occurred only upon Kore's annual return to her mother.

PASIPHAE *(Mythic, Crete)*: Described as a Cretan Moon goddess and "She Who Shines for All," Pasiphae was thought to be the daughter of Europa and the mother of Ariadne. According to Greek myth, she married Minos; however, as *Minos* meant "king" and did not refer to a particular man, she may have married the heir to the Minoan throne. The myth also recounts how Pasiphae fell in love with a white bull, hiding inside a wooden cow in order to mate with him.

PYTHON *(Mythic, Greece)*: According to Greek legend, Python was a female serpent who had a lair in the wooded hills near the temple at Delphi, which became famous as a center of oracular divination. Originally established by Cretan priestesses, this temple was built in Mycenean times in honor of the Goddess, and a real python (as a symbol of women's psychic power) was kept in one of its underground chambers to act as the guardian of the dead and a symbol of resurrection.

RHEA *(Mythic, Crete)*: Rhea was originally seen as the powerful Earth Mother of Crete, comparable to Gaea or Cybele. Representing fertility and the fruits of the soil, she was considered the ruler of the heavens, the Earth, and the Underworld. In later Greek myths she was described merely as the mother of Zeus. Then her identity became further fragmented into Demeter, Artemis, and Athene, each of whom assumed some of Rhea's original attributes.

Sophia

(LEGENDARY)

The concept of Sophia is associated with early Gnostic religions. They conceived of her as an incorporeal entity, the active thought of God, who was responsible for the creation of the world. It was believed that Sophia embodied the highest form of feminine wisdom, possessing a purely spiritual wholeness, in which the material world was altogether transcended. Her inclusion at *The Dinner Party* table is intended to represent the transformation of the earlier power of the Goddess into the insubstantiality of an entirely abstract symbol.

The plate image is based upon traditional conceptions of Sophia as a single delicate flower. During the Middle Ages, Sophia's identity often merged with that of the Virgin Mary in that both were depicted as having nurturing and regenerative powers. A medieval manuscript illumination presents Mary suckling two Apostles with her milk. In a comparably beautiful image, Dante rendered Sophia as the supreme flower of light. I drew upon both of these representations as inspiration for the plate and the runner, particularly in relation to their lives.

The Sophia plate rests upon a runner bordered by carefully formed flower petals, created from layers of colored chiffon. Color shades color to create a richly toned floral wreath around the plate. But the bright tint of the petals has been muted by layers of thin white fabric, and the overall runner is shrouded by a donated wedding veil to create a visual symbol of women's steadily diminishing power.

Sophia place setting

Grouped around the place setting for Sophia are the names of legendary figures and historical personages of the Greco-Roman period, along with heroines of Greek tragedies. I have included a number of literary personages to symbolize the transition from the mythical goddesses of prehistory to the emerging written historical record, which was to emphasize men's achievements at the unfortunate expense of women.

ANTIGONE *(Legendary, Greece)*: Antigone, the leading character in a play by Sophocles, represents the rebellious woman who flaunts masculine authority. She defied the king's edict denying her dead brother the right to a burial. Insisting that she would not have disregarded the king's decree had it been in relation to either a husband or children, Antigone stated that she felt obliged to honor the uterine relationship that was the basis of the matriarchal kinship line: "And yet what greater glory could I find than giving my

own brother [a] funeral? . . . When was it shameful to serve the children of my mother's womb?" To punish her, the king had Antigone walled up in a cave. She committed suicide in order to avert what would have been a long, painful death.

*A*RACHNE *(Legendary, Greece)*: Greek mythology attributes the discovery of woven cloth and the art of net-making to Arachne, whose weaving was said to be so perfect that she challenged the goddess Athene to a contest. Athene destroyed Arachne's work because of its extraordinary beauty, whereupon Arachne hung herself. Athene brought her back to life, turning her into a spider and her noose into a web.

*A*TALANTA *(Legendary, Greece)*: Atalanta was abandoned by her father, who'd desired a son. Raised in the woods by a she-bear sent by Artemis, she became a formidable hunter, warrior, and sportswoman. Although warned against marriage by the Oracle at Delphi, she promised to marry whichever of her suitors won a foot race with her, with the proviso that those who lost would be killed. According to the legend, Aphrodite gave Hippomenes three golden apples with which to tempt Atalanta. Because she stopped to retrieve them, he won the race.

CAMILLA *(Legendary, Rome)*: Camilla was the daughter of Metabus, king of the Volscians. When her father was driven out of his kingdom, he took Camilla with him. After praying to the goddess Diana for their safe passage (which was granted), the king dedicated his daughter to the service of the Goddess. Raised in the woods, Camilla became a hunter and warrior. She was killed by an Etruscan who was supposedly aided by Apollo, whereupon Diana avenged Camilla's death by sending a nymph to slay her killer.

CASSANDRA *(Legendary, Greece)*: According to legend, Apollo fell in love with Cassandra and taught her the art of prophecy in order to win her love. But after acquiring this knowledge, Cassandra rejected him. In revenge, Apollo condemned her to always tell truthful prophecies, which would never be believed. Cassandra tried to warn the Trojans of their impending doom at the hands of the Greeks, insisting that armed men would be inside a wooden horse. During the sub-

sequent sack of Troy, she took refuge in the temple of Athene, where she was found clinging to a statue of the goddess. The Greek soldier who discovered her destroyed the statue, then raped Cassandra. She was then taken prisoner by Agamemnon, who was subsequently murdered by his wife, Clytemnestra. Cassandra's announcement of this crime was ignored and she was killed by Clytemnestra. Cassandra's name has become synonymous with one whose wisdom is ineffectual because it is unheeded until too late.

CIRCE *(Legendary, Greece)*: Circe, who was considered an enchantress, exemplified the continuing tradition of the female powers of divination and prophecy. She lived alone on an island, transforming anyone who tried to invade her territory into an animal. According to Homer, when the men of Odysseus attempted to land on her island, she turned them all into swine. When Odysseus arrived, he enlisted the aid of the god Hermes and convinced Circe to return his men to human form. But Odysseus then became enchanted by her and remained on the island for three years, during which time Circe supposedly bore him three sons. Upon his departure, she used her psychic powers to predict the trials that lay in store for Odysseus, and he survived only because he heeded her warnings.

CLYTEMNESTRA *(Legendary, Greece)*: Clytemnestra, a Greek queen, was the wife of Agamemnon. At the outset of the Trojan war, Agamemnon sacrificed their daughter Iphigenia. Upon his return, Clytemnestra asserted her mother's right and avenged her daughter's death by killing Agamemnon. She was then slain by her son, Orestes, and her other daughter, Electra. The two were tried, then acquitted because the crime was only matricide, a symbolic illustration of the shift from a matriarchal to a patriarchal perspective.

*D*APHNE *(Legendary, Greece)*: Described as a nymph and hunter, Daphne was said to be the daughter of the River Peneuis. Because she was determined to remain chaste, she rejected all suitors, including the god Apollo. He chased her to the river, where she entreated her father's aid. He turned her into a laurel tree just as Apollo reached her, whereupon Apollo declared that henceforth laurel leaves would serve as wreaths for musicians and as a sign of victory. Earlier

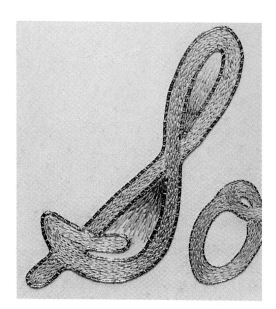

Sophia capital letter

versions, however, were different: Daphne was said to be a priestess of Mother Earth, and when Apollo pursued her, it was to her that she cried out. Mother Earth supposedly spirited her away to Crete and left a laurel tree in her place; from its leaves, Apollo made a wreath for consolation.

*H*ECUBA *(Legendary, Greece)*: In Homer's *Iliad*, Hecuba, queen of Troy, was the second wife of Priam and the mother of nineteen children, including Hektor, Paris, and Cassandra. Hecuba's husband and all her children were killed or enslaved by enemy soldiers, and she became the slave of Odysseus. After blinding a Greek warrior and killing his two sons, she escaped, metamorphosing into a dog, and swam to the Hellespont, a strait near the Aegean Sea.

*H*ELEN OF TROY *(Legendary, Greece)*: Helen, supposedly the most beautiful woman of her time, was said to be the daughter of the god Zeus and the mortal Leda and was a favorite of the goddess Aphrodite. After abandoning her husband, Menelaus, she fled to Troy with her lover, Paris. The attempts of Menelaus to reclaim her resulted in the ten-year Trojan war.

*H*ERSILIA *(fl. 800 B.C., Rome)*: Hersilia was one of the Sabine women abducted and raped by the Romans. Despite the violence done to them, the

women established bonds with their new husbands and children, which they were reluctant to break when the Sabine men finally came to free them. In an effort to avert bloodshed, Hersilia pleaded for peace, asking that original families be rejoined but that the newer family ties also be recognized. A truce was declared, and the Festival of the Matronalia came to be celebrated by Roman women to commemorate this somewhat odd pact.

LYSISTRATA *(Legendary, Greece)*: Lysistrata was the heroine of one of Aristophane's plays. In this bawdy comedy, the women, after taking over the Treasury, refuse to have sex with their husbands until the men bring a halt to the Peloponnesian War. The character of Lysistrata may actually have been based upon certain prominent women of Athens, who tried to alter the status of women in society and public affairs.

PANDORA *(Legendary, Greece)*: Pandora was originally considered a bestower of good upon the Earth, but she later came to personify the belief that women were the greatest evil ever inflicted on men. According to Hesiod, she was given a great jar as a dowry, which she was instructed not to open. It was in such jars that the Greeks both stored their food and buried their dead. Thus when Pandora disobeyed the injunction, her act became associated with the giving of both life and death. For in opening the jar, she was said to have unleashed all of the evils into the world.

PRAXAGORA *(Legendary, Greece)*: Praxagora, the leader of a female group, was a heroine in the *Ecclesiazuoe* of Aristophanes (ca. 400 B.C.). The women disguised themselves as men in order to participate in a public assembly, which, by a majority vote, managed to overturn the government and proclaim the supremacy of women.

PYTHIA *(Legendary, Greece)*: For almost a thousand years, the temple in which Pythia was consulted was an oracular center that had originally been dedicated to the Cretan Earth goddess. The priestesses of Pythia were considered to be in direct communication with the Great Goddess. They were selected for their exalted positions because of their occult powers, rather than social status, lineage, or training. The Pythian oracle was sought out for advice on religious procedures, politics, law, and everyday affairs. Its influence was considerable, since the entire country considered the temple the center of spiritual authority. By Homeric times, this oracle had been turned into a shrine to Apollo, and the Pythian priestesses were thought of as the instruments of Apollo, merely transmitting oracles from Zeus.

SIBYL OF CUMAE (AMALTHEA) *(fl. 500 B.C., Rome)*: In ancient history, Sibyls were considered prophetic women who, as a result of direct inspiration, possessed knowledge of the future and how evil could be averted. Stories about them are found in the histories of Egypt, Persia, Greece, Babylonia, and Italy. The most celebrated of these figures was Amalthea, who supposedly wrote the nine Sibylline books, which played a prominent part in the history of Rome. They are said to have predicted the Trojan war, the rise and fall of the empire, and the coming of Christ. These books were highly esteemed by Roman priests, who consulted them frequently until the books were destroyed in the same fire that devastated Rome during Nero's reign.

RHEA SILVA *(Legendary, Rome)*: Rhea Silva, a priestess of Vesta, was described as participating in the sacred marriage festival of the Oak Queen and King. She supposedly conceived the twins Romulus and Remus during one of these silent couplings, which were said to take place during festivals in the darkness of a sacred cave. Rhea Silva claimed that Mars had fathered her children, and since kingship still passed through the female line, Rhea Silva's sons would have had claim to the throne. In an effort to prevent this, her brother had her imprisoned and ordered her children drowned. The twins survived, however, and are considered the founders of Rome.

VESTA *(Legendary, Rome)*: According to early Roman legends, during the midsummer and winter festivals of the Oak King and Queen, there was a marriage feast whose primary purpose was for a vestal virgin to conceive a new heir to the throne. The women who participated in this ceremony were the priestesses of the goddess Vesta, whose worship was considered the duty of women exclusively. Vesta, who was similar to the Greek goddess Hestia, was held in such high honor that a flame was kept perpetually lit in her honor. This flame was maintained by young girls who entered into the service of the goddess at between six and ten years of age.

VIRGINIA *(Legendary, Rome)*: Virginia, a commoner of great beauty, was killed by her father in order to protect her from enslavement by a Roman noble. Her tragic death is said to have inspired a political revolt in Rome.

Amazon

(LEGENDARY)

Amazon societies are thought to have existed during the second and third millennia B.C., including one on a lost island off the coast of North Africa and another on the southern shore of the Black Sea. Amazons have been characterized as living most of the year in all-female societies, randomly mating with men in the spring. Girls were taught pride in their sex and were expected to learn athletics and the martial arts in order to preserve their independence.

While little tangible evidence has been found to support the reality of entire societies of warrior women, there are some documented instances of women going into battle side by side with men. Although the names of a number of these warrior queens are known, I chose to depict a symbolic Amazon rather than any particular woman. The plate image incorporates some of the symbols associated with the mother cults: the white egg, the red crescent, and the black stone, which combine to make the body of this mythical Amazon warrior.

The white egg, symbol of fertility, was presumably carried by the women of Anatolia on the helms of their ships. Other Amazon women were said to have strapped a red crescent onto their saddles as they rode across the plains, an act of homage to the Great Goddess, whose worship was tied to the moon. In Sumeria, Amazons reportedly displayed a black stone—one of the earliest incarnations of the Goddess—in a cart drawn by oxen. On *The Dinner Party* plate, these motifs are combined with metallic breastplates, which these mythical warrior women were thought to have worn in battle. On either side of the center image are upraised, lustred double axes, which were apparently used by Amazons in warfare, as well

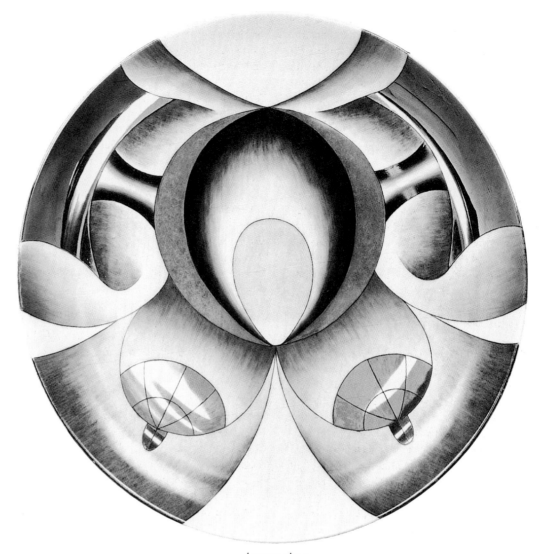

Amazon plate

as in felling trees, clearing land, and in the worship of the Goddess.

These symbols are repeated in the runner, whose simplicity belies the complexity of its construction. On the runner back, a padded white satin egg reiterates the lustrous form on the plate, while the appliquéd titanium double-axe blades refer once again to these multi-use tools. The blades are secured to the runner with French knots made of copper fibers. Stitched rondels recall the image of breastplates found on the plate. These are couched in silver and copper

fibers, then outlined in black thread edged with red.

The lacing that appears on the runner top, also attached with copper French knots, are derived from Greek images depicting the laced boots that were part of Amazonian battle array. The red snakeskin strip bordering the runner front refers to the material supposedly used by the Amazons for their boots and shields. The bold colors that unite the plate and runner are those traditionally associated with these great warrior women of antiquity.

The names of a number of Amazon queens are grouped around the place setting that symbolizes these mythical women. They are known to us primarily through the Greeks, who were particularly fascinated by these warrior women and represented them in art, mythology, and history. Although historical facts about their societies remain unclear, there are records of the names of a number of Amazon leaders. The earliest indication of an Amazon queendom seems that of Eurypyle's (ca. 1750 B.C.).

ANTIOPE *(13th c. B.C., Scythia)*: Antiope, supposedly one of a long line of Amazon warrior queens from the region of Themiscyra (now a part of Greece), is said to have fought Hercules. After being taken prisoner (along with her two sisters), she succeeded in freeing herself and one sister, with whom she then jointly ruled.

EGEE *(12th c. B.C., Libya)*: Egee is thought to have commanded a vast army of women who marched from Libya into Asia, apparently conquering all whom they engaged in battle, including the king of Troy. After the Trojan armies were vanquished, Egee and her troops were said to have acquired great booty in exchange for the soldiers' lives.

EURPYLE *(fl. 1760 B.C., Near East)*: Eurpyle was the leader of a women's expedition against Babylon. It has been conjectured that they conquered the capital of an area inhabited by a Semitic people living west of Mesopotamia, who had invaded Babylonia several hundred years before their own defeat.

HIERA *(fl. 1184 B.C., Asia Minor)*: Hiera, the general of an army of Mysian women who fought in the Trojan war, was one of Greece's most fa-

mous warriors. She is mentioned in the *Heroicus,* by Philostratus, who suggested that Homer chose to exclude her from the *Iliad* because she would have outshone Helen.

HIPPOLYTE *(13th c. B.C., Scythia)*: Hippolyte and her sisters, Antiope and Orithya, were joint rulers in the Amazon capital of Themiscyra when the city was invaded by Greek adventurers. Hippolyte was either killed or captured and the Amazons retaliated by attacking the militarily superior city of Athens. The warrior women were defeated, which supposedly contributed to the eventual downfall of the Amazonian empire.

LAMPEDO *(13th c. B.C., Greece)*: Lampedo and her sister Martesia, who called themselves the daughters of Mars, were ruling queens of an Amazon tribe. Because the majority of their males had supposedly been killed by Scythian princes, the women of this tribe coupled with men from neighboring communities. As soon as they became pregnant, they returned home. It has been stated that the male offspring were killed at birth, while female children were kept and educated in the military arts. Myth also states that the girls' right breasts were caused to wither so that they would not interfere with their use of the bow and arrow. The left breasts were supposedly left unharmed for the nurturing of future children. But these stories might have arisen as part of patriarchal efforts to discredit Goddess-worshiping and female-centered societies.

MARTESIA *(13th c. B.C., Greece)*: With the help of her sister Lampedo, Martesia ruled as queen of the Amazon nation in the region of Themiscyra. While her sister consolidated the empire and attended to domestic matters, Martesia is said to have enlarged the empire through military conquest. She was killed during an invasion and her

daughters—Antiope, Hippolyte, and Orinthya—succeeded their mother and Lampedo as sister queens.

MEDUSA *(fl. 1290 B.C., Greece)*: Leader of the Gorgons, an Amazon tribe, Medusa was killed by Perseus, king of Mycenae. After her death, the main shrines of the Goddess were smashed in an effort to destroy the matriarchal order.

MYRINE *(13th c. B.C., Libya)*: Myrine mounted a campaign in which she and her Libyan horsewomen conquered parts of Syria and Phrygia, along with the islands of Samos, Lesbos, Patmos, and Samothrace. Myrine died at Samothrace in a battle against patriarchal Thracian and Scythian invaders.

ORINTHYA *(13th c. B.C., Scythia)*: Martesia's daughter Orinthya—who ruled with her sisters, Antiope and Hippolyte, as virgin queens of Themiscyra—supposedly brought great military honor to the Amazons. According to myth, the warrior women were defeated only by the mighty Hercules and Theseus.

PENTHESILEA *(d. 1187 B.C., North Africa)*: According to legend, Penthesilea, the last in the dynasty of great Amazon queens, went to Troy with twelve of her warrior women to help defend the city against the Greeks. Although she and her troops fought valiantly, they were eventually defeated by Achilles.

THALESTRIS *(fl. 325 B.C., Asia Minor)*: Thalestris, an Amazon queen, led an expedition of over three hundred armed women across Asia. It is said that her purpose was to meet and mate with Alexander, whom she considered sufficiently brave to be the father of her child. The outcome of her voyage is unknown.

Hatshepsut

(1503–1482 B.C.)

In ancient Egypt men and women were considered equal under the law, and women enjoyed considerable economic independence. Affection and consideration for the woman of the family is a common motif in tomb art, where husbands and wives are frequently seen embracing and sharing activities. New Kingdom pharaohs prided themselves on keeping such good order in the country that women could travel anywhere without fear of being molested.

Although the position of women later underwent dramatic changes, certain features remained constant. The throne was always passed on through the female line; therefore the principles of matrilineal descent and matrimonial inheritance rights remained firmly established. Four women are known to have ruled as pharaohs, though little is known of any except Hatshepsut, the mighty ruler of the Eighteenth Dynasty, who was the daughter of a great warrior king.

Hatshepsut bolstered Egypt's economy through trade, and she achieved peace and prosperity during her reign. Her own words echo across the centuries, revealing the pride she felt in her many accomplishments: "My command stands firm like the mountains and the sun's disk shines and spreads rays over the titulary of my august person, and my falcon rises high above the kingly banner unto all eternity."*

Pharaohs were considered the human incarnations of the deity. The plate honoring Hatshepsut features—for the first time—a slightly reliefed surface. The introduction

* Barbara Lesko, *The Remarkable Women of Ancient Egypt* (Berkeley: Scribe Publishers, 1978).

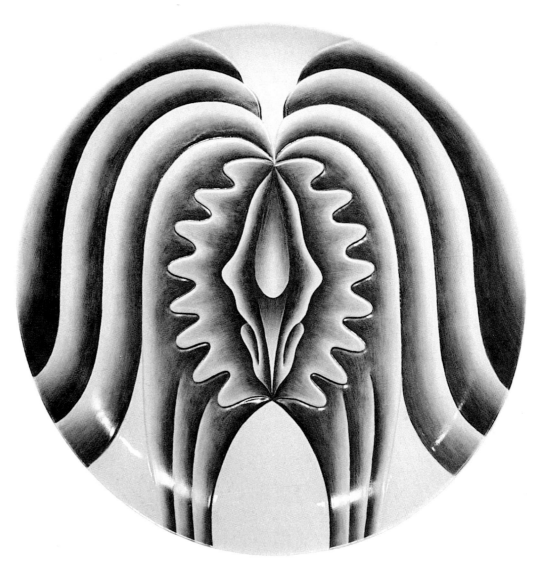

Hatshepsut plate

of dimension is intended to suggest the power enjoyed by this august figure. The image itself is based upon colors and motifs from Egyptian tomb painting, including stylized profiles, headdresses, and hairdos.

Hatshepsut's reign is praised in a series of embroidered hieroglyphic characters that border the runner. These were stitched onto strips of fine white linen cloth that approximate the high-quality fabric typical of ancient Egypt, then appliqued onto the runner surface. The runner designs repeat some of the motifs from the plate. These are combined with references to pharaonic costume, various signs and symbols connoting authority, and numerous visual elements based specifically upon the frescoes found in Hatshepsut's tomb. The colors of the plate are picked up in the runner, particularly on the embroidered blue roundlets featured on the runner back. These, like the outer forms of the plate, refer to the collars frequently worn by the pharaohs. Bordering the back of the runner is a decorative strip woven in a manner typical of Egyptian patterns and techniques.

The names grouped around the Hatshepsut place setting are primarily those of other Egyptian queens or prominent women. But a number of powerful queens from other cultures are also represented as an example of women's stature throughout the ancient world.

BEL-SHALTI-NARRAR *(fl. 540 B.C., Babylonia)*: Bel-Shalti-Narrar was dedicated by her father, the last king of Babylon, to the service of the Moon deity at Ur. As a high priestess, she was revered as a wise woman and consulted in many political, governmental, and military matters.

DIDO *(fl. 850 B.C., North Africa)*: Dido was a Phoenician princess who fled her home when her husband was murdered by her brother. After long wanderings, she settled on the African coast of the Mediterranean and founded the city of Carthage. She later committed suicide rather than submit to a forced marriage with a neighboring chief, who threatened war with the city if she refused him.

HASHOP *(fl. 2420 B.C., Egypt)*: Little is known of the Egyptian queen Hashop, other than the fact that she was an architect as well as a ruler.

KHUWYT *(fl. 1950 B.C., Egypt)*: Khuwyt, one of the first female musicians known to history, was a singer and harpist. She was portrayed in several paintings and was also represented as a female effigy adorning the top of a harp.

LUCRETIA *(fl. 600 B.C., Etruria)*: According to legend, a group of young nobles decided to test the character of the royal women by surprising them in their quarters. They found most of them eating or sleeping, but Lucretia was sitting with her handmaidens, weaving at her loom. Later that night, one of the king's sons returned secretly and threatened to kill Lucretia and one of her slaves if she did not submit to his sexual advances. Afterward Lucretia sent for her husband and father to tell them what had happened but, fearing that her attacker would accuse her of adultery, she killed herself. When Lucretia's story became known, the citizens supposedly revolted against the king, insisting on an end to such abuses of royal power.

MAKEDA, QUEEN OF SHEBA *(fl. 950 B.C., North Africa)*: Makeda, the queen of Sheba, was a scholar as well as a ruling queen. Her stature and many accomplishments have, unfortunately, been obscured by the historic focus on her relationship with King Solomon. In an effort to improve trade relations between their countries, the queen traveled twelve hundred miles to meet him. But the main emphasis in history has been on the fact that Solomon was responsible for her conversion to Judaism.

MAMA OCLO *(fl. 800 B.C., Peru)*: It is said that Mama Oclo taught the Inca women of ancient Peru the arts of weaving, sewing, and clothesmaking.

MENTUHETOP *(fl. 2300 B.C., Egypt)*: Mentuhetop was a queen of the Eleventh Dynasty at Thebes. In addition to being a ruling queen, she was a skilled medical doctor, and her medical bag, which has been preserved, is on exhibit at the Berlin Museum. (Among educated Egyptians, it was common for the queen to be the leading authority on medical matters.)

NAQI'A *(fl. 704–626 B.C., Assyria)*: Naqi'a was a great and energetic ruler who played an outstanding role in both the internal politics and general policies of the court. During the reigns of her son and grandson, she occupied the revered post of king mother and was officially represented with her son on a bronze tablet, a sign of the high esteem in which she was held.

NEFERTITI *(fl. 1300 B.C., Egypt)*: Nefertiti, the daughter of Queen Tiy and Amenhotep III, was the wife of the pharaoh Akhenaton. Unfortunately, she is remembered primarily because of a sculpture that reveals her as a woman of great beauty. Religious texts of the period, however, suggest that she shared the reign of Egypt equally with her husband, particularly since the iconography represents her as wearing a pharaoh's crown. There is some possibility that it was actually Nefertiti who was responsible for the religious

Hatshepsut capital letter

revolution in Egypt that has been attributed to Akhenaton. After his death, it is thought that she assumed leadership of Egypt.

NICAULA (*fl. 980 B.C., Ethiopia*): A learned woman and one of the wealthiest queens of the ancient world, Nicaula may have ruled over Arabia, as well as Ethiopia and Egypt. It is known that she traveled widely in order to study with the greatest teachers of the time.

NITOCRIS (*6th c. B.C., Assyria*): Queen Nitocris, a woman of extraordinary abilities, helped to sustain the Babylonian empire through her public works. She was responsible for building a bridge over the Euphrates to connect the two parts of Babylon, thereby improving commerce and trade. Upon her death, she left a vast sum of money to be used by the city.

NOFRET (*fl. 1900 B.C., Egypt*): Nofret, a queen who ruled in conjunction with her husband, Sesostris II, was considered a woman of great power and distinction. She was called "the ruler of all women" because she was responsible for progressive laws and practices concerning Egyptian women.

PHANTASIA (*12th c. B.C., Egypt*): Phantasia, a skilled storyteller, musician, and poet, is said to have traveled to Greece from Egypt during pre–Homeric times. She and another poet were reputed to have invented the hexameter, or heroic meter.

PUDUCHEPA (*fl. 1280–1250 B.C., Hittite empire*): Queen Puduchepa played an active role in the affairs of state, signing many of the royal documents of the time jointly with her husband, Hattusilis III. She also carried out the traditional role of priestess queen.

RAHONEM (*Old Kingdom, Egypt*): Egyptian queens were frequently served by an independent group of women including a prophetess, a spiritual teacher, and a priestess musician, who led an all-female community of dancers and singers. Rahonem, the director of one such group, held a position equivalent to that of the priestess musician.

SEMIRAMIS (*fl. 650 B.C., Assyria*): Semiramis, the queen of Assyria, was responsible for making Babylon one of the most magnificent cities in the world. In order to bring irrigation to its deserts and plains, she leveled mountains, filled valleys, and constructed dikes and aqueducts. She also led military campaigns that took her as far as India, which inspired her to design and wear trousers so that she could move about more freely. She ruled for forty-two years and was the only female ruler represented in a row of stelae of the great Assyrian kings at Ashur. Legend has it that her son was responsible for her death, whereupon she turned into a dove and became a deity.

TANAQUIL (*fl. 570 B.C., Etruria*): Tanaquil was a Roman queen emulated by many women. She managed to preserve the crown for her daughter's husband when the king died. Well regarded by the Romans, she was renamed by them Gaia Cyrilla, which means "the good spinner," a reference to her marvelous needlework and weaving. A law was actually passed that required newly married women to mention her Roman name (Gaia) upon entering their houses in order to bring good fortune upon themselves.

TETISHERI (*fl. 1650 B.C., Egypt*): Tetisheri was the first of six great queens of the Seventeenth Dynasty of Egypt, which, for six generations, was a matriarchy.

TIY (*fl. 1400 B.C., Egypt*): Queen Tiy, wife of the pharaoh Amenhotep III, was the mother of both Nefertiti and Akhenaton. Amenhotep, who was extremely fond of his mother, issued a commemorative scarab throughout Egypt to induce the people to accept her, despite the fact that she was a commoner. Tiy maintained a wide and politically astute correspondence with many foreign rulers, which helped maintain peace in Egypt.

Judith

(6th c. B.C.)

Judith was a very devout, learned, and courageous Jewish woman who lived in the town of Bethulia. Her story is told in the Book of Judith, presumed to have been written in order to inspire the Jews to acts of heroism. Bethulia had been conquered by the Assyrian general Holofernes and his troops, whereupon the Jews were forced into exile, taken into slavery, or persecuted for their refusal to pay tribute to the Assyrian king and the women sexually assaulted. Outraged, Judith decided to take action.

After praying for the strength to take vengeance on those "who had loosened a maiden's headdress to defile her and stripped her thigh to shame her, and profaned her womb to disgrace her," Judith donned festive attire, adorned herself in jewels, and —taking along wine, cheese, oil, bread, and figs—entered the camp of Holofernes. She passed easily by his soldiers, who seemed unable to imagine that a woman could be any real threat.

She was immediately invited into the general's tent, where they drank a great deal of wine. Judith, who was skilled in herbs and powders, had carefully prepared a liquid to put Holofernes to sleep. Judith then took up the tyrant's sword and, catching him by the hair, cut off his head with two quick strokes. After stealing silently from the tent, she placed Holofernes's head on one of the gateposts of the city. The Assyrian army, disoriented by the loss of their leader, retreated. The Jews honored Judith with feasts and praises. The women held a special ceremony in which they sang, played instruments, and danced all day and into the night in honor of their particular savior.

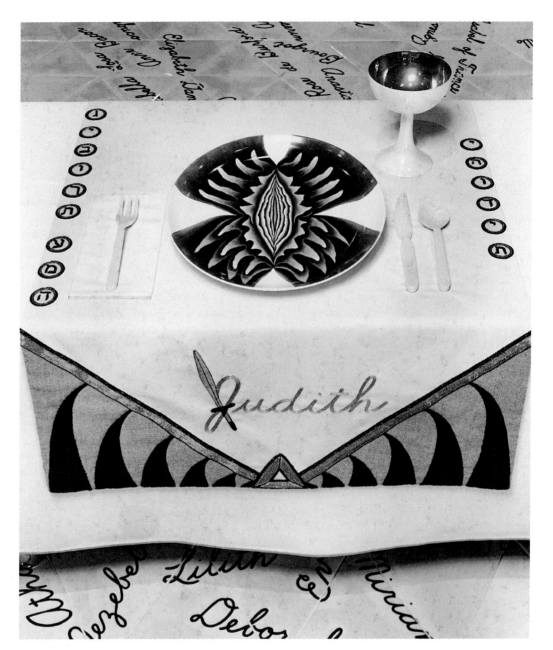

Judith place setting

The Judith plate at *The Dinner Party*, which presents a winged, leafylike image in strong colors, rests on a runner whose embroidered Hebrew letters identify her as a heroine of her people. The iconography of the runner—which is a rich mixture of wool, velvet, and linen, embellished with metallic embroidery—was inspired by the headdresses traditionally worn by Yemenite women during wedding ceremonies. The illuminated capital incorporates an embroidered sword in honor of Judith's courageous act, and the back of the runner contains thirteen coins engraved with pomegranates, which were early symbols of the Goddess.

Judith was not the only heroic or important woman in Jewish history, as the names grouped around her plate suggest. Perhaps it was because Jewish culture was always rooted in the family that so many strong women emerged, for within the family, women always enjoyed a certain traditional respect.

ABIGAIL *(fl. 1060 B.C., Hebrew)*: When David, the shepherd who would become king, asked Abigail's drunken husband, Nabal, for provisions, he refused. But Abigail generously complied, and when her husband died soon thereafter, she married David. Abigail has sometimes been considered the earliest female pacifist and the wisest woman in the Old Testament. She is said to have moderated David's tempestuous and willful personality with her gentle character.

ATHALIAH *(fl. 842 B.C., Hebrew)*: Despite the fact that Hebrew law prohibited women from ruling alone, Athaliah, the daughter of Queen Jezebel, claimed the throne of Judah as her own. During her six-year reign, she reinstated the ancient Goddess religion and was so popular that it required a violent revolution to dethrone her.

BERURIAH *(n.d., Hebrew)*: Beruriah, a scholar, legal expert, and the only woman mentioned in the Talmud, was one of the few women in Jewish history to write commentaries on the law. Because she often contradicted the judgments of her rabbi husband, he attempted to discredit her and even ordered one of his students to seduce her. After numerous attempts on her virtue, Beruriah committed suicide.

DEBORAH *(fl. 1351 B.C., Hebrew)*: The only woman of her time to possess political power by common consent of the people and the sole female judge mentioned in the Scriptures, Deborah's position was quite rare. She was considered a prophetess even before prophetic functions were given to Samuel. With a military man named Barah, Deborah devised a plan to overthrow the oppressors of the Jewish people. Her prophecy that God would deliver their enemy into the hands of a woman was fulfilled, and to celebrate this victory, the "Ode to Deborah" was com-

posed. Referred to as the mother of Israel, she is thought to have peacefully governed the Hebrews for forty years.

ESTHER *(fl. 475 B.C., Hebrew)*: When the king of Persia selected Esther as his wife, he did not realize that she was a Jew. After their marriage, he issued a decree ordering the massacre of the Jews, whereupon Esther told the king that she was Jewish and convinced him to not only reverse the order, but to pass a law allowing the Jewish people the right to defend themselves against their enemies. The holiday of Purim is celebrated in Esther's honor.

EVE *(Biblical)*: Derived from earlier myths that present a very different perspective, the biblical story of Eve presents her as responsible for all the evil that befell humankind. This now-familiar story transposes original creation myths, substituting the idea of the Goddess creating life into the story of Eve being created from the rib of Adam. Because Eve transgressed against the wishes of the Hebrew God by eating the forbidden fruit of knowledge, her punishment—and

that of all women—was to be endless pain in childbirth.

HULDAH *(fl. 624 B.C., Hebrew)*: Revered for her wisdom, the teacher and prophetess Huldah was often consulted by kings and religious leaders.

JEZEBEL *(9th c. B.C., Hebrew)*: Married to the Jewish king Ahab, Jezebel converted him to her belief in the Goddess. After being involved in the rule of the northern kingdom of Israel for over three decades, Jezebel was supposedly killed by fanatical worshipers of Yahweh.

LEAH *(fl. 1700 B.C., Hebrew)*: Leah was the niece of Rebekah, sister of Rachel, mother of Dinah, and the first daughter to be named in the Bible. She was duped by her father into having intercourse with Jacob, after which she married him, bearing seven children. Her sons went on to be among the major figures in the development of Judaism, and her story, though bleak, is meant to illustrate the importance of the mother in Jewish life.

Detail of *Judith* runner back; coins engraved by Juliet Myers

LILITH (*Apochryphal*): As Adam's first wife and supposedly his equal, Lilith was described as being created by God at the same time and in the same manner as Adam. But she is said to have resisted the recumbent posture that Adam demanded of her in sex and fled when he tried to compel her obedience. According to legend, Yahweh then sent three angels to retrieve her. They threatened that if she did not return, she would—as the mother of the human race—lose a hundred of her children each day. When Lilith still refused to submit, the angels tried to drown her, but Lilith pleaded her cause so eloquently that she was allowed to live. However, she was given to Satan as a wife and described thereafter as a heartless, devouring, tempting, and destructive creature.

MAACAH (*fl. 915 B.C., Hebrew*): Queen Maacah attempted to reinstate the Goddess religion within the Hebrew state, erecting an image in honor of Asherah. The statue was destroyed by her son, who dethroned Maacah and brutally suppressed Goddess worship.

MIRIAM (*fl. 1575 B.C., Hebrew*): Miriam, the sister of Moses, was a prophetess, teacher, and leader of the Jewish people. While Moses led the men of Israel to freedom, Miriam guided the women, supposedly walking on the dry sea bottom after a strong wind had backed up the waters.

NAOMI (*fl. 1000 B.C., Hebrew*): During the famine of Judah, Naomi migrated with her family to Moab, a fertile area east of the Dead Sea, where she lost her husband and both her sons. After ten years, she returned penniless to Bethlehem, accompanied by her daughter-in-law Ruth. Ruth pledged her devotion to Naomi in these immortal words, which suggest the deep love, loyalty, and friendship that existed between women in biblical times: "For whither thou goest, I will go; and where thou lodgest, I will lodge; thy people shall be my people, and thy god my god; where thou diest, I will die, and there I will be buried!"

RACHEL (*fl. 1753 B.C., Hebrew*): Rachel and Leah, along with their two maids, are said to have been the mothers of the twelve sons designated to head the twelve tribes of Israel. Rachel also had the dubious distinction of being the first woman in the Bible to die in childbirth.

REBEKAH (*fl. 1860 B.C., Hebrew*): After twenty years of infertility, Rebekah was at last able to conceive. Upon learning that she would bear twins, she asked God why this had happened. God answered that "two nations were within her and two manner of people, and . . . the elder should serve the younger." After giving birth to two sons, Esau and Jacob, she convinced her husband, Isaac, to give his blessing to Jacob—her favorite—and to name him as his successor. But when Esau threatened to kill Jacob, Rebekah interceded. She selflessly sent him away and never saw her beloved child again.

RUTH (*fl. 1000 B.C., Hebrew*): Ruth, the daughter-in-law of Naomi and the central figure in the Book of Ruth, was living in her native land of Moab when Naomi's family sought refuge there. Ruth married one of Naomi's sons, but when he, Naomi's other son, and husband died, Ruth chose to follow Naomi back to Bethlehem. In Jewish history, Ruth represents the heroic woman of devotion.

SARAH (*fl. 1900 B.C., Hebrew*): The story of Sarah is a prophetic one. Her life was one continuous trial of her faith in God's promise that she was to be the mother of nations. After years of waiting, and when she was far beyond childbearing age, Sarah finally gave birth to Isaac, a miraculous story intended to demonstrate the power of belief.

VASHTI (*fl. 475 B.C., Persia*): Queen Vashti, Esther's predecessor, was dethroned for disobeying her husband. When the king and some of his princes were drunkenly arguing about whose wife was the most beautiful, he insisted Vashti "display her beauty to them." She refused, which caused her to lose her royal position; she may even have been beheaded. The king then decreed "that all the wives will give to their husbands honor, both to great and small . . . and that every man should bear rule in his own house."

WITCH OF ENDOR (*fl. 1060 B.C., biblical*): Described as having gnarled hands, coarse leathery skin, and dark hair falling over stooped shoulders, the wise old Witch of Endor supposedly told fortunes, prophesied, and practiced witchcraft. Many people, including King Saul, were said to have gone to her cave seeking counsel, for she had a reputation for making accurate prophesies.

ZIPPORAH (*fl. 1500 B.C., Hebrew*): Zipporah, a learned woman, studied medicine alongside her husband, Moses, at the medical school in Heliopolis, Egypt. She refused to abide by the religious beliefs of her husband and resisted the circumcision of her two sons. Only the violent illness of Moses, which she viewed as a sign of God's anger toward her, persuaded her to finally accept this practice.

Sappho

(b. 612 B.C.)

Sappho, one of the finest poets in Western civilization, was born in Lesbos. She spent most of her life on this island, founding a *thiasos*: a sacred society of women who were bound by special ties. Each year, the members participated in women-only religious festivals, celebrating their belief that, because women gave birth, they also possessed power over life and death. This distinctly female power was to be expressed in singing, dancing, and the playing of instruments, which were considered divine arts belonging to women. Ancient rock paintings depict many female musicians, and hundreds of myths and legends describe the musical activities of goddesses and priestesses.

In tribal times, women gathered in sacred menstrual huts to welcome their daughters' first menses with celebratory songs. They sang as they worked in the fields and composed melodies as they wove. Women crooned softly to each other to ease the pain of childbirth, and when death struck, female musicians were summoned to mourn. The basic sound of women's music was the vocal wail, and through women's songs of ecstasy, grief, or joy, the feelings of the community were expressed. But when women's authority waned, their music ceased.

Sappho became such a renowned teacher that many women gathered around her to study the arts of poetry, music, and dance. Her fame spread throughout Greece: Statues were erected in her honor, her likeness was imprinted on coins, and her poetry was thought to rival Homer's. In addition to developing new poetic structures and meters, Sappho was known for poems expressing her love of women, often in openly erotic terms. (At that time homosexuality was viewed as a natural impulse among both women and

Sappho plate

men.) Because Sappho came from the island of Lesbos, the word *lesbian* has come to mean a woman who loves other women.

This eminent woman, so celebrated in her own time, later became the object of ridicule. She was satirized and maligned by the Greeks, and her love of women was represented by later Roman writers as perverse. After the Church branded her a criminal for her eroticism and homosexuality, fanatical monks burned her poems; sadly only a few hundred lines still survive.

In *The Dinner Party*, the Sappho plate

was inspired by the fact that she was known as "the flower of the Graces," whose colors were green and lavender. On the back of her runner is a padded and embroidered rendition of a Doric temple, while between its columns is a stitched image of the brilliant Aegean sky. Sappho's place setting stands for the last burst of unimpeded female creativity. Gradually, even the memory of women's former power began to be eroded, leaving in its place only a shadow of the freedom and authority that women had once enjoyed.

The island of Lesbos remained conducive to women's creativity for some time after the Greek mainland had already become repressive. Gradually, however, women's religious festivals were taken over by men and women writers were increasingly excluded from competitions. Men even attempted to appropriate the healing arts, which, like both magic and music, had always been considered part of women's sphere. The names grouped around the Sappho place setting embody the varying degrees of independence and achievement still possible for women in and around Greece.

AMYTE *(3rd c. B.C., Greece)*: Amyte, a poet and healer, was said to have introduced pastoral poetry, which supposedly influenced Virgil. Committed to a philosophy of complete equality, she frequently asserted that because the slave is the equal of the king in death, the same parity should prevail in life.

ANASANDRA *(5th c. B.C., Greece)*: The daughter of a well-known artist, Anasandra studied painting with her father. She eventually became an eminent painter in her own right.

CARMENTA *(8th c. B.C., Etruria)*: Revered as a poet, prophetess, and queen, Carmenta led her people into the area that would later become Rome. After establishing her son as king, she built the first temple, brought agriculture to the native inhabitants of the region, and also introduced them to music and poetry.

CLEOBULINE *(5th c. B.C., Greece)*: Influenced by Sappho, Cleobuline collaborated with her father, Cleobulus, in the writing of *Griphor* ("*Riddles in Verse*").

CORINNA OF TANAGRO *(fl. 490 B.C., Greece)*: Corinna, who was sometimes called the Lyric Muse, left five books of poems. She was a friend and critic of the great lyric poet Pindar, but sadly, her work, which was greatly esteemed, has not survived. While she lived, Corinna was considered to be second only to Sappho in poetic ability.

CRESILLA *(5th c. B.C., Greece)*: Cresilla took part in a competition with other sculptors to create seven Amazons for the ornamentation of the temple of Artemis at Ephesus. She placed third, behind noted artists Polyclitus and Phidias.

ERINNA *(6th c. B.C., Greece)*: Erinna was Sappho's most gifted student. She composed a 300-verse poem, "The Distaff," before her nineteenth year, the year of her premature death. Although her verses were considered as good as Homer's, only fragments of her work are extant.

HELENA *(5th c. B.C., Greece)*: Helena was a painter during the Hellenistic period in Greece. Her paintings were presented to a temple dedicated to Venus.

Sappho runner back; embroidery by Elfie Schwitkis

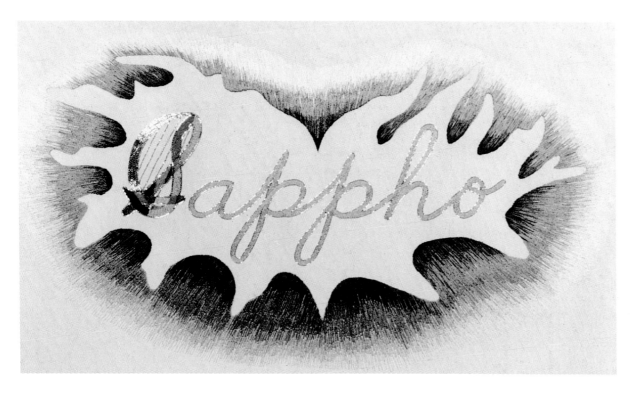

Sappho runner front: Embroidered
by Terry Blecher

KORA *(7th c. B.C., Greece)*: Kora, who was one of the earliest of women artists, is credited with having created the first bas-relief.

LALLA *(4th c. B.C., Greece)*: Lalla, known as the "Painter," primarily painted portraits of women. She executed at least one self-portrait, which was unusual for the time.

MANTO *(fl. 850 B.C., Greece)*: According to Greek legend, Manto was the daughter of a Theban seer who was sent to Delphi to become a priestess of Apollo. She became so famous for the inspiration and wisdom of her prophesies, it was said that Homer had incorporated many of her verses into his work.

MEGALOSTRATA *(fl. 600 B.C., Greece)*: Megalostrata achieved prominence as a poet, composer, singer, and leader of girls' choirs in Sparta at a time when female choirs were especially active and important in Greek life. Unfortunately, none of her compositions have been preserved.

MOERO OF BYZANTIUM *(3rd c. B.C., Greece)*: Moero is known to have written a heroic poem, "Mnemosyne," in addition to numerous epigrams and elegies. Only two of her works have been recovered.

MYRTIS OF ANTHEDON *(6th c. B.C., Greece)*: Myrtis was a member of a group of female poets referred to as the "Nine Earthly Muses." The teacher of Pindar of Thebes, she also instructed Corinna, another of the nine famous poets.

NANNO *(6th c. B.C., Greece)*: Little is known of Nanno other than that she was a famous flute player. Many elegies were addressed to her, suggesting that she was a prominent musician.

NEOBULE *(8th c. B.C., Greece)*: Neobule was a poet whose own accomplishments have been obscured by her inadvertent place in the creation of satiric verse. When her engagement to another poet was abruptly broken off by her father, her former lover blamed her. He attacked her in a poetic form that was said to be the basis for the development of this type of verse.

NOSSIS *(3rd c. B.C., Greece)*: Only fragments of Nossis's work survives. Because many of her poems supposedly dealt with themes of special interest to women, it is particularly sad that so much of her poetry was destroyed by Christian monks.

PENTHELIA *(pre-6th c. B.C., Egypt)*: Like many other Egyptian women, Penthelia was part of the tradition of musician priestesses who were trained for service in the temples. She described the events of the Trojan war in song and story, and her technique was said to have inspired Homer, as well as other Greek poets.

PRAXILLA *(fl. 450 B.C., Greece)*: Praxilla came from the city-state of Sicyon, where earlier customs of women playing a leading role in the religious and musical life of the times continued for a long time. Her many well-known songs were sung by choirs and soloists at banquets and festivals.

TIMARETE *(fl. 800 B.C., Greece)*: Timarete, an artist, produced an image of Artemis that was one of the most ancient examples of painting. The work was on view at the temple of Ephesus.

Aspasia

(470–410 B.C.)

Athenian society, which has been glorified for its democracy, was in fact harsher to its women than many other cultures of the time. In fact, as Athenian society became progressively more democratic for those men considered citizens, it became increasingly repressive to women of all classes, eventually forcing them into almost total segregation. Women sat with men only at their marriage feasts, after which they lived in separate quarters and were rarely permitted outside. While the girls were largely uneducated, boys were required to learn to read and write. This created a deep gap between the sexes, particularly since Athenian culture placed such emphasis on the intellect.

Aspasia came to Athens from an area of Greece where women were still allowed some degree of independence. She joined the ranks of the *hetaerae*, those few women who were able to participate in Athenian intellectual life. (The word *hetaerae*, which meant women who were unmarried and independent, was originally used by Sappho to refer to her companions. It only took on pejorative connotations later.)

Aspasia, a scholar and philosopher, became the companion of the orator and statesman Pericles. Soon the most learned men of the day frequented their house, where she established the first known salon. This allowed her—as it would allow other women after her—to be part of the intellectual dialogue of the day. She urged her male guests to bring their wives to her salon, which soon became known for discussions about the role of women in society, with Aspasia asserting woman's right to live as man's equal, rather than as his slave. For such heretical behavior, she was charged and tried for "impiety," and

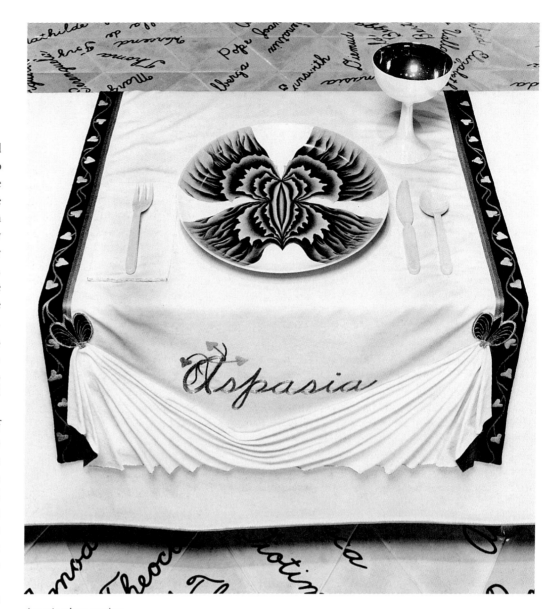

Aspasia place setting

only Pericles's intervention on her behalf saved her life.

The abstract portrait of Aspasia is done in muted earth tones, similar to the colors commonly used by the Greeks to paint their sculptures and their buildings. The plate sits on a runner combining visual references to Greek costume styles with ornamentation and motifs from the period. Draped fabric, formed to resemble the togas favored by the

Athenians, embellishes both the front and the back of the runner. The two embroidered pins that hold the fabric to the runner refer to the jeweled clasps that often decorated Greek clothing. Embroidered bands edge the runner, their design adapted from Greek vases. The palmette form, which appears frequently in Greek art, is repeated in a stitched panel on the back of the runner, the colors and style of which mimic motifs in Greek vase painting.

The names of other outstanding women of this period are grouped around Aspasia. This listing includes some who, in order to be educated, were forced to disguise themselves as men.

AGLAONICE *(5th c. B.C., Greece)*: Aglaonice, who always insisted on referring to her scientific skills as "her will," was able to predict eclipses of the moon and sun by means of the lunar cycles discovered by Chaldean astronomers. Although she was regarded as a sorceress, her observations were actually the result of her expertise in both astrology and astronomy.

AGNODICE *(fl. 505 B.C., Greece)*: Agnodice disguised her gender in order to study medicine. Her goal was to become an expert in gynecology in order to offer her services to women. After completing her studies, she revealed her true identity only to her women patients, who were happy to have a gynecologist of their own sex. Her male colleagues were outraged that their female patients preferred Agnodice, although they did not realize that she was a woman. In an effort to disgrace her, they brought her to trial for malpractice; when she publicly revealed her gender, they tried to enforce the law prohibiting women from practicing medicine. But a number of prominent women of the city protested this so strongly that they were able to revoke the statute.

ARETE OF CYRENE *(fl. 370–340 B.C., Greece)*: Arete was educated by her father, Aristippus, the head of a school of philosophy. After his death, she was unanimously elected to succeed him. Forty works are attributed to Arete, who passed on the family tradition of scholarship, educating her son just as her father had educated her. Concerned with science and ethics, she held a worldview that advocated equalized relationships among people.

ARISTOCLEA *(6th c. B.C., Greece)*: Aristoclea, the instructor of Pythagoras at the college at Delphi, was renowned for her wisdom. She is said to have been responsible for influencing Pythagoras's liberal attitudes toward women. As a result, many women were able to become involved with the Pythagorean school of philosophy.

ASPASIA OF ATHENS *(4th c. B.C., Greece)*: Aspasia, who became renowned for her surgical expertise, practiced medicine in Athens a century after her famous namesake lived there. She was especially knowledgeable in the treatment of women's diseases. The titles of her medical writings were recorded by Aetius, a physician and writer of the fifth century A.D.

AXIOTHEA *(4th c. B.C., Greece)*: Axiothea was a student of philosophy who studied with Plato. As women were not admitted into his academy, she attended the lectures in male attire. Plato reputedly refused to commence without her, saying that he would not begin "before the arrival of the mind bright enough to grasp his ideas." It is not known whether he was ever aware of her gender.

CYNISCA *(3rd c. B.C., Greece)*: Cynisca, the daughter of the king of Sparta, was celebrated for her skill in the Olympic Games. She won several victories in the chariot races and, as the first female to enter the Olympics, paved the way for many others. She was also the first woman horse breeder in recorded history.

DAMO *(fl. 500 B.C., Greece)*: The daughter of Pythagoras and one of his disciples, Damo was initiated into all the secrets of Pythagorean philosophy. She devoted much of her time to the education of women.

DIOTIMA *(5th c. B.C., Greece)*: According to the writings of Plato, it was Diotima who was responsible for instructing Socrates in social philosophy. A prophet and a Pythagorean philosopher, Diotima's theories on nature and life supposedly contributed to the philosophical ideas of Socrates.

ELPINICE *(5th c. B.C., Greece)*: In contrast to the women of Athens, Spartan women were able to control two-fifths of the land and property of Sparta through dowries, inheritances, and property laws. Though Athenian herself, Elpinice took the Spartan woman as her model, rejecting the expected domestic reclusiveness and attempting to participate in the intellectual life of the city.

EURYLEON *(3rd c. B.C., Greece)*: In the tradition of the charioteer Cynisca, Euryleon won an Olympic victory in the two-horse chariot race.

Detail of *Aspasia* runner back

In honor of her triumph, a statue of her was erected in Sparta.

HIPPARCHIA *(fl. 300 B.C., Greece)*: Hipparchia was a philosopher of the Cynic school of thought and at one time the companion of Alexander the Great. She resolved to live simply, repudiating all comforts. Hipparchia wrote several tragedies, philosophical treatises, and other works, none of which are extant.

HIPPO *(5th c. B.C., Greece)*: When Hippo became aware that a group of enemy sailors planned to rape her, she killed herself in order to avoid not only the physical abuse but also the violation of her vow of chastity. When her body was found and the reasons for her suicide understood, she was buried with veneration in a memorial built to celebrate both her personal morality and her martyrdom.

LAMIA *(4th c. B.C., Greece)*: The most renowned flute player in antiquity, Lamia was a child prodigy. She lived as an independent woman, traveling extensively and performing wherever she went. Altars were erected to her, a festival was created in her honor, and she was worshiped as a goddess.

LEONTIUM *(3rd c. B.C., Greece)*: Those Athenian women who were able to educate themselves by attending schools for the *hetaerae* were expected to act as companions to the educated men. Leontium, considered the most eloquent philosopher of the time, became the companion of Epicurus, with whom she had studied philosophy. But she owed her singular fame to her own writings, none of which, unfortunately, have survived.

NICOBULE *(fl. 300 B.C., Greece)*: A celebrated author, Nicobule wrote a history of Alexander the Great. She also composed many poems, none of which are extant.

PERICTYONE *(5th c. B.C., Greece)*: Perictyone was a Pythagorean writer and philosopher who may have been the mother or sister of Plato. One of her works, *On Wisdom*, was cited by Aristotle, and another, titled *Concerning the Harmony of Women*, dealt with the relationships between body and spirit, thought and action.

PHILE *(1st c. B.C., Greece)*: Phile was elected to the post of magistrate, the highest municipal office in her city. In this capacity, she was responsible for the construction of reservoirs and aqueducts.

SALPE *(1st c. B.C., Greece)*: Both a physician and a poet, Salpe wrote treatises on women's diseases and eye afflictions, as well as poetry about the importance of athletics.

TELESILLA *(fl. 50 B.C., Greece)*: Telesilla was a lyric poet who wrote verses to Artemis and Apollo. She is said to have saved her city by arming the women, who were thereby able to repulse the invading Spartans. A statue was erected in her honor in the temple of Aphrodite at Argos.

THEANO *(fl. 540–510 B.C., Greece)*: A brilliant mathematician who was knowledgeable about medicine, hygiene, physics, and early psychology, Theano succeeded Pythagoras as head of his institute of philosophy. When he was quite aged, she married him. It was supposedly Theano who first articulated the idea of the Golden Mean, considered a major contribution of Greek thought to the evolution of social philosophy.

THEOCLEA *(6th c. B.C., Greece)*: Theoclea, a student at the Pythagorean school of philosophy at Delphi, later became a high priestess at the temple of Apollo there.

Boadaceia

(1st c. A.D.)

Boadaceia, whose plate is the twelfth on the first wing of the table, represents the tradition of warrior queens extending back into legendary times. An image of a stone structure reminiscent of Stonehenge cradles a helmet form decorated with motifs like those on gold shields of the period. The plate rests on a runner whose surface includes pieces of handmade felt. These incorporate the curvilinear forms typical of Celtic art. Similar bold, convoluted shapes encircle the plate to signify both Boadaceia's personal strength and something of her life circumstances. These are embellished with rhythmic stitching and cording, as well as with jeweled pieces based upon the enameled jewelry worn during that time. This same type of enameled work embellishes the capital letter, whose form mirrors the runner motifs.

Although available information about early Celtic life is sketchy, it is known that women had many legal and political rights. Celtic religion honored powerful female deities who, much like Ishtar, were thought to confer the right to rule on the king through a ritual mating designed to ensure the fertility of the land and the people. This tradition allowed Boadaceia to establish her own reign after the death of her husband, the king.

During the period when the Romans were spreading their empire into the British Isles, Boadaceia's people, the Iceni, were conquered by the Romans and then—though only for a short while—left relatively undisturbed. Boadaceia's husband had willed half his property to the Roman emperor (this was required of conquered rulers) and the other half to Boadaceia and their two daughters in the hope that this inheri-

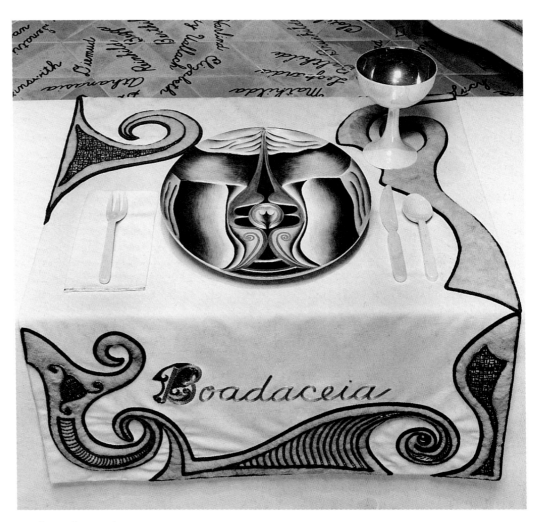

Boadaceia plate setting

tance would protect his family from the Romans. Instead, the will was used as a pretext for Roman officials to regard the whole kingdom as their spoil. First they seized the estate of Boadaceia's relatives, then broke into the queen's own quarters. Boadaceia was bound, flogged, and forced to witness the brutal rape of her daughters by Roman soldiers.

Enraged, this great queen called together neighboring tribes, uniting them into one great army. She proclaimed: "Roman lust has gone so far that not even our own persons remain unpolluted. If you weigh well the strengths of our armies, you will see that in

this battle we must conquer or die. This is a woman's resolve. As for the men, they may live or be slaves." With British men and women fighting side by side, her army attacked their Roman oppressors and were at first successful.

But their triumph was of short duration, because while Boadaceia's troops were inexperienced, the Romans were highly skilled. The Roman general vented his rage on her people, slaughtering more than 80,000 and leading a campaign of annihilation against entire sections of the community. Boadaceia managed to make her way home, where she took poison rather than accept defeat.

Grouped around Boadaceia are the names of a number of other ruling queens, mythological female warriors, and women who are thought to have participated in battles, planned military strategies, or led armies.

ALEXANDRA OF JERUSALEM *(d. 70 B.C., Judea)*: The widow and successor of Alexander Jannaeus, Alexandra established peace in Judea after the bloody and turbulent reign of her husband. Unfortunately, the later years of her rule were marred by her youngest son's opposition to Alexandra's commitment to religious tolerance.

ARETAPHILIA OF CYRENE *(fl. 120 B.C., Cyrene)*: Widowed at the hands of a conquering tyrant and then forced to marry him, Aretaphilia vowed to free both herself and her country. After she fulfilled this ambitious goal, the people of Cyrene asked Aretaphilia to reign. But she declined for unknown reasons, choosing to retire for the remainder of her life.

ARSINOE II *(3rd c. B.C., Egypt)*: Arsinoe II ruled Egypt in conjunction with Ptolemy II, her brother and husband. Although the two were worshiped as divine and were both represented on Egyptian coinage, Arsinoe seems to have exercised the primary governing power. She was responsible for the expansion of Egyptian sea power and is credited with having founded a great city, which bore her name.

ARTEMISIA I *(5th c. B.C., Halicarnassus)*: Upon the death of her husband and because of the minority of her son, Artemisia assumed the throne. In 480 B.C., she supported a military expedition against the Greeks, furnishing five ships and fighting a great naval battle. She distinguished herself as a military strategist and, according to Herodotus, was one of the most noble women of antiquity.

ARTEMISIA II *(4th c. B.C., Halicarnassus)*: Artemisia II immortalized herself by erecting a tomb for her husband, Mausoleus. This mausoleum (from which all such subsequent monuments obtained their name) was considered one of the seven wonders of the world. Though grief-stricken by her husband's death, Artemisia ruled for the two years that she outlived him. When the Rhodians attempted to dethrone her, she waged war against them, driving them back to the walls of their city, which she and her troops besieged in the year 351 B.C.

BASILEA *(n.d., Celtic)*: Queen Basilea, the legendary daughter of Gaea and the first ruler of Atlantis, is said to have brought order, law, and justice to the world after the mythical war against the forces of evil and chaos.

BRYNHILD *(n.d., Germany)*: Brynhild was the most famous of the Valkyries, a band of German horsewomen and warrior goddesses who might be described as greatly diminished Teutonic counterparts of the Amazons. Represented as virgins with swans' plumage who lived in forest lakes, these mythical women would supposedly become the slave of any man who stole their feathers. Brynhild's were stolen by King Agnar, whom she aided in a war against Hjalmgunnar. When she defied the sky god, Odin, he punished her by stripping her of her power and immortality. Secluded in a flame-encircled castle, she could be saved only by marrying the man who rescued her, the German hero Sigurd (Siegfried). This legend illustrates the change in women's status as they were, by this time, almost entirely dependent upon men.

CARTISMANDUA *(1st c. A.D., Britain)*: Cartismandua was one of the most outstanding queens of Celtic antiquity. She ruled the Brigates, whom she led to victory in several military campaigns, including one against her own husband. After triumphing against him, she challenged the Roman empire. Although meeting defeat at the hands of the Romans in A.D. 77, she was celebrated as a heroine by her people.

CHIOMARA *(fl. 180 B.C., Gaul)*: When the Gauls were defeated by the Romans, Chiomara was one of the many women taken captive. She resisted a centurion's attempts to seduce her, whereupon he raped her, then offered her her freedom only in exchange for gold. She retaliated by cutting off his head, which she took to her husband as a symbol of her revenge.

Detail of *Boadaceia* runner back

CLEOPATRA *(69–30 B.C., Egypt)*: At the height of her powers as the last great queen of Egypt, Cleopatra was considered the new Isis and thought of as she who would fulfill the prophecy that a woman would bring salvation to the strife-torn world. After the death of her father, Cleopatra was elevated to the position of ruler and deity. Well-educated, multilingual, and acutely aware of her powerful position, she was determined not to be used by ambitious nobles. Nonetheless, through the efforts of the guardian of her brother, young Ptolemy, she was driven out of the capital city. She then raised an army and, with Caesar's aid, conquered Ptolemy's forces, thereby recapturing the throne. In 47 B.C. Cleopatra joined Caesar in Rome and had a son, Caesarion, with him. She returned to Egypt after Caesar's assassination, and was proclaimed "Queen of Kings" by Marc Antony two years later. A new order was established by Cleopatra and Antony, which many thought would bring true partnership between Egypt and Rome. The two leaders had an important goal: the merging of the eastern and western parts of the empire. If they had accomplished their objective, the course of Western civilization might have been drastically altered. Under Cleopatra's rule, Egypt became an autonomous, allied, and protected kingdom. Although her desire to extend the realm had been supported by both Caesar and Antony, she was resented by the majority of Romans—both because she appeared on the battlefield with Antony and because of her power. In 30 B.C. the army of Octavian defeated Antony, who committed suicide, dying in Cleopatra's arms. She then killed herself by having a snake bite her.

CYNANE *(4th c. B.C., Macedonia)*: As was then customary, Cynane's father, Philip of Macedonia, arranged a marriage for her. But her husband soon died and she was left a widow with a daughter, Eurydice. To ensure that Eurydice would marry the heir to Alexander's lands, Cynane led her army to Asia. Macedonian warriors were sent to kill her, but Cynane was able to dissuade them from their mission, whereupon one of the generals carried out the deed. Her daughter became queen of Macedonia nonetheless, thus achieving her mother's goal.

EACHTACH *(4th c. B.C., Ireland)*: Eachtach was reputedly a warrior of such prowess that the men of Ireland saluted her with a distinguished burial, an unusual honor for a woman.

MACHA OF THE RED TRESSES *(fl. 330 B.C., Ireland)*: The warrior queen Macha is said to have disguised herself as a leper in order to beguile her enemies. After pursuing them into the woods, she captured them, then brought them tied together to Emhain. But instead of condemning the prisoners to death, as was customary, a council ruled by women ordered them to become the slaves of the queen. The men were made to build a great fortress, which supposedly became the capital of the province.

MEAVE *(n.d., Ireland)*: A powerful ruler, Meave was married to King Ailill. As the superior leader and strategist, she is credited with saving the city of Ulster from falling to the enemy. During peacetime, she provided stability in her kingdom through astute marriage alliances. Meave was sometimes identified with the original Queen Mab of fairy lore.

MEDB OF CONNACHT *(n.d., Ireland)*: A mythical warrior queen, Medb was the legendary ancestor of such historic warrior queens as Boadaceia and Cartismandua. Her predecessor was Macha, the fertility and warrior goddess who was worshiped in parts of pre–Celtic Ireland.

MUIRGEL *(fl. 882 B.C., Ireland)*: The warrior Muirgel is said to have courageously slain the chieftain of the Northmen during an invasion of her country, thereby ridding Ireland of a longtime foe.

OLYMPIAS *(fl. 350–320 B.C., Macedonia)*: Olympias was the most prominent woman in Macedonia during the stormy period in history when her husband, Philip II, ruled that country. Devoted to her son, Alexander the Great, she worked to ensure his succession to the throne.

TOMYRIS *(6th c. B.C., Scythia)*: Tomyris was a Scythian warrior queen and founder of the city that bore her name. Herodotus wrote admiringly of her, reporting that when Cyrus of Persia threatened the invasion of her land, she placed her own son at the head of an army in order to repel the invaders. After he was killed by the enemy, Tomyris herself led her forces in a fierce battle against Cyrus. After killing the Persian tyrant, she dipped his head in gore and proclaimed that she was justifiably avenging herself against the man who had murdered her beloved son.

VELEDA *(1st c. A.D., Celtic)*: A Celtic queen of the tribe of Batavi, Veleda was greatly respected by her people for her powers of prophecy. Because she was venerated as a goddess, approaching her was forbidden. While living in seclusion in a tower, therefore, she directed the affairs of state through one of her relatives.

ZENOBIA *(ca. A.D. 240–300, Palmyra)*: Zenobia, a queen of the east, was a scholar, warrior, brilliant military strategist, and the administrator of a large empire. She is said to have accompanied her husband, the king of Palmyra, on all his military ventures. After his death, she took over the empire, waging wars on her own in order to conquer Egypt, Syria, and Asia Minor. She ruled for many years, and her court was considered the most splendid of the time. Because Zenobia's power was considered a threat to Rome, two emperors besieged her land. She repulsed the first attack but, while traveling to Persia to seek aid, was captured. Taken to Rome as a valuable prisoner, she was treated well and managed to live to an old age.

Hypatia

(A.D. 370–415)

Unlike most of their Athenian sisters, upper-class Roman women could be educated, particularly those who lived where Egyptian influence was strong. Hypatia, a child prodigy, was tutored by the most celebrated scholars of her day, rapidly mastering mathematics, astronomy, and the natural sciences. She became an outstanding and very popular scholar and, as a result, was appointed the head of the University of Alexandria.

Hypatia attempted to create an intellectual reawakening of reverence for the Greek gods and goddesses, particularly stressing the importance of the Goddess and the feminine aspects of culture. She argued that Goddess religions conferred dignity, influence, and power on women. When consulted about the growing unrest in Rome, Hypatia stated that Roman men misused their women, thereby causing the next generation to be born not through love but through seduction and rape. She believed that this produced a level of violence and turmoil in the empire that could be solved only by elevating women to their former status. Through her eloquent teachings, Hypatia attracted both plain and cultured people to her philosophy, gradually becoming a political force that threatened the power of the emerging Church.

Hypatia became an anathema to many Christians, including the bishop of Alexandria, who despised her, no doubt in part because of her stature in society and also because she dared to preach. After she became an official advisor to the government, it was difficult for the bishop to openly attack Hypatia. Instead, he secretly organized a group of fanatical monks, who waylaid her on the way to her weekly lecture at the university. Dragging her from her carriage, they pulled her limbs from their sockets, plucked

Hypatia capital letter; embroidery by Susan Hill

out her organs, and hacked her remains to pieces and burned them. Years later, when the great library of Alexandria was sacked, Hypatia's writings were entirely destroyed.

The place setting for Hypatia symbolizes the destruction of female genius in the classical world. Coptic imagery is adapted to the design of both her plate and runner. The scalloped edges and slightly reliefed form of the plate are intended to suggest the degree to which she was able to break free from the constraints imposed upon so many other women of her time. Painted in strong colors, the leaf forms pull away from the

center, suggesting the brutal method of her death.

The plate is placed on a runner that repeats the tones of the plate, combining abstract and figurative imagery with traditional Coptic iconography. The woven and appliqued borders incorporate traditional Coptic designs, and the tapestry that comprises the runner back depicts the horror of this distinguished woman's death. A small embroidered face illuminates Hypatia's name. This tiny image represents the silenced Goddess, while also signifying the deliberate muting of other powerful women.

The names of the figures surrounding the place setting for Hypatia represent women's ongoing efforts to exercise their intellectual, cultural, and political power. In addition, women devoted to Christianity are included. Hypatia lived during a period when this new religion was spreading, and many women became martyrs to the new faith. At first, Christianity provided considerable support for women, but only if they accepted the tenets of the faith.

AEMILIA *(4th c. B.C., Rome)*: Aemilia was a physician who wrote books on gynecology and obstetrics.

AGATHA *(d. A.D. 251, Sicily)*: Because Agatha, a noblewoman and Christian, refused the advances of the Sicilian governor, he used the pretext of her Christianity to avenge himself upon her. He ordered her to be mutilated and rolled on burning coals, then left unattended in prison to die in torment.

BARBARA *(d. A.D. 235, Nicodemia)*: Barbara, a wealthy, well-educated woman, decided to convert to Christianity and commit herself to a celibate life. This so enraged her father that he exposed her as a Christian and delivered her over to a magistrate. After being cruelly tortured, she was beheaded.

BLANDINA *(d. A.D. 177, France)*: Blandina was the slave of a Christian mistress and one of the forty-eight martyrs to die in Lyons during the persecutions of Marcus Aurelius. After her body was broken and mangled, she was thrown to the animals in the amphitheater. After somehow surviving, she was finally burned at the stake without having recanted her faith. In her dying breath she cried out, "I am a Christian; no wickedness is carried on by us."

CATHERINE *(d. A.D. 307, Alexandria)*: Educated in the schools and libraries of Alexandria, Catherine was one of the most learned women of her time. When the emperor Maximus ordered that all his subjects offer a sacrifice to non–Christian deities, Catherine, a devout Christian, tried to show him the falsity of his beliefs. He called together fifty famous university scholars to refute her, but she managed instead to convert them all. Enraged, Maximus had the men burned alive and Catherine brutally killed in a specially constructed machine, which had four wheels armed with points and saws that turned in opposite directions.

CLODIA *(1st c. B.C., Rome)*: An early feminist, Clodia conducted an important salon that included many of the most gifted thinkers and outstanding politicians of her era. Like many women, she was able through her salon to establish and maintain a position of intellectual and social power.

EPICHARIS *(1st c. A.D., Rome)*: A freed slave and revolutionary, Epicharis was involved in a conspiracy against Nero. When the plot was uncovered, she was whipped, burned, and beaten, but she refused to divulge any information or the names of others involved. The following day, she was brought back to the tribunal in a chair because her body had been so badly broken that she could barely stand. Nonetheless, in an act of open rebellion, she took off the girdle that bound her breasts, tied it in a noose to the canopy of the chair, and hanged herself.

CORDELIA GRACCHI *(fl. 169 B.C., Rome)*: Cordelia's house was one of the social and intellectual centers of Rome. Fragments of her letters demonstrate that she corresponded with the most distinguished philosophers and scientists of her time. She was responsible for the education of her sons, known to history as the Gracchi, through whom Cordelia exercised considerable influence on Roman politics.

HESTIAEA *(2nd c. B.C., Alexandria)*: Hestiaea, a Homeric scholar, was one of the first people to attempt a scientific exploration of the actual locations of places named in the *Iliad.* She was also the first to throw doubt on the generally accepted view that New Ilium was the site of ancient Troy.

HORTENSIA *(fl. 50 B.C., Rome)*: Hortensia, known as an eloquent orator, represented fourteen hundred wealthy women who felt that they were being unfairly taxed. An early advocate of no taxation without representation, Hortensia argued that tax money was being used for a military venture of which most women disapproved. When she presented her case before the Roman forum, she succeeded in having these taxes reduced.

LAYA *(fl. 100 B.C., Greece and Rome)*: Thought to be the inventor of miniature painting, Laya was renowned for her small paintings on ivory, particularly her portraits of women. Her work, which supposedly commanded large sums of money, is known to history through the critical praise of Pliny.

METRODORA *(2nd c. A.D., Rome)*: Metrodora, a physician, wrote a treatise on the diseases of women that is the oldest extant medical writing by a woman. A twelfth-century copy (in the Laurentian Library in Florence) contains many revolutionary prescriptions for the treatment of diseases of the uterus, stomach, and kidneys.

PAMPHILE *(fl. A.D. 20, Greece)*: Pamphile, the daughter of a grammarian and the wife of a scholar, was an essayist and historian who wrote a thirty-three-volume work, as well as many important shorter treatises.

PHILOTIS *(fl. 380 B.C., Rome)*: Philotis, a maidservant in Rome, led the female slaves in a rebellion against the invading Gauls, who had demanded that all the women of the city be given to them. Philotis organized a plan involving all the female slaves. Dressed as Roman matrons, they went to eat and drink with the Gauls. When the soldiers fell asleep, Philotis lit a torch to signal the Roman soldiers. Together with the women, they conquered their Gallic enemies.

CORDELIA SCIPIO *(1st c. B.C., Rome)*: Cordelia Scipio, who was well educated, was a mathematician, philosopher, and musician. She was married to Pompey, with whom she traveled widely. Unfortunately, Scipio's later career is lost to history.

SHALOM *(fl. A.D. 70, Hebrew)*: Despite the fact that Shalom's husband, a religious scholar, believed that "whoever teaches his daughter the Torah, it is as though he taught her lechery," Shalom became a highly educated and respected woman.

SULPICIA *(1st c. A.D., Rome)*: Sulpicia, the author of thousands of poems, was the first Roman woman to encourage other women to believe that they could write quality poetry. Upset by the expulsion of Stoic philosophers from Rome, she wrote an influential satirical poem that chastised Roman men for not protesting this act. She also wrote a poem on conjugal affection that became extremely popular.

WING TWO

From the Beginning of Christianity
to the Reformation

THE SECOND WING of the table chronicles the fluctuations in women's position from the early days of Christianity—when, in many religious communities, women enjoyed a considerable amount of freedom—to the Reformation, which brought about the dissolution of the convents and the end of the education and independence that they had provided. As feudal society gave way to the Renaissance and the rise of the modern state, all classes of women were affected, often in negative ways. The Reformation eventually ushered in a new, though limited, form of secular female education, which was to contribute to the beginning of a dramatic change, as women gradually developed the intellectual tools to articulate arguments for equal rights.

These historical developments are reflected in the iconography of the second wing of the table, particularly in the runners, where the imagery moves up onto the runner tops and begins to encroach upon the plates. In response to the steady infringement of social constraints—as symbolized by the runner designs—the plate images become more active and dimensional as a metaphor for women's struggle to transcend their ever more limiting historical circumstances. To further emphasize the effort to break out of the limitations of female role expectations, the edges of the plates become more irregular, while the forms assume greater definition, a symbol of increasing individuation.

FACING PAGE: *Millennium Triangle II*; white silkwork; embroidery by Marjorie Biggs

Marcella

(325–410)

Marcella, who was born to a noble and wealthy family, lived in Rome during the time the empire was crumbling. Forced to marry at an early age, she was widowed while still young; but instead of following Roman custom and remarrying, Marcella dedicated herself to Christianity. After withdrawing from society, Marcella transformed her palace into a center for women who were interested in a simple life of purpose. In Marcella's community, called the Little Church of the Household, women studied religion and the Scriptures and, under her guidance, were educated in the Christian way of life. They traveled and preached, set up religious houses and schools for women, established hospitals, and ministered to the sick and needy.

In 410, during the sack of Rome by the Huns, Marcella was beaten by the invading soldiers and her estate was destroyed. Although she managed to escape, she died shortly thereafter, but not before helping to plant the seed that flowered into the great monastic system of Christianity.

The plate for Marcella at *The Dinner Party* is painted in luminous but modulated tones to emphasize her spirituality and her modesty, and the runner is based upon Christian iconography and architecture. A simple basilica form is embroidered across the runner surface, and the plate sits within the center of the nave shape. The apse and bay forms interlock with a woven material that suggests the hair shirts worn by ascetics as an act of mortification and penance. The embroidered motifs on the runner back—a scroll, a ship, and the combined image of a fish, staff, and triangle—refer to the symbols that she acquired when she became a saint.

Detail of *Marcella* runner back; embroidery by Terry Blecher

63

Grouped around Marcella are a number of important and powerful Roman women, as well as others who helped spread the gospel of Christianity. These religious women founded convents and hospitals, taught, preached, and/or administered religious houses. But Christianity brought mixed blessings to women: On the one hand, the Church provided a number of advantages, but it also contributed to the constriction of women's freedom.

AGRIPPINA I (*13 B.C.–A.D. 36, Rome*): Agrippina accompanied her husband, a Roman general, into battle and was said to have fought side by side with him. When he was poisoned, she attacked the man suspected of killing him. Returning to Rome carrying her husband's ashes, she was met by the citizens of the city. She was exiled by the Roman emperor, who so resented her popularity that he had her blinded. When he attempted to persecute her children, she starved herself to death in protest.

AGRIPPINA II (*15–59, Rome*): Agrippina II ruled the Roman empire in the name of her imbecile husband, Claudius. Her administration was brilliant and vigorous, and civil order was re-established during her ten-year reign. She was the first woman allowed to ride in the gilded imperial chariot reserved for priests, which reflected her position and power. As Nero's mother, Agrippina was largely responsible for putting him on the throne. She soon realized that he was going mad and would create chaos in the country if allowed to remain in power. Nero eventually had her murdered to prevent her from threatening his reign.

ANASTASIA (*d. 303, Rome*): A noblewoman, Anastasia was raised as a Christian by her mother. Her father arranged her marriage to a wealthy Roman, who, upon discovering that she was a Christian, treated her harshly. After her husband died, Anastasia devoted herself to scriptural studies and charitable works, spending what was left of her fortune aiding the poor and Christians in prison. She was eventually imprisoned and burned for her refusal to practice non–Christian rituals.

JULIA DOMNA (*ca. 157–217, Rome*): Well-educated in history, philosophy, geometry, and the sciences, Julia Domna communicated with the most distinguished and learned people of her time. She acted as advisor to her husband in all governmental affairs and as regent during the reign of her young sons. After being banished by the ruler who succeeded her sons, she committed suicide.

DORCAS (*1st c., Jerusalem*): An affluent woman whose name has become synonymous with charity, Dorcas made clothes for the needy and, upon her death, was said to have been resurrected by St. Peter. The Dorcas Sewing Societies, now worldwide, grew out of her work.

LIVIA DRUSILLA (*56 B.C.–A.D. 29, Rome*): As the first Roman empress, Livia Drusilla played a significant role in governing Rome for over seventy years. Setting a precedent for future empresses, she became co-regent with her husband, Octavian, and was given the title Julia Augusta. The couple's reign was marked by prosperity and tranquillity. Livia Drusilla was responsible for tempering her husband's harsh rule, using her wealth to help the poor and persecuted and to establish schools for children. She worked to secure the crown for her son, who ultimately renounced her and thwarted the plans of Roman senators to build an arch in her memory to honor her as the "mother of her country."

EUSTOCHIUM (*d. 419, Rome*): The daughter of St. Paula and a disciple of St. Jerome, Eustochium traveled with them to the Holy Land, where they founded the first women's convents in Bethlehem. Eustochium spent much of her life working with her mother, copying, translating, and revising the manuscripts of St. Jerome.

FABIOLA (*d. 399, Rome*): Fabiola was a wealthy noblewoman who was converted to Christianity by Marcella. Because divorce was then regarded as a male prerogative, she created a controversy by divorcing her first husband. Upon the death of her second husband, Fabiola devoted herself to a ministry of mercy. In 390 she founded the first public hospital in Rome, where she served as nurse, physician, and surgeon. Also a teacher of Christianity, she performed charitable works with Jerome, Paula, and Eustochium and was impor-

tant in the establishment of a distinctly female order of the Christian ministry. After her death, thousands of people converged upon Rome to pay her homage.

FLAVIA JULIA HELENA (*255–300, Rome*): The first Roman empress to be an avowed Christian, Helena was one of the most generous and influential supporters of the early Church. She and her son, Constantine, the first Christian emperor, were responsible for establishing Christianity as the official state religion. When her husband became emperor in 292, he was forced to divorce Helena, a commoner, in order to marry a noblewoman. When he died, Helena saw to it that her son was proclaimed emperor, and in gratitude Constantine restored her to power as empress mother.

LYDIA (*1st c., Macedonia*): A successful businesswoman in the city of Philippi, Lydia was engaged in the lucrative sale of purple dye, purple being the imperial color of the Romans. She is mentioned in the New Testament as an early convert to Christianity, perhaps the first in Europe. Her entire household subsequently converted, and her home became a haven for Paul and his followers.

MACRINA (*327–379, Turkey*): Macrina studied medicine in Athens and built a large hospital at Cappodocia in 370 that was quite revolutionary in that it included separate wings for different diseases, as well as living spaces for nurses and physicians. A pioneer in advocating the monastic life, Macrina founded a women's community in Asia Minor where she taught, preached, and prophesied. Macrina set an example of a life devoted to "no hatred, pride, luxuries, or honor." Her entire family was influential in the early Church, and she and her brothers, Bishops Gregory and Basil, were canonized.

CAELIA MACRINA (*2nd c., Rome*): Caelia Macrina, like a number of other philanthropic noblewomen of her time, believed that the best investment for Rome's future was its children. She therefore personally provided for the support of over one hundred children.

JULIA MAESA (*fl. 217, Rome*): Julia Maesa's knowledge of the workings of the Roman court

enabled her to manipulate political events and put her grandsons, Elagabalus and Alexander, on the throne. She acted as a military commander in the Roman army and made a place for herself and her daughter Soemias in the Senate. Julia Maesa then became the leader of the Senaculum, a body of women that decided issues pertaining to women.

MARY MAGDALENE *(1st c., Jerusalem)*: Mary Magdalene, who was one of the early female followers of Jesus, was closely associated with him throughout his ministry. She was present at his crucifixion and burial and was the first to report the resurrection. However, her identity has been obscured through various interpretations of the gospels. She has sometimes been confused with Mary of Bethany, as well as with an unnamed "sinner" who anointed Jesus with oil and was forgiven by him for her sins. Around 600, Pope Gregory decreed that these various Mary identities be combined under the name Mary Magdalene. She was thereafter considered a penitent prostitute, representing the idea that the evil associated with carnality was embodied in women and that only through Jesus could redemption be achieved.

JULIA MAMAEA *(d. 235, Rome)*: Trained in state affairs by her mother, Julia Mamaea led troops in a battle that established her regency in the name of her young son. Her reign was characterized by a level of peace, justice, and prosperity that was unprecedented in Roman history. Julia Mamaea established a strong, democratic form of government, but the Senate, incensed at the incorruptibility of her and her counselors, passed a law excluding all women from its ranks. She spent money generously on public works and on such reforms as free public education for orphans. But she failed to gain the loyalty of her soldiers, who felt that they were underpaid; she and her son were assassinated by the dissatisfied troops.

MARCELLINA *(4th c., Rome)*: In the first known ceremonial recognition of a nun by the Church, Marcellina received the virgin's veil in 353 at St. Peter's. Her brother, St. Ambrose, wrote his famous tract for her, setting forth the guidelines by which nuns were to live.

MARTHA OF BETHANY *(1st c., Jerusalem)*: Sister of Lazarus and Mary of Bethany, Martha was an early follower of Jesus. According to Scripture, she was one of the first women to open her home for the practice of Christianity, preparing meals for Jesus.

MARY OF BETHANY *(1st c., Jerusalem)*: Sister of Martha and Lazarus, Mary of Bethany was another early follower of Jesus. She is thought to have anointed him with oil before his crucifixion.

OCTAVIA *(ca. 69–11 B.C., Rome)*: As Roman empress, Octavia was instrumental in preserving the peace between two of the empire's rulers: her husband, Mark Antony, and her brother, Augustus. Octavia's marriage to Antony was deemed so politically expedient that the Senate passed a special resolution allowing her to marry him before the end of the official mourning period (she had been recently widowed). This marriage strengthened Antony's political position in the governing triumvirate. But Antony, determined to extend his power through a marriage alliance with Cleopatra, secured a divorce against Octavia's wishes. He sent his soldiers to Rome to forcibly remove the empress from her home. Despite this abysmal treatment, Octavia took responsibility for the welfare of all the children fathered by Antony, in addition to her own.

PAULA *(347–404, Rome)*: Paula was a wealthy Roman noblewoman and scholar who was converted to Christianity by Marcella. She became a philanthropist and celibate, founding a circle of women who studied literature and practiced ascetic rituals honoring Jesus. She established three convents, a monastery, and a hospital, and she collaborated with St. Jerome on his translations of the Bible, many of which are dedicated to her.

PHOEBE *(1st c., Rome)*: Phoebe, a deaconess of the early Church, was said to have carried Paul's Epistle to the Romans to Rome.

GALLA PLACIDIA *(ca. 390–450, Roman empire)*: Galla Placidia was the last significant empress in the crumbling Western Roman empire. Although she suffered at the hands of powerful men, who attempted to use her as a political pawn, she managed to rule from Ravenna for twenty-five years as regent for her son. She was responsible for many city improvements, including the construction of numerous public buildings.

PLOTINA *(d. 120, Rome)*: Plotina, empress and wife of Trajan, was widely regarded for her sound political judgment. She helped reduce governmental corruption and supported the Jews in a dispute between Jewish and Greek legations from Alexandria. She constructed harbors, highways, and buildings, fed orphans, improved the lot of slaves, and expanded the public-education system. In recognition of her accomplishments, the Senate proclaimed her Augusta. When Trajan died, Plotina, though unable to rule in her own name, was able to secure the throne for her favorite son, Hadrian; thus she continued to be active in government until her death.

PORCIA *(1st c. B.C., Rome)*: When Porcia, who was devoted to her husband, Brutus, realized that he was planning the assassination of Caesar, she inflicted wounds upon herself in order to discover how much pain she could bear without divulging her knowledge of this plot. Upon learning that Brutus had committed suicide, she killed herself by swallowing burning coals.

PRISCILLA *(1st c., Rome)*: Priscilla and her husband, Aguila, were early Roman converts to Christianity. They traveled with Paul to Ephesus, where they preached and held services in their home. Priscilla edited Paul's letters and was instrumental in having them copied and dispersed throughout the empire. She was one of the most influential women in the early Church.

St. Bridget

(453–523)

Like many other peoples, the Celts held on to the mores and customs of the matriarchal age for many centuries. When the early Christian evangelists arrived, Goddess worship was still prevalent in Ireland. In fact, religious leaders encouraged the populace to bring their convictions, deities, rituals, and holidays into the structure of the Christian faith. This process of cultural amalgamation is clearly demonstrated in the story of St. Bridget.

As a young girl, Bridget resolved to consecrate her life to religion. Since there were then no religious houses for women in Ireland, she established a cell in a trunk of a giant oak tree, a site formerly used as a shrine to the Celtic goddess Brigid (with whom Bridget later became identified). Bridget gathered a number of other young women around her, founding a convent—built on this very site—that eventually grew to be a great religious house and center of learning.

Bridget was one of the earliest Christians to make the monastery a kind of settlement house, to which all the neighboring peasants would come for help, advice, and education. Under her inspiration, the arts flourished, and at her monastery, a magnificent illuminated manuscript was produced. She also established a school of metalwork known for its exquisitely crafted products. Bridget became extremely influential in political and Church affairs, traveling extensively to establish new religious houses throughout the region.

After her death, countless churches, monasteries, and villages were named after her. Moreover, it was through Bridget that the Celts were able to maintain their religious ties to Goddess worship. She came to be associated with symbols that had specifi-

St. Bridget place setting

cally belonged to the traditional Celtic Goddess. Vestal virgins had long kept a sacred fire burning for the goddess Brigid, a custom taken over by nuns and maintained in honor of St. Bridget for many centuries, until the convents were dissolved. Fire was holy to the Goddess, who was often depicted with a column of fire—an image that I incorporated into the plate for St. Bridget, which is painted in the colors of Ireland.

Celtic and Christian motifs are combined in both the plate and the runner to represent the continued tradition of the Goddess as it was subsumed into the wor-

ship of this holy woman. The plate rests on a runner covered with bark-colored silk, a reference to the tree that cradled Bridget's cell. A wooden panel carved with Celtic motifs borders the runner front and an oak cross is featured on the back. The carving is based upon the cross of Muiredach, an elaborate stone cross that is one of the monuments of Irish Christianity. The painted flames of the plate, which symbolize the sacred fire, are repeated in the embroidery that surrounds the cross on the runner back and also in the illuminated letter of St. Bridget's name.

Grouped around St. Bridget are the names of other women who were prominent at that time. Those who, like her, supported the spread of Christianity had no way of knowing the degree to which the Church would eventually become oppressive toward women, particularly if they tried to exercise individual power or authority.

BASINE (*5th c., France*): The prophet and queen Basine predicted that her son would possess the strength of a lion but that later generations would be weak and would squabble like dogs. She divorced her royal husband to marry another king, Childeric of France. Her son, King Clovis, strengthened the Frankish kingdom and united it under Christianity. But as Basine had prophesied, later rulers (the Merovingians) weakened France through feudal warfare.

BRIGH BRIGAID (*70, Ireland*): Brigaid, a lawyer who rose to the position of judge (*brehan*), was responsible for many precedent-setting laws, particularly in the area of women's rights.

CAMBRA (*n.d., Britain*): Cambra, a scholar and mathematician, may have invented the method of building and fortifying citadels. Her father, a British king, was said to have consulted her on all important matters of state.

EUGENIA (*d. 258, Egypt*): Eugenia was a young, well-educated noblewoman, supposedly the daughter of a prominent man. She chose to convert to Christianity rather than submit to a political marriage. In an effort to protect her, the bishop of Heliopolis suggested that she disguise herself as a man and become a monk. She later founded a convent in Africa. Upon her return to Rome, Eugenia was beheaded for her Christian beliefs.

GENEVIEVE (*b. 419, France*): Genevieve, the patron saint of Paris, was twice credited with saving the city, the first time when Attila the Hun threatened to besiege Paris. She persuaded the women of Paris to pray for protection against Attila the Hun, and the city miraculously remained safe from the destruction suffered by nearby Orleans. She later averted a terrible famine by securing and distributing grain. She is buried in a church whose construction she helped plan.

LUCY (*d. ca. 303, Sicily*): When Lucy, a noblewoman who converted to Christianity, refused a marriage proposal, she was denounced as a Christian by the rejected suitor. Because she was unwilling to deny her faith, she was condemned to a house of ill repute. When she refused to move from the spot of the tribunal, she was tortured and murdered there.

MAXIMILLA (*3rd c., Rome*): Maximilla was one of the founders of Montanism, a movement that arose in reaction to the increasing worldliness of the Church. These reformers espoused fasts, trances, prophecy, and the religious equality of women and men. They also defended the rights of women prophets, who were being attacked by conservative churchmen.

MARTIA PROBA (*4th c., Britain*): English common law, upon which our legal system is based, was originated by Martia Proba, a Celtic queen who developed the Martian statutes. These introduced trial by jury—a concept previously unknown to Roman law—and reinstated ancient property laws that treated women and men equally.

SCHOLASTICA (*480–547, Italy*): Scholastica established the first religious order for women. Through her efforts, greater dignity for female monasticism was achieved. The nuns devoted their time to worship, study, manual labor, and the copying of religious and medical manuscripts. Through their spinning, weaving, and manufacture of cloth, they contributed to a textile industry that was one of the triumphs of the Middle Ages.

SYLVIA (*fl. 398, France*): St. Sylvia of Aquitaine, a noblewoman, left an extensive and unusual record—in the form of letters to nuns in a French convent—of a journey she made through the Holy Land.

THECLA (*1st c., Turkey*): Thecla, one of the first women to preach and to baptize converts, was responsible for converting many women to Christianity. The tract "Acts of Paul and Thecla," accepted as authoritative for the first two centuries of the Christian era, cites her as Paul's assistant. She may also have been the unknown author of the biblical books Luke and Acts.

Detail of *St. Bridget* runner back

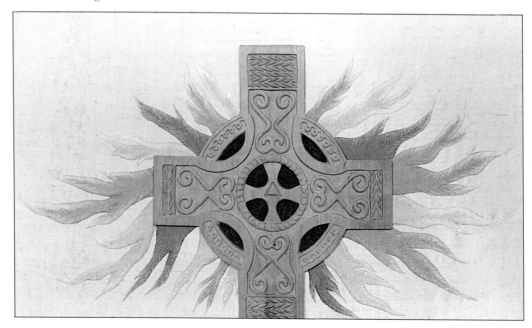

Theodora

(508–548)

Theodora began her life as an actress, a profession that was despised in Byzantine society. Moreover, actresses were often forced to sign contracts that bound them for years to the theater for which they worked. After a somewhat dissolute early life, Theodora became quite religious. She established a simple life, supporting herself by spinning. She soon met Justinian, the emperor's nephew, who married her as soon as he was able to have the laws changed to permit a union between himself and a woman of humble origins. Crowned with Justinian in 527, Theodora became the empress of Byzantium.

From the beginning of her reign, she was deeply concerned about the position of women. She seemed never to have forgotten the suffering and humiliation she had seen women endure, particularly through prostitution, which was then rampant. To supply the many brothels throughout the city, procurers traveled around the empire, enticing poor women through offers of clothes, jewelry, and money. Others were forced into prostitution through seduction and even rape. Once women had been brought to a brothel, they were virtual prisoners. Even if they were able to escape there was nowhere for them to go, for, like actresses, they were considered moral outcasts.

Theodora established laws aimed at breaking down the barriers that kept actresses in a socially inferior role. She also issued an imperial decree making it illegal—and punishable by death—to entice a woman into prostitution. She even turned one of her palaces into an institution where prostitutes could go to start new lives. She went on to raise the low status of women in marriage by protecting them from mistreatment from

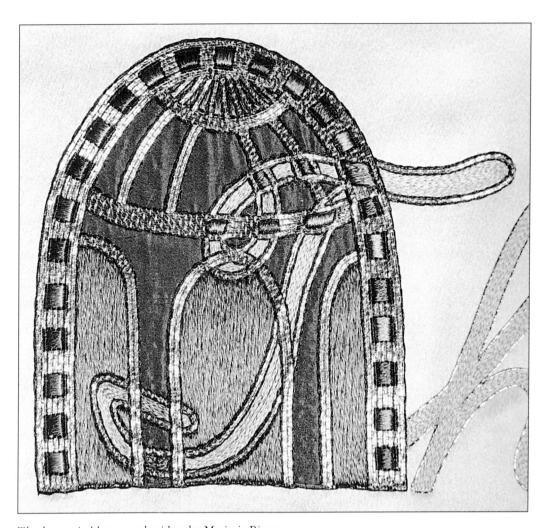

Theodora capital letter; embroidery by Marjorie Biggs

their husbands and improving divorce laws in their favor. She also saw to it that women could inherit property, and instituted the death penalty for rape. Moreover, Theodora's insistence that these edicts be enforced created a legacy that benefited Byzantine women for many centuries.

The iconography of the plate and runner honoring Theodora draws upon the colors and techniques of Byzantine art, particularly the mosaic tableau honoring this great empress that appears in the Church of San Vitale in Ravenna, which was built by her and her husband, Justinian. The embroidered gold halo beneath the plate mimics the halo

around her head in the ornate Ravenna mural. Red, purple, and gold—the colors associated with royalty—are used on the runner, which is embellished with gold and jeweled embroidery in imitation of the design of imperial costumes.

The stitched shell forms on the runner back symbolize the female principle and hence seem a fitting motif for this great advocate of women's rights. The capital letter is illuminated with a tiny image of the Hagia Sophia, the great basilica of Constantinople, built in 530 in honor of the Virgin Mary, who came to embody some of the attributes of ancient goddesses.

Grouped around the place setting for Theodora are other Byzantine queens, as well as a number of prominent and important women from that culture. In addition, rulers from other countries join women from pre–Christian German society, which was already patriarchal by the time of Theodora. However, Teutonic society retained evidence of an earlier matriarchal order in its traditions, customs, and legends.

ADELAIDE *(931–999, Burgundy)*: Adelaide, a noblewoman and heiress, was married at the age of fifteen and widowed by eighteen. Imprisoned and tortured for refusing to marry an invading conqueror, she managed to escape and was rescued by Otto I of Germany, whom she married. Her son, Otto II, who succeeded his father, turned against her, and Adelaide fled to Burgundy. After spreading her wealth among the French abbeys and rebuilding the monastery of St. Martin of Tours, she finally returned to Germany, where she was able to re-establish her influence.

AETHELBURG *(fl. 680–700, England)*: At a time when it was still common for women to have power and influence within Anglo-Saxon governments, Aethelburg ruled jointly with her husband, Ine, king of Wessex.

AETHELFLAED *(d. 918, England)*: The daughter of Alfred the Great, Aethelflaed was another queen who ruled jointly with her husband, the earl of Mercia. After his death, she gained complete control of England, even earning the title of king. She conducted military operations on a scale not attained by any other woman of the Saxon era, establishing a network of fortresses that later developed into centers of government and commerce.

BALTHILDE *(7th c., France)*: Born in England, Balthilde was a princess who was captured, sold into slavery, taken to France, and forced into marriage with Clovis II, the Frankish king. At his death in 657, she became ruler. She used her position to liberalize the laws, restoring the rights of individuals, abolishing the slave trade in France, and establishing equalized taxation.

BERTHA OF ENGLAND *(d. 612, England)*: In order to create a political alliance between England and France, Bertha, a French princess, was married to the king of Kent. She insisted that the marriage contract stipulate her right to practice the Christian religion. It was through Bertha's influence that Christianity was introduced into England, and it was she who established the first Christian church at Canterbury. She was also primarily responsible for establishing the first body of written law in England.

BRUNHILDE *(d. 613, France)*: Queen Brunhilde, who was originally from Spain, tried to introduce some of the refinements of Roman civilization to Austrasia, a Frankish kingdom, but her efforts to improve society met with considerable opposition. Nonetheless, Brunhilde persisted, overseeing the construction of highways, bridges, castles, churches, monasteries, and monuments. She was also an early patron of the arts. After a strenuous political life, she perished at the hands of Clothaire II, the son of an old political rival. He cruelly ordered her paraded before the army on the back of a camel, then kicked to death by an unbroken horse.

CLOTILDA *(475–545, France)*: Queen Clotilda was responsible for converting her husband, Clovis—as well as three thousand of their subjects—to Christianity. This act, which was a turning point in the history of Christian Europe, resulted in Clotilda being honored by historians as the "mother of France."

ANNA COMNENA *(1083–1148, Byzantium)*: Anna Comnena, one of the great medical writers of the twelfth century, was a physician who founded a hospital, then supervised its operation. It was her ambition to succeed her father, Alexius Comnenus, to the throne, but her brother was appointed heir. Disappointed, she declared that nature had "made a pretty mess of things, clothing her masculine spirit with a woman's body." When her brother became emperor, he forced her into a convent, where, undaunted, she undertook the writing of an ambitious fifteen-volume work. The first extensive historical work written by a woman, *The Alexiad* recorded the achievements of her father's reign, as well as the events of the First Crusade.

ANNA DALASSENA COMNENA *(11th c., Byzantium)*: Anna Dalassena, the mother of Anna Comnena, re-established her family upon the Byzantine throne. When her son, Alexius, was declared emperor, she was honored for the important role she had played as his mother and advisor. For twenty years thereafter, she and her son jointly ruled the empire.

DAMELIS *(9th c., Byzantium)*: Damelis, who was a major landowner in the Peloponnesus, established a number of factories in which women wove magnificent silks, exquisite carpets, and fine linens.

ENGLEBERGA *(9th c., Germany)*: Queen Engleberga, the wife of Ludovico II of Italy, was the first German woman of the Middle Ages to rule equally with her husband.

EUDOCIA *(ca. 401–460, Byzantium)*: Eudocia, a scholar, writer, and patron of education, was educated by her father, an Athenian philosopher. She established the University at Constantinople, where she encouraged the study of Greek literature. She eventually married the emperor of

Portrait of Theodora from mosaic mural in San Vitale, Ravenna

Byzantium but was later exiled to Jerusalem. She spent her years there founding churches and medical schools, along with a hospital where she personally tended the sick.

EUDOXIA (*d. 404, Byzantium*): In the year 400, Eudoxia was crowned Augusta, empress of Byzantium. Her portrait was sent throughout the Eastern empire, which was a rare honor. A forceful and independent ruler, her reign was cut short by an untimely and painful death through miscarriage.

FREDEGUND (*d. 597, France*): Despite her peasant background, Fredegund rose to become the wife of Chilperic, the Frankish king. She is said to have exerted considerable influence upon the political and ecclesiastical affairs of her time, including planning and implementing her husband's assassination. This act had a sad precedent, as Chilperic had murdered his first wife in order to marry Fredegund. After his death, she became sovereign and the guardian of her infant son, holding this position for thirteen years.

IRENE (*752–803, Byzantium*): In the five years during which Irene ruled the Eastern Roman empire, she ended a disastrous war, restored a long-abandoned policy of religious toleration, lowered taxes and tariffs, reformed fiscal policies, and founded charitable institutions. She also proclaimed herself emperor, something no woman had ever done. Incensed at the idea of a female head of state, the pope severed all ties with Byzantium, naming Charlemagne the emperor of the West. Although Irene sought reconciliation with the papacy, she was dethroned and eventually died in exile.

LEOPARDA (*4th c., Byzantium*): Leoparda was a gynecologist of wide renown who practiced medicine at the Byzantine court.

MAUDE (*895–968, Germany*): Queen Maude, who was convent-educated and devout, continued to lead a pious life even after marrying Henry I of Germany. She had favored her second son as the successor to the crown, but the elder, Otto became king and robbed his mother of her dowry.

The queen took refuge in a convent while Edith, Otto's wife, worked to accomplish a reconciliation between mother and son. Maude's wealth was finally restored, and she used it for philanthropic work, helping the poor and establishing hospitals, churches, and abbeys.

OLGA (*892–971, Russia*): Olga, princess of Liev, was married to Igor, the second monarch of Russia. After his assassination, she ruled the country, improving the system of government, regulating the amount of taxes to be paid by different provinces, and establishing courts of justice. After being converted to Christianity in 959, she helped to pave the way for the general conversion of the Russian people some thirty years later, which took place under her grandson Vladimir.

OLYMPIA (*360–408, Byzantium*): Olympia, a church deaconess, refused all offers of marriage in order to devote herself to her work. She headed a community of women who cared for the sick and performed charitable works.

PULCHERIA (*399–453, Byzantium*): The daughter of Eudoxia, Pulcheria began to exert an influence on state affairs when only fourteen years old. After her father died, she formally took on the regency in the name of her brother, who was then a minor. For forty years, she virtually ruled the Eastern empire, counseling and directing her brother even after he came of age. Due to her wise rule, the empire enjoyed an era of peace and prosperity.

RADEGUND (*518–587, Germany*): Queen Radegund was kidnapped as a child and forced to marry her father's enemy, who became king of the Franks. She became a prominent figure in the medical annals of the early Middle Ages, studying medicine with the most learned men of her court and converting her private palace into a hospital where she personally cared for all the patients. She eventually escaped from the court, taking refuge in a convent, then founding a religious house and hospital at Poitiers. Even after abandoning court life, she continued to exert considerable influence on political affairs.

THEODELINDA (*580–628, Lombardy*): Theodelinda, regent of Lombardy, encouraged and improved agriculture, endowed charitable foundations, and built monasteries. Due to her influence, the Lombards were converted to Christianity. During her regency, she reduced taxes and attempted to improve conditions for the lower classes.

THEODORA II (*d. ca. 867, Byzantium*): During the years that Theodora II governed as regent for her son, she preserved the tranquillity of the empire, greatly enhancing its prestige. Nevertheless, when her son reached his majority, he pressured his mother to retire to a monastery. When she resisted, he had her forcibly removed from the throne.

THEODORA III (*980–1056, Byzantium*) and **ZOÉ** (*980–1055, Byzantium*): After the death of their father, Constantine VIII, Theodora and her sister, Zoé, ruled the Byzantine empire jointly until Zoé forced her sister into religious retirement. Zoé then adopted her nephew as her heir. But as soon as he attained the throne, he banished his adopted mother to an island and tried to get her to become a nun. But the people and the Senate overthrew him, re-establishing the joint reign of the two sisters. Theodora, the more able of the two, gradually assumed control, presiding at meetings of the cabinet as well as the Senate, while also hearing appeals as a supreme-court judge in civil cases. Upon Zoé's death, she took sole control of the throne.

WANDA (*8th c., Poland*): Legend suggests that because of Queen Wanda's great beauty, a German prince fell in love with her, initiating a violent suit for her hand. When she refused him, he threatened to invade her country and forcibly make her his wife. Rather than submit, she gathered a large army and defeated the Germans, returning triumphantly to Cracow. Fearing that she might become the inadvertent cause of more wars, she threw herself into a river and drowned, a tragic example of female self-sacrifice and one that has been frequently extolled in poetry, art, and music.

Hrosvitha

(935–1002)

With the development of feudalism, German women lost many of their traditional property rights. Countless princesses, determined to retain their lands, were aided by the Church in founding religious houses on their estates. They then retreated to these convents, often as ruling abbesses. Because many of these women were related to the ruling families, heading an abbey could make them extremely powerful as they were responsible only to the king.

These early convents provided homes to many spirited women and became both places of residence and training schools for numerous women of the ruling classes. Those who wished to devote themselves to learning and the arts gathered there, with or without taking vows. Held in great esteem and treated with respect, many of these religious women traveled widely and received visitors freely. Gandersheim, which Hrosvitha entered when she was young, was a free abbey whose abbess enjoyed a close relationship with the nobility. Hrosvitha thereby had the opportunity to associate with the many scholars, churchmen, and royalty who visited.

Like other girls who were convent-trained, Hrosvitha was educated in Latin, Greek, scholastic philosophy, mathematics, astronomy, and music. She proved to be a gifted student and soon began to write: "Unknown to others and secretly, I wrote by myself. Sometimes I composed, sometimes I destroyed what I had written." Her work was discovered by her abbess, who brought it to the attention of the educated world.

Hrosvitha was to become Germany's earliest poet and dramatist, as well as the first playwright in medieval Europe. Her early poems were so well received that she was soon able to expand her writing to include

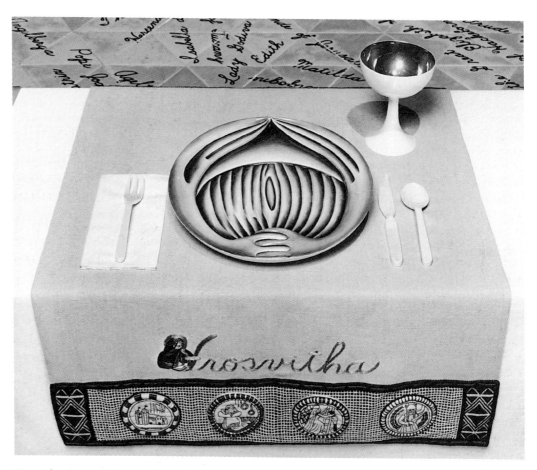

Hrosvitha place setting

sacred legends in verse, historical poems, prose prefaces, a history of the Ottonian dynasty, and, most important, a series of plays.

Hrosvitha's dramas dealt with the theme of the conflict of virtue and spiritual aspiration versus evil and the temptation of sin. In developing these pieces, she looked to the Roman playwright Terence, whose plays all turned on the frailty of the female sex. Hrosvitha challenged Terence's misogyny in that the keynote of her work was its celebration of women. In her plays, men embodied paganism and lust, while women were shown as strong, steadfast, and representing the purity and gentleness of Christianity.

The story of Hrosvitha's remarkable life is recounted on the back of her runner in three scenes, which are embroidered in a needlework technique based on *opus Teutonicum*. Commonly employed by German nuns, this type of embroidery utilized flat patterning and simple drawing. The front of the runner is embellished with four raised, circular forms that resemble the medieval coins traditionally minted by ruling abbesses. These padded discs portray popular tales and legends from pre–Christian Germany. Images of an armed Valkyrie and a vengeful Cimbrian princess recall a time when Teutonic women participated in battles. The plate representing Hrosvitha is deeply reliefed, the image pushing itself upward. References to the ivory carving typical of Ottonian art are combined with depictions of praying hands and a nun's cap, both associated with religious women.

Grouped around the Hrosvitha place setting are the names of other women who availed themselves of the opportunities afforded by a religious life, along with medieval rulers, and a number of poets, writers, and scholars from Spain. During the Moorish period, women of the Iberian Peninsula had access to both education and considerable freedom, which resulted in a flowering of female creativity.

AGNES *(fl. 1184–1203, Germany)*: Agnes, abbess at the monastery of Quedlinburg, supervised the manufacture of tapestries. She collaborated with her nuns on ecclesiastical embroideries, as well as on a series of manuscript illuminations.

AISHA *(12th c., Spain)*: Aisha, a distinguished poet, left a large body of work, a well-selected library, and a reputation for having frequently presented her verses and orations at the Royal Academy of Cordoba.

MARIA ALPHAIZULI *(10th c., Spain)*: Alphaizuli, a poet, was often referred to as the Arabian Sappho, although Sappho lived over fifteen centuries before her and her work bears no resemblance to that of this Spanish writer. (Women from one period are frequently linked to a few earlier women, as if there were certain "unchangeable" types of female achievers.) Some of Alphaizuli's work is preserved in the library of the Escorial.

ATHANARSA *(d. 860, Greece)*: During this period, vows of celibacy were forbidden in Greece and—despite her desire for a religious life—Athanarsa's parents forced her into an arranged marriage. When her husband chose to become a monk himself, she inherited all his possessions and was thereby able to found a great convent.

FRAU AVA *(d. 1127, Germany)*: Frau Ava was a sacred singer and the first woman known to compose biblical and evangelical stories in the German language. Because most religious writings were in Latin, Ava's work made Christian ideas available to the laity.

BAUDONIVIA *(6th c., France)*: Baudonivia was educated in the monastery of St. Croix at Poitiers, which was founded by Radegund. After Radegund's death in 587, Baudonivia wrote an important biography of her life, which was included in the first volume of *The Acts of the Saints of St. Benoit.*

BEGGA *(d. 698, Belgium)*: Begga, the daughter of Blessed Ata and the sister of St. Gertrude, established a convent at Ardenne. She is believed to have been the founder of the order of the Beguines.

BERTHA *(d. 783, Frankish empire)*: During the reign of her husband, Bertha performed many administrative duties. Along with running the large royal household, she established a court of women to make laws concerning women. Bertha was responsible for the education of her son, Charlemagne, and many of his later religious policies can be directly attributed to her influence.

BERTHA OF FRANCE *(8th c., Frankish empire)*: Bertha, one of Charlemagne's daughters, was a scholar particularly known for her abilities as a poet and musician. It was said that her father forbade her and her sisters to marry, as he couldn't bear to part with them.

BERTHILDIS *(d. 680, France)*: One of the most progressive abbesses of the seventh century, Berthildis tried to abolish slavery and oppressive taxation within her region, but her attempted reforms eventually aroused strong opposition. She was forced to retire to another monastery, where she devoted the remainder of her life to medical work.

BERTILLE *(652–702, France)*: Bertille, the daughter of a propertied family near Soissons, was abbess of the convent at Chelles for forty-six years.

CARCAS *(8th c., France)*: During a siege in which her husband, the king, was killed, Carcas courageously sustained the city of Carcassonne. Charlemagne was so impressed with her bravery that he named her governor. Later, the Saracens attacked her, jesting at the idea of a female warrior who, they stated, should be "spinning rather than fighting!" Carcas became so enraged at their ridicule that she armed herself with a lance to which she attached a bundle of hemp. Setting fire to her makeshift weapon, she rushed into the midst of the enemy, who supposedly became so terrified that they fled.

CLARICIA *(fl. 1200, Germany)*: Claricia was a painter and illustrator who worked at manuscript illumination and bookmaking. Although it was quite unusual for an artist of this period to be identified, there is a signed self-portrait of her in the Walters Art Gallery in Baltimore, Maryland.

DHUODA *(9th c., France)*: Dhuoda, a devout and aristocratic woman, wrote the *Manual,* which chronicles the period when the empire of Charlemagne was breaking up.

DIEMUD *(12th c., Germany)*: A nun who worked as a calligrapher and manuscript illustrator, Diemud reproduced forty-five books that were greatly prized, including a Bible that was so valued it was exchanged for an estate. Her work, said to be of exquisite beauty, was distinguished by its ornate letters and small, elegant writing.

EADBURGA *(fl. 730, England)*: According to some historians, Eadburga was a queen of Wessex who was accused of deliberately poisoning her enemies, as well as inadvertently poisoning the king. She supposedly fled her country with a huge treasure and became an abbess.

EANSWITH *(fl. 630, England)*: With land given to her by her father, Eadhald of Kent, Eanswith founded the first religious settlement for women in Anglo-Saxon England.

EBBA *(10th c., Ireland)*: In the ninth and tenth centuries, as waves of non–Christian invaders assaulted Europe, nuns were commonly raped and tortured by the invading armies. In an effort to protect her convent from marauding Danes, Abbess Ebba persuaded the nuns of her monastery to disfigure their faces, whereupon the whole community cut off their noses and upper lips. Unfortunately, when the soldiers saw what they had done, they became so enraged that they set fire to the convent and all the nuns were killed.

ENDE *(10th c., Spain)*: An artist and illuminator, Ende executed the first extensive cycle of miniatures known to be by a woman. She also helped produce the famous *Gerona Apocalypse.*

ETHELBERGA *(ca. 616, England)*: Ethelberga established the first Benedictine nunnery in England, where she taught medicine to women and devoted herself to healing and tending the sick. She also helped prepare the way for the mission of St. Augustine to England in 597.

ETHYLWYN *(11th c., England)*: Ethylwyn embroidered ecclesiastical vestments, and her stitching was renowned throughout England.

GERTRUDE OF NIVELLES *(626–659, Belgium)*: After the death of her father, Gertrude and her mother, St. Ata, retired to a convent in Nivelles, where Gertrude became the abbess, bringing monks from Ireland to educate her nuns. Devotion to her was quite widespread in Belgium, Germany, and Poland.

GISELA *(d. 807, Germany)*: Gisela founded a Benedictine abbey, where she became a nun and later an abbess. She directed the first major convent scriptorium, in which thirteen manuscripts were created. Among them was a three-volume commentary on the Psalms signed by nine female scribes who probably worked under Gisela's direction. She was also a member of the scholarly circle in the court of her brother Charlemagne.

GISELA OF KERZENBROECK *(d. 1300, Germany)*: Gisela was a manuscript illuminator who worked independently in the town of Rulle, in Westphalia.

GORMLAITH *(10th c., Ireland)*: Gormlaith was Ireland's first female historian, writing verse and history that helped preserve Irish traditions. She was also influential in planning the Battle of Clantarf, which drove the invading Danes from Ireland.

GUDA *(12th c., Germany)*: Guda wrote and illuminated a discourse on morality, signing it with a self-portrait, thought to be the first surviving self-portrait of a woman in the West.

HARLIND AND REINHILD *(fl. 850–880, Germany)*: Harlind and her sister Reinhild were trained in both religious practices and the arts at a French convent. When they returned home, they could find no secular use for their talents, so they decided to return to religious life. Their parents helped them establish a settlement devoted to weaving and embroidery. The two sisters transcribed gospels and psalms, and under their direction, the women of the convent created vestments and altarcloths.

HILDA OF WHITBY *(614–680, England)*: Hilda, the abbess of Whitby for thirty years, was the most distinguished churchwoman of Anglo-Saxon times, influencing political and religious affairs of her time. The abbey she established was a celebrated religious and educational center housing both men and women. Her monastery became a training ground for bishops, abbesses, and priests, and her power extended far beyond her convent. Hilda was also the patron of Caedmon, the first religious poet to write in English.

HYGEBURG *(8th c., England)*: Hygeburg was an English nun who accompanied Boniface and helped him convert Germany. She recorded the recollections of Willibald, bishop of Eichstat, the first Englishman to have traveled in the Near East. Her book is the earliest extant travel document and the first book known to be written by an Englishwoman.

JOANNA *(fl. 1200, Germany)*: With the help of several nuns, Joanna, the prioress of Lothen in Germany, wove a series of tapestries telling the tumultuous history of their convent.

LEELA OF GRANADA *(13th c., Spain)*: Leela of Granada was a Moorish Spaniard who was celebrated for her learning.

LIADAIN *(9th c., Ireland)*: A renowned poet of Ireland, Liadain benefited from the monastic system of the Middle Ages, which provided women with education.

LIBANA *(d. 975, Spain)*: A Moorish Spaniard of noble parentage, Libana was an established poet, as well as a philosopher and musician.

LIOBA *(d. 779, Germany)*: A pioneer in the Christianization of Germany, Lioba left England around 740, traveling to Germany at the request of St. Boniface, a distant relative. He placed her in charge of all nunneries under Benedictine rule. Considered the most important churchwoman in Germany, she was frequently consulted in Church matters.

MABEL *(13th c., England)*: Mabel was a professional embroiderer who was commissioned by Henry III of England to execute a gold and ruby banner for Westminster Abbey.

MARYANN *(9th c., Spain)*: Maryann founded a school for girls in Moorish Spain, which provided instruction in science, mathematics, and history.

MATHILDA *(10th c., Germany)*: Mathilda was the abbess of the monastery at Quedlinburg and Hrosvitha's cousin. Because of her extensive knowledge of both medicine and history, she was able to provide Hrosvitha with information for some of her writings. Together with Adelheid, regent for Otto III, she practically ruled the empire during the young king's minority. He later entrusted her with the control of royal affairs during his prolonged absences. In 983 Mathilda raised an army and defeated the invading Wends.

ELIZABETH STAGEL *(ca. 1300–1360, Germany)*: Stagel, a Dominican nun, was a historian, writer, and religious reformer. She wrote biographies of forty of the sisters who lived in her convent (in what is now Switzerland). She was also associated with an informal religious group known as the Friends of God and was responsible for recording much of their history.

THOMA *(d. 1127, Spain)*: A distinguished scholar who was also known as Habeba of Valencia, Thoma wrote highly celebrated books on grammar and jurisprudence.

LADY UALLACH *(d. 932, Ireland)*: A learned woman in the tradition of St. Bridget of the sixth century, Uallach was one of the great poets of Ireland.

VALADA *(d. 1091, Spain)*: Daughter of the king of Cordoba, the well-educated Valada was celebrated for her scholarship and known for her skills in debate.

Trotula

(d. 1097)

In Salerno, as in most of southern Italy, Byzantine influence remained strong, thanks in part to the laws put in place by Theodora. In fact, the position of women was better than in most other societies of the time. Women were even able to study at the medical school, which was the first university of the Western world. While most of Europe was still relying on saints' relics, prayers, and poisonous remedies for curing sickness, Salerno doctors were employing more advanced forms of medical healing. Among these physicians was a group of women, the most prominent of whom was Trotula. Although she was a renowned doctor, author, and professor, it was as a gynecologist that she won lasting fame.

Trotula wrote prolifically on gynecology and obstetrics and her book *Diseases of Women* was consulted for seven hundred years after her death. In this book she synthesized the extensive information she had gained from her vast practical experience concerning pregnancy, menstruation, sterility, difficulties in labor, emergency procedures for midwives, and abortions. Since doctors were forbidden by the Church to dissect the human body, diagnosis was entirely dependent on symptoms of disease.

Trotula excelled at observations of the pulse, urine, facial expression, and "feel" of the skin; using these indices, she could distinguish between diseases whose overt symptoms were similar. The first doctor to give advice on the care of newborn infants, she stressed hygiene, cleanliness, and exercise at a time when people still thought diseases could be cured by magic. When she died in 1097, her casket was attended by a procession of mourners two miles long.

The twelfth century brought with it a

Trotula runner front and top

general revolution in medical training, one unhappy result of which was that women were gradually excluded from the profession. Although women continued to practice as lay healers, medicine slowly became closed to them through civil restrictions, prohibitions, legal actions, and, finally, persecution. Centuries later male doctors dismissed Trotula as a witch, and for a long time, it was asserted that her book had been written by a man.

The symbols on the reliefed plate representing Trotula at *The Dinner Party* combine a serpent form (associated with the Aztec goddess of healing) with pre–Columbian designs; a birth image; and a caduceus (the modern symbol of medicine, a rod entwined with two snakes). The snake image echoes earlier motifs as a way of emphasizing the continued identification between feminine wisdom and the powers of healing.

The plate rests on a runner whose overall pattern forms a tree of life, an appropriate setting for the plate honoring this eminent physician. The tree of life dates back to ancient myths and iconography associating the Goddess with a cosmic tree, which symbolized the world in a continual process of regeneration. The *trapunto* technique (a padded quilting process) was chosen for the runner because one of the earliest examples of such a quilt dates back to the eleventh century in Sicily, which was not far from where Trotula lived. An embroidered bird encircles the illuminated letter, while other small, colorful stitched birds perch in the branches of the quilted tree.

Grouped around Trotula are the names of others who practiced medicine, along with female rulers of the period and those few medieval women who, like their Greek predecessors, felt that they could only achieve their goals by disguising themselves as men.

ABELLA OF SALERNO (*14th c., Italy*): An instructor and lecturer in Salerno, Abella wrote highly esteemed medical treatises and lectured on the nature of women.

ADELBERGER (*8th c., Italy*): Adelberger (also known as Bertha) was a member of the guild of lay physicians in northern Italy.

ALOARA (*d. 992, Italy*): From 982 until her death, Aloara ruled the principality of Capua with her son Landenulph. She was recorded as having been a wise and courageous ruler, supposedly sharing equal authority with her son.

ANGELBERGA (*fl. 875, Italy*): Known for her great strength and ability, the empress Angelberga was responsible for building one of the most famous monasteries in Italy. Her daughter, who wished to exploit her mother's political knowledge, had Angelberga kidnapped and brought to Germany for the purpose of aiding in the overthrow of the French king. Eventually the pope intervened to obtain her release.

AGELTRUDE BENEVENTO (*9th c., Italy*): Determined to maintain her estates and her rights, the empress Ageltrude successfully defended her property against both invasions and intrigues by political and religious leaders. At a time when women were often forcibly married for their property, she was able to ensure that her lands and hereditary rights were respected.

BERTHA OF SULZBACH (*d. 1162, Germany*): Bertha's marriage to Manuel, brother of Anna Comnena, was arranged as a political alliance between Germany and Byzantium. When Manuel inherited the throne at Constantinople in 1127, Bertha became empress of the Byzantines. She worked to support the continuing alliance between Germany and Byzantium.

CONSTANTIA (*ca. 1147–1200, Italy*): When Constantia, a princess of Sicily and Naples, inherited these two lands, she claimed them with her husband, Henry VI, emperor of Germany. In order to put down a rebellion against their rule, he later returned with an army he had originally raised for the Crusades. Constantia was outraged by his brutal torture of the Sicilian rebels. Encouraging the people to continue their rebellion, she renounced her loyalty to Henry. After raising an army, she personally led them to victory over her husband's troops.

STEPHANIE DE MONTANEIS (*13th c., France*): De Montaneis was apparently taught the art of healing by her father, a doctor in Lyons, which is how she became a practicing physician at a time when few women could obtain such skills.

ETHELDREDA (*ca. 630–679, England*): Etheldreda founded the church and convent at Ely in 673, later becoming its abbess. She practiced medicine and taught her nuns the treatment for many diseases and how to properly care for the poor.

FRANCESCA OF SALERNO (*fl. 1321, Italy*): In the tradition of earlier Italian women doctors, Francesca studied medicine at the school of Salerno. But in order to receive her degree in surgery, she had to prove herself to a panel of male judges. Even then, she was only allowed to practice medicine after obtaining permission from the duke who governed the area.

BETTISIA GOZZADINI (*d. 1249, Italy*): Born of a noble family in Bologna, Gozzadini so desired a university education that she attended classes disguised as a man, achieving the highest standing in the college by the time she obtained her degree. At age twenty-seven she became a doctor of civil and canon law, obtaining a professor's chair and devoting her life to teaching and writing about law.

POPE JOAN (*d. 855, Italy*): A brilliant scholar, Joan disguised herself as a monk in order to study in Athens, where she obtained a degree in philosophy. She then went to Rome, where Pope Leo IV made her a cardinal; upon his death in 853, she was elected pope by her fellow cardinals. After two years, four months, and eight days as pope, she was discovered to be a woman when she gave birth to a baby, whereupon she and the child were stoned to death. She remained recognized as a pope until 1601, when Pope Clement VIII officially declared her to be mythical.

ODILLA (*8th c., Germany*): Odilla, who established a monastery in 720, also founded a hospital that became famous for its cures of eye diseases.

RACHEL (*ca. 1070–1100, Hebrew*): Rachel, the daughter of a famous biblical and Talmudic scholar, received a thorough education from her father in Jewish tradition and law. She wrote many of the legal decisions attributed to him.

SARAH OF ST. GILLES (*fl. 1326, France*): Sarah, a Jewish physician in St. Gilles, practiced and taught medicine, supervising a large medical school. A document—dated August 28, 1326—sanctioned her to teach medicine to her husband.

THEODORA THE SENATRIX (*901–964, Italy*): Never before or since has a woman gathered such ascendancy over papal affairs as this Theodora, whose influence was so great that popes were supposedly chosen and disposed of at her bidding. Between the years 901 and 964, she and her daughter Marozia controlled the election of the pontiffs, and for over sixty years they managed to have their sons and grandsons selected.

URRACA (*13th c., Portugal*): Queen of Portugal and sister of Blanche of Castile, Urraca was famous for both her hospital work and her support of advanced medical practices.

WALPURGIS (*710–778, England*): Walpurgis was an English princess who studied medicine in order to establish a practice among the poor. She went to Germany as a missionary and later became the abbess of a monastery she founded in Heidenheim, near Munich.

Eleanor of Aquitaine

(1122–1204)

Eleanor of Aquitaine was one of the most powerful women of the Middle Ages. Born to a ruling family of southern France, she was raised in a court where women had considerable autonomy. Eleanor inherited the rich duchy of Aquitaine, and she brought her property—along with the liberal ideas of her childhood—to the court of Louis VII, to whom she was married when she was fifteen. The young queen attempted to find an outlet for her many interests in Paris, but her husband was hostile toward women's independence and thwarted her every effort. When the king informed Eleanor of his intention of leaving for the Crusades, she insisted on going with him. Louis was adamantly opposed, but he finally capitulated only because the nobles of southern France would not support him unless they were led by their queen.

In addition to providing this aid, Eleanor organized three hundred women to follow her on the Crusades. They hoped to be of service in attending the sick and even fighting, if and when they could. Called the "Queen's Amazons," they dressed in coats of mail and skirts of tinted silk and carried the special insignia of an Amazonian corps on their sleeves. But the Crusade turned into a disaster, which ultimately contributed to a divorce between France's king and queen.

Eleanor then married Henry of England, whom she helped to gain the crown. She hoped that her efforts would result in an expansion of her base of power, but she ended up imprisoned by her husband instead, who laid claim to her land. In an effort to regain both her ancestral property and her freedom, the queen encouraged her sons, Richard and John, to revolt against their father. Eventually the princes and the king became reconciled, but Eleanor remained sequestered for sixteen years.

Detail of *Eleanor* runner top; woven by Audrey Cowan

Before her imprisonment, Eleanor had established the courts of love, graced by the troubadour poetry that had first been introduced by her grandfather, then brought by Eleanor from France to England. She made this "religion of the gentle heart" the foundation for courtly love throughout Europe. By supporting the troubadours, noblewomen were able to make their courts into major cultural and social centers. In their feudal castles, women heard cases concerning relationships between women and men and laid down codes of behavior. Their judgments were then communicated by the minstrels in a "service of love" patterned on the feudal system of vassalage, with the women as lords and the troubadours as the troops.

The plate for Eleanor presents her as a fleur-de-lis, a motif derived from the iris, the flower that was sacred to the Virgin Mary, whose worship reached a high point in the Middle Ages and was intimately connected with courtly love. The lustred, dimensional, and pierced plate—suggesting both containment and power—rests on a tapestry based upon the famous Unicorn Tapestry. Woven in the Aubusson style of Renaissance tapestries, the runner top features an image of a corral, within which the plate appears—a metaphor for the tragic imprisonment of this great queen. Surrounding the corral are tiny woven flowers, patterned upon the *mille fleurs* motif of medieval tapestries and also referring to the flowers with which women covered their castle floors when the courts of love were held. The fleur-de-lis motif is repeated in the illuminated capital and on the runner back.

The whole body of doctrine associated with chivalry was profoundly influenced by the intense veneration of the Virgin Mary, who was particularly revered by the troubadours. Mary, along with the names of some of these minstrels, are grouped around the place setting for Eleanor. The names of other important rulers of the period, prominent women, and patrons of the courts of love also appear in this stream of names.

ADELA OF BLOIS *(1062–1137, France)*: A noblewoman, scholar, and extremely gifted needleworker, Adela participated in the creation of the Bayeaux Tapestry, apparently designed by Queen Matilda of Flanders and executed by her and the women of her court.

ADELAIDE OF SUSA *(1091–1150, Italy)*: After witnessing constant war and slaughter, Adelaide led an army in defense of the territory she was to inherit from her father. Afterward she married Otto of Savoy, with whom she shared authority and then governed alone after his death. Adelaide was also a patron of the arts, supporting and protecting poets and troubadours in her court.

AGNES OF POITOU *(11th c., France)*: As empress of the Holy Roman empire, Agnes of Poitou became regent for her son Henry III in 1056, governing during a turbulent historical period and continuing to exert great influence after her son assumed the throne. This was a period when the ambitious designs of her son and the growing independence of the papacy were in conflict. Agnes acted as an intermediary between Pope Gregory VII and Henry in their struggle for power. Although historians have attempted to hold her responsible for the weakening of the realm, she actually tried to hold off its inevitable disintegration.

LADY BEATRIX *(11th c., England)*: Lady Beatrix was a skillful and daring swordswoman whose prowess in combat earned her the name La Belle Cavaliere. Discovered practicing sword drills in secret, she was encouraged to engage in public displays of her ability.

BERENGUELA *(13th c., Spain)*: Berenguela, a princess and the granddaughter of Eleanor of Aquitaine, astonished all of Europe by challenging the authority of both a king and a pope. A defiant and independent woman, she refused to submit to a marriage arranged by her father, the king of Castile. She then chose her own husband—Alfonso IX of Leon—and even after the pope had annulled the marriage, Berenguela continued to live with him for seven years. When her parents died, she returned to Castile, where she became regent for her younger brother. When he unexpectedly died, the crown passed to her. Described as the "fittest ruler in all Spain," she successfully arranged for her son to become king of both Castile and Leon, thereby reuniting the two provinces under a single ruler.

BLANCHE OF CASTILE *(1188–1252, France)*: Another granddaughter of Eleanor of Aquitaine, Blanche's arranged marriage at the age of twelve was one of the conditions of a truce between England and France, who were at war. A political pawn like many royal women, Blanche was married to the French king and became regent after his death. Though the French nobility and the king of England organized against her, she was able to repress their insurrection and conclude a peace treaty with England. She remained in power for ten years, until her son was old enough to assume the throne.

ALMUCS DE CASTENAU *(fl. 1140, France)*: A troubadour from a town near Provence, de Castenau wrote at the height of the classical period of troubadour poetry.

BEATRICE DE DIE *(12th c., France)*: de Die was a noblewoman who wrote poems and songs derived from personal experience. Her most notable work was "Of Deceived Love." Unfortunately, only five short poems still exist.

ISABELLA DE FORZ *(fl. 1249–1260, England)*: Through skillful manipulation of the laws of inheritance and dowry, a woman in thirteenth-century England could still control a vast complex of estates, which is what De Forz was able to do. Married at twelve and widowed at twenty-three, she managed to acquire so much property that the king, who regarded her property holdings as being too great for any subject (particularly a woman), tried to pressure her into selling them to him. But he did not succeed until she was on her deathbed, and even then he obtained only a portion of her holdings.

MARIE DE FRANCE *(12th c., France)*: Marie de France was the first professional woman writer in France. It is probable that she lived in England for a time and was most likely connected to the court of Eleanor of Aquitaine. In addition to collecting folktales, legends, and songs from the oral traditions of Europe, she composed poems and stories. Recognized as the finest examples of storytelling in any European vernacular up to that time, her writing presented a woman's perspective, standing in sharp stylistic contrast to the masculine genre of the *chanson de geste,* or heroic epic.

DERVORGUILLA *(1213–1290, Scotland)*: Dervorguilla, one of Scotland's wealthiest women, married John de Balliol, who founded Balliol College at Oxford University. When he died in 1269, she continued to be involved with the college. She was able to expand the school's lands, stabilize its financial position, and influence the tenor of the institution by drawing up a strict code of conduct for scholars. In addition to supporting the college, she promoted the construction of bridges, convents, monasteries, and abbeys.

MARIA DE VENTADORN *(b. ca. 1165, France)*: As well as being an innovative troubadour herself, de Ventadorn, a noblewoman, was an important patron of the troubadours.

BARBE DE VERRUE *(13th c., France)*: De Verrue, a troubadour who earned a considerable fortune traveling and performing her own compositions, was much admired by her contemporaries.

EDITH *(fl. 1043–1066, England)*: Noted for her skill with the needle, Queen Edith was also extremely well educated. Because she was adept at the subtleties of argument, she often took part in intellectual debates at court, which was quite unusual for a woman of her time.

FAILGE *(13th c., Ireland)*: An intellectual noblewoman, Failge opened her home to all those who wished to discuss ideas and worship according to the old Celtic traditions, thereby helping to pre-

serve and transmit aspects of traditional Irish culture and religion.

FIBORS (12th c., France): Fibors is the earliest known female troubadour, though little other information remains of her other than that her brother was also a famous troubadour.

LADY GODIVA (fl. 1040–1080, England): The popular story of Lady Godiva presents her as a rebel against the oppressive tax that her husband levied against the people of Coventry. He agreed to rescind the tax if she would ride through the town naked on horseback and in daylight. Because Godiva was convinced of the unfairness of the tax, she did so; but the townspeople were so grateful and respectful of her honorable motives that they stayed in their homes with their blinds drawn.

HAWISA (12th c., England): Hawisa was one of the great ladies of twelfth-century Anglo-Norman society, and her marriage to the earl of Essex in 1180 was the social event of the year. After he died leaving no heir, she was forced by King Richard I to marry a man of lower status, which provided a pretext for his seizure of her lands and stock on behalf of the crown.

JEANNE OF NAVARRE (1271–1309, France): Despite her marriage to Phillip IV of France—who could have taken her property from her by law—Jeanne, the heiress of Navarre and Champagne, kept title to both her kingdoms. When Champagne was attacked, she placed herself at the head of the army and personally defended her lands. She is, however, best known for having founded the famous college of Navarre—a school for the French nobility—and for her patronage and support of intellectual and literary activities.

MARGARET (1045–1093, Scotland): Margaret was an Anglo-Saxon princess raised in Hungary and married to the king of Scotland. An educated woman, she tried to bring culture to the country, teaching her husband to read and the ladies of her court to embroider. An able diplomat who played an important role in the political affairs of Scotland, she was also a philanthropist who built churches and monasteries and housed the destitute in her own palaces.

MARGARET OF LINCOLN (13th c., England): After the death of her husband, Margaret took over the management of a large estate, running the farm, the dairy, and the household.

MARIE OF CHAMPAGNE (fl. 1170, France): Marie of Champagne, the daughter of Eleanor of Aquitaine, was an important patron of literature. She worked with her mother to develop the elaborate code of chivalric manners in the courts of love and was influential in cultivating the art of the troubadours. One of the most famous of these, Chrétien de Troyes, author of *Lancelot* or *Le Conte de la Carette*, was reputedly inspired and influenced by Marie.

MATHILDE OF TUSCANY (1046–1115, Italy): As the daughter of the most powerful nobleman of the time, Mathilde became the sole inheritor of his vast estate, which she ruled with her mother as advisor. She established churches, convents, monuments, public baths, and a hospital, while also promoting and protecting the guilds of Florence. A devout Catholic and niece of the pope, Mathilde became active in the power struggle between the German emperors and the papacy. After leading her troops to victory on the side of the pope, she attempted to further solidify the power of the papacy by willing all her land to the Holy See. Although Italy was united under Mathilde, it broke up after her death.

MATILDA (fl. 1100–1135, England): Queen Matilda founded two free hospitals at which she personally nursed the sick. She also enacted a welfare program to provide for underprivileged pregnant women and influenced her husband, Henry I, to grant the important legal charter that was the model and precedent for the Magna Carta. She protected the civil rights of the Saxons (paving the way for peace between them and their Norman conquerors), endowed religious institutions, and built, repaired, and improved bridges.

MATILDA OF FLANDERS (d. 1083, England): Queen Matilda is thought to have designed and supervised the execution of the Bayeux Tapestry. This monumental work, which took years to produce, depicts events related to the Norman conquest of England in which her husband, William the Conqueror, figured prominently. Although

called a tapestry, the piece is actually an elaborate embroidery in worsted wool on linen. The work, which is over two hundred feet long and contains seventy-two scenes filled with people, horses, castles, ships, and churches, is believed to have been completed in England, then brought to France. Displayed in Bayeux cathedral, it is probably the world's most famous embroidery.

MELISANDE (d. 1161, Jerusalem): In 1143 Melisande became the sole ruler of Jerusalem and refused to relinquish power when her son came of age. A struggle between them ensued and she was eventually forced to surrender. In her later years, Melisande devoted herself to the Church.

SOBEYA (10th c., Spain): Considered the most powerful of the Muslim sultanas, Sobeya was regent for her son Heschem II. Her lover—who had helped her to secure this position—began to usurp her power. She attempted to overthrow him but was unsuccessful and was forced to withdraw into seclusion for the remainder of her life.

VIOLANTE (14th c., Spain): Famed for its elegance, good manners, and grace, the court of Queen Violante re-created the brilliant atmosphere of the French courts of love, attracting poets and knights from all over her realm. Many women, encouraged by contact with the literary figures whom Violante brought to her court, began writing verse.

VIRGIN MARY (Biblical, New Testament): The ancient reverence for a humane and nurturing female deity could be said to have found its Christian expression in the veneration of this mother of Jesus. The image of the Virgin with her son at her knee was actually derived from traditional representations of the Goddess with her son/lover (e.g., Isis and Horus or the nameless goddesses with their male progeny).

Mary seemed far easier for local popuations to accept than the harsh Christian God. Because new converts were needed, the Church allowed the worship of Mary to flourish for many centuries. The adulation of Mary was widespread during the High Middle Ages, reflecting an enhanced status for women, though one that would soon deteriorate.

Hildegarde of Bingen

(1098–1179)

In addition to being one of the greatest and most original thinkers of medieval Europe, Hildegarde of Bingen was an abbess, scientist, leading medical woman, scholar, musician, prolific composer, political and religious figure, and visionary. Her writings are among the earliest important mystical works of the Middle Ages. In terms of her position, she could be said to be the monastic counterpart of Eleanor of Aquitaine.

She spent almost her entire life in the convent, where she received an excellent education. A series of visions instructed Hildegarde to found a small monastery for women, but the Church fathers attempted to denounce the authenticity of her revelations. They finally agreed to her plan after she became gravely ill; only then was she able to establish and head her own religious house.

Hildegarde was particularly important for her books on medicine, which foreshadowed later ideas on the circulation of the blood and the characteristics of the nervous system. Her remedies for disease revealed a wide knowledge of drugs and herbs, and her medical treatments—despite their emphasis on magic—were quite progressive. She also cataloged and described numerous plants, particularly those with medicinal properties.

In her writings, Hildegarde described her revelations and their allegorical meanings and wrote commentaries on the Scriptures, the Trinity, and other religious issues. These works, which became quite popular, helped reinforce the idea that a strong Church was necessary as a source of morality and spiritual regeneration. In her later years, she concentrated on developing a theory of the universe that stressed the relationship between the divine and the human. Like Dante, Hildegarde

Hildegarde of Bingen place setting

conceived the universe holistically, emphasizing the inseparability of the physical and the spiritual.

The plate honoring Hildegarde is painted to resemble a stained-glass window. It rests inside an embroidered Gothic arch to suggest a rose window, the exalted spiritual focus of every medieval church. The top and front of the runner represent the facade of a Gothic cathedral, with two stitched windows flanking her name. These repeat the colors and lustre of the plate. The illuminated capital letter, like the runner, is executed in techniques that

mimic *opus anglicanum,* the highest form of medieval ecclesiastical embroidery.

On the back of the runner is an elaborately worked image combining applique, silk embroidery, and padded gold work characteristic of *opus anglicanum.* Based upon one of Hildegarde's own illuminations, it presents her concept of the universe, which appeared to her during one of her visionary trances. I modified her drawing while trying to stay faithful to her vision of the universe as "round and shadowy . . . pointed at the top, like an egg . . . its outermost layer of a bright fire."

Women played an important role in the medieval mystic movement, which emphasized the breaking down of barriers between the Church and the laity, along with reform of the Church. Grouped around the place setting for Hildegarde of Bingen are the names of other important mystics and religious women, as well as noblewomen who were involved in medical work or who used their wealth to found and administer hospitals.

AGNES *(1218–1282, Bohemia)*: Agnes, in defiance of her father's insistence that she marry, remained single in order to devote her life to religious work, founding a nunnery and a hospital in Prague. She devoted herself to helping women who were ill or in trouble and to the care of lepers, whose clothing she dutifully washed and mended.

ANNA *(fl. 1253, Bohemia)*: Princess Anna, sister of Agnes of Bohemia, was trained in medicine, specializing in the treatment of children. In 1253 she founded a nunnery and hospital at Kreutzberg and another at Neumarkt, which is still in operation.

PHILLIPE AUGUSTE *(1164–1225, France)*: Phillipe Auguste was a prominent member of the

Hildegarde capital letter; embroidery by L. A. Hassing

Augustinian Sisters, the oldest nursing order in existence. She worked at a hospital in Paris that was founded in 650.

BERENGARIA *(d. ca. 1230, Spain)*: Queen of Castile, sister of Blanche of Castile, and mother of Ferdinand of Spain, Berengaria was renowned for her knowledge of both medicine and hygiene. She was revered for providing personal attention to the sick and for trying to alleviate the suffering among her people.

BIRGITTA *(1303–1373, Sweden)*: Birgitta (or Bridget) was the dominant figure of Swedish politics, religion, and literature during the fourteenth century. After the death of her husband in 1344, she began to experience revelations. These inspired her to form a new religious order (the Bridgettines), which encouraged humility, simplicity, and the contemplative life. Birgitta was active in Church reform and traveled extensively throughout Sweden, becoming a favorite of the people and an advisor to kings and princes. Respected as a visionary and a prophet, her revelations—which were published, widely read, and translated into several languages—exerted a profound influence on the literary history of Sweden.

CATHERINE OF SIENA *(1347–1380, Italy)*: Catherine, who became one of the greatest mystics of the Western world, was also an early feminist. She was born at a time of great political conflict and extensive Church corruption. No woman in history understood Church matters better than Catherine, who tried to restore the Church to its original purity through the establishment of a spiritual community. She traveled, preached, wrote to, and advised all the rulers in Europe, exercising considerable influence on the political affairs of the Church, reconciling enemy factions, and attracting numerous disciples. Catherine claimed that Christ had appeared to her when she was a young girl, saying, "You must know that in these days, pride has grown monstrously among men and chiefly among those who are learned and think they understand everything. . . . I have chosen unschooled women . . . so that they may put vanity and pride to shame. If men will humbly receive the teaching I send them through the weaker sex, I will show them great mercy; but if they de-

spise these women, they shall fall into even worse confusion and even greater agony."

CLARE OF ASSISI *(1194–1253, Italy)*: Clare, who was from a noble family, became a co-worker with Francis of Assisi. She organized the Poor Clares, a religious order for women that stressed preaching and ministry to both the body and the soul. In addition to founding branches of the order throughout Italy, France, and Germany, she was also a visionary. It was said that she possessed the ability to see and hear things happening miles away.

CUNEGUND *(1224–1292, Poland)*: The daughter of the king of Hungary, Cunegund was extremely well educated. Despite being married at sixteen to a king, she insisted on retaining her chastity because she was entirely committed to a devout life. She lived austerely and spent her time caring for the poor and the sick. When her husband died, she refused the wishes of the nobles that she assume the throne, preferring to become a Poor Clare at the convent she had founded. She spent the rest of her life building churches and hospitals and trying to save the nuns in her convent when Poland was invaded.

ALPIS DE CUDOT *(12th c., France)*: De Cudot was a visionary who insisted that the earth was a round globe and a solid mass and that the sun was larger than the earth at a time when these ideas were considered heretical.

AGNES D'HARCOURT *(13th c., France)*: D'Harcourt, the abbess at Longchamp, wrote a biography of Isabel of France. Originally published in 1668 and written on vellum, this manuscript is still referred to by medieval scholars.

DOUCELINE *(13th c., Germany)*: Douceline was the founding member of the Beguines of Marseilles, an order of lay nuns that were part of an effort to reform the Church. Devoted to charitable works, these women lived communally, maintaining themselves despite persistent attempts of the authorities to discredit them as heretics.

ELIZABETH *(1207–1230, Hungary)*: Elizabeth, one of the most noted medical women of the thirteenth century and the daughter of a king,

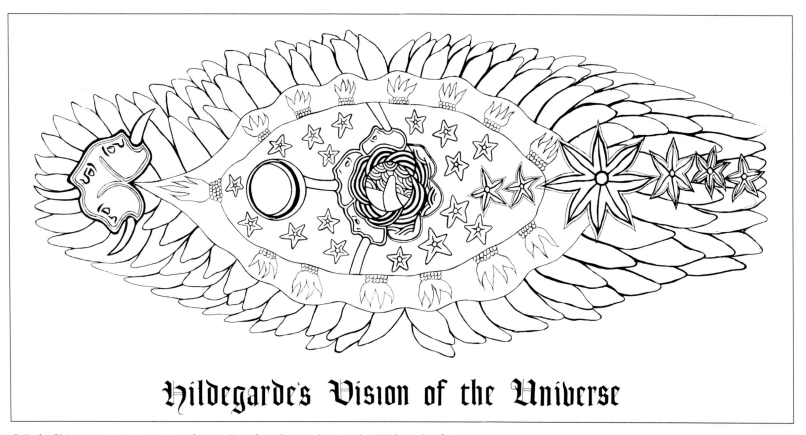

Hildegarde's Vision of the Universe

© Judy Chicago, 1977: 13" x 30"; ink on vellum based upon drawing by Hildegarde of Bingen

was betrothed at four, married at fourteen, and widowed with several children while still young. After being brutally treated by her brothers-in-law, she was deprived of the regency and, along with her children, driven from court. During her brief reign, Elizabeth had used her royal revenues to relieve suffering among her people, building a hospital and home for lepers, nursing the sick, and feeding the poor. During the terrible famine of 1226, she provided bread and soup for thousands, causing the king's treasurers to unjustly accuse her of squandering money. As a result, she was stripped of her dowry along with her throne.

ELIZABETH OF SCHONAU (d. 1164, Germany): Elizabeth of Schonau was a contemporary of Hildegarde of Bingen and, like Hildegarde, was regarded as a divinely inspired messenger of God. She entered the convent at Schonau in 1141, becoming its superior in 1157. Her ideas

appeared in three books, which recounted her visions and mystical experiences from 1152 to 1160. These writings became extremely popular, and her prophecies, messages, and sermons were taken to be the word of God.

GERTRUDE THE GREAT (1256–1301, Germany): A great mystic and healer, Gertrude was one of the most eminent religious figures of the Middle Ages. She studied Latin, philosophy, and the liberal arts at the convent where she was brought at the age of five. In 1281 she had a vision that caused her to give up all but religious studies. Thereafter she spent her time studying and writing, recording her revelations and her religious experiences in books that are still in use today.

GERTRUDE OF HACKEBORN (13th c., Germany): Gertrude, a mystic and writer, was an important abbess for forty years. Her convent at Helfia, where intellectual activity was encour-

aged, became a center of the thirteenth-century mystical movement.

HEDWIG (1174–1243, Poland): Educated at a convent ruled by her sister, Hedwig was taken from the religious order and forced to marry at the age of twelve. As soon as her husband died, she returned to the religious life. She founded a nunnery where she and her nuns (whom she educated) cared for the sick, particularly lepers. Famous for her medical skills, she founded a number of hospitals.

HELOISE (1101–1164, France): The story of Heloise and Abelard has been told many times but usually from a perspective that has rendered the woman's identity somewhat unclear. While still quite young, Heloise became known for her extraordinary intelligence. Abelard, who was a philosopher and theologian, became impressed by what he had heard about her and became her tutor when she was seventeen. They fell in love, but when

81

Abelard proposed marriage, Heloise refused. They were finally married secretly, and Abelard arranged for his bride to be placed in a convent for a short time. Heloise's uncle discovered that she was pregnant and became outraged, primarily because he believed that Abelard had deserted her. He and his friends castrated Abelard, who sought refuge in a monastery. Heloise eventually became the prioress, then the abbess of the convent in which she had been placed by her lover. Her letters to Abelard proved her to be one of the first great female writers of France. She also became one of the most learned women doctors of her era. She worked to elevate the intellectual level of her order and established a college of theology. But her many accomplishments have been overshadowed by the story of her tragic romance with Abelard.

HERRAD OF LANSBERG (d. 1195, Germany): Herrad, abbess of Hohenberg, created the encyclopedic work *Hortus Delicarum* (*Garden of Delights*) for the purpose of educating her nuns. Her convent was destroyed by fire in 1870 when Strasbourg was bombarded by the Germans, and what knowledge remains of this priceless manuscript is derived only from tracings.

HERSEND (fl. 1249, France): As physician to Louis IX, Hersend accompanied him to the Holy Land in 1249, providing care for the queen as well as for other women who followed the armies. The king rewarded her service with a lifelong pension, an unusual honor for a woman.

LAS HUELGAS (12th c., Spain): Las Huelgas was an abbess who practiced medicine. She also preached, a common practice in the sects considered heretical at the time.

ISABEL OF FRANCE (ca. 1225–1270 France): Influenced by her mother, Blanche of Castile, Isabel chose a disciplined life dedicated to religious observance and scholarship. After devoting herself to the study of Scripture, natural history, medicine, logic, Eastern languages, and Latin, she founded the abbey of Longchamp. Refusing many offers of marriage—including one that would have made her Holy Roman empress—she stated that she preferred to be "last in the ranks of the Lord's virgins to being the greatest empress in the world."

JULIANA OF NORWICH (ca. 1342–1413, England): Juliana of Norwich wrote the *Revelations of Divine Love*, which was one of the first spiritual works written by an Englishwoman. This inspired and artistic book—regarded as a rare reflection of the spirit of the Middle Ages—enjoyed a popular revival when it was reprinted in 1902.

JUTTA (12th c., Germany): Jutta, the first ruling abbess of the Benedictine abbey where Hildegarde of Bingen was educated, personally supervised Hildegarde's studies. When Jutta died, Hildegarde succeeded her as abbess.

LORETTA (fl. 1207, England): After the rest of her wealthy family had died, Loretta chose to live a simple life. Disposing of most of her personal property, she lived as an anchoress, attended by a few servants in a modest house and being fed by wealthy people in the neighborhood.

MARGARET (1242–1271, Hungary): Margaret was educated by the Dominican Sisters of Hare Island (now Margaret Island). As the spiritual advisor of the order, she lectured widely and became renowned throughout Europe. Her advice and diplomatic skills were often sought by the royal family.

MARGUERITE OF BOURGOGNE (fl. 1293, France): Daughter of Blanche of Castile, Marguerite built a medical facility that was a vast improvement over most hospitals of the period. Its wards were large and well ventilated; it afforded privacy, as each bed was screened as well as comfortable; the ceilings were high; and beautiful stained-glass windows depicted scenes from the Bible.

MECHTHILD OF HACKEBORN (13th c., Germany): A nun at the convent of Helfde, Mechthild (with the help of other nuns in the convent) wrote the widely read *Book of Special Grace*, which described her visions. Her book inspired other women to take their revelations seriously and to record them. Famous for her musical abilities, she often sang during her visions.

MECHTHILD OF MAGDEBURG (1210–1297, Germany): One of the greatest religious figures of the Middle Ages, Mechthild was a mystic, a member of the Beguines, and a writer who was at the center of the German literary and mystic movement. She wrote *The Flowing Light of God*, a beautiful collection of visions, parables, reflections, and letters, along with a number of dialogues in both prose and verse that brought her renown. Because she was determined to reform the decadence of the Church, she was persecuted and charged with being "unlearned, lay, and, worst of all, a woman"! Fortunately, the influential Gertrude the Great helped and protected her because she admired her writing, her courage, and her visionary powers.

FINOLA O'DONNEL (d. 1528, Ireland): A nun for twenty-two years and co-founder of a Franciscan monastery, Finola O'Donnel is significant primarily because any references to Irish nuns during this period are extremely rare.

ROSALIA OF PALERMO (fl. 1130–1160, Italy): Rosalia is said to have delivered the town of Palermo from the plague in 1150, for which she was canonized.

THERESA OF AVILA (1515–1582, Spain): "The very thought that I am a woman is enough to make my wings droop," wrote Theresa of Avila, a monastic reformer, visionary, and one of the greatest mystical writers of all time. Through her work, Theresa challenged the apostolic precept forbidding women to teach. She established sixteen nunneries for women and fourteen religious houses for men and was responsible for reforming the Carmelite order. Her primary objective was to restore the former purity of the order and thereby bring about a regeneration of the Church. Theresa wrote a number of mystical works, one of which, *The Way of Perfection*, might be said to be an early feminist work. Admonishing her nuns to be disciplined and strong, she urged them to live a purposeful life, continually stressing that although convent life was difficult, it was "better than being a wife."

YVETTE (1158–1228, Hungary): Yvette was married against her will at a young age, then left a widow with two sons at the age of eighteen. Rather than remarry, she chose to spend the next ten years nursing lepers and thirty more as an anchoress in a walled cell.

Petronilla de Meath

(d. 1324)

Despite the spread of Christianity throughout Europe, much of the local population continued to practice the traditional worship of the Goddess, sometimes incorporating it into the veneration of the Virgin Mary. Some of these ancient practices and rituals came to be identified with witchcraft, and its ongoing hold on people threatened the authority of the Church, which responded by launching the witchcraft trials.

The extent of the medieval witch-hunting craze was much wider than is commonly thought. Women were tried and burned on countless pretexts, their real crimes seemingly their efforts to preserve the traditions of the past or their resistance against the Church's intensifying attempts to limit female power. One of the earliest documented witchcraft trials took place in Ireland in 1324.

The place setting for Petronilla de Meath, represents the many women persecuted as witches. She worked as a maid for Lady Alice Kyteler, an extremely rich woman whose fourth husband claimed that she was bewitching him. A bishop, inspired in no small part by his desire to confiscate Kyteler's property, pursued this and other absurd charges. Lady Alice, her son, Petronilla, and several others were accused of denying God and the Church, making animal sacrifices, and concocting secret potions. The noblewoman was also charged with having sexual relations with a man who could supposedly appear as both a black male and a cat. (The witch hunters always emphasized sexuality, and through the years, the sexual charges brought against women became increasingly preposterous.)

Lady Kyteler was able to escape to England, taking Petronilla's child with her, but Petronilla herself was imprisoned and tortured. Her arrest took place before the

Petronilla de Meath runner top and back; embroidery by Elaine Ireland and Adrienne Weiss

Church had devised detailed instructions on the use of torture to procure confessions and denunciations. It would later become common to strip the accused woman naked, shave off all her body hair, and then subject her to thumbscrews and the rack, spikes, and bone-crushing boots, starvation, and beatings. Petronilla was merely flogged and burned, refusing to the last to accept the Christian faith.

The plate for Petronilla employs numerous symbols of the witches' covens. A bell, book, and candle are combined with a cauldron, which traditionally represented the Great Mother and around which witches often gathered during ceremonies. The flames that surround the center of the plate are meant as a metaphor for the terrible inversion of the sacred fire that once burned in honor of the ancient Goddess. The twisting runner patterns, which threaten to encroach upon the plate, are derived from symbolism associated with witches as well as the famous ninth-century Irish manuscript *The Book of Kells*, which served as a source for the convoluted and interlaced forms. The illuminated capital letter incorporates a broomstick—closely identified with witches—as was the red garter, referred to by the red edging that accentuates the runner forms.

The witch hunts occurred during a period in European history in which women's status was undergoing a profound transformation, and grouped around the place setting commemorating Petronilla are the names of others caught up in the frenzy. The traditional occupations of women included lay healing and textile production, trades that were being steadily usurped by men. Weavers and healers, along with thousands of other women, were accused of witchcraft and brought to trial.

MADELEINE DE DEMANDOLX (1593–1670, France)

At the age of fourteen, de Demandolx became a novice in a convent in Marseilles, where she confessed to having had intercourse with her family priest. When she began to experience fits, severe cramps, and hallucinations, the priest was summoned to exorcise her. But her hysteria became even more uncontrollable, and she was put in jail "to protect her from the Devil." The priest—who denied any relationship—was tried by the Inquisition and executed for witchcraft. After his death, de Demandolx became subdued, but she was later charged with witchcraft, convicted, and condemned to a lengthy prison sentence.

ANGÉLE DE LA BARTHE (d. 1275 France)

De la Barthe was accused of copulating with the Devil, found guilty, and executed in the first witchcraft trial in France, in 1275.

CATHERINE DESHAYES (d. 1679, France)

Deshayes, a fortune teller, was charged with witchcraft. She was tortured, then executed for her alleged involvement in a scandal involving the nobility. Some members of the ruling classes had supposedly gone to sorcerers for the purpose of obtaining poison and spells to kill their spouses. But when their actions were exposed, only Deshayes was arrested. She was accused of killing two thousand infants with her potions.

MARIA DE ZOZOYA (d. 1610, Spain)

De Zozoya was an elderly woman brought to trial as the principal member of a large group of witches, who were all tried for heresy and burned alive.

GEILLIS DUNCAN (d. 1590, Scotland)

Duncan, a lay healer, was one of the first witches tried in the famous North Berwick trials, which triggered a purge that was officially sanctioned by James I of England. Duncan worked as a servant in the home of a town official, who insisted that her ability to heal was a power given to her by Satan. She was tortured into saying that she had made a pact with the Devil, then arrested and tortured again to force her to name her accomplices.

JACOBE FELICIE (b. 1292, France)

Felicie was a physician who was brought to trial by the University of Paris medical faculty in 1322, accused of performing medical procedures without a degree. She defended herself by arguing for the need for women doctors, especially for treating female patients. Despite six cured patients testifying on her behalf and the fact that her competency was not an issue, she was forced to pay a heavy fine and, worse, prohibited from practicing medicine.

GOODY GLOVER (d. 1698, Massachusetts Bay Colony)

Glover, who was executed at the Salem witchcraft trials, purportedly bewitched the children of the family for whom her daughter worked. After she'd scolded them, they supposedly contracted strange illnesses. A doctor accused her of witchcraft and had her brought to trial. The evidence used against her included her inability to recite the Lord's Prayer in English and the existence of dolls found in her home.

GUILLEMINE (13th c., Bohemia)

Guillemine was the founder of a religious sect for women and a reformer who questioned the prevailing Church doctrine on the evil nature of women. She argued for the right of women to prophesize, interpret the Scriptures, and commune directly with God. Because of her direct challenge to the clergy's authority, her sect was denounced by the Inquisition.

JOAN OF ARC (1412–1431, France)

When Joan was thirteen, she began to hear voices that convinced her that she would save France by obtaining the crown for the exiled dauphin, Charles VII. At the age of seventeen, she obtained an audience with the king and convinced him that she was destined to be his savior. She then led a small army to Orleans, and after she'd won battle after battle against the English, Charles was crowned the king of France. Convinced that her mission had been fulfilled, she attempted to return home, but Charles insisted that she lead more campaigns. She was defeated, then captured by the English, who charged her with heresy and witchcraft for wearing male attire, cutting off her hair, and listening to inner voices rather than to the authority of the Church. Charles made no attempt to gain her release, perhaps fearing the power that she had acquired, for there were many people who believed that Joan was God incarnate. Steadfastly refusing to reassert her faith in the Church during her trial, Joan was confined and tortured for three months, then forced to sign a submission to the Church. Although there was no legal proof against her, she was burned at the stake. Twenty-four years after her death, Joan was acquitted of all charges. She is considered by many historians to have been a military genius because she employed martial strategies that were not commonly used until later centuries.

MARGARET JONES (d. 1650, Massachusetts Bay Colony)

Jones was a medical practitioner who so aroused the jealousy and distrust of male physicians that she was accused of witchcraft, brought to trial, and convicted. She was the first woman to be executed as a witch in America.

MARGERY JOURDEMAIN (d. 1441, England)

Jourdemain allegedly used magical powers to help the duchess of Gloucester by making a waxen image of the king in order to destroy him and thereby secure the crown for her husband. Although the king arrested all three conspirators, only Jourdemain was executed.

URSLEY KEMPE (d. 1582, England)

One of two women executed in a famous witchcraft trial, Kempe was a midwife and wetnurse and a fairly typical example of those targeted by the witch hunts. Because she lived as she pleased (bearing several children out of wedlock), her neighbors considered her a loose woman. Even her own children testified against her, a common though sad occurrence in witchcraft trials. Kempe was pressured into a confession by a magistrate who believed that convicting a notorious witch would enhance his prestige. In exchange for a promise of

clemency, she implicated others, but this failed to save her from execution.

ALICE KYTELER (fl. 1324, Ireland): In 1324 Kyteler and the members of her coven were tried for worshiping a deity other than the Christian God. Although Kyteler was able to escape, her personal maid, Petronilla de Meath, was not so fortunate.

MARGARET OF PORÉTE (d. 1310, Germany): Margaret of Poréte, a mystic and a member of the Beguines, wrote a religious tract espousing a form of mystical pantheism that so outraged the Church that she was brought to trial. When she refused to recant, she was publicly burned as a heretic.

PIERRONE (d. 1430, France): Pierrone, a follower of Joan of Arc, was accused of witchcraft and burned at the stake. Insisting that her god had appeared to her in human form and spoken to her personally, she steadfastly refused to accept Christian dogma.

ANNE REDFEARNE (d. 1612, England): In 1596 Redfearne, along with her mother, was accused by the local magistrate of "witchcraft by common complaint." She was later charged with causing the death of Robert Nutter, a man who had once tried to rape her. When the court found the evidence against them inconclusive, the crowd and the judges demanded that Redfearne not be allowed to go free. To appease the mob, a second trial was held in which she was accused and found guilty of murdering Nutter's father, who had died twenty years before, whereupon she was executed.

MARIA SALVATORI (d. 1646, Italy): Salvatori, an old woman (like many of those persecuted), was brought to trial as a witch on the grounds that she had used the Communion wafer for casting spells. The Inquisition was so brutal in torturing her that she died in prison before she could be executed.

AGNES SAMPSON (d. 1592, Scotland): Sampson, a lay healer, was one of the chief witnesses in the North Berwick witch trials. When she confessed, under torture, that her coven had been involved in a plot against the life of the king and queen of Scotland, she was strangled, then burned.

ALICE SAMUEL (d. 1593, England): Samuel was a victim of the Warboys witchcraft trial in 1593, the first trial in which the accusers were children. Three young children sent this eighty-year-old woman to the gallows by stating that she had bewitched them. They had tormented Samuel for four years before the trial by scratching her face until it was raw in the conviction that, if bewitched persons could scratch and draw blood from their supposed bewitcher, they would immediately recover. The children's parents had insisted that Samuel stay in their employ despite the fact that their children's repeated mistreatment of her caused her to become completely deranged. In a pathetic effort to save herself, she pleaded that she was pregnant, but she was found guilty and hanged two days after the trial.

ANNA MARIA SCHWAGEL (d. 1775, Germany): Schwagel was the last woman to be tried and executed for witchcraft in Germany, where the most savage of the witch hunts occurred. She fell in love with another servant who worked for the same family. Discovering that he was married, she ran away and was later found half-demented and begging for alms. She accused her lover of being a Satanist who had convinced her to renounce Christianity, but the authorities found her guilty of witchcraft.

ELIZABETH SOUTHERN (d. 1613, England): Southern was one of the main defendants in England's first mass witchcraft trial. She reportedly became a witch in 1591, soon becoming involved in a feud between her family and another. The two families secretly attempted to use witchcraft against one another, and when their

activities became known, they were charged with "witchcraft by common complaint." Southern eagerly provided the magistrate with details of her career as a witch, for she was extremely proud of her craft. She was put into prison, where she died awaiting trial.

GERTRUDE SVENSEN (d. 1669, Sweden): Svensen was the first victim of the worst mass witch hunt in Sweden. She was arrested and accused of kidnapping children in order to hand them over to the Devil. Svensen implicated seventy people who were charged with witchcraft, including fifteen children. A spectacular trial ensued and, despite an absence of evidence, all were found guilty and burned.

TITUBA (fl. 1697, Massachusetts Bay Colony): On the word of three little girls in whose household she was a slave, Tituba was arrested as a witch. Because she practiced herbal medicine, the children accused her of knowing spells and magic. She confessed, telling an imaginative story of orgies, witches' sabbaths, and other strange activities, which threw the town of Salem into a panic. Eventually released for lack of evidence, Tituba became the slave of whatever unknown person paid her prison fees.

AGNES WATERHOUSE (d. 1566, England): At the age of sixty-four, Waterhouse was brought to trial, accused of employing her cat in acts of murder and violence. In an effort to save her own life, her daughter, who had also been accused, testified against her. Despite a lack of any real evidence, the mother was hanged.

JANE WEIR (d. 1670, Scotland): Weir was accused of practicing witchcraft. The charges included committing incest with her brother (who was said to be a god of the witches); consulting other witches; and keeping a "familiar" (a supernatural being often embodied in an animal). She and her brother both proudly confessed their commitment to witchcraft and refused to recant, even under torture.

Christine de Pisan

(1363–1431)

During the Renaissance, the concept of female inferiority, a theme certainly present in medieval thought, took on a new dimension. Throughout the Middle Ages, misogynist thinking was somewhat moderated by the early Christian belief in the spiritual equality between women and men. The increasing secularization of society undermined this attitude and reinforced—in both theory and practice—women's second-class status.

By the fourteenth century, townships had begun to rival the monasteries as intellectual centers. Although women were generally excluded from the developing universities, if a male professor happened to believe in education for women, he might allow them to sit in on his classes, but usually they were not permitted to speak. A father might decide to educate his daughters or let them assist him in his work; however, a woman could not be apprenticed to an artist or tradesman.

In the nunneries, meanwhile, the quality of female education was steadily deteriorating. The intellectual and artistic excellence of earlier times was giving way to stricter confinement of nuns and greater control of female houses by male bishops. Literature attacking women was becoming both more prevalent and increasingly popular. In the late fourteenth century, one woman emerged to take up the task of defending her sex.

Because Christine de Pisan was educated and encouraged by her father, a humanist from Italy, she was able to surmount many of the barriers placed before women. Widowed at twenty-five, she supported herself and her three children by writing, becoming the first professional female author in France. She became quite prominent after attacking a popular book, *Le Roman de la Rose*, which

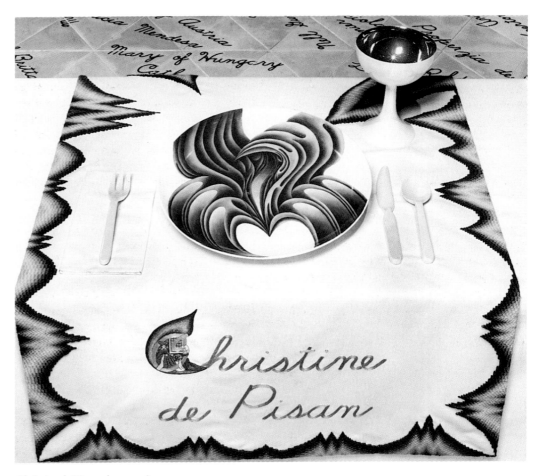

Christine de Pisan place setting

outraged Christine because of its vicious attack on women. In her counterstatement, she argued for the equality and worth of women. Because she was one of the few women accepted in the world of letters, her arguments carried considerable weight, initiating a widespread philosophical debate.

Christine followed up this treatise with a book recording the achievements of women of the past. *The Book of the City of Women* describes a mythical city peopled by the greatest women of all periods and social classes. Arguing that writing that degrades women exerted an evil influence on peoples' minds, Christine offered her book chronicling the contributions of hundreds of women as a tribute to the women of her own times.

The image honoring Christine depicts

one wing of the butterfly form as raised in a gesture of defense, to symbolize her efforts to protect women. The colors of the runner extend the tones of the plate, but its sharp points—executed in the Bargello needlepoint technique popular in Christine's time—thrust aggressively toward the plate. The runner design's encroachment on the space surrounding the plate image is a deliberate metaphor for the increasing constraints on women's lives ushered in by the Renaissance. One of the few ways in which a woman like Christine could hope to succeed was through patronage. The tiny stitched illuminated letter is based upon a medieval manuscript illumination depicting Christine gratefully presenting one of her books to her patroness, the queen of France.

Grouped around the place setting for Christine de Pisan are the names of scholars, artists, and writers, including a number of women who also put forth feminist arguments. Their achievements are all the more remarkable in the face of the difficulties they faced in even being able to obtain an education.

AGNES OF DUNBAR *(1312–1369, Scotland)*: The story of the countess of Dunbar—or Black Agnes, as she was called—symbolizes Scottish independence and resistance to English domination. While her husband was away at war with the English, Agnes successfully defended their castle against the most memorable siege in Scottish history. Agnes plotted the defense, walking the battlements and nearly killing the enemy leader herself. After five months of heroic resistance, a cessation of arms was finally concluded after the Scots triumphantly repulsed an English attack.

ANASTASIA *(14th c., France)*: Anastasia, described in *The Book of the City of Women,* was an artist who may have executed some of the illuminations for the manuscripts of Christine de Pisan.

JANE ANGER *(fl. 1589, England)*: Anger was a writer whose works include *Protection for Women,* an early feminist tract protesting a misogynist piece written by a man denouncing and slandering all women. Anger argued that women spent far too much time catering to men: "Our good toward them is the destruction of ourselves; we being well-formed are by them foully deformed."

MARTHA BARETSKAYA *(fl. 1471, Russia)*: Baretskaya, the mayor of the ancient northern republic of Novgorod, was the leader of a movement resisting the subjugation of the region by Moscow. In 1471 a majority group under her direction appealed to the king of Poland, offering their allegiance if he would respect their rights. As this was a direct threat to Ivan III of Moscow, he sent an army to sever the new alliance, and Baretskaya was captured and sent to a convent.

MARGARET BEAUFORT *(1441–1509, England)*: The mother of Henry VII, Beaufort was one of the first female authors in England, writing books dealing with theological issues and lecturing on divinity at Oxford and Cambridge. Deeply interested in education, she founded several free grammar schools, built and endowed Christ College, and founded St. John's College. She also studied medicine in order to personally aid the poor and sick, founding hospitals at which she attended patients, while providing refuge for the indigent in her own home.

JULIANA BERNES *(b. ca. 1388, England)*: A well-educated noblewoman, Bernes—trained in hunting, fishing, and hawking—displayed the technical knowledge she had acquired in a book titled *Julyan Bernes, Her Gentleman's Academy of Hawking, Hunting and Fishing and Armorie,* published in 1481. This was the first book by an Englishwoman to appear in print. It was particularly remarkable for its subject matter, as Bernes's expertise was in areas that were then definitely regarded as male provinces.

BOURGOT *(14th c., France)*: Bourgot, a famous manuscript illuminator of the fourteenth century, learned the art from her father. Although the decoration of books was an acceptable occupation for women, individuals were usually anonymous, so it is noteworthy that her name is known.

MADDALENA BUONSIGNORI *(14th c., Italy)*: Buonsignori, who taught law, wrote a Latin treatise on the legal status of women.

ROSE DE BURFORD *(14th c., England)*: De Burford, who was from a wealthy London family, worked with her husband as a wool merchant. After her husband's death, she successfully carried on the business alone.

TERESA DE CARTAGENA *(15th c., Spain)*: De Cartagena was a mystic and writer who spoke out in defense of women. In her major work, *Arboleda de los Enfermos,* she argued on behalf of their unrecognized capacities.

FRANCISCA DE LEBRIJA *(15th c., Spain)*: De Lebrija, who taught history at the University of Alcala, was educated by her father, a humanist scholar.

ALIÉNOR DE POITIERS *(fl. 1430–1480, France)*: De Poitiers, the daughter of a lady-in-waiting to Queen Isabelle (wife of King Philip), wrote *Les Honneurs de la Cour (The Honors of the Court),* a detailed biographical record of famous women in the French court from 1380 to 1480. This book, which provides an invaluable account of court etiquette, tradition, and style, places particular emphasis upon women who broke with tradition in order to achieve their goals and ambitions.

BEATRIX GALINDO *(1473–1535, Spain)*: Educated in Italy, Galindo became a professor of philosophy, rhetoric, and medicine at the University of Salamanca. Known as La Latina because her knowledge of Latin was so extensive, she was appointed Queen Isabella's instructor.

CLARA HATZERLIN *(1430–1476, Gemany)*: A scholar who worked as a professional scribe, Hatzerlin assembled a collection of folk songs and poems documenting major trends in German literature. This collection, containing 219 examples (many of an erotic nature), represents the transition from the medieval to the modern style.

INGRIDA *(15th c., Sweden)*: Ingrida, a nun at the convent of St. Birgitta, was a distinguished literary stylist. An epistle that she wrote to her lover is considered a classically elegant example of the use of the Swedish language, as well as of the liberal nature of religious life at the time.

MARGARETA KARTHAUSERIN *(15th c., Germany)*: A nun from a Dominican convent in Nuremberg, Karthauserin was an artist and a scribe. A number of handsomely written and illustrated manuscripts from 1455 to 1470 are signed by her.

MARGERY KEMPE *(1373–1438, England)*: Kempe was the author of the first known autobiography in English, the first nonreligious book by a woman. Though uneducated and illiterate, she was driven by inner voices to record her life's struggles by dictating her story to scribes. The book, which was lost to history for five hundred years, was finally discovered in a library in England in 1934.

ANGELA MERICI *(1474–1540, Italy)*: Merici, who was noted for opposing the then-common use of physical punishment in the schools, founded the first women's teaching order of the Catholic Church in 1494. A strong advocate for women's education, she organized the Ursuline Order, whose aim was educating girls through individualized attention.

COBHLAIR MOR *(fl. 1395, Ireland)*: Mor was a preserver of Gaelic customs at a time when they were being undermined by the English king Edward III and his government. She gathered people in her home to practice Gaelic cultural traditions, although they had been declared illegal by the Statute of Kilkenny in 1367.

ISOTTA NOGAROLA *(1418–1466, Italy)*: By the time she reached the age of eighteen, Nogarola's knowledge and eloquence had been recognized by many prominent humanists, but because she was a woman, her attempts to pursue an intellectual career were repeatedly thwarted. After several years of trying and failing to gain acceptance as a serious scholar, she entirely renounced secular studies. Retreating to her family home in Verona, she spent the rest of her life as a virtual recluse devoted to religious studies. Her choice of theological scholarship combined with her vow of chastity (apparently more acceptable than her secular pursuits) brought her praise and encouragement from the very same men who had previously denounced her aspirations. They began to exchange letters with her, which allowed her to participate in theological debates; sadly, these were cut short by chronic illness. Despite many frustrations and poor health, she produced a number of works and hundreds of letters, which have been preserved, including a famous dialogue with a male humanist on the question of whether Adam or Eve was the greater sinner in eating the forbidden fruit. Nogarola cleverly defended Eve, arguing that if she were, as so many men claimed, an "inferior being," she should therefore not be held responsible for the human fall from grace.

MARGARET O'CONNOR *(15th c., Ireland)*: O'Connor, a wealthy woman, was an important patron of medieval literature who devoted herself to social, artistic, and religious causes. Her home became a center of culture and charity, and she supervised the construction and adornment of many churches and was a benefactor of numerous causes.

MARGARET PASTON *(1423–1484, England)*: Paston, a member of the rising English gentry class, conducted extensive correspondence with her family, and her letters provide important information on both English social history and the role of women at the time. As mistress of the manor, she not only ran the household and managed the land but was also her husband's agent, transacting all business in his absence. Because she had an intimate knowledge of the law, she was able to preserve her family's property during the turbulent period of civil war in England.

MODESTA POZZO *(b. 1555, Italy)*: Pozzo was a feminist writer whose book, *The Merit of Women,* maintained that women are equal to men in understanding and integrity. She also wrote poetry, including a work on the passion and resurrection of Christ.

MARGARET ROPER *(1505–1544, England)*: Roper, who was considered the greatest pre–Elizabethan woman of learning, was the favorite child of Sir Thomas More, who believed that women should be given the same education as men. She was educated in Greek, Latin, philosophy, astronomy, physics, mathematics, logic, and music. A friend of Erasmus, she translated his *Treatise on the Lord's Prayer.* It was printed with an introduction by a man who used her accomplishments as an argument for university education for women. When her father was beheaded and his head put on London Bridge, Margaret defied the king by rescuing it, for which she was arrested and imprisoned. However, her eloquence before the judges so won their respect and admiration that she was released

Isabella d'Este

(1474–1539)

In Renaissance Italy, noblewomen generally exercised far less power than had their predecessors in feudal times. What power they retained was largely a result of the continued tradition of female inheritance. Although this allowed women certain rights, even these were becoming steadily more indirect and provisional. Some few women were able to gain access to education—even studying the same subjects as men—but most Renaissance ladies were expected to be charming, docile, and pleasing to their fathers, brothers, and husbands.

Isabella d'Este seems a perfect example of a Renaissance princess, and her place setting symbolizes the countless women who have played important, though supportive, roles in the family as well as in political and social life. Born during the height of the Italian Renaissance to the governing family of Ferrara, she was betrothed at the age of six to the duke of Mantua. Isabella, who was educated according to humanist principles, became a more serious scholar than women were usually expected to be, studying the classics, as well as literature, theology, and languages. She read voraciously—with a particular love for poetry—was a talented musician, and, like other noblewomen, was proficient in embroidery and design. By the time she left her family's court to marry the duke of Mantua, she was well prepared for her position as a noble Renaissance wife.

Isabella's rank allowed her some degree of influence in the shaping of Renaissance culture. But she brought an unusually developed taste and intelligence to the expected role of art patron, and she soon gathered a collection that was considered the best in the land. And although she knew that her acquisitions were supposed to bring glory to

Detail of *Isabella d'Este* runner front and top

her husband, she treasured her private museum, where she claimed the best work as her own.

Like numerous other Renaissance women of her class, her correspondence was vast. Two thousand of her letters still exist, many of them written to the leading scholars and statesmen of her day. She became a significant political figure, who often governed and defended Mantua in her husband's absence. Isabella devoted a considerable amount of energy to consolidating her family's position, trying to ensure the success of her sons' careers. But despite the fact that she played an important part in Italian history, her biography was not written for more than four hundred years—and even then, many of her personal achievements were ignored.

Her plate was inspired by a richly decorated ceramic ware, Urbino majolica, originally made at a factory that Isabella helped to support. The plate design combines traditional majolica decoration with a reference (at its center) to Renaissance pictorial space. The runner repeats the plate's motifs, incorporating a type of Assisi needlework that Isabella herself might have done. The back of the runner carries an image derived from the d'Este crest, but in this case, it is used to honor this remarkable woman, rather than, as was usually the case, the male members of a family.

Isabella d'Este's situation mirrored that of many Renaissance noblewomen who, as members of the ruling families, exercised a provisional degree of authority as regents and queens. Grouped around the d'Este place setting are the names of other prominent Renaissance women, including a number of female musicians, who seem to have enjoyed great popularity in the Renaissance courts.

CATHERINE ADORNI *(1447–1510, Italy)*: Adorni, who worked in the hospital of Genoa, was a nurse, mystic, and the leader of a group of religious disciples. When the plague broke out, she saved many lives by organizing the first open-air wards. She also wrote such mystical and theological works as *Purgatory* and *A Dialogue Between the Soul and the Body.*

LAURA AMMANATI *(1513–1589, Italy)*: Considered one of the finest poets of the sixteenth century, Ammanati was also a scholar in philosophy and literature and a member of the Academy at Siena. Her most renowned works include the *Glory of Paradise* and a translation of *Penitential Psalms.*

ISABELLA ANDREINI *(1562–1604, Italy)*: Andreini was famous as an actress, poet, and musician. We know of her because many of her sonnets, madrigals, and songs, as well as her letters, were published in Venice in 1610.

ANNE OF BEAUJEU *(ca. 1462–1522, France)*: One of the most important political figures of her day, Anne was so distinguished for her knowledge of government that her father, Louis XI, declared her regent during the minority of her brother Charles. Her appointment was disputed by the duke of Orleans, who provoked a civil war. He was not only defeated but became Anne's captive for several years. An astute stateswoman, she weathered many diplomatic storms and challenges to her authority.

ANNE OF BRITTANY *(1476–1514, France)*: Anne, who was considered learned, refined, and pious, took over the administration of France when her husband, Charles VIII, fought in the Italian wars. She later married Louis XII and was supposedly the first queen to give women an important place at court. Considered a patron of the arts, she won many privileges for the office of queen, including her own guard.

LUCREZIA BORGIA *(1480–1519, Italy)*: Behind the myth of Lucrezia Borgia—who is thought of as the prototypical image of feminine evil—was actually an innocent woman who, like many Renaissance noblewomen, became the political pawn of her father. Pope Alexander VI manipulated his daughter's beauty and political acumen to further his own ambitions. Her third marriage, to the duke of Ferrara, was relatively happy, and as duchess of Ferrara, she made her court a lively center of intellectual activity. She also founded numerous hospitals and convents, pawned her jewels to aid famine victims, and proclaimed a special edict to protect Jews from persecution.

DOROTEA BUCCA *(fl. 1436, Italy)*: The daughter of a physician and philosopher, Bucca received a doctorate from the University at Bologna. She succeeded her father as professor of medicine and moral philosophy, teaching for forty years.

FRANCESCA CACCINI *(b. 1581, Italy)*: A versatile musician at the court of the Medicis, Caccini sang and played the harp, guitar, and harpsichord. She composed many songs, which were published as *Il Prima Libro*, one of the largest collections of solo songs to appear in print. In the 1620s she received a commission to compose what is believed to be the first opera written by a woman.

LAURA CERETA *(1469–1498, Italy)*: Although little of her work is extant, it is known that Cereta was an eminent scholar and professor, who devoted most of her life to work in philosophy and the languages, both ancient and modern.

VITTORIA COLONNA *(1490–1547, Italy)*: Colonna, considered the most influential woman of the Italian Renaissance and Italy's greatest woman writer, dealt with nature, religion, patriotism, and the human condition in her voluminous writings, which included hundreds of sonnets. She

Detail of *Isabella d'Este* runner back

was also deeply concerned with religious reform, as were many other great thinkers of the day, many of whom gathered at her castle at Ischia. Colonna was a friend and inspiration to Michelangelo, who wrote of her: "Without wings, I fly with your wings; by your genius I am raised to the skies; in your soul my thought is born."

CATERINA CORNARO (1454–1510, Italy): Cornaro, a member of the Venetian nobility, became a political pawn. Married to the king of Cyprus in order to further the political ambitions of the doge, she was in Cyprus for only a year when her husband was killed. She was declared regent for her unborn child, but once the control of Cyprus was achieved by the Venetian government, she was sent back to Venice. She was eventually given an estate in the Alps, where she founded a salon, hospitals, and institutions for the poor.

ISABELLA CORTESI (d. 1561, Italy): Cortesi is thought to have written books on the subjects of chemistry, alchemy, and medicine. But her only extant work is *Secreti Medicinal: Artificiosi de Alchemici*, published posthumously some time between 1561 and 1565.

NOVELLA D'ANDREA (14th c., Italy): D'Andrea, a scholar in law and literature, was instructed by her father, whose assistant she became when he was appointed professor of canonical law at the University of Bologna.

TULLIA D'ARAGONA (1505–1556, Italy): D'Aragona, who was considered one of the most illustrious women of her time, established an academy in her home. Platonic thought, Latin, and Greek were studied there, along with music, singing, and poetry. Her poems include a treatise on embittered love, *"Dell Infinita d'Amor,"* and an epic poem, *"Il Meschino"* ("The Unfortunate").

MARIE DE MEDICI (1573–1642, France): Marie married Henry IV of France in 1600 and became an important patron of the arts during their ten-year marriage. In order to ensure the political legitimacy of her offspring, she had herself formally crowned queen in 1610; when Henry was assassinated, she became regent for her son

Louis XIII. In 1617 her son exerted his authority and exiled her. Allowed to return to Paris two years later, she remained, as queen mother, an influential art patron, building and decorating the Luxemburg Palace and Gardens and commissioning Rubens to paint a series of works depicting events from her life. She also commissioned eight statues of famous women to surround the entrance to her residence.

JEANNE DE MONTFORT (fl. 1341, France): Jeanne played a key role in the Hundred Years War, in which she supported her husband in his claims to the duchy of Brittany. Together, they took certain towns and fortresses and garrisoned them; when de Montfort was captured, Jeanne, an able military strategist and leader, was able to obtain the aid of the English, thereby helping to achieve victory for her family.

ANNABELLA DRUMMOND (d. 1401, Scotland): Drummond and her husband ascended to the throne in 1390, but because he was often ill, the responsibility of governing was largely assumed by her. Although she died of the plague in 1401, Scotland enjoyed a long period of relative tranquillity as a result of her ten-year reign.

CASSANDRA FIDELIS (fl. 1484, Italy): Fidelis, renowned for her knowledge of medicine, was also a poet and accomplished musician who held public lectures in Padua and corresponded with the leading figures of the Italian Renaissance. Her letters and orations were not published until 1636.

VERONICA GAMBARA (1485–1550, Italy): Gambara was a poet and musician who was widowed while still young. Thereafter, she devoted her time to study, correspondence, literature, and the education of her two sons, with the result that one became a general and the other a cardinal. In 1528 she moved to Bologna and established a salon, where the most eminent literati gathered.

ALESSANDRA GILIANI (1307–1326, Italy): A pioneer of anatomy, Giliani devised a means of drawing blood from the veins and arteries of cadavers, then filling them with different-colored liquids to render them more visible. She became the assistant to the surgeon Mondino (considered

the father of modern anatomy), and her work was featured in his anatomy text.

ELIZABETTA GONZAGA (15th c., Italy): Gonzaga, a sister-in-law of Isabella d'Este, received many important Renaissance figures at her court, including Piero della Francesca, Jan Van Eyck, Raphael, and Baldassare Castiglione, whose famous work *The Courtier* was based upon conversations in her drawing room. Her salon was considered the heart of the intellectual and cultural life of the city of Urbino.

ISABELLA OF LORRAINE (fl. 1429, France): Isabella of Lorraine, the patron of Agnes Sorel, was an extremely wise ruler and one of the most illustrious women of the fifteenth century. When her husband was taken prisoner in 1429, she assembled an army of nobles to rescue him. While imprisoned, the king inherited another kingdom, which Isabella claimed and successfully established her reign there as well.

MAHAUT OF ARTOIS (d. 1329, France): A noblewoman and lady of the manor, Countess Mahaut first inherited her father's estate of Artois and then her husband's estate of Burgundy. She ruled over these two domains for many years, surviving intrigue, scandal, and insurrection, proving to be an able administrator, a skillful diplomat, a dedicated art patron, and a conscientious philanthropist. Not only did she study and practice medicine—leaving many illustrated manuscripts on the treatment of disease—but also founded eighty hospitals and thirty institutions for quarantining people with contagious diseases.

BAPTISTA MALATESTA (d. 1460, Italy): Malatesta, a scholar and philosopher, lectured and wrote on philosophy and theology before eventually retiring to a convent.

MATHILDA OF GERMANY (fl. 1470, Germany): Mathilda was largely responsible for the introduction of humanism into Bavaria and Swabia. Interested in literary reform, she collected old court poetry, encouraged the oral tradition of Germanic folk songs, promoted writing based on ancient Germanic traditions, and also had important masterworks translated into German. She in-

spired the humanist Nicholas von Wyle to compose a eulogy for her praising the many blessings women had brought into the world.

TARQUINIA MOLZA (1542–1617, Italy): A musician at the later d'Este court, Molza was a singer, composer, and conductor of an orchestra of women musicians. Her career was cut short when she was dismissed from court over her involvement in a love affair. Unfortunately, her music may have been banished as well, for none of her compositions are extant. A true Renaissance woman, Molza was also a poet, translator, and scholar.

OLYMPIA MORATA (1526–1555, Italy): Educated by her father, Morata became a distinguished classical scholar and professor of philosophy who was respected by the greatest thinkers of her day. Her Greek and Latin dialogues and poems, as well as her letters and translations, were published in 1555. As she was sympathetic to the Reformation (which made her religious views unpopular), she was forced to move to Heidelberg. The university there offered her a professorship of Greek, but the plague cut short her career.

CATERINA SFORZIA (1463–1509, Italy): Sforzia was an illegitimate daughter of the heir to the duchy of Milan. When he was assassinated, she was married off in order to strengthen an alliance between her family and another that controlled the papacy. Caterina's husband was made a count, and when the pope died and her husband was later assassinated, she decided to take command of the territory as regent for her son. But it was her military strength and political skill rather than her position as regent that was the source of her power. Even though she was finally overthrown by Cesare Borgia, she remains one of the few Renaissance women to have seized and wielded power directly.

AGNES SOREL (1409–1450, France): Sorel was a politically astute woman who won a powerful position as advisor to King Charles VII and—together with Yolanda of Aragon and Joan of Arc helped to consolidate and strengthen France.

GASPARA STAMPA (15th c., Italy): Stampa was a famous Venetian poet, musician, and composer, who, after being abandoned by her lover (the count of Collato), gathered her love lyrics into a volume dedicated to him. It was not until after her death that her verses enjoyed wide publication and acclaim.

BARBARA STROZZI (16th c., Italy): Strozzi, a singer who performed her own compositions, was one of the earliest female musicians to receive recognition as both a performer and composer.

LUCREZIA TOURNABUONI (ca.1430–1482, Italy): Tournabuoni, a politician, businesswoman, banker, writer, art patron, and philanthropist, was powerful in all spheres of public life. As the wife of Piero de Medici and the mother of Lorenzo the Magnificent, she wielded considerable influence over political appointments and financial transactions. A cultivated woman who supervised the education of her grandson (later Pope Clement VII), she also patronized the arts and wrote several religious works.

YOLANDA OF ARAGON (15th c., France): An important political figure in French history, Yolanda sought to strengthen the interests of France against the English after they had conquered much of France. Married to a French nobleman, she supported Joan of Arc's army financially, exerting pressure on Charles VII to favor Joan's plans. Yolanda proclaimed her belief in Joan's divine mission and, when Joan went to trial, testified on her behalf. Yolanda introduced Agnes Sorel to Charles VII with the idea that Sorel could, as his mistress, exert considerable political influence. Together, Sorel and Yolanda exercised a positive influence on the king. Yolanda made an alliance with Navarre and Brittany, thereby uniting the two provinces and strengthening the French crown.

Elizabeth I

(1533–1605)

The opulent place setting for Elizabeth I honors a great queen who, in response to those counselors who pressured her to wed, stated: "I am already bound unto a husband, which is the Kingdom of England, and a marble stone should hereafter declare that a queen, having reigned such a time, lived and died a virgin." (She referred to herself as a virgin in the traditional rather than the modern sense of that word—that is, an independent woman, not dictated to by any man.)

Elizabeth—whose birth had been cursed by her father, Henry VIII, because he'd wanted a male heir—ascended to the throne of England in 1559. Among the most erudite women of the sixteenth century, she continued the tradition of female scholarship advocated by English humanists and first introduced into England by Catherine of Aragon (who'd brought these ideas from the Spanish court of her mother, Isabella, an ardent supporter of women's rights).

Despite the presence of a number of strong and learned women in the English courts, by that time arguments against female rulers abounded. Government was considered an exclusively masculine affair, and Elizabeth was constantly urged to find a husband in order to give England a king. But she was determined to retain her autonomy and rule England herself, sometimes manipulating her marital status to forge alliances under the pretense of an engagement, always forestalling the actual marriage while she maneuvered to obtain her political goals.

During the forty-five years of Elizabeth's humane and tolerant reign, the country prospered; there was a vast increase in national power and economic wealth, as well as a cultural renaissance that made England an intel-

Detail of *Elizabeth I* runner top and back

lectual and artistic center. She introduced religious tolerance, maintained relative peace, modernized the British navy, and made diplomacy an art. As one of the earliest heads of state to recognize the sovereignty of the people, Elizabeth built a popular base of support, establishing the right to a fair trial and organizing governmental relief for the old, the infirm, and the poor. Unfortunately, her death brought an end to a period in which women enjoyed at least some increase in respect. Reformation ideas, at first progressive in regard to women, later became increasingly conservative, evidenced by Luther's dictum that "women should remain home, sit still, keep house, and bear and bring up children."

Paintings of Queen Elizabeth in her gor-

geous costumes and wide, elaborate ruffs inspired both the runner and the presentation of the plate, which is painted in the rich colors traditionally associated with royalty and set off with a fabricated ruff form covered with a "cloth of gold" (intended as a contemporary analogue to one of the fabrics associated with Elizabeth's father, Henry VIII). The embroidery on this ruff and on the runner mimics the distinct style of Elizabethan blackwork. The imagery in the two illuminated capitals is based upon Elizabeth's own royal signature. The runner surface is further adorned with pearls, a special gift from Susan Grode, who contributed the jewelry she'd inherited from her mother as homage to this noble queen.

The position of women improved during Elizabeth's reign, a result of her policies and example, along with expanded educational opportunities. Humanist philosophy influenced many ruling queens to support female education in their courts, which produced numerous women of achievement and a startling number of exceptional monarchs. The names of these women are grouped with the place setting for Elizabeth.

ANNA SOPHIA (*1531–1585, Denmark*): Known as the mother of her country, Anna Sophia, the daughter of the king of Denmark and wife of August I of Savoy, improved education, built schools and churches, and established numerous botanical gardens. Interested in agriculture, she raised her own medicinal herbs, founding an apothecary that remained in existence for three hundred years.

ANNE BACON (*1528–1610, England*): Scholar, translator, and tutor and governess to Edward VI, Anne Bacon published a translation of twenty-five sermons by the celebrated Italian religious figure Bernardine Ochine. She also translated Bishop Jewel's *An Apology for the Church of England* from Latin into English. The translation of this book, which was an important and controversial document, made it accessible to the common people. In addition to her many achievements, she was also the mother of Sir Francis Bacon, whose thought and life she helped to shape.

CATHERINE OF ARAGON (*1483–1536, England*): Catherine's classical education was supervised by her mother, Isabella of Castile, who brought such outstanding female scholars as Beatrix Galindo and Francisca de Lebrija to her court. After marrying Henry VIII of England, Catherine continued her intellectual pursuits, providing patronage for writers and support for the education of women. Under her auspices, many treatises on women's education were written, and her ideas helped shape female education for the next hundred years. But because she did not produce a male heir, she was forced from her royal position.

CATHERINE II (THE GREAT) (*1729–1796, Russia*): During her reign, Catherine's wisdom and organizational ability affected nearly every phase of Russian life. In agriculture, she introduced improved animal-breeding techniques, crop rotation, and silkworm cultivation. In industry, this great queen encouraged immigrants to settle in labor-short regions, broke up monopolies, and extended manufacturing and mining. She expanded the educational opportunities available to girls and built many schools. Her commitment to medical progress was demonstrated by her willingness to be the first in Russia to receive a smallpox inoculation. She also attempted to free the serfs, but the nobility resisted her intended reforms.

GEORGIANA CAVENDISH (*1757–1806, England*): The most important female member of the Whig party in England, Cavendish took an active part in politics. As the duchess of Devonshire, she was extremely liberal and progressive, supporting middle-class commercial interests as well as favoring representative government.

CHRISTINA OF SWEDEN (*1626–1689, Sweden*): Christina, the troubled sole heir to the throne of Sweden, was the first woman to be crowned king. During her ten-year reign, she tried to raise the standards of Swedish culture by attracting many of the leading intellectuals of the day to her court, including Descartes and Scarlatti. Christina's refusal to marry so that the country could have a male king, coupled with her desire to travel and live a life free from the constant pressure of courtly criticism, eventually led to her abdication. She then settled in Rome, where she converted to Catholicism, founded academies, compiled a comprehensive library, and collected many paintings and antiques.

JEANNE D'ALBRET (*1528–1572, France*): Daughter of Margaret of Navarre, d'Albret was a scholar, poet, religious reformer, and later the queen of Navarre. Because she ardently opposed Catholicism, she provoked the wrath of the Inquisition, which was invoked against her in 1563. Nonetheless, she succeeded in establishing Protestantism throughout her country, seizing the property of the Catholic Church and using it to support new ministries and schools. She supported advanced religious ideas and studies at her palace, where she also designed and worked a series of tapestries with religious liberty as the theme. It was due to her influence that her son Henry IV established religious toleration in France.

ELIZABETH DANVIERS (*16th c., England*): Danviers, a noted authority on Chaucer, was one of many learned women during the reign of Elizabeth I.

MARIA DE COSTE BLANCHE (*fl. 1566, France*): De Coste Blanche, an instructor of mathematics and physics in Paris, published a scientific treatise in 1566 titled *The Nature of the Sun and the Earth*.

PENETTE DE GUILLET (*16th c., France*): De Guillet, who was fluent in Spanish and Italian, was an accomplished musician and poet who also composed verses in Latin. Some of her work has survived.

ISABELLA DE JOYA ROSERES (*16th c., Spain*): De Joya Roseres, a theologian, preached in the cathedral at Barcelona, one of the few women to address the congregation of a Catholic church. She later went to Rome, where she became a member of the papal court of Paul III, discoursing on theological problems before the College of Cardinals.

MARIA-CHRISTINE DE LALAING (*1545–1582, Belgium*): De Lalaing organized the military defense of her city when it was besieged by the Spanish in 1581. Continuing to fight even after being wounded, she provided a valiant model for her soldiers, who surrendered only when their food and ammunition ran out.

CATHARINE FISHER (*d. 1579, Germany*): One of the most precise linguists of the sixteenth century, Fisher was responsible for the education of her son James, who became a celebrated philosopher.

KENAU HASSELAER (*1526–1589, Holland*): Hasselaer, who was from a brewer's family, married a shipbuilder, who left her a widow with four children. After registering as an independent shipwright, she traveled extensively in order to

obtain business in the Netherlands and Scandinavia. She achieved fame for her participation in the defense of Haarlem during the wars of liberation in 1573.

ELIZABETH HOBY (*fl. 1558, England*): By the age of twenty-five, Hoby, a midwife, surgeon, and general medical practitioner, was managing an estate comprising two hundred houses and four mills.

ISABELLA OF CASTILE (*1451–1504, Spain*): Isabella is best known as the supporter of Columbus's expeditions to the New World, an act in keeping with her breadth of vision, which led to the founding of new universities and the subsidy of scholars in the sciences and the arts. Isabella opened many new opportunities for women, assigning women to university posts and supporting several female scholars in her court. She instituted formal education for her daughters, one of whom, Catherine of Aragon, passed on this tradition to her stepdaughter, Elizabeth I. Although industry flourished during her reign, as did conservation, her support of the Inquisition and the consequent persecution of the Jews severely undermined some of the more positive aspects of her reign.

JADWIGA (*1370–1399, Poland*): In default of a male heir, Jadwiga ascended to the throne in 1384, the first legitimate queen to rule Poland. Her reign ushered in the heroic age of Poland, which lasted for two hundred years. Jadwiga tried to bring religion and learning within the reach of more of the people, re-establishing the University of Krakow, supporting and improving Church music, and trying to raise the cultural level of her country.

JANE OF SUTHERLAND (*1545–1629, Scotland*): A pragmatic yet visionary businesswoman, Jane was responsible for turning the town of Brora into an industrial center. She oversaw the working of a new coal mine and the establishment of a saltworks, and even though her Catholicism meant that she was often out of favor politically, she steadfastly remained true to her faith.

SARAH JENNINGS (*1660–1744, England*): A major influence in Queen Anne's court, Jennings

ultimately disagreed with royal policies, eventually becoming the leader of the opposition Whig party. Because this duchess of Marlboro (also known as Queen Sarah) was a shrewd businesswoman, she became one of the richest peeresses in England. Even when she was too old to leave her rooms, she continued to transact her own business from her bed, working six hours a day until her death. Jennings's memoirs, which she self-published, recorded her distinguished life and times.

HELENE KOTTAUER (*1410–1471, Austria*): Kottauer was a servant to Queen Elizabeth of Hungary. She wrote her memoirs, recounting her experiences in the court and describing Elizabeth's struggles to maintain her power.

LILLIARD (*d. 1547, Scotland*): Lilliard, a Scottish soldier, fought against the English in retaliation for a raid in which her parents and lover were killed. Wearing a suit of armor, she joined the battle at Ancrum, where she killed the English leader. Although she died in battle, the Scots won, their victory often attributed to her heroism.

ISABELLA LOSA (*1473–1546, Spain*): Losa, a brilliant scholar, was famous for her knowledge of Greek, Latin, and Hebrew. After being widowed, she entered the Order of St. Clare and went to Italy, where she founded a hospital.

ELIZABETH LUCAR (*1510–1537, England*): An exquisitely skilled needleworker and an excellent calligrapher, Lucar was also proficient in mathematics, knew Latin, Italian, and Spanish, and was an accomplished musician.

MARGARET OF AUSTRIA (*1480–1530, Austria*): As regent of the Netherlands from 1507 until her retirement, Margaret helped to achieve financial stability. She negotiated important trade agreements in Western Europe, including the Treaty of Cambrai (1529), which was established by Margaret and Louise of Savoy and referred to as the "Ladies' Peace." After using her political influence to secure the crown for Charles V, she retired, devoting herself to study and to the encouragement of the "new learning" of the Renaissance.

MARGARET OF DESMOND (*fl. 14th c., Ireland*): A Gaelic warrior and stateswoman, Countess Margaret governed her estates jointly with her husband, maintaining and leading her own private band of warriors. As a patron of the arts and education, she invited weavers from Flanders, founding a school so that they could teach and establish tapestry-making in her realm.

MARGARET OF NAVARRE (*1492–1549, France*): It is said that Margaret of Navarre contributed more to the development of learning in France than any other individual of the period. A staunch patron of the arts and literature, her salon became a stronghold for those who advocated and initiated the Reformation. Margaret was also a writer, producing a volume of religious poems, *The Mirror of the Sinful Soul*, and the *Heptameron*, a collection of medieval tales.

MARGARET OF SCANDINAVIA (*1353–1412, Denmark*): Margaret, daughter of the king of Denmark and wife of the king of Norway, became regent of both thrones (in the name of her son) after both kings had died. After her son's premature death, Margaret was unanimously elected queen of Denmark, despite the fact that there was no precedent for a ruling queen. She also established her reign in Norway, becoming such a popular ruler that the people of Sweden, oppressed by their own king, asked her to take the throne. After defeating the Swedish king in battle, she tried to unite the three countries in order to end the continuous warfare between them. During her tenure, she laid the foundation for future commerce and for the establishment of a just legal system.

MARIA THERESA (*1717–1780, Austria*): Maria Theresa ascended to the throne in 1740, ruling for forty years despite the efforts of the leaders of several nations who attempted to plot her downfall. She engaged the support of Hungary in the Seven Years War against Prussia, establishing an alliance with Holland, Denmark, and Russia. Once peace was restored, Maria Theresa instituted many needed reforms in the army, the courts of law, and the educational system. She suppressed the Inquisition, lowered taxes, and founded orphanages and hospitals. As the economy improved, the arts flourished, and

during her reign Vienna became the musical capital of Europe, fostering the talents of Mozart, Haydn, and Gluck. Maria Theresa was the mother of Marie Antoinette and eighteen other children, all of whom were born in her first nineteen years of marriage.

MARY OF HUNGARY *(d. 1558, Spain)*: In 1521 Mary, the daughter of Philip of Spain, married Louis, king of Hungary, and upon his death she became the ruler of the Netherlands. She reigned there until 1555, when she returned to Spain, where she is remembered as a patron of the arts and a friend to the Protestants.

GRACIA MENDESA (BEATRICE DE LUNA) *(1551–1569, Portugal)*: A philanthropist, Mendesa spent much of her immense fortune trying to relieve the suffering of persecuted Jews, founding synagogues, giving support to Jewish scholars, and working to prevent the Inquisition from entering Portugal. Denounced as a Jew, she was put in prison in Venice and her property was confiscated. When she was finally freed, she and her daughter fled to Constantinople.

GRACE O'MALLEY *(fl. 1580s, Ireland)*: A sea captain and pirate, this so-called Lady Chieftain of the O'Malleys commanded a fleet of three galleys, along with two hundred of the most lawless men in the British Isles. Considered a terror to all merchant ships on the Atlantic, she ruled the sea for years. O'Malley was considered so powerful that, in order to curtail her activities, Elizabeth I invited her to court, offering to make her a countess. But O'Malley refused, saying that she "would serve no one but herself." This meeting did, however, help to cement a short-lived alliance between England and Ireland.

CATHERINE PAVLOVNA *(1788–1819, Russia)*: A grand princess of Russia, Pavlovna formed social and political associations for women, promoted education for both sexes, established agricultural societies, and provided food for her subjects during a terrible famine.

ELIZABETH PETROVNA *(1709–1762, Russia)*: As empress of Russia, Petrovna singlehandedly ruled the nation from 1741 to 1761, refusing all offers of marriage, preferring "love affairs and absolute sovereignty." Greatly influenced by Western ideas, she founded the University of Moscow and later the Academy of Arts at St. Petersburg in order to encourage both popular education and native literature. She tried to eradicate the long-standing corruption in Russian government; established alliances with France and Austria; introduced a better system of taxation; encouraged pioneer settlements in eastern Russia; opened mines; and established banks.

PHILIPPA OF HAINAULT *(1314–1369, England)*: Queen Philippa led an army of twelve thousand soldiers against the Scots, capturing the king of Scotland and thereby becoming a heroine to the English people. Recognized throughout Europe for her remarkable innovations in social welfare and her concern for the poor (especially women), she established the wool industry at Norwich and the coal industry at Tynedale, enterprises that became the backbone of the English economy.

OLIVA SABUCO *(16th c., Spain)*: Sabuco produced a body of work that investigated the relationship between mental and physical health, as well as the effects of culture and environment on human development. She also wrote on political and social reforms, but because her theories were quite advanced, her writings were attacked by the Inquisition, which destroyed all but two volumes.

MARY SIDNEY *(1555–1621, England)*: Sidney established a salon in her home where she exchanged ideas with some of the most illustrious people of the period, including Raleigh, Shakespeare, Jonson, and Donne. With her brother, she translated the "Sidnean Psalms" into English verse.

SOPHIA OF MECHLENBERG *(16th c., Baltics)*: As queen, Sophia tried to alleviate the suffering that grew out of her nation's custom of "a baby a year." Because this led to the death of so many mothers, she taught birth control, stressed the proper training of midwives, and also ended the practice of killing illegitimate children. In addition, she instituted many hygiene reforms, such as isolating the sick, enforcing stricter burial laws, and encouraging frequent bathing. After her husband's death, she ruled both Norway and Denmark until her son Christian IV reached his majority.

ELIZABETH TALBOT *(1518–1608, England)*: Talbot, who was multi-titled (known as both the countess of Shrewsbury and Bess of Hardwicke), was a successful architect and businesswoman. She designed and built houses on property that came to her through inheritances from her two husbands.

JANE WESTON *(fl. 1560, England)*: Extremely well traveled and highly educated, Weston was considered one of the leading Latin poets of the sixteenth century and became internationally known for her prose and verse.

Artemisia Gentileschi

(1590–1652)

Artemisia Gentileschi's father, an Italian painter and humanist, recognized his daughter's talent when she was young and trained her in his own studio. Unfortunately, an artist that he later hired to teach Artemisia perspective skills raped her, thereby almost ruining her life. Although the rapist was brought to trial, it was Artemisia who was tortured and questioned. Nonetheless, she refused to retract her accusation. Although the man was finally imprisoned, he served less than eight months.

Because she had openly admitted to being assaulted, Artemisia became the object of endless gossip, gaining a reputation as a loose woman that followed her throughout her life. In an effort to protect his daughter from scandal, her father arranged for her to be married. When the marriage did not last, she began to move about from town to town to find work. Everywhere Artemisia went, she painted portraits as well as historical and religious works, slowly becoming a well-established artist. Although she received a number of commissions, she sstruggled constantly to be paid as much as a man would have been for the same work. She was, however, admitted to the Academy of Design in Florence—a rare honor for a young woman.

Artemisia's canvases exhibit the dramatic use of lights and darks and the sensuous movements characteristic of the Italian Baroque school. Her important role in seventeenth-century painting has only recently begun to be acknowledged. Although she became quite famous and successful in her own time, her art was later obscured, and some of her work even attributed to male artists. Though Artemisia died in 1652, her paintings reach out across the centuries, offering solid evidence that women have indeed been great artists.

Artemisia Gentileschi place setting

Artemesia's female figures—primarily heroines of the Bible or mythology—are strong and courageous. One of her favorite themes was the story of Judith, from which she was able to create a series of powerful paintings. To suggest the link between these two women—as expressed in Artemisia's use of the Judith theme—I combined a sword (also used in the capital letter of the Jewish heroine's name) with an image of brushes and a palette to embellish Artemisia's name.

The relationship is further expanded through the repetition of the pomegranate motif on the runner. Stenciled onto the fabric in imitation of a seventeenth-century fabric known as "bizarre silk," the design is a reminder of both the engraved coins gracing the back of the Judith runner and the pomegranate's association with the ancient Goddess. The twisting and turning forms of the plate image represent the Baroque style typical of Artemesia's paintings, along with the extraordinary efforts required of any woman of her time who desired to become an artist. The engulfing forms of the velvet on the runner top are intended to suggest the protection her devoted father had vainly tried to provide for his talented daughter.

Women who wished to be artists encountered often insurmountable obstacles, including the fact that apprenticeships, the primary vehicle for training, were available only to men. One of the few ways in which a woman could acquire the necessary art education was if her father were an artist and would train her himself. Any improvement in women's social or political status often brought with it the appearance of more women in the arts. Thus, women artists emerged in various countries at different times, depending upon their particular historical or personal circumstances. Their names are grouped with the place setting honoring Artemesia Gentileschi.

SOPHONISBA ANGUISCIOLA *(1527–1624, Italy)*: Renowned for her portraits, Anguisciola was the first woman to emerge as an eminent professional painter, becoming the court painter to Philip II in 1560.

LEONORA BARONI *(17th c., Italy)*: In addition to her fine voice and musical talents, Baroni possessed a profound knowledge of music. A poet as well, her work was widely published.

ROSALBA CARRIERA *(1675–1757, Italy)*: Carriera was the greatest painter of pastels and miniatures of her day. By 1720, when she visited Paris and executed portraits of Watteau and the young Louis XV, her work had become so popular that she was one of the few women elected to the French Academy. She began to go blind, however, and it is said that the loss of her sight so depressed her that she ended her life in a state of complete mental collapse.

MARIE CHAMPMESLÉ *(1642–1698, France)*: An actress who was instrumental in the formation of the Comédie-Francaise, Champmeslé achieved fame for her portrayals of Iphigenia and Phaedre in dramas by Racine.

ELIZABETH CHERON *(1648–1711, France)*: Cheron's historical paintings and portraits won her the admiration of—though not membership into—the Royal Academy, but her work was so respected that she was given an annual pension by Louis XIV.

MARIA DE ABARCA *(d. 1656, Spain)*: De Abarca, a celebrated portrait painter, was a contemporary of both Rubens and Velasquez, both of whom held her in high esteem.

PROPERZIA DE ROSSI *(1490–1530, Italy)*: De Rossi was a sculptor who worked in several media, the most unique of which was peach stones. A series of her fine miniature carvings—depicting the saints and apostles—is in the Grassi Museum at Bologna. She also sculpted two angels for the church of St. Petronius, as well as bas-reliefs of Potiphar's wife and Joseph.

ELIZABETH FARREN *(1759–1829, Ireland)*: Farren was a leading English actress who attempted to expand the available repertoire, but her efforts were not well received. She often performed in the plays of Elizabeth Inchbald, one of the first female dramatists in Ireland.

LAVINIA FONTANA *(1558–1614, Italy)*: Trained by her father, Fontana was one of the most prolific women artists prior to the eighteenth century. Her subject matter was not confined to portraiture and still lives, as was many women's (primarily because they were not permitted to study anatomy). Her figurative works portrayed both female and male nudes (unusual for a woman), and she created many large-scale paintings, executing a number of public and private commissions. Her oeuvre also included portraits, small religious works, and altar pieces for churches in Bologna, Cento, and Rome.

FEDE GALIZIA *(1578–1630, Italy)*: Famous for her still lifes and portraits, Galizia's precocious artistic talent was written about when she was only twelve years old. By her late teens, she was an established portrait painter, producing still lifes and religious works and receiving public commissions, such as the high altar piece of Santa Monica Magdalena in Milan in 1616. A number of her works in Milanese churches survive, as does her painting *Judith and Her Handmaiden*, which is in Sarasota, Florida.

MARGUERITE GERARD *(1761–1837, France)*: Gerard's sister, who was married to Fragonard, summoned her to Paris, where she became

part of the artistic community surrounding her brother-in-law. The first woman to succeed as a genre painter—an area that was particularly male-dominated—she was also a portraitist and miniaturist.

NELL GWYN *(1650–1687, England)*: One of England's greatest actresses, Gwyn made her theater debut in 1665. A favorite on the London stage for nearly twenty years, she was also a singer, dancer, and comedienne. A mistress to Charles II and well known for her generosity, she influenced Charles to build Chelsea Hospital and, upon her death, willed most of her fortune to the poor.

ANGELICA KAUFFMAN *(1741–1807, Switzerland)*: Kauffman was one of the major artists and intellectuals of the eighteenth century. Equally gifted in music and painting, she recognized that she must devote herself to one or the other. Though she chose painting, years later she depicted the difficulty of that decision in an allegorical work titled *Angelica Hesitating Between the Arts of Music and Painting*. While living in Italy, she became involved in the emerging style of Neoclassicism and was elected to the prestigious Academia di San Luca. Kauffman received numerous commissions from European royalty and nobility, painting portraits of the leading artists, writers, and intellectuals of her day. Renowned for her paintings, Kauffman was one of the original founding members of the British Royal Academy. Only one other woman—Mary Moser—was allowed membership prior to 1922. But in the official portrait of the academy, Kauffman and Moser are represented only by small portraits on the wall, while their male colleagues are pictured painting a nude female model.

JOANNA KOERTON *(1650–1715, Holland)*: Koerton was an artist who excelled in drawing, painting, embroidery, cut-paper portraits, and landscapes. Her work, which was admired by Peter the Great, was often commissioned by the emperor of Germany.

ADELAIDE LABILLE-GUIARD *(1749–1803, France)*: Despite coming from a low social-class background with no artistic tradition in her family, Labille-Guiard became one of the most ac-

tive and influential artists of the eighteenth century. Her work as a portrait painter gained her admittance to the Royal Academy in 1783 where she became a vocal member, arguing for such things as the appointment of female art professors. Unlike some of the other painters of her time, Labille-Guiard was a supporter of the Revolution, building up a clientele among the leaders of the new regime. But when she embarked upon a monumental historical work, (because it glorified royalty), it was unacceptable to the new government, which had it destroyed. She died a few years later.

JUDITH LEYSTER (1609–1660, Holland): Leyster was a major Dutch artist of the seventeenth century who, by 1635, was a member of the Painters Guild in Haarlem. Her paintings are characterized by her interest in the psychology of the sitter and by her dramatic use of light and shadow, as well as by her domestic scenes, which display a special sensitivity toward the everyday lives of women.

MARIA SIBYLLA MERIAN (1647–1717, Switzerland): A naturalist and artist, Merian produced a series of definitive works on the insect life of Switzerland and the Dutch colony of Surinam in South America. She revolutionized the sciences of zoology and botany, laying the foundation for the eighteenth-century classification of plant and animal species. Merian also wrote and illustrated a three-part catalog of flower engravings called *The New Flower*.

HONORATA RODIANA (d. 1472, Italy): Rodiana was supposedly the only woman fresco painter in fifteenth-century Italy, though, unfortunately, none of her works are extant. It is said that she worked for the ruler of Cremona until one of his courtiers attempted to (and possi-bly did) rape her, after which Rodiana fatally stabbed him, then fled. Disguised as a man, she joined a band of professional soldiers, dividing her time thereafter between painting and fighting. She died defending her birthplace of Castelleone.

LUISA ROLDAIN (1656–1704, Spain): Roldain, who was trained by her father, executed life-sized carved wooden terra-cotta sculptures for the churches of Spain, which so impressed Charles II that he appointed her his court sculptor.

RACHEL RUYSCH (fl. 1664–1750, Netherlands): Ruysch was one of the first women to achieve an international reputation as a major artist. Her talent was evident early, and by age fifteen she was able to be apprenticed to one of Holland's finest painters. In 1701 she was received into the Painters Guild at the Hague, later becoming the court painter to the elector in Dusseldorf. Despite ten children and extensive domestic responsibilities, she produced a total of eighty-five works, remaining an active painter until three years before her death.

SARAH SIDDONS (1755–1831, England): Siddons, the greatest tragic actress of her day, ruled the London stage for thirty years. Her farewell performance as Lady MacBeth was so moving that the play was stopped after her sleepwalking scene.

ELIZABETTA SIRANI (1638–1665, Italy): Extremely prolific during her short lifetime, Sirani was a professional artist and the instructor of an entire generation of women artists. She produced at least 150 paintings on subject matter ranging from portraits to religious, allegorical, and mythological scenes.

LEVINA TEERLING (ca. 1520–1576, Flanders): Teerling was a court painter to Henry VIII, Edward VI, Mary I, and Elizabeth I. Trained in the tradition of her father and grandfather, she was a painter of miniatures. Although her fame spread throughout England and the Netherlands, no extant works can be securely attributed to her.

LUIZA TODI (1753–1833, Portugal): An internationally famous soprano, Todi performed throughout Europe during the latter part of the eighteenth century.

CATERINA VAN HEMESSEN (ca. 1528–1587, Flanders): Van Hemessen, one of the earliest recorded female artists in northern Europe, was probably trained as a painter by her father and even collaborated with him on some of his works. She received commissions from the upper-class families of Flanders, as well as from Queen Mary of Hungary, whom she accompanied to the court of Philip II of Spain. Best known for her small, elegant portraits (mostly of women), she also executed at least two elaborate religious paintings.

MARIE VENIER (1590–1619, France): Venier, the first French actress recorded by name, was famous for her portrayal of tragic heroines.

ELIZABETH VIGEÉ-LEBRUN (1755–1842, France): Vigeé-Lebrun was one of the most prolific and popular artists of her day. While still in her teens, she began receiving commissions from the aristocracy, eventually becoming a favorite at Versailles and a court painter to Marie Antoinette, with whom she became a close friend. Because she was a Royalist, Lebrun had to flee with her daughter to Italy on the eve of the Revolution. She spent twelve years in exile, living and working in the courts of Europe and becoming a member of the academies of Rome, Florence, Bologna, St. Petersburg, and Berlin. She was finally able to return to Paris, spending the remaining twenty-two years of her life in France under the Napoleonic regime. She painted over eight hundred portraits and landscapes and maintained a journal that provides a fascinating account of the life and times of an eighteenth-century professional woman artist.

SABINA VON STEINBACH (fl. 1318, Germany): Von Steinbach has been credited with sculpting the stone figures on the south portal of Strasbourg Cathedral in the fourteenth century. After the master builder died, she received the contract to complete the work, and although there is some dispute as to the validity of this attribution, there is an inscription on one of the sculptures that bears her name.

WOMAN HAS THE SAME WISH FOR SELF-DEVELOPMENT AS MAN, THE SAME IDEALS, YET SHE IS TO BE IMPRISONED IN AN EMPTY SOUL OF WHICH THE VERY WINDOWS ARE SHUTTERED.

Detail of *Anna van Schurman* runner top; embroidery by L. A. Hassing.

Anna van Schurman

(1607–1678)

Embroidered on the runner for Anna van Schurman is an abbreviated version of this aching statement from her book advocating female education: "Woman has the same erect countenance as man, the same ideals, the same wish for self-development, the same longing after righteousness, and yet she is to be imprisoned in an empty soul of which the very windows are shuttered." The lack of adequate training for women increasingly became the focus of books written by those few who had the opportunity for such education during the Reformation. One of the most extraordinary women of this period was Anna van Schurman.

Born in Holland, van Schurman was a genius at a time when female genius was considered an impossibility. Because northern Europe was somewhat more liberal in its attitudes toward women, she was not only allowed to study but was able to achieve some recognition for her work. Anna, a child prodigy, was educated at home by her father, from whom she and her brothers all received a classical education. At first she directed most of her energies toward art, devoting herself to those techniques she could teach herself. She did fine engraving, drawing, modeling in wax, wood carving, etching on glass, oil painting, and intricate needlework. Unhappily, most of her work has been destroyed, though some examples can still be found in European museums and in the area where she lived.

At that time, most intellectual discussions in Holland centered on religious and theological issues, and van Schurman soon became interested in these questions, learning Greek, Hebrew, and the ancient languages in order to read and interpret the Bible herself. As women were not admitted to the university, she had to attend lectures concealed behind the curtains of a box. This injustice stimulated her to write a book in which she argued, by both logic and example, that women's native abilities were not being recognized. This work was followed by another in which van Schurman demanded the same educational opportunities for women as for men.

These books made her famous and brought her into contact with the international world of letters. (Correspondence with important cultural figures was one way women could participate in the intellectual dialogue of the day.) As van Schurman grew older, however, she chose to increasingly withdraw from society, finally joining a religious community in which women had equal rights and living there for the rest of her life.

Although the plate for van Schurman is modestly colored, its butterfly form struggles to fly, a metaphor for Anna's valiant efforts on behalf of women's rights. The plate rests on a similarly colored runner, embroidered in the needlework sampler techniques popular during her lifetime. These samplers, while extraordinary in terms of embroidery, provided an effective method of confining the activities of little girls. Young women were forced from childhood to learn tiny stitches, a type of work that required patience and forbearance, while also teaching them how to "think small."

As a result of the Reformation, marriage became the only acceptable option for most Protestant women, although women did enjoy a new respect within the family. But if a woman had other ambitions, life was very difficult. Grouped around the place setting for Anna van Schurman are the names of a number of other women who tried to make themselves heard, many arguing for women's right to education, others articulating early feminist ideas about the basic equality of the sexes.

MARIA AGNESI *(1718–1799, Italy)*: Agnesi, a child prodigy, spoke fluent French by the time she was five and Greek by the age of eleven. At age nine, she spoke publicly for an hour in Latin on the rights of women to study science. She was so gifted in mathematics that before she was twenty she had embarked on a monumental work—a treatise in two volumes on calculus, to which she devoted ten years of uninterrupted labor. When completed, the work caused a huge sensation in the intellectual community, as it demonstrated that women could aspire to the highest eminence in science. The French Academy of Science sent Agnesi a letter congratulating her on her work while apologizing for not being able to offer her membership in the academy, as admitting a woman would be against their rules. Agnesi soon retired from the world, devoting the rest of her life to charity. She made her views on the limitations of life as a woman entirely clear: "Nature has endowed the female mind with a capacity for all knowledge and . . . in depriving women of an opportunity for acquiring knowledge, men work against the best interests of the public welfare."

MARIANNA ALCOFORADO *(1640–1723, Portugal)*: Alcoforado wrote *Letters of a Portuguese Nun*, a major piece of self-analytical writing, and an important record of the life of seventeenth-century women.

ANNA AMALIA *(1739–1807, Germany)*: Although best remembered as a music collector, Anna Amalia, the sister of Frederick the Great and regent for her son, was highly skilled performer and composer. She composed music to accompany the words of her close friend Goethe and also played an active part in the musical life of Weimar. Distinguished artists and writers of both sexes were drawn to her court, either as visitors or as permanent residents under her patronage. In 1775 she retired from court, devoting her life to the study of music and the arts.

ANNE ASKEW *(1521–1546, England)*: Askew, a Catholic, became convinced of the necessity of the Reformation and, after intensive study of the Bible, became a Protestant, which so enraged her husband that he drove her from the house. She escaped to London but, at her husband's instigation, was taken into custody and examined as a heretic. After being tortured on the rack and despite all her bones being dislocated, she continued to reason calmly with her tormentors. When she refused an offer to recant her beliefs, she was burned at the stake. The published account of her martyrdom helped strengthen the Protestant cause.

Anna van Schurman runner back

MARY ASTELL (1666–1731, England): Astell's precursory feminist treatise, *A Serious Proposal to the Ladies for the Advancement of Their True and Greatest Interest*, which was published in 1694, dealt with the defects and limitations of women's education. As a result of this work, a wealthy woman pledged the money needed to build a college for women, but she was later dissuaded by the local bishop. Though disappointed, Astell wrote *An Essay in Defense of the Female Sex*. Her goal was to raise "the general character of women and rescue them from ignorance and frivolity."

LAURA BASSI (1711–1778, Italy): Bassi received a liberal education in the sciences and languages, earning a doctorate in philosophy in 1732 and carrying on experimental philosophy at the University of Bologna. She became a famous and popular teacher, drawing students from all over Europe. Bassi maintained a steady correspondence with the most well-known intellectuals of Europe, including Voltaire, whom she aided in gaining admittance to the Bolognese Academy of Science.

ANNE BAYNARD (1672–1697, England): Baynard, who received a classical education from her father, studied Latin, Greek, astronomy, natural science, mathematics, and religion. She was greatly respected for her intellect and scholarship.

APHRA BEHN (1640–1689, England): A novelist, playwright, and the first Englishwoman to earn her living as a writer, Behn was the author of a number of plays as well as eighteen novels. Determined to make her living by writing, she defied convention by competing with male playwrights. Her courage in expression, coupled with her honest criticisms of male contemporaries, resulted in a great deal of hostility toward her, particularly when she openly defended both her own work and the works of other women writers.

HELEN CORNARO (1646–1684, Italy): Cornaro challenged the practice of excluding women from academia. In 1672 she made formal application to enter the prestigious University of Padua in order to qualify for the doctor of philosophy degree. On June 25, 1678, before an immense audience of male scholars, ecclesiastics, and foreign dignitaries, Cornaro stood to defend her thesis. Her scholarly dissertation was met by a unanimous shout of approval, and she was formally invested with the academic symbols designating her "*Prima Donna Laureate del Mondo*," the first woman in the world to receive a doctorate of philosophy.

ISABELA CZARTORYSKA (1746–1835, Poland): A princess and a writer, Czartoryska attempted to spread universal culture and national consciousness among the Polish people. She founded an educational institute for young people, a school for girls, and a school for peasant children, establishing her estate as a center of the literary and political life of Poland.

ANNE DACIER (1651–1720, France): Dacier was one of the most famous women in seventeenth-century France and a scholar supposedly unequaled in her knowledge of classical literature. Her translations into French and Latin included the works of Anacreon, the sixth-century B.C. lyric poet; the existing poems of Sappho; and Homer's *Iliad* and *Odyssey*. Her father agreed to educate her only after he'd discovered that she was supplying her brother with the answers for his lessons. Dacier knew and corresponded with other important scholars of her time and was invited by Queen Christina to join the Swedish court. She declined the invitation, going instead to the French court, which was then the center of intellectual activity in Europe.

MARIA DE AGREDA (1602–1665, Spain): De Agreda was a nun, abbess, and essayist who had recurrent visions in which she experienced God commanding her to write the life of the Virgin Mary. This work, which required many years, filled nine volumes. When it was first published it was quite controversial, primarily because de Agreda portrayed Mary as a powerful queen. Under the advice of a priest, she destroyed the work but began it all over again after continued visions. It took her thirty years to complete the rewriting. Although the Inquisition at Madrid permitted publication of her work, the Inquisition at Rome was not so tolerant, and because she was a woman, her entire body of work was condemned and destroyed.

LUISA DE CARVAJAL (1568–1614, Spain): One of the most illustrious writers of the sixteenth century, de Carvajal wrote lyric poetry that was said to be unsurpassed in Castile. She was an outspoken Christian, publicly destroying paintings and writings that offended her faith. Because she opposed the monarchy of Spain, she emigrated to England, where she founded a free community for pious women.

MARIE LE JARS DE GOURNAY (1565–1645, France): A writer and early feminist and one of the staunchest defenders of women in sixteenth-century France, de Gournay wrote *L'Egalité des Hommes et des Femmes*, an early argument for equality between the sexes. Attacks upon women—or praises of their unique merits—had been commonplace in French literature, and de Gournay's originality lay in her contention that the gulf between men and women was due largely to the limited educational opportunities available to women.

BERNARDA DE LA CERDA (17th c., Portugal): De la Cerda was a scholar and writer whose poems and prose were so well known throughout Spain and Portugal that she received recognition in the academies of both countries. Fluent in several languages, she was also versed in rhetoric, philosophy, and mathematics.

MARIE DE MIRAMION (1629–1696, France): De Miramion founded a school for young women, trained teachers and nurses, established a dispensary, and instructed women in the preparation of salves and plasters. She also opened a home for former prostitutes, where they could develop other means of support.

LUISE GOTTSCHED (18th c., Germany): In the eighteenth century French had almost replaced German as the polite language of Germany. Gottsched was partly responsible for re-establishing the use of German, although her husband has received total credit for this accomplishment. She gave up her personal literary efforts in order to help her husband write both a dictionary of the German language and a model grammar.

JEANNE MARIE GUYON (1648–1717, France): Although Guyon established hospitals and aided the poor, she is most remembered as a mys-

tic and religious educator. She traveled throughout France and Spain, writing over forty books in her campaign to educate others in the philosophy of Quietism, a system of mysticism emphasizing inner religious experience as the true way to attain spiritual perfection. Guyon was persecuted for heresy, her books were publicly burned, and she was imprisoned for seven years, finally achieving her release because of ill health. Guyon lived another fifteen years as a virtual prisoner in her own home. Nonetheless, she refused to stop writing about her religious beliefs.

SUSANNA LORANTFFY *(1600–1660, Hungary)*: Lorantffy, who managed the estates of her family, was also its economical and financial head. Although she was influential in securing her husband's appointment as prince of Transylvania in 1636, her great legacy was her contribution to the development of Hungarian cultural life. She founded the Reformed College of Sarospatak, established boarding schools, and created scholarships and endowment funds. In 1644–1645, during the Thirty Years War, she organized the army and ran military operations.

BATHSUA MAKIN *(fl. 1670s, England)*: Involved in the beginnings of English feminism, Makin was a teacher and educational theorist whose *Essay to Revive the Ancient Education of Gentlewomen in Religion, Manners, Arts and Tongues* was published in 1673, as was her important treatise on women's education. Makin supported herself through writing and teaching.

LUCRETIA MARINELLI *(1571–1653, Italy)*: Marinelli was best known for her eight-volume work *The Excellence of Women and the Defects of Men*, published in 1601, though she also wrote poetry and two religious works.

CHARITAS PIRCKHEIMER *(fl. 1524, Germany)*: An abbess who presided over the convent of Santa Clara at Nuremberg during the period of extreme Lutheran agitation, Pirckheimer strongly opposed the Reformation and wrote a memoir expressing her beliefs.

Detail of *Anna van Schurman* runner; embroidery by L. A. Hassing

BRIDGET TOTT *(17th c., Denmark)*: Tott translated the works of the most celebrated authors of antiquity into Danish.

BARBARA UTTMAN *(1514–1575, Germany)*: Uttman was the founder of the lace industry in Annaburg, Saxony. She had learned this then-little-known art in Nuremberg, opening a school in her home that established the beginnings of what was to be a vast and profitable industry for the impoverished town of Annaburg. Through her efforts, schools were opened throughout Germany, and by 1561 lacemaking was an active trade employing thirty thousand people, mostly women.

GLUECKEL VON HAMELN *(1646–1724, Germany)*: Although she was not recognized as a historian in her lifetime, von Hameln's work on her family's history is now viewed as a classic. The seven-volume set, published only in 1896, presents a cross-section of Jewish-German history in the seventeenth century, providing valuable information about the customs and lifestyles of the time.

HORTENSIA VON MOOS *(1659–1715, Switzerland)*: Von Moos was a scholar, writer, and supporter of the emancipation of women. Her published works dealt with such subjects as medicine, geology, physiology, and child rearing.

MARIA ANTONIA WALPURGIS *(1724–1780, Germany)*: Walpurgis, the electress of Saxony, was a composer, poet, painter, singer, and patron. She became a member of the Arcadian Academy in Rome under a pseudonym, using the initials E.T.P.A. to sign her works.

HANNAH WOOLLEY *(b. 1623, England)*: Woolley, a professional educator, was one of many women active in the early stages of English feminism. She published many writings, the most widely read being the *Gentlewoman's Companion*. She argued that if women could obtain the same education as men, their "brains would be as fruitful as their bodies." She supported her views about women's abilities by providing information on role models such as Anna van Schurman.

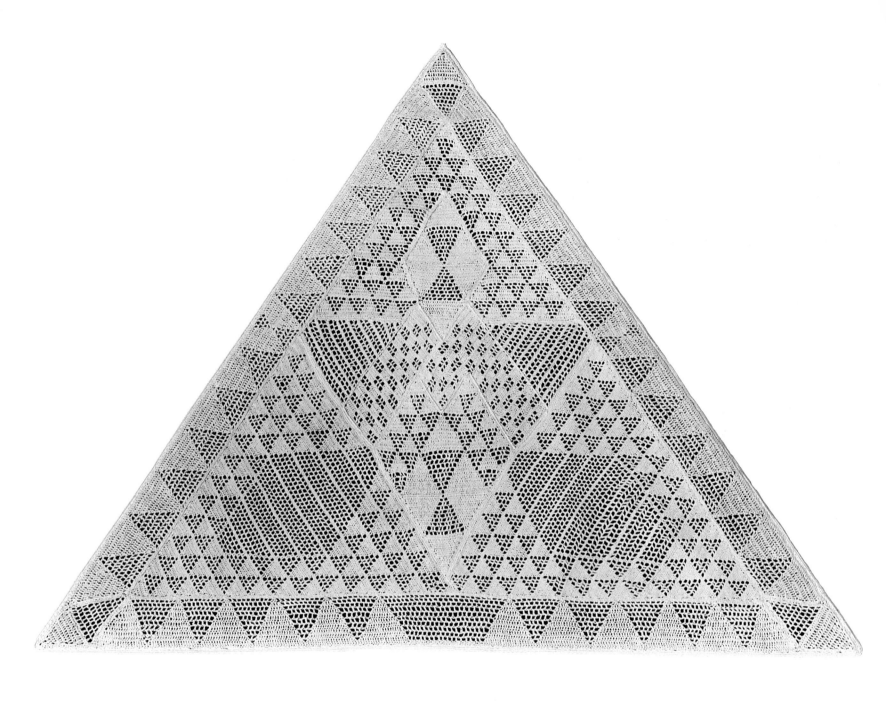

WING THREE

From the American Revolution
to the Women's Revolution

THE LAST WING OF THE TABLE begins with the place setting for the American religious leader Anne Hutchinson. The plate, which is painted in somber tones, is presented on a runner modeled upon traditional eighteenth-century mourning pictures. The imagery is intended to "mourn" the constriction of women's options that was set in motion by the Renaissance, reinforced by the Reformation, and firmly locked in place by the attitudes of the early nineteenth century, by which time Western women had few legal rights.

The advent of the Enlightenment and the French Revolution were to have important implications for women, particularly after the eighteenth-century writer and philosopher Mary Wollstonecraft applied the modern principles of democracy to her arguments for the full equality of women. Her work helped kindle the feminist revolution that erupted in the mid-nineteenth century. The changes ushered in by this rebellion, which became international in scope, are depicted in the third wing of the table.

The nineteenth-century feminist revolution made it possible for women to speak publicly; to change oppressive laws; to achieve significant political reform; to gain access to education; to enter previously restricted professions; and to begin forging organizations, philosophies, and creative forms through which women's experiences and perspective could be articulated. The plates become increasingly dimensional and unique as a metaphor for the increased freedom and individualization available as a result of what was a profound transformation in Western women's historical circumstances. The rigid, rectilinear form of the runners begins to break open as a symbol for these new privileges. Finally, the butterfly—as a symbol of liberation—becomes more prominent in both the plate and runner designs, representing women's ever-intensifying struggle to achieve both independence and full creative power.

Millennium Triangle III; crochet; executed by Stephanie Martin

Anne Hutchinson

(1591–1643)

Anne Hutchinson arrived in Massachusetts Bay Colony with her husband and family in 1634. Raised in England and educated at home, she had been trained in theology by her father, a minister. After emigrating to America, she became actively involved with the religious issues of the day. A follower of John Calvin, Anne organized theological discussions in her home with the women, who were not allowed to attend the regular after-sermon debates. Eventually between fifty and one hundred women were meeting weekly, sometimes traveling great distances to hear Anne's commentaries and to voice their own thoughts.

Anne Hutchinson's teachings contradicted those of the Church, which required as blind a submission to its doctrines as was then demanded of a wife by her husband. Anne argued that the Holy Spirit dwelt in everyone rather than—as some ministers insisted—only in those who had been selected for grace. She encouraged her followers to believe in their own inner powers, which sometimes led them to argue with clergymen during sermons, even walking out of services when they were ordered to "be silent and remember women's place."

The clergy tried to convince Hutchinson to modify her views, but because she enjoyed so much community support, they felt that they had to move slowly in their public criticism of her. She was finally brought to trial for heresy, accused of stepping out of her place, of being a "husband rather than a wife, a preacher rather than a hearer, and a magistrate rather than a subject." Although no charges were actually proven against her, she was excommunicated and banished from the colony. She and her family settled in Rhode Island, but the Church elders followed them there, forcing them to leave again. After her husband died,

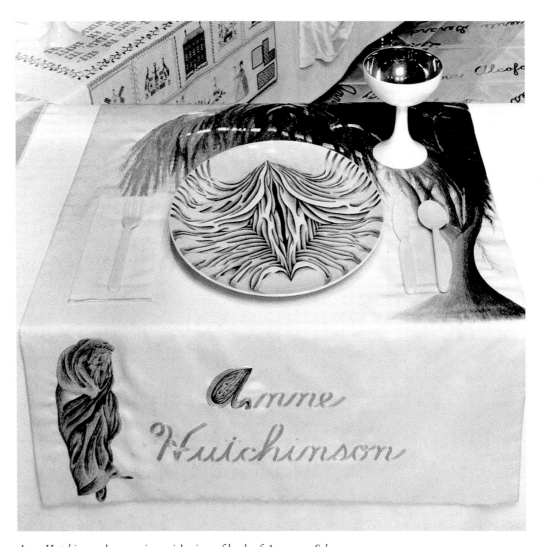

Anne Hutchinson place setting with view of back of *Anna van Schurman* runner

Anne tried to find safety near New York, but it was not long before she, several of her children, and two others of her household were brutally killed in an Indian raid.

The bony image on the plate—which depicts a shawl-like form that also resembles a shroud—desperately grips the plate edge, a metaphor for Hutchinson's efforts to escape from an environment that "contained" women by expecting them to "suffer and be still." The runner motifs are adapted from mourning pictures, an entirely original form of needlework painting created by American

women after the death of George Washington. Intended at first to commemorate the president's death, they soon became a vehicle to express grief for the death of a loved one or sympathy for a neighbor's loss. Here the traditional motifs used in mourning pictures—an embroidered weeping willow tree, a tombstone, and a Grecian urn, along with grieving women dressed in Neoclassical-style clothing—"mourn" the persecution and suffering endured by this significant American religious figure, as well as by her entire family.

Surrounding the place setting for Anne Hutchinson are the names of other women active in reform efforts, either through religious work, political activism, or revolutionary struggle. In both the political and religious arenas, women were often welcomed during the early days of radical movements, only to find themselves excluded when the organization, institution, political movement, or party they helped establish became formalized and more firmly established.

ABIGAIL ADAMS (1744–1818, United States): A patriot, revolutionary, abolitionist, writer, and feminist, Adams was entirely self-educated. In addition to managing her family's business and farm affairs, she was one of the great letter writers of her time. Eighty-five years before the abolitionist movement, she spoke out against slavery, writing: "I wish most sincerely that there was not a slave in the province. It always appeared a most iniquitous scheme to me to fight ourselves for what we are daily robbing from those who have as good a right to freedom as we have!" She also advocated the need to include a women's rights clause in the Declaration of Independence, telling her husband, John, in a prescient statement that the men should "remember the ladies and be more generous and favorable to them than [were] your ancestors. Remember all men would be tyrants if they could. . . . Give up the harsh title 'master' for that of 'friend' . . . [for] if particular care and attention is not paid to the ladies, we are determined to foment a rebellion and will not hold ourselves bound by any laws in which we have not voice or representation."

HANNAH ADAMS (1755–1831, United States): With the 1812 publication of her *History of the Jews,* Adams became the first female historian in the United States and the first American woman to support herself by her writing.

MARY ALEXANDER (1694–1760, United States): Alexander, who invested her inheritance in trading ventures, developed a prosperous business. It was said that hardly a ship docked in New York harbor without a consignment for her, which she sold, together with colony products, in her own store.

PENELOPE BARKER (18th c., United States): A heroine of the Revolutionary War, Barker was the leader of a women's group that drew up a document opposing taxes levied upon the colonies by the British Parliament.

HELEN BLAVATSKY (1831–1891, Russia): Born in Russia, Blavatsky left when she was seventeen to travel, becoming greatly influenced by ancient religions, Hinduism, the Kabbala, occultism, and spiritualismIn 1875 She established the Theosophical Society of New York; its goals included familiarizing people with ancient thought and investigating the laws of nature in order to develop one's divine powers. By the time of her death in 1891, the Theosophical movement—which had spread to England, France, and India—included more than one hundred thousand members.

MARY BONAVENTURE (fl. 1630s, Ireland): Bonaventure was one of the founders of the historic community of the Poor Clares in Galway. She recorded the struggles of the order under the persecution of the Catholics by Cromwell. Ultimately, she was forced into exile in Spain.

ANNE BRADSTREET (1612–1672, United States): Bradstreet was America's first published poet. In 1650 she authored the first volume of original verse to be written in New England.

MARGARET BRENT (1601–1671, United States): In 1647 Brent, a businesswoman, became one of Maryland's largest landowners and the executor of the governor's estate. She was the first woman in America to demand suffrage, applying to the Maryland Assembly for the right to vote. Her request was denied.

HANNAH CROCKER (1765–1847, United States): A staunch advocate of women's education, Crocker wrote in *Observations on the Real Rights of Women* (1818): "The wise author of nature has endowed the female mind with equal powers and faculties and given them the same right of judging and acting for themselves as [he] gave to the male sex." Crocker believed that Christian doctrine supported the idea that the sexes shared equally in divine grace and that marriage should be a state of mutual affection and trust, with all responsibilities borne equally by both partners, including earning the family income.

MARIE DE L'INCARNATION (1599–1672, Canada): De l'Incarnation was a Frenchwoman who spent thirty-two years working among the indigenous people of the Quebec region. She established an Ursuline mission, taking Algonquin girls into her care and tutelage. To further the possibilities of communication between the societies, she mastered several native dialects and wrote a French-Algonquin dictionary.

MARY DYER (d. 1660, United States): Mary Dyer was an ardent advocate of freedom of religion. In defiance of strict prohibitions against women in the pulpit, she insisted upon preaching. Despite the threat of dire punishment for associating with an "ostracized person," she publicly supported Anne Hutchinson throughout her trial. Moreover, she openly visited imprisoned Quakers at a time when Massachusetts law condemned avowed Quakers to death. Even after being arrested, she agitated for the repeal of all anti–Quaker laws, writing tracts from her jail cell. In 1660 she was hanged.

MARY BAKER EDDY (1821–1910, United States): Eddy, the founder of the Christian Science metaphysical and scientific system of healing, was the first woman to establish a major religion. She explained her philosophy in *Science and Health,* founding Christian Science in 1866, then developing it into a worldwide organization. She established her own publishing house, printing periodicals that included *The Christian Science Monitor,* a daily newspaper devoted to world events, which is now circulated in 120 countries and is consistently honored for its excellent reportage.

MARGARET FELL FOX (1614–1702, England): Fox, one of the founders of the Quaker religion, wrote a tract in 1666 titled "Women's Speaking Justified, Proved and Allowed by the Scriptures," which supported the ministry of women. She also established women's meetings that provided training in midwifery, along with guidelines for aid to the poor. Her lobbying efforts resulted in the King James III Declaration of Indulgence of 1687 and the Toleration Act in

1689, which signaled the end of persecution of the Quakers in England.

MARY GODDARD (1736–1816, United States): In 1775 Goddard became the publisher and manager of Baltimore's first newspaper, and her press printed the Declaration of Independence. Appointed by Benjamin Franklin as postmistress of the country, she was later replaced by a man. When Goddard complained to the government, her complaint was ignored on the basis that the job was "too strenuous" for a woman.

CATHERINE GREENE (1731–ca. 1794, United States): After Greene had invented a method for separating cotton from its seed, she entrusted the fabrication of the machine she had designed to her boarder, Eli Whitney. By law, women were not able to apply for patents, so Whitney received credit for the invention of the cotton gin.

SELIN HASTINGS (1707–1791, England): Hastings built over sixty chapels, founded a religious school, and helped establish Mthodist missions throughout the British Isles.

HENRIETTA JOHNSTON (1620–1728, United States): Johnston, one of the earliest women artists in America, supported herself by doing pastel portraits of public officials, prominent families, and clergymen.

ANN LEE (1736–1784, United States): Known as Mother Wisdom, Lee was the founder of the American Shaker Society, the largest, most significant American religious utopian community, committed to the absolute equality of the sexes.

JUDITH MURRAY (1751–1820, United States): In 1779 Murray wrote one of the earliest feminist essays in America, demanding equal education for girls on the basis that men and women had comparably good minds. She followed this up with numerous other writings, including a piece concerning women's education, *Desultory Thoughts upon a Degree of Self Complacency Especially in Female Bosoms* (1784). In this work she contended that all women should be prepared to make their own living.

SARAH PEALE (1800–1885, United States): Sarah Peale and her sister Anna are considered the first professional women painters in America. Sarah studied with her father, a miniaturist, and her uncle, the portraitist Charles Willson Peale. It was he who inspired her to become a portrait painter. Peale was commissioned to paint over one hundred portraits of Baltimore's leading families. She made numerous trips to Washington, where she painted portraits of cabinet members, senators, and foreign dignitaries.

MARGARET PHILIPSE (d. ca. 1690, United States): Before her marriage to a merchant trader, Philipse was a merchant and shipowner, and after she was married she still carried on her business in her maiden name. When her husband died in 1661, she took over his trading interests, making frequent business trips overseas.

ELIZA LUCAS PINCKNEY (1723–1793, United States): Pinckney experimented with diversified crops in the South Carolina soil, helping to develop indigo as a major resource. Indigo sales sustained the Carolina economy for three decades, until the Revolution cut off trade with England. As a young woman, Pinckney defied the law by secretly teaching reading to two black girls with the intention of training them as schoolteachers for other Negro children. Her correspondence is one of the largest surviving collections of letters by a colonial woman.

MOLLY PITCHER (1750–1832, United States): Pitcher, whose real name was Mary Hays, was one of the women who followed the Continental Army during the Revolution in order to care for the wounded. When her husband was shot, she took his place as a gunner, and it is said that she fired the last shot against the British at the Battle of Monmouth. After she carried a wounded soldier two miles to safety, she nursed him back to health. Honored by General Washington, she was buried with military honors.

DEBORAH SAMPSON (1760–1817, United States): In 1781, dressed in men's clothing, Sampson enlisted in the Continental Army and fought in a number of battles. It was not until a year and a half after she was discharged from the army that her gender was discovered, after which she began to travel and lecture, telling her life story in towns throughout New England. As a result of old army wounds, she became ill, whereupon Congress granted her a pension.

MERCY OTIS WARREN (1728–1814, United States): Warren—like Abigail Adams and other significant women of the period—was self-educated. Despite the difficulties women faced in acquiring education, she became a poet, satirist, and historian, and in 1805 she published a major historical document, titled *The Rise, Progress and Termination of the American Revolution*. She maintained a large correspondence with the important figures of the Revolution, many of whom consulted her on political issues. She was a staunch advocate of women's right to equal education and opportunity.

SUSANNA WESLEY (1669–1742, England): Wesley educated all nineteen of her children at home, providing the same training for both girls and boys. She eventually ran a home school for twenty years, working six hours a day and educating hundreds of neighborhood children. Because she also wrote the religious textbooks and conducted her own services for the students, she provoked considerable opposition from the local curate. Among her most distinguished students was one of her sons, John Wesley, the founder of Methodism, which, it has been suggested, had its origins in his mother's teachings.

PHILLIS WHEATLEY (1753–1784, United States): Bought directly off a slave ship in Boston, Wheatley was only eight years old when she became the personal maid to Mrs. John Wheatley. After being educated by her mistress, she began to write verse, becoming the first black poet in America. Her work helped to support abolitionist arguments that educating blacks was both possible and desirable, an idea that was fiercely resisted by most slave owners. She died at the age of thirty-one after an unhappy marriage, expressing in one of her poems these poignant feelings:

> *I, young in life, by seeming cruel fate*
> *Was snatch'd from Africa's fancy'd happy*
> * seat;*
> *What pangs excruciating must molest,*
> *What sorrows labour in my parent's breast?*

Sacajawea

(1787–1812)

As the fur trade developed in North America, European traders often became involved with Native American women. These early travelers, who were dependent upon the good will of the Indians in order to move safely through their territory, were generally less prejudiced than some of the later settlers, many of whom brought extremely harsh attitudes toward the native peoples. Many Europeans were determined to be altogether rid of the Indians, whom they despised. Native women were even hunted like animals and clubbed to death or shot.

At the time of the European conquest, many Indian women enjoyed high status, though their position varied from tribe to tribe. Sacajawea was born a Shoshone and captured as a child by the Minnataree. While still young, she was married to a fur trader, who may have "won" her, either as a result of barter or in a gambling game. He was hired by Lewis and Clark to act as interpreter for their expedition, which had been organized to explore some of the land gained through the Louisiana Purchase and to find a route to the Pacific Ocean. But it was Sacajawea who—despite being only sixteen with a six-week-old child—ultimately became both the interpreter and the guide.

As the only woman on the expedition, it fell to her to forage and prepare the food, gather herbs and make healing potions, nurse the sick, and mend the clothes, all the while caring for her infant son. Sacajawea's daily assistance was accepted by the explorers without comment, though her very presence protected them. The Indians that they encountered knew that their mission was peaceful, as a war party never traveled with a woman and baby. While in Shoshone country, she secured horses and equipment,

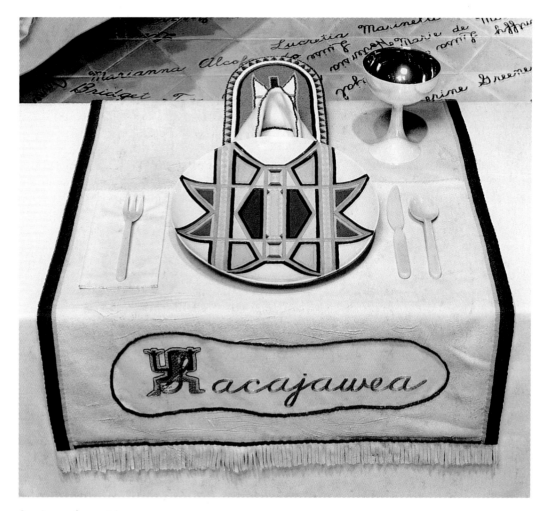

Sacajawea place setting

thereby helping to assure the success of the trip. But despite her importance to the outcome of the long and arduous journey, she received no pay and her name was almost lost to history. Even sadder, Sacajawea, like many other native women caught up in the Indian and European conflict, had no way of knowing that her help in opening up the Northwest Territory would contribute to the tragic destruction of so many Native American tribes.

The place setting for Sacajawea stands as a symbol for the many efforts she made to bring about peace between Indians and whites, while also honoring her participation in the complexity of American history. The plate, which is carved in low relief, mimics the iconography of the *parafleche* (rawhide paintings) traditionally done by the Shoshone tribe. The straight lines and simple patterns preferred by Shoshone artists characterize the design of both the plate and runner. Attached to the plate is a beaded cradle board like that in which Sacajawea might have carried her own child. The runner was constructed from hand-tanned deerskins and stitched together in the traditional Indian method. Elaborate beading embellishes the runner, and the capital letter incorporates a beaded bird form that refers to the Indian meaning of *Sacajawea*, which translates into "Birdwoman."

Grouped around the place setting for Sacajawea are the names of other Native American, Mexican, Hawaiian, and Latin American women. Their experiences represent the struggle to maintain the traditions of their respective heritages; reflect a later amalgamation of cultures; or demonstrate women's efforts to resist or otherwise come to terms with the conquest of their societies. The Spanish invasion of Mexico and South and Central America brought traumatic changes to the cultures there. Sexual relations between native women and the conquerors—both forced and voluntary—produced interracial, intercultural societies with strong race and class distinctions. Also, because the emergence of independence movements in the nineteenth and twentieth centuries stimulated the growth of both political and feminist consciousness, the names of some of the prominent feminist and revolutionary leaders are placed with this stream of names.

ANACONDA *(fl. 1562, North America)*: Anaconda was a warrior who attempted to stop the invasion, exploitation, and colonization of her land by European conquerors. After she'd led a war party in an effort to destroy a Spanish settlement, the Spanish retaliated by sending more troops to re-establish the settlement. They captured Anaconda and executed her.

AWASHONKS *(fl. 1671, North America)*: Awashonks was the leader of a tribe that inhabited the lands that now comprise the state of Rhode Island. She led many battles against the encroaching English settlers, finally signing a peace treaty at Plymouth Colony in 1671. But four years later, with the support of French forces, she again fought the English after they'd violated the terms of the treaty.

MARIA BARTOLA *(16th c., Mexico)*: Bartola, whose Aztec name is not known, was the first female historian of Mexico. She wrote an account of the Spanish conquest of Mexico from the perspective of the Aztec people.

ANA BETANCOURT *(fl. 1850s, Cuba)*: Betancourt was a feminist who was actively involved in Cuba's struggle for independence from Spain, speaking up at the constitutional assembly of the new republic to demand equal rights for women.

CAPILLANA *(16th c., Peru)*: Capillana was famous for her illuminated manuscripts, particularly her paintings of ancient Peruvian monuments, along with a short historical text that is now in the Dominican library in Peru.

ROSA CHOUTEAU *(fl. 1875, North America)*: After the death of her uncle, Chouteau was elected chief of the Osage Beaver band in 1875. Her election was unusual because the Osage were a patrilineal tribe, prompting her to say: "I am the first one [female chief] and expect to be the last one. I think my band obeys me better than they would a man."

JOSEFA DE DOMINGUEZ *(1773–1829, Mexico)*: De Dominguez was a heroine of the 1820s Mexican independence movement. As the wife of the mayor of Queretaro, she had access to information about the movements and plans of the Spanish troops, which she passed on to the revolutionaries. When her activities became known to the Spaniards, she was imprisoned for three years. She was later offered compensation for her service in the revolution, which she refused, stating that she needed no reward for doing what she considered right. On her deathbed, she said: "My struggle has been as a Mexicana against the Spaniards who have come to steal the land, enslave Mexicans, exploit their labors, degrade their families, humiliate their dignity, and torment their flesh more cruelly than if they were beasts."

ISABEL DE GUEVARA *(16th c., Spain)*: In 1535 de Guevara set sail for the New World with a large Spanish expedition, eventually settling with her husband among the Guarani Indians in what is now Argentina. After the colony was established, she wrote to the Spanish ruler to describe the hard physical labor performed by the women. She complained that even though they had done all of the planting, cultivating, and harvesting of the first crops, defended the colony, and cared for the ill and dying, the women were being forgotten in "the glory of the men."

JUANA DE LA CRUZ *(1651–1695, Mexico)*: De la Cruz, a child prodigy, taught herself to read and began writing verse at a very early age. She begged her mother to let her dress as a boy so that she could attend the university. Instead, she was sent to live in her grandfather's house in the city, where she educated herself by reading all of the books in his library. She soon became famous for both her erudition and her poetry and was invited to live in the home of a noblewoman as one of her attendant ladies. When de la Cruz was seventeen, she was paraded before forty male university professors and made to "defend herself" during an examination of her intellectual merits. Her abilities and accomplishments made her vulnerable to ongoing attacks for aspirations considered inappropriate for a woman. In an effort to continue her studies, de la Cruz entered a cloister, but even in the convent, she was harassed and rebuked for her scholarly interests. The pressure to give up her so-called unwomanly pursuits finally forced her into selling her prized library of thousands of books, along with all of her scientific and musical instruments. Under threat of the Spanish Inquisition, this brilliant woman had no choice but to give up her intellectual and literary life. After nursing the nuns in her convent who were stricken by the plague, she died at the age of forty-three.

EHYOPHSTA *(fl. 1869, North America)*: Ehyophsta, Yellow-Haired Woman, was a Cheyenne woman who belonged to a small select group of female warriors.

CANDELARIA FIGUEREDO *(1852–1913, Cuba)*: Figueredo, a revolutionary soldier, was the first Cuban woman to fight in her country's struggle to achieve liberation from Spain. She joined the army at age sixteen, participating in the defense of Cuba until 1871, when she was taken prisoner.

MARIA DEL REFUGIO GARCIA *(fl. 1931, Mexico)*: Garcia, the secretary of the United Front for Women's Rights, was an active promoter of both political justice and equality for women. As a delegate to the Women's National Congress in 1931, she publicly accused the provisional president of Mexico of reneging on his promised support of women's suffrage. She was arrested and imprisoned, but a huge women's demonstration forced the president to release her. Garcia was elected to federal office but she was

denied her seat because the constitution did not allow women to hold office; she appealed to the Supreme Court and won. Garcia used her position to improve working conditions for women, working for their legal protection and helping to create training centers for unemployed women.

JOVITA IDAR (*fl. 1911, Mexico and United States*): Idar wrote for *La Cronica*, a Spanish-language newspaper published in Texas in the early 1900s. In 1911 she organized the first Mexican Congress, which was held in Laredo, Texas, later becoming the president of the Mexican Feminist League.

MARIE IOWA (*19th c., North America*): Iowa was a guide whose work was invaluable to European exploration parties. Her knowledge of the terrain and expertise in wilderness survival techniques contributed to the opening up of the Pacific Northwest.

KAAHUMANU (*1772–1832, Hawaii*): By the eighteenth century, women's position in Hawaii had been severely restricted by religious *kapus* (or taboos). Women were segregated from men and certain foods forbidden them. When Kaahumanu, the first female ruler and lawmaker, took power, she abolished these practices. When her husband, King Kamehameha I, died, she dressed in warrior's clothing and announced that, despite

her son being the formal heir to the throne, the king had wished that they rule together. She helped to establish schools and educational rights for women, passing laws to try and rid the islands of the drunkenness, venereal disease, vandalism, social disruption, and sexual exploitation of women that had been introduced by the traders. A major figure in Hawaiian history, Kaahumanu is an outstanding example of a woman who used her position to secure rights for other women.

LA MALINCHE (*16th c., Mexico*): To understand La Malinche's life, it is essential to see it in the context of the conquest of Mexico, when the position of many native women was reduced to near slavery. One of the few ways for a woman to improve her situation was through an association with a European man. Fluent in Spanish, Mexican, and Aztec, La Malinche was sold by her parents as a slave to Cortez, later becoming Cortez's interpreter and eventually his lover. Because of her relationship with him, La Malinche has sometimes been represented as a traitor to her people and symbolically responsible for their colonization. Recently, however, there have been new interpretations of her life and actions, in which she is understood as having tried to make the best choice she could given her constrained circumstances.

MARIA MONTOYA MARTINEZ (*b. ca. 1880, United States*): Martinez, a Tewa Indian from

the San Ildefonso pueblo in New Mexico, was an acclaimed craftswoman. She perfected an exquisite pottery-making technique that had been lost for almost seven hundred years. Martinez became acquainted with the ancient pottery-making techniques of her village and, with her husband, redeveloped the lost art of black-work pottery. They began teaching this style in the 1920s, building a pottery industry that benefited their entire pueblo and continues to flourish.

CARLOTA MATIENZO (*1881–1926, Puerto Rico*): After being educated at the University of Puerto Rico and Columbia University in New York, Matienzo was offered work in Venezuela, Nicaragua, Mexico, and the United States. But she instead chose to return to her native Puerto Rico. An ardent feminist, she was instrumental in the revitalization and expansion of the public-school system in Puerto Rico. Matienzo was posthumously honored when a hall was named after her by the female students of the University of Puerto Rico. The Carlota Matienzo Prize is awarded every year to the graduate who shows the greatest aptitude for teaching.

LUISA MORENO (*fl. 1940s–1950s, United States*): Moreno was a major figure in the labor movement, working for the Agricultural and Packing Workers of America. She organized the Congress of Spanish Speaking Peoples, which brought together Mexicans, Puerto Ricans, and Cubans to discuss working conditions and police brutality. In the 1950s, as a result of her activities, Moreno was deported to Mexico, even though her birthplace was Guatemala and she was married to a United States citizen.

MARY MUSGROVE (*18th c., North America*): The Creek Indians, like many Native American tribes, accorded women considerable respect and power, and Musgrove, a warrior chief, was an important political leader in the history of both her tribe and Georgia. By deciding which alliances were advantageous for her people and which wars her people should fight, Musgrove influenced the politics and trade of Georgia during the early days of its settlement.

ISABEL PINOCHET (*fl. 1870s, Chile*): It was due to Pinochet's efforts that the women of Chile

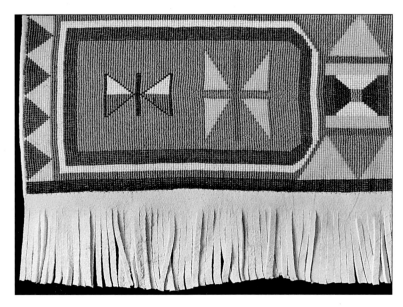

Detail of *Sacajawea* runner back; beaded by Kathleen Schneider

gained the right to higher education and the opportunity to earn professional degrees. She founded a school for women in 1875, which trained the first women physicians in South America.

POCAHONTAS (1595–1617, North America): Pocahontas was instrumental in the survival of the early colonists in Virginia, giving them advice on their agricultural problems and saving the Jamestown colony from starvation more than once. She is best remembered for having saved the life of John Smith after he was taken prisoner, but it would seem more appropriate to honor her for her work in trying to bring about peaceful relations between the colonists and the Indians.

MAGDA PORTAL (fl. 1930s, Peru): Portal was a leading socialist, political activist, and founder of a revolutionary political party—which (unfortunately) opposed women's suffrage on the grounds that women would be influenced by the Church and their husbands to vote conservatively. Portal, like a number of Latin American and European intellectuals, believed that the socialist revolution must take precedence over feminism and that only after the success of this revolution would women be ready to become full political participants.

MARIA LUISA SANCHEZ (20th c., Bolivia): Sanchez, a writer and translator, was the founder and organizer of the Women's Athenaeum, a group that worked for the continuation and consolidation of the culture and education of women. Elected the group's first president, she headed the organization for twenty-eight years. After women gained the right to vote in Bolivia, she organized the first all-women's political conference. In 1929 Sanchez tried to build bridges between liberal and radical women's groups, stressing the importance of women working together to achieve equality.

LAURA TORRES (fl. 1900s, Mexico): Torres, a labor organizer, was employed at a cigar factory where the women were forced to work seventeen hours a day for extremely low wages. One of the women tried to get food for her sick child from the company store and was refused because she had no money. When the child died, the out-raged women went out on strike and the local police were called in to control them. Torres confronted them, bravely asking: "Men of Mexico, will you shoot your sisters?" The police retreated and the army was then called in. The soldiers shot the police and arrested the six hundred women, along with the three thousand men who had gone out on a sympathy strike. They were all sent to labor camps, where most of them died. This Rio Bravo Massacre was typical of the violent labor struggles that eventually led to the 1914 revolution.

OJELIA URIBE DE ACOSTA (20th c., Colombia): Uribe de Acosta was an active feminist who, as part of her efforts to improve the position of women in Colombia, worked to raise women's consciousness. She argued that in order to end their oppression, women must first be educated to free themselves from prevailing myths and build confidence in their own self-worth. Because she understood that the exploitation of women cut across class barriers, she agitated on behalf of both working and middle-class women, writing many articles calling for working women to join unions and for housewives to organize. She also tried to end the abusive treatment of female workers and to raise the low status of the female office worker.

SAAREDRA VILLANUEVA (fl. 1916, Bolivia): Poet, teacher, intellectual, and feminist, Villanueva founded the Women's Legion for Popular Education, which investigated women's issues, commissioning articles that advocated civil and political rights for women and full civil rights for children. An active official in the Ministry of Defense, she founded the Women's Auxiliary Service and the Intra-American Organization for Women, which expanded educational opportunities for women. She worked to develop career opportunities for women and helped to open the professions. She edited an anthology of women poets while also pursuing her own writing, which concerned itself with women's experiences.

ANDREA VILLARREAL AND TERESA VILLARREAL (fl. 1910, Mexico): Andrea Villarreal and her sister, Teresa, were feminists, anarchists, and revolutionaries who worked for both the cause of women and the independence of Mexico. They founded a feminist club for political action, published La Mujer Modern (The Modern Woman), were members of the Mexican Liberal party, and were active in the Mexican revolution.

NANCY WARD (1738–1822, North America): Ward, of the matriarchal Cherokee tribe, was head of the women's council and a member of the council of chiefs. Called Aqi-qa-u-e (or "Beloved Woman"), she was in the forefront of the peace negotiations between her tribe and the settlers, attempting to pacify both sides and thereby bring about friendly relations. She warned the settlers of Cherokee invasions while also supporting the tribal council's decision not to part with any more land.

WETAMOO (d. 1676, North America): Wetamoo sided with King Phillip in his war against the English during 1675 and 1676 and tried to prevent expanding British colonization by uniting the East Coast Indian tribes. She led attacks on fifty-two of the ninety existing English towns, twelve of which were completely destroyed. In 1676, when her soldiers had all been captured, Wetamoo managed to escape, only to drown.

SARA WINNEMUCA (fl. 1870–1880, North America): Winnemuca was a scout who became a translator and arbitrator for her tribe, the southern Paiutes, in their attempts to negotiate peace with the whites. In an effort to force the Paiutes into fighting the settlers with them, the Bannock, who were not so tolerant of Europeans, kidnaped her father, the Chief, her brother, and others from her village. Winnemuca traveled hundreds of miles on horseback to rescue her family. She then waged a six-year struggle with the U.S. government in order to obtain farmland where the Paiutes could continue their self-sufficient, agricultural existence. She was revered by her tribe for helping preserve their traditional way of life.

XOCHITL (fl. 900, Meso-America): Xochitl was a queen of the Toltecs and the wife of Tecpancaltzin, who was said to have led battalions of warrior women. Legend has it that she was killed in battle and that the blood that flowed from her wounds foretold the destruction of the Toltec nation.

Caroline Herschel

(1750–1848)

Caroline Herschel, an astronomer and one of the leading women in science during the eighteenth and nineteenth centuries, composed her own epitaph, which read: "The eyes of her who is glorified here below turned to the starry heavens."

Born in Hanover, Germany, Caroline was tutored secretly by her father because her mother was opposed to her daughter being educated. As a young woman, she became obsessed with the goal of earning her own living; as she was gifted in music, she was able to become a solo performer. Just as she had begun to achieve some measure of success, she was forced to give up her career and move to England in order to aid her brother William with his work.

When William's involvement in astronomy became his sole preoccupation, he insisted that Caroline give up her music altogether in order to spend all her time helping him. At night she took notes on her brother's observations and each morning recopied the notes, made calculations, and systematized his findings. Each day she planned that evening's work and—in order to accomplish all that was expected of her—taught herself mathematics by sheer force of will. She also aided William in the tedious task of constructing telescopes, making models, and grinding and polishing lenses. In addition to all of this, she became determined to do scientific work of her own.

It was primarily when her brother and his family vacationed that Caroline was able to concentrate on her own astronomical studies. She was the first woman to discover a comet, finding eight in all. In 1798, the Royal Astronomical Society published two catalogs of stars that she had compiled, and in 1825 she completed her own (along with

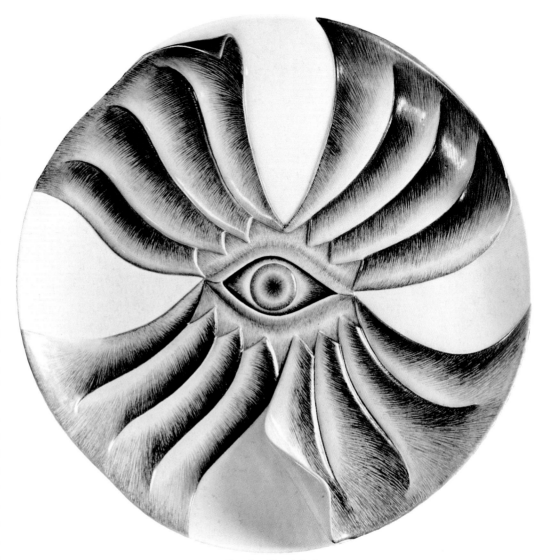

Caroline Herschel plate

her brother's) work by presenting a star catalog of 2,500 nebulae and clusters to the Royal Society. She was made an "honorary" member—as, needless to say, women were not admitted to regular membership. She was finally awarded a small salary by the king, which, despite its being only one-fourth of the sum paid to her brother, achieved Caroline's modest goal of earning her own keep.

The place setting for Caroline Herschel pays homage to this noble woman. Wings lift from the plate in a gesture symbolizing her struggle to become an independent woman. An eye gazes out from the center of the plate, as if to peer at the embroidered image of the universe on the runner top. The runner pays homage to Caroline's own astronomical work, with the embroidered comets on the back referring to her personal discoveries. The shape that surrounds her name on the runner front is derived from Caroline's own drawing of the Milky Way. The illuminated capital letter presents an image of the type of telescope through which she would have gazed at the vast sky.

The seventeenth-century invention of the telescope and microscope precipitated a widespread interest in the pursuit of amateur scientific studies at home, which many women took up. But in order for them to become professional scientists, they had to overcome prejudice, discrimination, and deeply entrenched ideas about women's intellectual inferiority. One of the few ways in which women could participate in the sciences (as well as many other professions) was to work with a brother, husband, or father. Arranged around the Caroline Herschel place setting are the names of numerous other women who attempted to work in scientific, medical, and other such fields, many in the shadow of male relatives.

KATHERINE BETHLEN (1700–1759, Hungary): Bethlen, who wrote about current scientific developments and supported a wide variety of scientific activities through her donations and work, published several scientific works, including A Strong and Protected Shield (1751) and Monuments to Immigration (1723).

LOUYSE BOURGEOIS (1563–1638, France): Bourgeois acquired her medical expertise by first studying with the midwife who delivered her own children; from books; and by consulting medical texts and working with one of the few physicians who favored medical education for midwives. She was instrumental in the advancement of midwifery as a science. Her medical treatise titled Observations (1609) covered the various stages of pregnancy, abnormalities occurring in labor, the anatomy of the female pelvis, and the care of mother and child. In 1635 a group of midwives, eager for a better medical education, petitioned the king to allow Bourgeois to give a public course in obstetrics, but their petition was denied.

ANNIE JUMP CANNON (1863–1941, United States): Cannon, a noted astronomer, studied astronomy and physics at Wellesley, then worked at the Harvard Observatory for forty-five years. She discovered three hundred variable stars and five novae; through her classification of the spectra of all stars from the North to the South Pole, she produced the enormous and invaluable Henry Draper Catalogue (1918–1924). Cannon built Harvard's astronomical research collection into the largest in the world. She received many honorary degrees, was appointed to numerous scientific societies (including, in 1914, the Royal Astronomical Society), and won many prizes. An ardent believer in women's suffrage, she joined the National Women's Party, evidencing her staunch support of other women scientists by establishing a prize to be given to outstanding female astronomers.

MARGARET CAVENDISH (1624–1674, England): The emergence of the (so-called) "scientific lady" in the seventeenth century began with Margaret Cavendish, the first woman to write extensively about science. In 1653 she published her first book in an effort to make scientific ideas more accessible. Before this time, there had been no attempt to direct scientific ideas to women. Cavendish experimented with microscopes and telescopes, insisting upon publishing her findings under her own name. This shocked English society, which not only doubted women's capacity for abstract thought but thought it inappropriate for a woman to openly author and publish her own work. Cavendish forced an invitation from the Royal Scientific Society and, by presenting her work there, helped open the doors of science to other women.

MRS. CELLIER (fl. 1662, England): An intelligent and progressive midwife, Cellier tried to elevate the status of her profession and improve the practice of midwifery. Claiming that the then-high mother and infant mortality rates could be improved through the education and organization of professional midwives, she attempted to organize a clean, well-staffed royal hospital to provide education for nurses. She also tried to establish a program that would find homes for unwanted babies. Her plans ultimately failed because of lack of support, and she was put in the stocks several times for her efforts.

MARIE COLINET (16th c., Switzerland): Colinet was a physician and surgeon who was trained by her husband, a famous surgeon. He reported upon several of his wife's accomplishments, which included healing a man whose ribs were so severely injured that she had to wire them back in place and devising a method of using hot bags to stimulate and dilate the uterus during childbirth. She was the first doctor to employ a magnet to extract steel from a patient's eye, an innovation wrongly attributed to her husband.

FRAU CRAMER (1655–1746, Holland): Cramer, who was married to a physician, was able to study medicine with some of the leading doctors of her day, thereby successfully establishing a practice in obstetrics. For fifty-two years, she kept a journal of case histories of all the deliveries she made, which were given to the Medical Association of Holland and published in 1926.

MARIA CUNITZ (1610–1664, Germany): Cunitz, who was fluent in seven languages (including Latin, Greek, and Hebrew), is the earliest known European woman to have been active in astronomy. Her simplification of the Rudolphine Tables was acclaimed throughout Europe. She also excelled in the arts.

GENEVIEVE D'ARCONVILLE (1720–1805, France): A great anatomist who wrote on chemistry, medicine, natural history, and philosophy, d'Arconville also did work in osteology, translating a major text on the subject and supervising illustrations drawn directly from cadavers. In addition to being an important scientist, d'Arconville was the author of several biographies, including a three-volume work on Marie de Medici.

BARONESS DE BEAUSALEIL (17th c., France): The first female mining engineer in France, de Beausaleil wrote prophetically about the relationship between a country's power and independence and the appropriate use of its natural resources. In her report, "La Restitution de Reuton," she recorded the location of mines and ore deposits throughout the country, urging the French toward proper management of their mineral resources.

ANGELIQUE DE COUDRAY (1712–1789, France): A noted obstetrician, de Coudray was the head of the maternity section of a French hospital, where her delivery methods had a major impact upon the education of midwives.

JUSTINE DIETRICH (fl. 1689, Germany): Dietrich was one of the most important obstetri-

cians in seventeenth-century Europe, publishing an illustrated textbook on midwifery that demonstrated the most advanced techniques of the time. Her book allowed rural midwives, who had little access to sophisticated training, to become more highly skilled.

EMILIE DU CHATELET *(1706–1749, France)*: Known primarily as Voltaire's companion, du Chatelet was actually an important and influential mathematician, astronomer, scientific writer, and philosopher in her own right. Her most noted achievement was her translation into French of Newton's *Principia* (the first such translation), which was published after her death. Her progressive philosophic and scientific views—which opposed those of both Newton and Descartes—proved to be in accord with modern thought. She devoted most of her time to work, writing, and study, while also carrying on an extensive correspondence with some of the major thinkers of the time. She was also known for the women-only dinner parties that she held at her chateau.

JEANNE DUMEÈ *(fl. 1680, France)*: A celebrated Parisian astronomer, Dumeè wrote *Entretiens sur l'Opinion de Capernic Touchant la Mobilite de la Terre*, in which she defended and corroborated the findings of Copernicus. She also championed women's right to study science, challenging the prevailing prejudice that a woman's brain was not only smaller in size than a man's but inferior.

SOPHIE GERMAIN *(1776–1831, France)*: Germain, a French mathematician and founder of mathematical physics, won the Grand Prix of the French Academy of Sciences for her theoretical work on the vibration of elastic surfaces. In 1816 she became the first woman invited to attend sessions at the Institute de France. Although she wrote a major work on the philosophy and history of science and was quite prominent during her time, her reputation and achievements were obscured soon after her death.

LOUISE LE GRAS *(1591–1671, France)*: Le Gras was one of the first leaders of the Society of Visiting Nurses established by St. Vincent de Paul. Born into the nobility and well educated, she learned medicine and surgery from her physician husband. After his death, she devoted her life to the sick and destitute, preparing medicines and instructing her assistants, the first Sisters of Charity.

ANNE HALKETT *(1622–1699, England)*: Halkett, who was born into the court of Charles I, was able to receive a thorough education in theology, science, and medicine. Skilled in surgery, she also wrote a series of religious works, leaving thirty-six books in manuscript form at her death.

MOTHER HUTTON *(18th c., England)*: Hutton was a biologist, a pharmacist, and the discoverer of digitalis as a treatment for heart conditions. In 1785 Dr. William Wilhering bought her prescription, analyzed its content, and arranged for the inclusion of digitalis in the new London Pharmacopoeia. Ever since, the product and its discovery have been associated with his name rather than hers.

JOSEPHINE KABLICK *(b. 1787, Czechoslovakia)*: A paleontologist and naturalist, Kablick began her career by collecting specimens for her own herbarium as well as for schools and colleges in Czechoslovakia and throughout Europe. Many fossil animals and plants were named in her honor.

MARIA KIRCH *(1670–1720, Germany)*: Kirch, who was trained by her husband, a Berlin astronomer, went on to become his assistant. In 1702 she discovered a comet and in 1710 published *A Discourse on the Approaching Conjunction of Jupiter, Saturn, Etc.* Her daughters, who also became astronomers, worked for the Berlin Academy of Sciences.

MARY LAMB *(1764–1841, England)*: As a young girl, Mary was educated along with her two brothers. But she was forced to give up her schooling and work as a needlewoman to help support them while they completed their educations. When she was thirty, she went mad and killed her mother, after which she was committed to an asylum. Upon her release, her brother Charles, an established writer, took charge of her. Although his position in the literary world brought Mary into contact with some of the leading writers of the day, it also allowed him to subsume her accomplishments. She was the pri-

mary author of *The Tales of Shakespeare*, which became a classic in English literature, but it was published under Charles's name. She also wrote a fascinating but little-known essay on needlework in which she put forth the then-radical idea that women should be acknowledged and paid for their work.

MARIE LAVOISIER *(1758–1836, France)*: Lavoisier assisted her husband in his scientific work. Like many women, she devoted herself entirely to her spouse's career. She learned Latin and English in order to translate books that might be useful to him, wrote descriptions of the results of his experiments, and executed the engravings for his textbook, which was the first on modern chemistry. After her husband's death, she edited his memoirs, distributing them to many prominent scientific figures in order to promote his ideas.

HORTENSE LEPAUT *(1723–1788, France)*: An important astronomer, Lepaute investigated the oscillation of pendulums, studied Haley's comet, calculated and charted the path of eclipses, prepared and published a table of parallactic angles, edited the astronomical annual of the Academy of Sciences, and was the author of a number of scientific works.

DOROTHEA LEPORIN-ERXLEBEN *(1715–1762, Germany)*: Leporin-Erxleben, who was trained by her physician father, displayed such exceptional talent that—despite the prohibitions against women attending classes—Frederick the Great granted her permission to attend the university. But her studies were interrupted, first because of illness, then by marriage. After her husband died she resumed her studies, becoming the first woman to graduate from a medical school in Germany. She successfully practiced medicine for a number of years, but despite her example, German medical schools refused to admit any other women for over 150 years.

JEANNE MANCE *(1606–1673, Canada)*: In 1641 Mance crossed the Atlantic to open the second hospital in North America, acting as its primary physician, nurse, administrator, and fundraiser. She returned to France to raise money and obtain nurses for her hospital, persuading the

women of the court of Louis XIII to support the ongoing needs of her institution. In 1902 the Jeanne Mance School of Nursing was founded in her honor in Montreal.

ANNA MANZOLINI *(1716–ca. 1774, Italy)*: For many years, Manzolini was a professor of anatomy at the University of Bologna, where she was noted for the discoveries that she made as a result of her dissections of cadavers. The anatomical models that she created in wax were known throughout Europe, becoming the prototypes for all subsequent models and considered among the most prized possessions of the university.

MARTHA MEARS *(fl. 1797, England)*: In 1797 Mears wrote *Candid Advice to the Fair Sex on the Subject of Pregnancy*, a practical book on gynecology and obstetrics in which she stressed the importance of hygiene and the naturalness of pregnancy and childbirth. This was an attempt to dispel certain prevalent unscientific beliefs concerning pregnancy, one of the most bizarre being that it was a pathological state.

RENIER MICHIEL *(1755–1832, Italy)*: Michiel, a renowned scholar who was well educated in literature and music as well as the sciences, wrote and published treatises on botany.

MARIA MITCHELL *(1818–1889, United States)*: Mitchell was the first distinguished American woman astronomer, achieving international acclaim when she discovered a comet in 1847. When Vassar opened in 1865, she was offered the chair of astronomy, which she held for twenty-three years. An effective, innovative, and inspiring teacher, she refused to give grades because she believed that the work—not the reward—was important. She became the first woman to be admitted to the American Academy of Arts and Sciences, in 1887, and through her achievements, her tutelage, and her pioneering efforts, Mitchell helped to open the previously all-male profession of astronomy to American women.

MARY SOMERVILLE *(1780–1872, Scotland)*: Somerville was considered the leading scientific writer and thinker of her day. In 1827 she translated an important work, *The Mechanism of the Heavens*, into English, amplified by her own commentary. Although honored primarily for her work in astronomy, Somerville also contributed to the field of physics with two important treatises, *Connection of the Physical Sciences* and *Physical Geography*.

DOROTHY WORDSWORTH *(1771–1855, England)*: Known primarily as the devoted muse of her brother William, Dorothy Wordsworth is entitled to an independent place in English literature as one of the earliest writers on the beauties of nature. She wrote vivid descriptions of her travels with her brother and of their walks in the Lake District in England, where they lived for fifty years, even after William's marriage. In her journals, she also described her endless duties as William's housekeeper, including washing, cleaning, and baking, noting that "William, of course, never does anything."

Mary Wollstonecraft

(1759–1797)

Mary Wollstonecraft—English novelist, pivotal feminist writer, and theoretician—became acutely aware of women's oppression by watching her father constantly bully her mother. As soon as possible, Mary fled home, opening a girl's school, which, she hoped, would give her a chance for greater independence. In 1786, after the publication of her book *Thoughts on the Education of Daughters*, Wollstonecraft obtained a job as a magazine reviewer in London, which brought her into contact with many of the major social and political issues of the day. The French Revolution was creating turmoil in the intellectual community, and like many of the women of her era, Mary looked to the changes taking place in France to bring about the emancipation of women.

After visiting France, however, she became extremely disillusioned. "Liberty, equality, and fraternity," the rallying cry of the Revolution, seemed to apply (as the word *fraternity* suggests) only to men. In a rage, Wollstonecraft wrote *A Vindication of the Rights of Women*, a work that made her famous overnight. She took a radical philosophical step in this book by arguing that the principles of democracy that defined the French and American revolutions must be extended to women if real democracy were to be achieved.

She went on to state that if women failed to become men's equals, the progress of human knowledge would be halted. Moreover, in a visionary insight, Mary asserted that the tyranny of men had to be broken both politically and socially if women were ever to become free to determine their own destinies.

Wollstonecraft did not live long enough to see the profound long-range effects of these ideas. She died in her thirties, shortly after giving birth to her second daughter, Mary Shelley, who would become the author

Detail of *Mary Wolstonecraft* runner top

of *Frankenstein*. On her deathbed, Wollstonecraft proclaimed: "I have thrown down the gauntlet. It is time to restore women to their lost dignity and to make them part of the human species."

The back of the Wollstonecraft runner depicts her tragic death. The image combines needlepoint, petitpoint, silk embroidery, crochet, and stumpwork (an odd form of raised embroidery typified by quaint, pastoral scenes). This stumpwork entirely covers the top and front of the runner as a visual symbol for the confining environment or "silken fetters," which, according to Wollstonecraft, held women in chains.

On the top of the runner, there are three scenes: In the first, she is represented with several female students; in the second image, she is explaining to several young girls that they are entitled to an equal education; and in the last, she is depicted working on the book that made her famous. The serious tone of this eloquent treatise—the title of which appears on a satin banner over Wollstonecraft's embroidered name—is belied by the array of minuscule needleworked objects that meander across the runner surface.

The contrast between the meaning of the designs and the obsessive way in which they have been stitched is intensified by the contradiction between the imagery of the plate and that of the runner. The powerful, dimensional form of the plate struggles to transcend the confines of the runner context as if by sheer force, a metaphor for Mary's incandescent intelligence and strong will.

The names surrounding the place setting for Mary Wollstonecraft include women associated with the French Revolution, other writers (both feminist and nonfeminist), explorers who found world travel infinitely more rewarding than traditional roles, and women who influenced society through their salons. The salons were one impetus for the expression of feminist ideas, because women not only presided over intellectual dialogue but actively participated, defending both their ability to reason and their right to express themselves. Many of the salonists supported the French Revolution, only to discover that many of the reforms this ushered in were quickly swept away by the Napoleonic codes.

JOSEFA AMAR (*b. 1753, Spain*): Amar, a linguist and writer, was deeply concerned with the position of women. She presented a dissertation defending women and their aptitude for government service, along with other positions then held only by men. In other works, she addressed the need for women's education, condemning men's attempts to judge, define, or constrict women in any way.

BRIDGET BEVAN (*1698–1779, Wales*): A noted patron of the Welsh schools, Bevan first established and directed two schools, then became director of the school system.

ISABELLA BISHOP (*1831–1904, England*): One of the first female world explorers, Bishop traveled extensively throughout Asia, writing travelogues that are considered masterpieces. She was the first woman elected to the Royal Geographical Society.

JEANNE CAMPAN (*1753–1822, France*): Campan founded the first secular school in France to provide girls with a liberal education, opening the school to students from modest and upper-class families, an unusual precedent in class-conscious France. She also published a number of important books on education.

ELIZABETH CARTER (*1717–1806, England*): Carter belonged to the Bluestocking Society, the first literary society in England, which was famous for its support of women's rights. She was a linguist, translator, poet, excellent conversationalist, and noted wit.

CHARLOTTE CORDAY (*1769–1793, France*): Corday was horrified by the violence of the Revolution, which she had believed would bring a new order. She assassinated Marat, whom she held responsible for the execution of hundreds of thousands of people. After being arrested, tried, and sentenced to be guillotined, she tried to justify her act by stating: "I have killed one man to save the innocent—a famous monster—to procure peace for my country."

LEONOR D'ALMEIDA (*1750–1839, Portugal*): D'Almeida conducted a salon that became an intellectual center, bringing European literary ideas to Portugal. Her salon introduced English, French, and German pre–Romantic and Romantic works into the culture, thereby influencing the development of Portuguese literature.

YEKATERINA DASHKOVA (*1744–1810, Russia*): Dashkova, a scholar and author, was appointed by Catherine II to head the Russian Academy of Arts and Sciences, which had been founded at her suggestion. Dashkova established public lectures, increased the number of student fellowships, and organized a translator's department, which made the best foreign literature available to the Russian public. She was instrumental in the writing of a dictionary of the Russian language, published and wrote for several periodicals, translated foreign works, wrote poetry and plays, and generally tried to popularize fine literature.

OLYMPE DE GOUGES (*1745–1793, France*): In response to the 1789 Declaration of the Rights of Man (the preamble to France's new constitution), de Gouges—who had established women's clubs all over France in the name of the Revolution—wrote the *Declaration of the Rights of Woman.* In this work, she demanded equal rights for women before the law and in all aspects of public and private life. After realizing that the revolutionaries were proving themselves enemies of the emancipation of women, she covered the walls of Paris with signed bulletins, exposing the injustices against women of the new government and openly attacking Marat, Robespierre, and the Jacobins. She was brought to trial, and when she appeared, she cried out to the women in the crowd, "What are the advantages you have derived from the Revolution? Slights and contempt more plainly displayed." De Gouges was sentenced to death by Robespierre and guillotined.

MARIE DE LAFAYETTE (*1634–1693, France*): Madame de Lafayette organized a salon that became the most aristocratic and learned in Paris. She was renowned as a businesswoman and legal expert, becoming an insider to the intrigues of the court, which provided her with material for her memoirs and novels. Her major works, *La Princesse de Cleves* and *Zaide,* marked an important development in the history of literature and were precursors of the psychological novel.

FRANCOISE DE MAINTENON (*1635–1719, France*): Born in the prison cell where her parents were incarcerated for being Huguenot agitators, de Maintenon eventually became tutor to the children of Louis XIV, then his mistress, and, later, secretly his wife. Through the king, de Maintenon influenced both government and education for forty years. She was responsible for the passage of laws that improved the quality of life of the French people, established homes and educational institutions for poor young women, and founded the convent of St. Cyr, where she retired after Louis's death.

THÉROIGNE DE MERICOURT (*fl. 1789, France*): On July 14, 1789, the French celebrated the storming of the Bastille, which signaled the outbreak of the Revolution. Although it is a documented fact that de Mericourt led this assault, her name is generally left out of the historical record.

JEANNE DE POMPADOUR (*1729–1764, France*): As the mistress of Louis XV, de Pompadour influenced the choice of ministers and the making of government policy. Her extensive patronage of the arts included the construction of a theater at Versailles, the funding of the Gobelin tapestry factory, and the establishment of the Sevres porcelain factory. By 1754 de Pompadour was considered something of a world force and the indispensable agent of the French government.

GERMAINE DE STAËL *(1766–1817, Switzerland)*: A novelist, philosopher, and political writer, de Staël was a pivotal figure in post-revolutionary France. In 1794 she published a book advocating the immediate end of revolutionary wars and the re-establishment of the absolute monarchy, which brought her the friendship of Napoleon. But she soon found herself outraged by Napoleon's ambitions, and her drawing room became the meeting place for a powerful opposition. *Dulphine*, published in 1802 and containing her views on the circumscribed intellectual climate in France under Napoleon, became so popular that the emperor exiled her. In 1807 her novel *Corrine* sympathetically described the passions, struggles, and difficulties a woman of genius faced. In 1814 she published a three-volume work that challenged the prevailing literary ideas in France and set the stage for the later French Romantic movement. After Napoleon's downfall, de Staël was able to return to France and, despite bad health, continued to write until her death.

CELIA FIENNES *(1662–1741, England)*: Between 1687 and 1702, Fiennes took a series of journeys through England, Scotland, and Wales, in a "spirit of pure curiosity." The record of her travels was intended to encourage women in the "study of those things which tend to improve the mind."

ELIZABETH HAMILTON *(1758–1816, Scotland)*: Hamilton, a successful novelist, historian, and astute observer of Scottish rural life, wrote *The Letters of Education*, in which she promoted education for women of the lower classes.

MARY HAYS *(1760–1843, England)*: Influenced by Mary Wollstonecraft, Hays praised her in her book *Letters and Essays Moral and Miscellaneous* (1793). In this work, written with her sister Elizabeth, she urged women to actively agitate for their rights. In her writings, which included numerous fiction and nonfiction works, she argued the need for more equitable property and ownership laws, inveighing against marriage and supporting women's sexual freedom. She also wrote a six-volume work containing biographies of noted women.

MARY MANLEY *(1663–1724, England)*: An early British journalist, Manley published political tracts that challenged the ideas of the Whig party. After the publication of her *Secret Memories* in 1709, she was arrested and charged with libel. After her release, she became a newspaper editor.

MARY MONCKTON *(1747–1840, Ireland)*: A member of the Bluestocking Society, Monckton was a social leader and influential figure in the English literary community. She was known for encouraging women to frequent the salons.

ELIZABETH MONTAGU *(1720–1800, England)*: Montagu, an influential writer and critic, was the organizer of the Bluestockings, which included many accomplished women. The people who were invited to her salon were asked because of their merit rather than their rank, which was unusual at the time. She gained fame for her many critical writings, along with her intellectual and conversational talents.

MARY WORTLEY MONTAGUE *(1689–1762, England)*: Writer, explorer, and social leader, Montague is best known for having introduced smallpox inoculation into England, a practice she had observed in Turkey during her travels. The record of her journey, titled *Letters from the East*, is the first account of that region by a woman.

HANNAH MORE *(1745–1833, England)*: More and her sisters were educated by their father, the village schoolmaster. Encouraged by him to write, her first work, *The Search for Happiness,* was published in 1762. It was an immediate success, establishing More's literary reputation. From 1775 on, she spent her time in the heart of London life and, as a member of the Bluestocking Society, wrote *Bas Bleu,* in which she described this feminist circle. More became active in the antislavery movement, writing political commentaries along with a series of religious and moral reflections that were among the most widely read books of the day.

SUZANNE NECKER *(1739–1794, Switzerland)*: Necker's classical education enabled her to support herself as a teacher in her native Switzerland. After the death of her parents, she went to Paris, where she married a wealthy banker who became a prominent figure. She opened a literary salon that marks the transition between two distinct phases in the salons: the first more literary and the second more political. As the Revolution approached, the influence of her daughter, Germaine de Staël, gave Necker's salon an important political and semirevolutionary character. After 1776, she devoted herself entirely to prison and hospital reform, establishing a model hospital in 1778.

IDA PFIEFFER *(1797–1858, Austria)*: Pfieffer, an explorer, anthropologist, and naturalist, traveled nearly two hundred thousand miles, recording her observations and collecting artifacts. At the age of forty-five, after raising a family, she embarked on her first journey and, in *Woman's Voyage Round the World*, described her experiences. The first European visitor in many countries, she amassed a large collection of artifacts, which were distributed among British and European museums.

KAROLINE PICHLER *(1769–1843, Austria)*: Pichler, a leading saloniére of Vienna, was an extraordinarily prolific writer. In addition to numerous works on the French Revolution, Napoleon, and the Congress of Vienna, she wrote sixty romances and plays whose productions she personally supervised. Because her work has not been widely translated, she is known primarily in Germany and Austria.

MARY RADCLIFFE *(fl. 1799, England)*: An early advocate of women's rights, Radcliffe wrote an important feminist work, *The Female Advocate, or An Attempt to Recover the Rights of Women from Male Usurpation.*

JEANNE MANON ROLAND *(1754–1793, France)*: Roland was a distinguished stateswoman and political leader. She first became aware of the inequities of society as a child, when she began to brood over the injustices of class distinctions. She married the politically active M. Roland, and their house soon became the center for the political group the Girondists. The discussions in her salon centered on transforming France from a monarchy to a republic. Roland became increasingly outspoken in her support of revolutionary ideas and acts. Arrested and taken to prison, she wrote a letter protesting her incarceration, then began work on her life story. Given a mockery of a trial, she was taken to the guillotine, pronounc-

ing the now immortal words "O Liberty, what crimes are committed in thy name!"

ALISON RUTHERFORD (*18th c., Scotland*): Arriving in Edinburgh in 1731, Rutherford established a literary salon patterned on those in Paris, where she entertained the leading artists, writers, and political figures of the day. She wrote character studies of her contemporaries and satirical poems about government officials, as well as serious poetry. Throughout her lifetime, she corresponded with, supported, and encouraged women and their work.

CAROLINE SCHLEGEL (*1763–1809, Germany*): Schlegel grew up in the university atmosphere of Gottingen, where her father was a professor. Because she belonged to a group that was ardently sympathetic to the French Revolution, in 1793 she was arrested and imprisoned. After her release, she became important in the German Romantic movement. She transcribed manuscripts, wrote critical essays, and exchanged letters with many leading Romantic figures.

MARY SHELLEY (*1797–1851, England*): Shelley, the daughter of Mary Wollstonecraft, was never able to forget that her mother died of complications resulting from her birth and grieved throughout her life at never having known her. When she was seventeen, she ran away with the then-unknown poet Percy Shelley (whom she later married), thereby provoking her father, the famous literary figure and publisher William Godwin, to disown her. By the time she was twenty-two, she had borne four children (three of whom died), and shortly thereafter her husband drowned. Fortunately, she had already written *Frankenstein*, which was a tremendously popular success and a bestseller for thirty years in England, which helped her support herself and her remaining child. Mary also wrote novels, short stories, scholarly articles, and edited and published the major editions of her husband's poetry, devoting the last thirty years of her life to his work. But *Frankenstein* established her as a pioneer in the development of the Gothic novel and the creator of the genre of science fiction.

HESTER STANHOPE (*1776–1839, England*): The niece of the English prime minister William Pitt, Stanhope acted as his advisor, confidante, secretary, and hostess until his death in 1806. With her lifelong female companion, she then settled in Palestine, adopting Arab manners, customs, and dress. She soon gained considerable influence among the Arab tribes, coming to be regarded as a queen of the desert. She established a refuge for the persecuted and distressed at an unused convent in Lebanon, saying, "Show me where the poor and needy are and let the rich shift for themselves." Stanhope left a six-volume record of her travels and memoirs.

MARIE TUSSAUD (*1760–1850, Switzerland*): Tussaud, who began her career in her uncle's studio, became celebrated for her wax models of the human body. During the French Revolution, she cast the heads of Marat, Marie Antoinette, and Louis XVI after they were guillotined. Later, she gained the favor of Napoleon and became a state portraitist, eventually going to London to set up her collection, the still-famous Madame Tussaud's Wax Museum.

RACHEL VARNHAGEN (*1771–1838, Germany*): Varnhagen, a Jewish leader of the Berlin intellectual community, insisted that the primary evils of Europe included the slave trade, war, and marriage. She challenged popular attitudes toward women, particularly the idea of their being the incarnation of sin. Arguing for women's basic honor and moral purity, she advocated complete equality between the sexes. A supporter of education for women, she insisted that women, as citizens, had every right to work outside the home. She believed that women should regard themselves with respect, as evidenced by her own description of herself: "I am at one with myself and consider myself a good, beautiful gift."

ELIZABETH VESEY (*1715–1791, England*): Vesey, who gathered people of influence around her, exerted considerable influence upon English life through her salon.

Sojourner Truth

(1797–1883)

"Look at me!" demanded Sojourner Truth, an abolitionist and feminist. The audience at the Women's Rights Convention in Akron, Ohio, gasped at the sight of this tall, imposing black woman. "Look at my arm," she continued. "It's plowed and planted and gathered into barns and no man could head me—and ain't I a woman?" Seemingly unaffected by the sneers and hisses of the men in the audience, Sojourner's challenge was particularly directed to a clergyman who had warned that, if women continued their efforts to obtain "rights," they would lose the "consideration and deference" with which men supposedly treated them. But this former slave knew all too well that the special privileges enjoyed by some white women, particularly in the South, were built in large part on the exploitation of African Americans. Moreover, the "deference" to which this minister referred was definitely not offered to black women.

Sojourner had discarded her slave name (Isabel Hardenburgh) when she finally gained her liberty. She replaced it with Sojourner—because *sojourn* meant "to dwell temporarily" (which she thought an apt description of one's tenure in this life)—and Truth as the message that she intended to carry to the world. Traveling around the country on foot, she told her life story as a way of exposing the evils of slavery. She would recount the horror of seeing her brothers and sisters sold off and of how she herself had been sold several times, terribly mistreated, and repeatedly raped by her master, who deceived her with promises of freedom.

Sojourner came to believe that the liberation of blacks and that of women were closely related, and her antislavery lectures became infused with arguments for women's rights. In 1850 she published her autobiography

Sojourner Truth place setting

and, with the proceeds from the book, was able to support herself. During the Civil War she visited and spoke with Union troops; after the war she spent her time finding jobs for and helping the newly freed slaves.

The plate for Sojourner Truth was inspired by African art. Three faces emanate from a single body form. The upraised arm and clenched fist refer to her brave actions in the Ohio church. The sad face on the left, which is painted naturalistically, weeps for the suffering of the slaves and the racism of American society. The highly stylized face on the right conveys a barely disguised rage against such injustice. The stylized center face, based

upon traditional masks, symbolizes the rich cultural traditions from which African Americans were so violently uprooted.

The blacks, browns, and yellows of the runner—which is a pieced quilt—repeat the bold colors of the plate. The runner incorporates bands that were woven in a technique patterned upon African strip-weaving, intended to commemorate the African American influence on quiltmaking. These strips also honor the efforts of slave women to retain some vestige of their heritage—specifically, the piecing of smuggled scraps of precious African fabric into the large, beautiful quilts they were forced to make for their owners' beds.

Arranged around the place setting honoring Sojourner Truth are the names of both black and white women who were activists during the Civil War or in the antislavery movement, as well as African Americans who struggled to achieve success in fields that were even more closed to them than to their white sisters.

MARIAN ANDERSON (*b. 1902, United States*): Anderson's talent was recognized at an early age. Through the support of her family and donations from church and community members, she was able to obtain musical training. She joined the all-black Philadelphia Choral Society and in 1930 was granted a Rosenwald Scholarship. She then studied in Europe, where, like many other black American performers, she began her professional career and achieved her initial fame. On Easter Sunday in 1939, Anderson was scheduled to sing at Constitution Hall in Washington, D.C. But the Daughters of the American Revolution, who owned the hall, refused to allow her to perform. Outraged, First Lady Eleanor Roosevelt arranged for the concert to take place instead at the Lincoln Memorial. Anderson, the first African American to perform with the Metropolitan Opera, also performed at the White House and at Eisenhower's inauguration. The recipient of twenty-three honorary doctorates, she became a delegate to the United Nations.

JOSEPHINE BAKER (*1906–1975, United States*): Baker, who began her legendary fifty-year career as an entertainer in Harlem night clubs, appeared with the *Révue Négre* in Paris, becoming the sensation of Europe. As the star of the *Folies Bergére*, she epitomized the Jazz Age with her flamboyant and exuberant singing and dancing. Baker performed in numerous films, operettas, and revues. During World War II she was active in the French Resistance, receiving the Croix de Guerre, the Legion of Honor, and the Rosette of the Resistance. In later years she became active in the civil rights movement in the United States.

MARY McLEOD BETHUNE (*1875–1955, United States*): Bethune was born of slave parents. She graduated from the Moody Bible Institute in Chicago in 1895, at which point she commenced her lifelong commitment to working for expanded opportunities for blacks. In 1904 she founded the Institute for Girls in Daytona Beach. When in 1923 this institution merged with a men's school (becoming Bethune-Cookman College), she became its president. Bethune served on numerous federal commissions under the administrations of four presidents.

ANNA ELLA CARROLL (*1815–1893, United States*): Carroll, who contributed to the Union victory in the Civil War, was a writer of books, pamphlets, and articles on the state of American politics. She was also involved in espionage activities for the Union, which attracted the attention of President Lincoln. He sent her on a mission to the West to investigate and evaluate the Union's war policy. On that trip, Carroll became aware of the inadequacy of the Union's military strategy, which led her to mastermind the Tennessee Plan. It was this plan that finally won the war. However, her monumental achievement went unrecognized as Lincoln and the War Department felt it necessary to "protect" the public from the knowledge that it was a woman—rather than the army generals—who had engineered the victory.

MARY ANN SHAD CARY (*1829–1892, United States*): Cary was the first black woman to practice law in the United States and the first in North America to edit a newspaper. During the 1850s, she taught in Canada and while there edited the abolitionist newspaper *The Provincial Freeman*. But with the outbreak of the Civil War, she returned to the United States, becoming active in the recruitment of blacks into the militia. After the war, she attended Howard University, earning a degree in law.

PRUDENCE CRANDALL (*1803–1890, United States*): Crandall, a pioneer educator who advocated the right of blacks to be educated, admitted a black girl to the girls' school that she had founded in Connecticut in the 1820s. White parents, who had previously supported her, angrily withdrew their daughters. Undaunted, Crandall began another school for black girls, an act for which she was jailed in 1832. Her trial attracted the attention of abolitionists, who came to her support, but mob violence succeeded in closing her school.

MILLA GRANSON (*19th c., United States*): Granson, a slave in Kentucky, was taught to read by the children of her owner, even though it was illegal to educate slaves. She then organized a clandestine school, eventually educating hundreds of slaves. She carried on this secret project first in Kentucky and then in Louisiana for seven years, helping many slaves to write freedom passes that allowed them to escape to the North. The school was finally discovered by authorities in Kentucky, becoming the subject of lengthy debate in the state legislature. After much deliberation, they passed a bill making it possible for slaves to teach other slaves.

ANGELINA GRIMKE (*1803–1879, United States*): and SARAH GRIMKE (*1792–1873, United States*): The Grimke sisters were the first women in the United States to publicly argue for the abolition of slavery. Cultured and well educated, the sisters had gone north from South Carolina with firsthand knowledge of the condition of the slaves. In 1836 Angelina wrote a lengthy address urging all women to actively work to free the blacks. The sisters' lectures elicited violent criticism because it was considered altogether improper for women to speak out on political issues. This made them acutely aware of their own oppression as women, which they soon began to address along with abolitionism. A severe split developed in the abolition movement, with some antislavery people arguing that it was the "Negro's hour and women would have to wait." The Grimkes refused to accept this idea, insisting on the importance of equality for both women and blacks. Sarah became a major theoretician of the women's rights movement, challenging all the conventional beliefs about women's place. As to men, she demanded: "All I ask of our brethren is that they will take their feet from off our necks."

FRANCES HARPER (*1825–1911, United States*): Harper's novel about the Reconstructed South, *Iola Leroy, or Shadows Uplifted* (1892), was the first book published by a black American. Born of free parents and self-educated, Harper worked as a nursemaid, seamstress, needlework teacher, and writer. She produced ten volumes of poetry and many articles, along with her novel. Advocating women's rights as well as abolition, Harper lec-

tured at the 1866 Women's Rights Convention and at the 1869 meeting of the Equal Rights Association. But when the schism developed between abolitionists and feminists, she sided with Frederick Douglass, who believed that the issue of race had priority over that of gender. Harper continued her work on behalf of black women, founding the National Association of Colored Women and serving as its vice president until her death.

ZORA NEALE HURSTON (1901–1960, United States): Singularly dedicated to the preservation of black culture and traditions, Hurston traveled throughout the South collecting folklore and mythology. During the 1930s she was able to garner WPA grants and a Guggenheim Fellowship. She published several collections of stories, as well as novels and an autobiography, *Dust Tracks on a Road*. But by the 1950s, she was no longer able to find any support for her writing and was forced to work as a teacher, a librarian, and even a maid. She suffered a stroke in 1959 and died in 1960 as an indigent and unknown patient in a county welfare home. Thirteen years later the writer Alice Walker and Hurston scholar Charlotte Hunt placed a commemorative tombstone on her previously unmarked grave, reading: "Zora Neale Hurston, a Genius of the South, Novelist, Folklorist, Anthropologist, 1901–1960."

EDMONIA LEWIS (1845–1890, United States): Lewis, America's first black woman sculptor, was born to a Chippewa mother and a free black father. After being orphaned at age twelve, she was adopted by abolitionist parents. Lewis received a scholarship to study at Oberlin College in Ohio and developed into an accomplished Neoclassical sculptor. She went to Rome, where she worked and exhibited with Harriet Hosmer's famous group of female sculptors. In her most important works, she depicted major Native American figures, expressed her interest in black history, and incorporated images of heroic women.

MARY LIVERMORE (1850–1905, United States): During the Civil War, Livermore worked in hospitals, was a correspondent for numerous journals, wrote books, edited her husband's newspaper, and was the only woman reporter at Lincoln's nomination. After the Civil War she was active in both the temperance and suffrage movements.

BESSIE SMITH (1894–1937, United States): Born in Chattanooga, Tennessee, Smith made her stage debut at the age of nine. As a teenager, she appeared with Gertrude ("Ma") Rainey's minstrel show on the black vaudeville circuit. Influenced by Rainey, she developed her own unique art form—a blend of classical blues, country blues, and jazz—singing to packed houses wherever she performed and working with every great jazz musician of her day. Her music reflected the oppression she experienced as a woman, as a black, and as a victim of alcohol and hard times. At one time she was considered Columbia Records' most valuable artist, but her career declined dramatically during the early Depression years. After struggling to make a comeback, she died in a tragic automobile accident.

MARIA STEWART (fl. 1830s, United States): In the early 1830s, Stewart initiated a lecture series in which she asked her people to work for the abolition of slavery and to take pride in their race and heritage. This marked the first time an American-born woman ever spoke publicly. Her public speaking precipitated such intense criticism that she was forced to retire from the lecture circuit. She devoted the remainder of her career to educational and church work, founding schools in Baltimore and Washington, organizing and teaching Sunday schools, and working as a matron in the Freedman's Hospital in Washington.

HARRIET BEECHER STOWE (1811–1896, United States): Stowe's landmark novel, *Uncle Tom's Cabin*, has often been cited as one of the causes of the Civil War. She became outraged by written accounts of the injustice and cruelty of the slave system and traveled to the South to investigate it herself. The material she gathered became the source for *Uncle Tom's Cabin; or Life Among the Lowly*. The book, which was first published in 1831 in serial form in an abolitionist newspaper, became an immediate sensation, soon gaining worldwide popularity. Stowe was also an ardent supporter of women's rights, and she collaborated with her sister, Catherine Beecher, on nineteen domestic-science books.

HARRIET TUBMAN (1826–1913, United States): Tubman, who was born into slavery, escaped to the North in 1849, establishing her fa-mous Underground Railroad, from which she reputedly "never lost a single passenger." She rescued over three hundred men, women, and children, risking her own freedom nineteen times on her heroic trips into the slave states. Dubbed Moses, she became a legendary figure. A reward of forty thousand dollars was offered for her capture, but she was never caught. During the Civil War, she worked as a spy, scout, nurse, and commander in the Union Army of both black and white troops. Tubman expressed her beliefs in freedom and liberty by lecturing, organizing, and inspiring others. In her later years, she linked her work in the black community with feminist activities, attending women's suffrage conventions and helping to organize the National Federation of Afro-American Women (1895).

MARGARET MURRAY WASHINGTON (1863–1953, United States): Washington, who graduated from Fisk University in 1889, became a principal at Tuskegee Institute. After marrying Booker T. Washington (the founder of the Institute), she worked with him in expanding the school, becoming the first director of Girls' Industries and, later, the dean of women. In 1896 she united two major national black women's associations with hundreds of local organizations, founding the National Association of Colored Women.

IDA B. WELLS (1862–1931, United States): The child of slave parents, Wells initiated her long and dedicated struggle for equality for blacks by sitting in a whites-only railroad coach. She was forcibly removed, after which she instituted a legal suit, which she won. But a higher court struck down the decision. She then became a part owner of the *Memphis Free Speech*, writing articles condemning lynchings. Undeterred even by the destruction of her office by racist mobs in 1895, she began a one-woman campaign against this terrible practice, lecturing in New York and Boston and founding antilynching societies and black women's clubs. In 1893 she published *A Red Record*, an uncompromising account of three years of lynchings. She participated in the founding of the National Association for the Advancement of Colored People but, as an uncompromising militant, she withheld her full support from this somewhat conservative organization.

Susan B. Anthony

(1820–1906)

In 1848 Susan B. Anthony, her colleague Elizabeth Cady Stanton, and numerous other women gathered together in Seneca Falls, New York. Determined to overturn the laws that restricted women, they formulated a list of grievances. Their goals included control over their own bodies, the right be educated, to enter any occupation they chose, to manage their own earnings, to sign legal papers, to administer their own property, and, most fundamentally, the right to vote. Their demands were met by the insistence that they return "to their place." However, by the 1860s they had managed to achieve some significant measure of reform. Then, though both Anthony and Stanton argued forcefully against it, many of the women turned away from the women's struggle, involving themselves instead in what they presumed was of greater importance—that is, the Civil War.

As had happened so many times in history, many women assumed that what was considered the national interest must take precedence over their own. But they fully expected that their sacrifice for the country would earn them the vote. Instead, they were repaid by the word *man* being entered into the Constitution for the first time.

Though some of the original leaders of the movement became discouraged, there were others, particularly Anthony, who stood firm. Her dedication and clarity of purpose was an inspiration. By 1893, when she attended the Columbian Exposition in Chicago, everywhere she appeared, tens of thousand of people stood and cheered in recognition of all the changes that by then, she and her colleagues had accomplished. Partly through her personal efforts, the Woman's Building was erected, where a World Council of Women took place. Decades of work had helped create

Susan B. Anthony runner front

an international feminist movement, and all over the Western world, women were agitating for their rights.

The leaders of this vast movement are commemorated by a series of memory bands that are pieced together on the runner top with a red triangle whose fringed edges and silky surface are intended as a reminder of a scarf that Anthony bought with a supporter's gift when she was sixty-five years old—one of the few luxuries that she had ever allowed herself. Its triangular shape reiterates the configuration of *The Dinner Party* to suggest both Anthony's importance and her power. Its position within the context of the memory bands is intended to emphasize the crucial necessity for unity among women, a theme frequently stressed by this great patriot.

"Independence Is Achieved by Unity" is emblazoned on the back of the runner, which is patterned upon a nineteenth-century "crazy quilt." Fastened onto the runner back is a series of specially made buttons carrying another of Anthony's oft-repeated beliefs— "Failure Is Impossible."

The plate honoring Susan B. Anthony presents a raw and angry image struggling to escape its constraints, although the almost fully dimensional form is still anchored firmly in place. The front of the runner is embellished with three illuminated letters, as befitting a woman so deserving of honor. These symbolize Anthony's long dedication to women's struggles, her place in American history, and her relationship with Stanton. These two giants of the women's movement were joined by their respective understanding that only through a fundamental transformation of the world could the position of women really be changed. In fact, on her deathbed, Anthony grasped the hand of one of her co-workers as if to communicate this vision, as if to say "Our job is just begun."

The women's names surrounding Susan B. Anthony's place setting—the largest grouping on the floor—represent some of the major leaders and activists of the international women's movement. In addition to commemorating these courageous women, each of their names is also intended to symbolize the countless others who worked together to change women's circumstances and, in so doing, bequeathed expanded opportunities to millions of women.

BARONESS OF ADLERSPARRE *(fl. 1880s, Sweden)*: In 1859 the baroness began advocating feminist ideas through her magazine, *For the Home.* She later founded the Frederika Bremer League, named for the early Scandinavian women's rights advocate.

GUNDA BEEG *(20th c., Germany)*: Challenging the clothing conventions that encumbered women was an important aspect of feminist activity. Beeg, who was a founder of Germany's dress-reform movement, designed a loose-fitting dress to replace the restrictive Victorian style of women's clothing.

ANNIE WOOD BESANT *(1847–1933, England)*: Besant, a feminist, birth-control advocate, and early convert to Fabian socialism, worked as a strike leader, union organizer, and social and educational reformer. She was elected president of the Indian National Congress in 1918.

ALICE STONE BLACKWELL *(1857–1950, United States)*: Blackwell was the daughter of the early feminist theoretician Lucy Stone. As a reporter for the *Woman's Journal* at the 1891 national convention of the Women's Christian Temperance Union (WCTU), she began to perceive the relationship between liquor-related violence against women and children and more fundamental feminist issues, writing: "Multitudes of women who began by seeing only the drunkard are learning through the WCTU to look beyond him to the principle." As the early temperance assaults on bars gave way to more sophisticated political analysis, strong ties were forged between temperance and suffrage movements. Blackwell helped to unite the two major factions of the suffrage movement in the United States by helping to form the National American Woman Suffrage Association (NAWSA). This alliance was instrumental in passage of the Nineteenth Amendment, through which, after decades of work, women finally achieved the vote.

BARBARA BODICHON *(1827–1891, England)*: A leading feminist in the early English women's movement, Bodichon was instrumental in securing passage of the Married Women's Property Act. She worked to open university education to women, helped establish a women's college in Cambridge, and in 1857 formed the first women's employment bureau in Britain. She also helped publish the *Englishwomen's Journal*, which served as the voice of the suffrage movement.

FREDERIKA BREMER *(1801–1865, Sweden)*: Bremer's writings helped launch the Swedish women's rights movement, and her 1856 book, *Hertha,* became its primary textbook. Bremer, a peace activist as well as a feminist, organized a universal women's league to promote peace through social legislation, thereby linking the women's and peace movements.

MINNA CANTH *(1844–1897, Finland)*: Canth was a realist novelist and playwright who dealt with both women's issues and working-class problems. In 1885 she wrote an early feminist novel, *The Worker's Wife,* which was shocking to the community because of its overt criticism of the Church's reactionary attitudes toward women.

CARRIE CHAPMAN CATT *(1859–1947, United States)*: After the death of Stanton and Anthony, Catt assumed leadership of NAWSA, helping to finally secure passage of the long-worked-for suffrage amendment. In 1904 she founded the International Woman's Suffrage Alliance, traveling around the world to help forge an international movement that would bring change in women's status to many Western countries. In 1920 she established the League of Women Voters, then brought together eleven national women's organizations to create the National Committee on the Cause and Cure of War. After World War II she worked to place qualified women on crucial United Nations committees.

MINNA CAUER *(1841–1922, Germany)*: Cauer played a major role in the German suffrage and women's rights movement. Influenced by Susan B. Anthony, she established *The Women's Movement* magazine and began lecturing widely on feminism. She openly challenged German laws prohibiting women from holding or attending political meetings, laws that severely restricted women's ability to organize on their own behalf.

FRANCES POWER COBBE *(1822–1904, Ireland)*: A feminist educator, author, and philanthropist, Cobbe was deeply concerned with the problem of obtaining higher education for women. Among her important writings—most of which addressed women's issues—was an introduction to *The Woman Question in Europe* (1884), a monumental publication chronicling the progress of the suffrage movement.

MILLICENT FAWCETT *(1847–1929, England)*: In 1866 Fawcett helped found the Woman's Suffrage Committee, which, within a year, had gathered enough momentum to present Parliament with the first women's suffrage petition. A staunch advocate of education for women, Fawcett helped her sister, Elizabeth Garrett Anderson, open the medical profession to women. In 1897 she helped unify the English suffrage movement by creating the National Union of Women's Suffrage Societies, also becoming its first president.

AUGUSTA FICKERT *(1855–1910, Austria)*: An educator and feminist, Fickert worked ceaselessly to improve the social and economic position of Austrian women. Her activities included organizing the General Women's Club of Austria (which sought to improve women's wages); opposing state sanctions and regulation of prostitution; initiating free legal aid for women; editing a women's magazine; working for higher education and employment opportunities for women; and setting up community kitchens to serve families with working mothers.

MARGARETE FORCHHAMMER *(20th c., Denmark)*: Forchhammer was a peace and women's movement activist who won international acclaim for her work, which included the founding (in 1899) of the Danish National Council of

Women, a group that fought for suffrage and women's rights. Sixteen years later, leading a procession of twenty thousand women to celebrate the achievement of women's suffrage in Denmark, Forchhammer became the first woman to address the Danish parliament. In 1920 a conference held by the International Council of Women decided that female delegates should be chosen to represent all of the governments at the League of Nations; only Norway, Sweden, and Denmark appointed women delegates—Forchhammer being among them.

CHARLOTTE PERKINS GILMAN

(1860–1935, United States): Gilman was a visionary writer who was considered the voice and conscience of an entire generation of women who were taking their first steps outside of the domestic sphere. She introduced a number of revolutionary ideas, including a model for modern day-care centers and cooperative kitchens aimed at freeing women from domestic slavery. In her widely acclaimed book *Women and Economics* (a declaration of the importance of women's economic independence from men), she wrote: "The labor of women in the house certainly enables men to produce more wealth than they otherwise could; and in this way women are economic factors in society. But so are horses!"

VIDA GOLDSTEIN *(1869–1949, Australia):*
Goldstein was a major leader of the Australian women's suffrage movement. Devoting herself full-time to the suffrage cause, she spoke and lobbiied at Parliament and published an influential feminist journal, *The Australian Women's Sphere.* In 1902, years before their English or American sisters, Australian women achieved the right to vote. The following year, Goldstein became the first woman in the British empire nominated for Parliament. She ran for that office five times and—though never elected—used her campaigns as opportunities to educate the public on a range of women's issues.

HASTA HANSTEEN *(b. 1824, Norway):*
Hansteen, an important feminist writer, was the founder of the women's rights movement in Norway.

AMELIA HOLST *(fl. 1802, Germany):* Holst
was the first German woman to write a book advocating the necessity for educational opportunities for women. Her writings were used by later feminists as a theoretical foundation for their political activism.

ALETTA JACOBS *(1849–1929, Holland):* The
first woman physician in the Netherlands, Jacobs worked extensively with the American feminist leader Carrie Chapman Catt to build support for the international women's suffrage and political rights movement.

ANNIE KENNEY *(1879–1953, England):*
Kenney, who became a leader of the suffrage movement, began working at a mill at age ten. The deplorable working conditions there led to her involvement in the textile unions. After meeting the Pankhursts in 1905, she joined the Women's Social and Political Union (WSPU), and she and Christabel Pankhurst were the first women arrested in connection with suffrage activities. In 1912, with the WSPU leadership in prison, Kenney became director of the movement.

ELISKA KRASNOHORSKA *(b. 1847, Czechoslovakia):* A poet, educator, and patriot, Krasnohorska was also an important leader of the women's education movement. In 1875 she founded the *Women's Journal,* which advocated unrestricted education for women. She then became the head of the Women's Industry Society, which opened educational opportunities in technical work and the arts, and founded the Minerva Society, whose goal was to secure higher education for women. In addition to her political activities and poetry, Krasnohorska became known for her translations of English, Polish, Russian, and German literature.

MARY LEE *(fl. 1895, Australia):* Lee was the
founder and leader of the suffrage movement in South Australia, where women first succeeded in gaining the right to vote in all state elections in 1895, seven years before they gained federal voting rights from Parliment.

BERTHA LUTZ *(20th c., Brazil):* Lutz—a
multi-talented woman who came from an intellectual family—was educated at the Sorbonne, becoming a linguist and naturalist, then the secretary of the National Museum. Always a women's rights activist, she organized the Brazilian Association for the Advancement of Women to work for child welfare, suffrage, and educational opportunities for women. In 1923 she was a delegate to the Pan-American Association for the Advancement of Women, which tried to stimulate the development of feminist and suffrage organizations in South and Central America and Mexico. One of her major goals was realized when Brazilian women won the vote in 1932. Four years later, Lutz was elected to Parliament, continuing her activism as an official of the Federation for the Advancement of Women.

CONSTANCE LYTTON *(1869–1923, England):* Despite being a member of the aristocracy, Lytton passionately believed in the eradication of all class distinctions. She was also an advocate of women's rights, joining the WSPU and actively taking part in demonstrations, for which she was arrested many times. At one of her repeated trials, she testified: "I have been more proud to stand by my friends in their trouble than I have ever been of anything in my life." Because of Lytton's social position and the prison officials' knowledge that she had heart trouble, she consistently received preferential treatment in jail. She insisted upon protesting this by carving a *V* (for *Votes*) on her chest with a hairpin. After attempting to disguise herself, she was arrested again but released after her identity was discovered. Shortly thereafter, she suffered a heart attack, which left her partially paralyzed. Determined to record her prison experiences, Lytton learned to write with her left hand. She later died an invalid.

LUCRETIA MOTT *(1793–1880, United States):*
Mott, a Quaker minister and leading abolitionist, opened her home as a station on the Underground Railroad and in 1833 founded the first integrated abolition society in the United States. Together with Elizabeth Cady Stanton, she traveled to London for a world antislavery convention, only to discover that, because they were women, their participation was to be severely restricted. They returned to America determined to organize a convention and form a society to advance women's rights. At the historic Seneca Falls meeting,

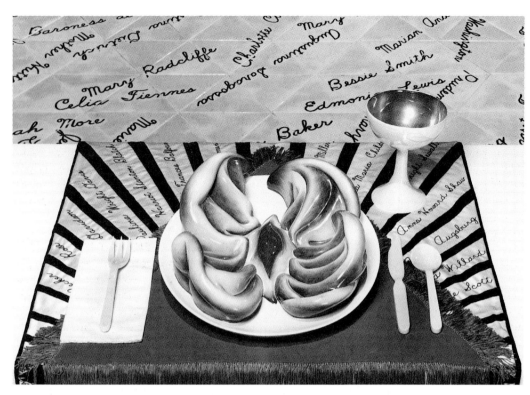

Susan B. Anthony plate and runner top view

Mott addressed the audience concerning the social, civil, and religious restraints on women. It was resolved "that it is the sacred duty of the women of this country to secure for themselves their sacred right to the elective franchise." Mott became a major figure in this effort.

MARY MUELLER *(1820–1902, New Zealand)*: Mueller, an early theorist of New Zealand's women's suffrage movement, first presented her feminist ideas in a series of influential newspaper articles. In 1869, under the pseudonym "Femina," she published "An Appeal to the Man of New Zealand," a pamphlet that argued for women's rights and eventually influenced the passage of the Married Woman's Property Act of 1884. In 1893 New Zealand became the first country in the world to grant women the vote.

CARRIE NATION *(1846–1911, United States)*: Nation, who has been maligned by historians and represented as eccentric, was actually an important activist leader of the WCTU, which was formed in 1874 to combat the growing problem of alcoholism, which was then disrupting a vast number of American families. Because women had few social and political rights, they had no protection from beatings by alcoholic fathers and husbands, who felt free to squander their earnings on liquor. Nation, like many other women, struck out in whatever way she could, primarily by breaking into saloons and smashing the liquor stocks. The liquor industry massed against the WCTU and later, when some temperance and suffrage groups joined forces, against the women's rights movement as well. Though arrested over thirty times for her militant reform tactics and continually ridiculed, Nation steadfastly continued her disruptive campaigns.

CAROLINE NORTON *(1808–1877, England)*: Norton, a prominent writer, became involved in women's rights when she was sued for divorce by her husband and realized that, by law, she stood to lose all her property along with custody of her children. She soon began to use her writing talents to work for social reform on a wide variety of issues. Her influential poem "A Voice from the Factories" was an exposé of child-labor conditions, and through lobbying and pamphlet writing, she contributed to the passage of the Infants' Custody Bill of 1838. In 1857 the Marriage and Divorce Act was passed, reforming the laws that had so incensed Norton during her own divorce and which she had worked to change.

LUISE OTTO-PETER *(1819–1895, Germany)*: Otto-Peter, one of the founders and leaders of the German women's movement, became involved in the struggle for equality as early as the 1840s. During the revolutions of 1848, she began advocating women's emancipation through a newspaper she founded that was suppressed by the government. Otto-Peter helped found and became the president of the Association for Women's Education (formed in 1865), which later became the basis for the National Association of German Women, an organization that was dedicated to the struggle for women's equality and right to work.

CHRISTABEL PANKHURST *(1880–1958, England)*: With her mother, Emmeline, Christabel Pankhurst, an able administrator, inspiring leader, brilliant theoretician, and militant crusader, organized the WSPU in 1903. When the government attempted to subvert the suffrage movement by imprisoning the WSPU leaders, Pankhurst escaped to Paris. Directing its activities through her friend Annie Kenney, she launched the radical newspaper *The Suffragette*. In 1918, after a bitter and often violent struggle, suffrage was finally achieved in England. Pankhurst became a lawyer and continued to fight for women's rights for the remainder of her life.

EMMELINE PANKHURST *(1858–1928, England)*: As the registrar of births and deaths, Pankhurst came into direct contact with the conditions of working-class women's lives. Convinced that it was not only these women who were treated as servants, but *all* women, she became altogether determined to change women's position. With her daughter Christabel, she created the WSPU with a membership that cut across class barriers. Their goal and motto was "Votes for Women," and when it became clear that the government was completely

unsympathetic to their views, Pankhurst, with her daughters Christabel and Sylvia, inaugurated violent tactics. Crying "Deeds, not words!" the women engaged in window-breaking demonstrations, chained themselves to the gates outside the prime minister's house, and even committed arson, which led to many arrests and imprisonments. At the outbreak of World War I, Pankhurst, like many others, directed her energy toward the war effort. In England, supposedly in part because of women's wartime contributions, the vote was granted to women over thirty; and in 1928 the bill was amended to grant the vote to women over twenty-one.

SYLVIA PANKHURST (1882–1960, England): Sylvia Pankhurst was an artist who decided to put aside her own work to engage in the suffrage cause. She worked closely with her mother and sister in the early days of the WSPU, organizing, speaking, and officiating as treasurer. Working with women in London's East End slums led to a strengthening of her socialist beliefs and to a commitment to the need for social reform for women *and* men. She was expelled from the WSPU by her mother and sister because of her divergence from a singular commitment to suffrage, but as Sylvia had a large working-class following, she soon formed the East London Federation for Women's Suffrage. She also continued her East End work by trying to improve factory conditions along with organizing clinics, day nurseries, and communal restaurants. A pacifist, she broke with her family again on the issue of supporting the war. But even though she may have differed from her mother and sister in some ways, ideologically, all three were committed to social change.

KALLIRHOE PARREN (fl. 1896, Greece): A committed feminist and writer, Parren established the Federation of Greek Women in 1896, an organization that worked for women's social and political equality. She also belonged to the International Council of Women, which developed communication channels and strategies for women's organizations around the world. In addition to writing several dramas dealing with women's issues, Parren was the editor of a women's magazine in Athens for eighteen years.

ALICE PAUL (ca. 1885–1976, United States): Paul, who was from a Quaker family, spent time working with the Pankhursts, the radical English suffrage activists. She became convinced that the only way to achieve the vote in America was through the aggressive pursuit of a federal amendment, returning from London a dedicated and militant suffragist. She and her American colleagues were repeatedly arrested, jailed, and force-fed during their prison hunger strikes, until the suffrage amendment was finally passed. Paul, an extraordinary organizer, fundraiser, and politician, then drafted the Equal Rights Amendment, steadfastly fighting to keep this and other women's issues before Congress for nearly twenty years.

ANNIE SMITH PECK (1850–1933, United States): An avid feminist, suffragist, scholar, lecturer, and mountaineer, Peck was the first person to scale Peru's Mt. Huascaran, which at the time was believed to be the highest peak in the Western Hemisphere. In 1912, at the age of sixty-one, she climbed another mountain in Peru, planting a "Votes for Women" sign at its summit.

EMMELINE PETHICK-LAWRENCE (fl. 1900s, England): Pethick-Lawrence was an upper-class woman who was active in both feminist and socialist causes. She and her husband did philanthropic and labor movement work. Through Emmeline Pankhurst, they became involved in the WSPU, publishing the suffrage journal *Votes for Women*. Like many of the other activists, they were repeatedly imprisoned for participating in what often became violent political demonstrations.

ADELHEID POPP (1869–1939, Austria): The founder of the socialist women's movement in Austria, Popp was considered the "awakener" of European feminist socialism. Her dedication to both women's issues and socialism was reflected in her fifty years of work as a political organizer, administrator, writer, speaker, and elected official to the Austrian government.

KATHE SCHIRMACHER (fl. 1911, Germany): Schirmacher, a suffrage leader, wrote several influential books, including *The Riddle Woman*, in which she argued that women not only

needed equal rights and opportunities but had to forge their own unique vision and plans for the future. In *The Modern Woman's Rights Movement*, she examined the status of feminism internationally.

AUGUSTA SCHMIDT (19th c., Germany): Schmidt was one of the founders of the German women's movement. As a member of the executive committee of the NAGW and associate editor of its official paper, *New Paths*, she helped develop its activities and goals, which involved supporting women's right to education, choice of work, and full participation in public life.

KATHERINE SHEPPARD (1848–1934, New Zealand): Sheppard, who succeeded Muller as head of New Zealand's suffrage movement, drew up and submitted a suffrage petition to the House of Representatives in 1888. Despite its initial defeat, she persistently continued the effort, submitting petitions in 1891, 1892, and again in 1893. The last petition, which was signed by one-third of all New Zealand's adult females, finally led to passage of the bill granting women suffrage.

ELIZABETH CADY STANTON (1815–1902, United States): The lifelong friend and colleague of Susan B. Anthony and one of the major figures of the women's movement, Stanton devoted most of her life to the struggle for equal rights. Her initial involvement in social and political reform was as an abolitionist, but like many other women, she soon came to realize that women were treated as second-class citizens even in the antislavery movement. She then turned her attention to obtaining educational opportunities for women, property and divorce law reform, and suffrage. Neither she nor Anthony, who joined with her in 1851, ever imagined that obtaining the vote would be so difficult or require the efforts of so many women. Rather, they saw it as one small step in the struggle for complete equality, an equality that, she argued in a visionary treatise, required a total transformation of relations between the sexes: "We have every reason to believe that our turn will come . . . not for women's supremacy, but for the as yet untried experiment of complete equality, when the united thought of man and woman will inaugurate a just government . . . a civilization at last in which

ignorance, poverty, and crime will exist no more."

LUCY STONE (1818–1892, United States):
Stone was one of the first women to attend liberal Oberlin College when it opened its doors to women and blacks, graduating as valedictorian in 1841. However, because she was a woman, she had to sit in the audience while a male student read her speech. This experience helped make her an avowed feminist, which resulted in her combining her abolitionist sentiments with her advocacy of women's rights by speaking for women during the week and for blacks on the weekend. When the Anti-Slavery Society objected to her work on behalf of women, she offered to resign, stating: "I was a woman before I was an abolitionist; I must speak for women." When in 1869 the suffrage movement split into liberal and conservative factions, Stone headed the American Woman Suffrage Association, which advocated working first for suffrage at the local and state levels. In 1855 Stone married Henry Blackwell, who actively supported the women's rights movement as well as his wife's involvement in it. Their marriage contract was quite unconventional at the time, in that it specified that their relationship would be totally equalized.

MARY CHURCH TERRELL (1863–1954, United States): Terrell—a leading black educator, lecturer, writer, and activist—was an influential leader in both the suffrage and civil rights movements. In 1884 she graduated from Oberlin College at the head of her class, taught school, then served for eleven years on the board of education in Washington, D.C., the first black woman ever appointed. She was also the first president of the National Association of Colored Women (1896–1901).

ALEXANDRA VAN GRIPPENBERG (1856–1911, Finland): An author and leader of the Finnish feminist movement, Van Grippenberg published an important collection of tales advocating temperance and women's rights. After attending the 1888 Women's Congress in Washington, D.C., she became an activist in the international struggle for women's rights, establishing a branch of the International Council of Women in Finland. For twenty years she was president of this early Finnish society for the promotion of women's rights. Believing that women's struggle to secure equality should be documented, Van Grippenberg wrote an extensive history of the feminist movement.

FRANCES WILLARD (1839–1898, United States): Because of her deep commitment to women's social and political equality, Willard gave up a promising career as an educator to work on the expansion of WCTU's membership and to widen its focus to include the struggle for women's suffrage. Arguing that women needed the vote in order to protect their homes and children against alcoholic husbands, Willard skillfully led otherwise conservative women into the suffrage campaign. In 1879 she became the president of WCTU, a position she held until her death.

VICTORIA WOODHULL (1838–1927, United States): Woodhull's career was as varied as it was criticized. She initially joined the women's movement as a speaker, outraging people with her radical views. In 1872 she ran for president of the United States in order to demonstrate the absurdity of the laws that inexplicably allowed women to run for public office while denying them the vote. Because of her Marxist leanings and open advocacy of free love, Woodhull frightened many people, becoming a target through which critics were able to attack the entire women's movement. She was forced to flee the United States after she exposed an affair between an important minister and a female member of his congregation as an example of the hypocrisy of many leading so-called moral men. Disillusioned by the double standards of the American system, Woodhull eventually advocated that women declare their complete independence by setting up a government of their own.

FRANCES WRIGHT (1795–1852, United States): In 1828 Wright spoke publicly in support of women's rights and education, an event signaling the beginning of what would become widespread feminist agitation in the United States. Also vitally interested in the antislavery movement, Wright helped freed slaves reach Haiti, giving them money for a new life there.

Elizabeth Blackwell

(1821–1910)

Elizabeth Blackwell was the first woman in America to graduate from a medical school and become a licensed physician. Having decided early in life that she would challenge the restrictions that barred women from becoming doctors, she studied medicine on her own, carefully saving money to attend school. She applied to twenty-one institutions and was rejected by all but one, where a doctor agreed to let her sit in on his classes provided that she wear male attire. Although she knew that some women had agreed to this, Blackwell refused; it was *as a woman* that she wanted to be accepted.

Blackwell was finally admitted to Geneva College, a small school in New York. The dean had asked the male students to decide her fate, and—more as a joke than anything else—they'd agreed to let her attend. When Blackwell arrived, not only was she treated rudely by the students, she was ostracized by all the "proper" women of the town. Nonetheless, she graduated with honors in 1849 and went to Paris and London to complete her training.

Blackwell, who decided to set up her practice in New York City, was met with such intense rejection that in 1851 she wrote dejectedly: "I stand alone." For she was denied work at hospitals, was refused office space, and went months without any patients. Determined to educate women on sex, birth, and health, she began to lecture publicly, which resulted in her being followed down the streets by people shouting insults and her being sent vile anonymous letters. Finally, Blackwell established a practice with her sister Emily and Marie Zakrzewska, both of whom had—with her help—become doctors. Together, they opened the New York Infirmary for Women and Children, the

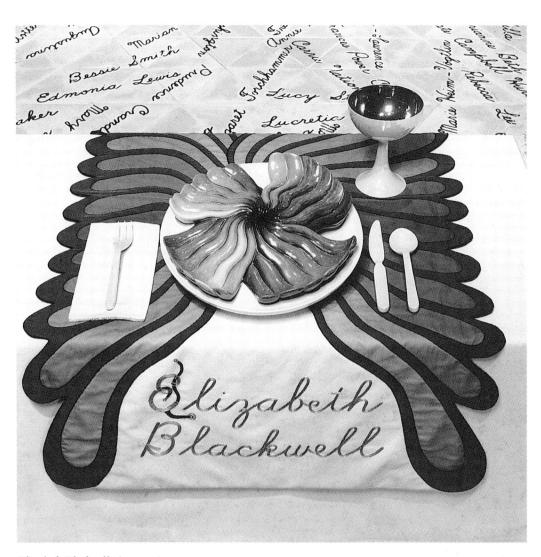

Elizabeth Blackwell place setting

first hospital where female doctors could get both training and clinical experience. In 1865 Elizabeth Blackwell founded a medical school for women; then, despite the obstacles encountered in America, she went to England, insistent upon opening the medical profession to women there.

The spectral-colored Elizabeth Blackwell plate twists and squirms around the "black well" at its center, which is intended as a visual pun on her name. The capital letter is illuminated by an embroidered stethoscope, and the runner extends both the forms and the colors of the plate. Its scalloped edges continue the gradual alteration of the runner contours that began earlier on this third wing of the table. Executed in reverse appliqué—which involves the cutting away of layers of fabric—the technique itself is a metaphor for the "cutting away" of the obstacles faced by women wishing to break into the various professions. The runner is formed of brightly colored fabrics whose intensity is shrouded with gray chiffon to suggest both the triumph and the difficulties of Blackwell's long struggle to achieve her noble aims.

Surrounding the place setting for Elizabeth Blackwell are the names of other courageous women. The difficulties of women in medicine epitomized those of many women who tried to open previously closed professions; help women rid themselves of constraining clothing; or throw off the torpitude of physical inactivity. In terms of breaking into the professions, there was a repeated pattern. A few women would win entry into a field, then have to establish training schools for other women in order to counteract the continued resistance of the entirely male-dominated institutions. Blackwell's words about the difficulties faced by female doctors seems to apply to the experiences of these many other women, as well.

A blank wall of social and professional antagonism faces the woman physician and forms a situation of singular and painful loneliness, leaving her without support, respect, or professional council.

ELIZABETH ANDERSON *(1836–1917, England)*: For nineteen years, Anderson was the first and only female member of the British Medical Association. When Blackwell went to England, an intense campaign to open the medical profession to women was already underway, and Anderson was deeply involved. She eventually became the general director and chief surgeon of the new hospital for women (which was subsequently named for her) and was instrumental in establishing the London School of Medicine for Women, of which she later became the president.

CLARA BARTON *(1821–1912, United States)*: Barton, the founder of the American Red Cross, began her professional career as a schoolteacher. With the outbreak of the Civil War, she went to the front to nurse the soldiers. Working without pay and using her own money, she spent four years with the armies in the field. In 1870 she went to Europe to work with the International Red Cross. Returning to the United States determined to organize a branch, she did so in 1881, serving as its president until 1904.

MARIANNE BETH *(b. 1890, Austria)*: The first Austrian woman to receive a doctorate of law, Beth specialized in international law. She became known for her politically liberal views, writing many influential papers on women's rights issues. Although she was academically qualified to study law, she was at first allowed only to study the history of Church law, earning a Ph.D. Later, after it became possible for women to earn law degrees, she went back to school, graduated, and established a practice as a lawyer.

EMILY BLACKWELL *(1826–1910, United States)*: Emily Blackwell, Elizabeth's sister, was a physician who devoted her life to training female medical students and to treating women patients. Though first admitted to medical school in Chicago in 1852, she was turned away the next year because of her gender. Finally accepted to medical school in Cleveland, she graduated in 1854, then traveled to Britain for postgraduate work in obstetrics. In 1856 she helped found the New York Infirmary for Women and Children. By 1868 she, Elizabeth, and Marie Zakrzewska had established a first-rate medical school for women, for which Emily Blackwell assumed full responsibility. For the next thirty years, she served as dean and professor of obstetrics and the diseases of women.

SOPHIE BLANCHARD *(d. 1819, France)*: Blanchard was the first woman in the world to earn her living as a professional balloonist. In 1810 she became the chief of air services to Napoleon, performing at royal functions.

MARIE BOVIN *(18th c., France)*: Considered the first great woman doctor of modern times, Bovin was awarded the honorary degree of doctor of medicine for her important work and research in gynecology. Because women were denied admission to medical school, Bovin was entirely self-taught.

EDITH CAVELL *(1865–1915, England)*: Before the outbreak of World War I, Cavell was the head of nursing at the Birkendall Medical Institute in Brussels. When the Germans invaded Brussels, the school became a Red Cross hospital. Cavell insisted upon treating all wounded soldiers, regardless of their nationality, and allowed

Elizabeth Blackwell capital letter

the hospital to be used as an underground stop for French and British soldiers crossing to Holland. Discovered by the Germans, she was arrested and court-martialed. She was convicted of helping Allied soldiers cross the border and was put to death.

MARIE LA CHAPELLE *(1769–1821, France)*: Trained in obstetrics by her mother, la Chapelle took over as head of maternity and midwifery at the hospital after the death of her mother, who had held that position. La Chapelle organized the maternity and children's hospital at Port Royal, training midwives and writing a three-volume work on obstetrics that was the major text on midwifery for many years.

MARIE CURIE *(1867–1934, Poland)*: Educated by her father in chemistry, Curie became his laboratory assistant, then went to Paris and entered the Sorbonne. After graduating, the only job she could find was as a poorly paid assistant in a laboratory, but as a result of her extraordinary talents, she was promoted to doing original

research. She met and married Pierre Curie and, working with him, began a long series of experiments on the compounds of uranium and theorium. Their work eventually resulted in the discovery of radium, an event that not only caused many long-held theories to be challenged but created a new view of the nature of energy and the constitution of matter. They received many joint awards for their discoveries, among them the Nobel Prize for physics and the French Legion of Honor. But because the Legion of Honor could be awarded only to men, Pierre Curie declined it. When Pierre died in 1906, Marie was appointed his successor as special lecturer at the Sorbonne, the first time a woman obtained a full professorship. She continued her scientific research, sharing another Nobel Prize in 1903 for her discovery of radioactivity and radioactive elements and, in 1911, winning on her own the Nobel Prize in chemistry.

BABE DIDRIKSON (1914–1956, United States): Considered the world's greatest woman athlete, Didrikson set world records in the 1932 Olympics, winning gold medals in the javelin throw and the eighty-meter hurdles. She was a member of the Amateur Athletic Union's All-American women's basketball team, scoring 106 points in a single game. She then concentrated on golf, winning seventeen consecutive professional tournaments and every important title for women golfers. In addition, she swam, boxed, and played tennis, billiards, football, and baseball (she was said to have once struck out Joe Di Maggio). While recovering from a major operation for cancer, she won the National Women's Open Golf Tournament in 1954 but died two years later, at the age of forty-two.

MARIE DUGES (1730–1797, France): Because Duges married an officer of health, she was able to be trained in medicine. She then reorganized and dramatically improved the maternity department of the hospital in which she worked. She also wrote several important books on midwifery.

MARIE DUROCHER (1809–1895, Brazil): Durocher, one of the first woman doctors in Latin America, was born in France and raised in Brazil, where she studied obstetrics. In 1834 she became the first recipient of a degree at the new medical school in Rio de Janeiro where she conducted successful practice for sixty years.

AMELIA EARHART (1898–1937, United States): Earhart's pioneering efforts in aviation were intended to improve the industry, as well as create opportunities for women in this new field. In 1936 she embarked on an around-the-world flight to document the effects of prolonged air travel on the human body, conduct mechanical tests on the aircraft, and record her observations of the lives of women in the countries where she stopped. It is believed that her plane went down in the Pacific Ocean. Before she disappeared, she wrote: "Women must try to do the things men have tried. When they fail, their failure must be but a challenge to others."

EMILY FAITHFULL (1835–1895, England): In 1863 Faithfull founded The Victoria Magazine, which explored the problems of working women and advocated the revolutionary idea of "equal pay for equal work." The periodical, which was printed by Faithfull's own publishing house, the Victoria Press (established in 1860), employed only women compositors.

ALTHEA GIBSON (b. 1927, United States): Gibson, whose ambition was to be "the best woman tennis player who ever lived," was the first black tennis player to win the United States National Tennis Championship. Brought up in Harlem, she began to play tennis seriously at age thirteen, quitting school and working as a chicken cleaner and factory worker in order to support herself. A prominent Southern black family became her "foster" family. Their support allowed Gibson to concentrate on improving her game, finish high school, go to college, and get a degree in physical education. In 1950 she became the first black invited to play in the U.S. Lawn Tennis Association championships and, in 1957, the first black to win at Wimbledon. She then went on to win the U.S. Championships at Forest Hills.

CHARLOTTE GUEST (1812–1895, Wales): Guest was the first British woman to manage an ironworks, the Dowlais Iron Company, which she inherited and ran after her husband's death. She was also a writer and patron, donating her exquisite collection of china to the Victoria and Albert Museum.

SALOMÉE HALPIR (18th c., Poland): Halpir, who initially received training from her husband, an oculist, went on to become a renowned specialist in cataract surgery.

JANE HARRISON (1850–1928, England): Harrison, who became the assistant director of the British School of Archaeology in Rome, had, by 1925, been awarded more honorary university degrees than any other woman in the world. Her interpretation of Greek culture, myths, and religions revolutionized the study of the classics.

SOPHIA HEATH (1890–1934, England): In 1922 Heath, an advocate for women's sports, founded the Women's Amateur Athletic Association, then went on to challenge the Olympic Committee's policies banning women from participation. It was largely as a result of her pioneering work that women were able to compete in the Olympics for the first time in 1928.

MARIE HEIM-VÖGTLIN (1846–1914, Switzerland): One of the first professional female physicians in modern Europe, Heim-Vögtlin received her degree in 1873 from the Zurich Medical School. She then established her own practice, specializing in gynecology and obstetrics. In 1901 she helped found a hospital and nurse-training school, which treated only women and children and was run by an all-female staff.

SONJA HENIE (b. 1913, Norway): Henie, a championship figure skater, was the first woman to win an Olympic gold medal for figure skating, winning the award again in 1936. She was the world champion ten years in a row, earning more money than any athlete before her. She later became a movie star.

KATE CAMPBELL HURD-MEAD (1867–1941, United States): Hurd-Mead was a physician, pioneer medical historian, and specialist in the diseases of women and children. She established the Baltimore Dispensary for Working Women and Girls, a nurses' organiza-

tion, and the Medical Women's International Association. But the absorbing interest of her life was the history of women in medicine. She spent years collecting information in the United States, Europe, Africa, and Asia, especially after 1925, when she retired from her practice. She published two books, *Medical Women of America* (1933) and *A History of Women in Medicine from the Earliest Times to the Beginning of the Nineteenth Century* (1938), which were the first comprehensive chronicles of women's medical contributions.

IRÈNE JOLIOT-CURIE *(1897–1956, France)*: Joliot-Curie, no doubt strongly influenced by her mother, Marie, became a leading scientist in the field of radioactivity. She and her husband discovered the neutron, a fundamental subatomic particle, for which they received the Nobel Prize for chemistry. An ardent antifascist and feminist, Joliot-Curie served in the Popular Front government in 1936, repeatedly appearing before the Academie des Sciences to argue women's right to membership. After 1937 she and her husband worked on nuclear fission, and following World War II they helped develop nuclear reactors and establish the French Atomic Energy Commission. In 1946 Joliot-Curie became director of the Radium Institute but was removed without explanation by the government in 1950.

ELIN KALLIO *(1859–1927, Finland)*: Kallio helped popularize gymnastics in Finland. She began teaching the sport at age seventeen, training other teachers and publishing books on the subject. In an effort to bring women athletes together, she founded an athletic association for women, the first of its kind in northern Europe.

BETSY KJELSBERG *(20th c., Norway)*: Kjelsberg was the first woman elected to the Norwegian Legislature. She founded a businesswomen's union, worked for legislation to protect factory workers, and established an inspection program of factories to ensure safety and health standards for workers.

SOFIA KOVALEVSKAYA *(1850–1891, Russia)*: Unable to gain access to higher education in her native Russia, Kovalevskaya went to Germany in order to earn her doctorate in mathematics. She was finally able to obtain a job in her field at the New University of Stockholm, becoming the first woman outside of Italy to achieve a university chair.

REBECCA LEE *(fl. 1860s, United States)*: Lee was the first black woman doctor in the United States, receiving her degree in 1864 from the New England Female Medical College. She returned to the South after the Civil War and established a successful practice in Richmond, Virginia.

BELVA LOCKWOOD *(1830–1917, United States)*: Lockwood was the first woman to plead a case before the Supreme Court. She had applied to Columbia Law School, was turned down, and had to fight, first for admission and then to actually receive her diploma. When she was finally admitted to the bar in 1873, a justice remarked, "I have no qualms about admitting you, because I don't believe you'll succeed." When one of her cases went to the Supreme Court, Lockwood was not allowed to plead it herself. For the next five years, she struggled for passage of a bill allowing women lawyers to argue before the Supreme Court, finally reversing what was a centuries-old prejudice.

MADAME A. MILLIAT *(fl. 1921, France)*: An advocate for women's athletics, Milliat founded the Federation Sportive Feminine International. Because women were denied the right to take part in the Olympic Games of 1922, Milliat organized an alternative competition for women, held in Paris that same year.

MARGARET MURRAY *(1863–1963, England)*: Murray, who was an archaeologist and the first woman to conduct her own digs, was also a professor, folklorist, and author who did extensive and innovative research and writing in Egyptology. She produced an original study on the matrilineal descent of property in early Egypt. She later did important work on witchcraft, which resulted in two major works, *The Witch Cult in Western Europe* and *The God of the Witches*. Murray was the first person to promulgate the theory that the witches of Western Europe were adherents of an earlier religion that was displaced by Christianity.

FLORENCE NIGHTINGALE *(1820–1910, England)*: At a time when nursing was considered menial labor that needed neither study nor intelligence, Nightingale elevated the practice to a professional level. In 1853 she became superintendent of the Hospital for Women in London, and when the Crimean War broke out, Nightingale and thirty-eight other nurses (whom she trained) went to the Crimea. She was put in charge of all hospitals in the war zone and, within a few months, had reduced the death rate from 42 percent to 2 percent. When she returned to England, she established the Nightingale School and Home for Nurses with the money she had received in recognition of her war work. In addition to revolutionizing nursing, Nightingale established standards and educational programs that laid the foundation for the entire system of modern nursing.

EMMY NOETHER *(1882–1935, Germany)*: Noether, who was considered a mathematical genius, made significant contributions to the development of modern algebra and, in addition, was an innovative and important teacher. With the rise to power of the Nazi regime, Noether—an intellectual, a Jew, a liberal, and a pacifist—was dismissed from the university and persecuted. She escaped from Germany and emigrated to the United States, where she worked as a professor at Bryn Mawr and a lecturer at the Institute for Advanced Studies.

SUSAN LA FLESCHE PICCOTTE *(fl. 1900, North America)*: Piccotte was the first Native American woman to study Western medicine. A daughter of the chief of the Omaha tribe, she graduated from the Women's Medical College of Pennsylvania in 1889, then returned to practice medicine among her people.

MARIE POPELIN *(1846–1913, Belgium)*: Popelin, the first woman to earn a degree as professor of law in Belgium, was then denied admission to the bar on the basis of her gender. Enraged by this injustice, she became the driving force behind the first Belgian feminist organization, which was established in 1892. Five years later,

she organized an International Feminist Congress in Brussels.

CLEMENCE ROYER (1830–1902, France): An expert in the fields of anthropology and prehistoric archaeology, Royer received acclaim for her French translation of Darwin's *Origin of Species* in 1862. She later published her own treatise on evolution, titled *Origine de l'Homme et des Societes.*

ANNA SCHABANOFF (19th c., Russia): Schabanoff, the first woman to graduate from the Academy of Medicine in St. Petersburg, received her M.D. in 1877. In addition to practicing as a pediatrician, she founded and supported the Child Welfare Association.

EMILIE SNETHLAGE (1868–1929, Brazil): A zoologist, ornithologist, and ethnologist, Snethlage traveled on foot, by canoe, and on horseback to collect zoological specimens. Born in Germany, her life work was done in Brazil, where she specialized in the study of birds, writing extensively about her findings. She became the director of the Zoological Museum and Gardens at Porto Belho, Brazil.

MIRANDA STUART (1795–1865, England): "Thee must go to Paris and don masculine attire to gain the necessary knowledge," a Quaker gentleman advised Elizabeth Blackwell when she was struggling to be accepted into medical school. Stuart did just that, thereby becoming the first English-speaking woman in the world with a medical degree from an established school.

AMELIA VILLA (d. 1942, Bolivia): Villa, Bolivia's first woman doctor, received her degree in 1926. The Bolivian government decorated her for her work in pediatrics, further honoring her by founding a children's ward at a hospital in Oruro that still bears her name.

DOROTHEA VON RODDE (1770–1825, Germany): Von Rodde was educated by her father only because he wanted to demonstrate that women could be capable and intelligent. She proved to be a brilliant student and, by the time she was eleven, had mastered numerous languages. After studying mathematics, the sciences, and history, at age seventeen she was paraded before a group of professors and tested, then awarded a doctorate. But because women were not allowed to take part in academic ceremonies, this honorary degree was presented in a private home.

MARY WALKER (1832–1919, United States): For her heroic work on the battlefield during the Civil War, Walker, who served with an Ohio regiment as an army surgeon, was awarded the Congressional Medal of Honor. After the war, she continued her medical practice, becoming a feminist activist who was particularly committed to dress reform. She advocated trousers as ideal for working women, calling the traditional corset "a coffin of iron bands." In 1917 a review board revoked her medal, saying that because she was a woman she had been awarded it by mistake. But she refused to give it up, continuing to wear it until she died. Her great-grandniece successfully campaigned to have the medal officially restored in 1977.

NATHALIE ZAND (fl. 1930s–1940s, Poland): Zand, who was involved both nationally and internationally as a physician and feminist between the wars, specialized in the pathology of the central nervous system. Her papers were published in Poland, England, and France. She disappeared during World War II.

Emily Dickinson

(1830–1886)

Emily Dickinson lived an outwardly uneventful life, remaining in her father's Massachusetts house as a spinster daughter and spending most of her time alone in her room. Even after she was grown, her father treated her almost like a child, forcing her to beg for postage stamps for her correspondence and plead for money with which to buy books. But she forged a life in which she had the personal freedom to read, think, and write at a time when few women had even a modicum of independence or psychic space.

Dickinson understood that her poetry might be considered dangerous in that it expressed feelings that women were not expected to have or at least not admit. Her intense creativity must have seemed hopelessly at odds with the prevailing ideas of what a woman was supposed to be and do. Binding her prodigious production of 1,775 poems into booklets by stitching them together with a darning needle, Dickinson carefully placed her secret "letters to the world" in trunks—to be found, read, published, and hopefully appreciated after her death.

While working on the image depicting Dickinson, I kept thinking about the contrast between the stereotypes of a typical Victorian lady and the poet's fierce statement that "I took my power in my hand and went out against the world." The strong though delicate center of the plate is imprisoned within layers of immobile lace, created through a process called lace draping, which was originally used in the production of Dresden dolls. I intended this image to be both witty and ironic in that it employs a technique associated with the most "feminine" of forms—i.e., porcelain dolls—to represent the most powerful of female creators.

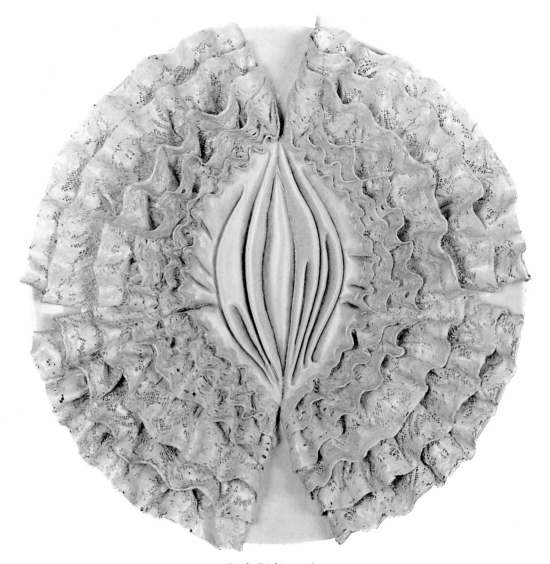

Emily Dickinson plate

The runner, constructed of lace and netting, extends the metaphor of the plate, which rests upon an exquisite antique lace collar that both surrounds and complements its imagery. Ribbon work—a nineteenth-century technique that would have been done by many women in Dickinson's milieu—borders the edges of the runner and cascades around the capital letter of her name. This nearly lost technique, in which different flowers are created through the deft manipulation of shaded ribbons, refers to one of Dickinson's own poems, in which she poignantly wrote about hiding herself "within my flower."

Tiny violets, roses, and irises embellish the runner surface, the same flowers that appear in the weaving on the Eleanor of Aquitaine runner. This deliberate visual repetition is intended to connect these two strong women, both of whom found ways of transcending the confines of their respective circumstances to remind us of the irrepressibility of the female spirit.

The steadily expanding international women's movement provided a supportive climate for female writers and also for the advancement of female education. Grouped around the place setting for Emily Dickinson are the names of other writers, along with women who worked to expand educational opportunities for women.

JANE AUSTEN (1775–1817, England): Austen, the first major female novelist, was the educated, unmarried daughter of a clergyman. She began writing at an early age, ostensibly to entertain her family. Although she fully expected to publish her work, she was aware of the prevailing negative attitudes toward female ambition. She therefore kept a piece of needlework close by to cover her literary efforts in case anyone came to call. Nevertheless, she was able to create a body of extremely well-crafted work whose language is some of the most luminous in English letters. Austin realistically described the lives and limited options of her female characters; marriage was their primary focus, for it provided the measure of their success and established their social status. Even a bad marriage was considered better than no marriage at all.

JOANNA BAILLIE (1762–1851, Scotland): Baillie published anonymously a series of poems and several plays, which, though well received, were initially attributed to a man. In 1799 a woman decided to produce the plays, insisting that their author must be female because the heroines were "clever, captivating, and rationally superior." Baillie decided to reveal herself as the author, proving the producer right. Although her works continued to be popular with the public, the previously favorable male critics changed their opinion of her writing.

ELIZABETH BEKKER (1738–1804, Holland): Bekker wrote a number of works considered classics in Dutch literature.

CHARLOTTE BRONTË (1816–1855, England): Charlotte Brontë, like her two writer sisters, had to publish her work under a male pseudonym (Charlotte's was Currier Bell). But even though the author had to hide her gender, her first book,

Jane Eyre, was the first modern novel in which a woman character honestly expresses her feelings. In her second novel, *Shirley,* Charlotte Brontë displayed an even more openly feminist perspective. The heroine longs to have a trade rather than the "vacant, weary, lonely" life of a woman of her class, "even if it made her coarse and masculine." *Villette,* her next novel, took two years to write, as it was interrupted by her own illness and the tragic death of her sisters and brother. Charlotte married her father's curate, then died from an illness caused by pregnancy. Her bitter feelings about the constraints on women echo across the decades: "There are evils, deep-rooted in the foundation of the social system, which no efforts of ours can touch; of which we cannot complain; of which it is advisable not too often to think."

EMILY BRONTË (1818–1848, England): Emily, like her sisters, Charlotte and Anne, was brought up in the isolated environment of her father's parish house. After their mother died, the children spent their time making up stories and creating little books, which are thought to have been the source for the sisters' later novels. Emily, who died young and left only one other work (a book of poems), is best known for *Wuthering Heights,* often considered the greatest piece of romantic fiction ever written.

FRANCES BROOKE (1724–1789, Canada): Brooke, the first Canadian novelist, wrote *The History of Emily Montague* (1769).

ELIZABETH BARRETT BROWNING (1806–1861, England): Browning, the daughter of a tyrannical father who dominated her meek mother, was the eldest of twelve children. Elizabeth became an invalid at the age of fifteen, and a series of family tragedies drove her ever more deeply into illness and invalidism. She immersed herself in the study of languages, literature, and poetry. In 1845 Robert Browning read some of her poems and wrote to her, thereby initiating a courtship. With Browning's devotion and encouragement, she slowly threw off the cloak of illness that had isolated her from the world and ran away with him. They married, and she bore a child in a union that lasted until Elizabeth's death in 1861. Her *Sonnets for the Portuguese* are often referred to as the greatest sonnets since Shakespeare, and in *Aurora Leigh* she published one of

the earliest autobiographical discussions of a woman's conflict over social expectations.

FANNY BURNEY (1752–1840, England): Burney, who began writing as a child, destroyed all of her early work because of her stepmother's disapproval. After the publication of a secretly written novel, *Evelina,* Burney became quite famous. Following her marriage, she stopped writing fiction, devoting herself instead to her diaries, which span seventy-two years and are her best-known works today.

ANNE CLOUGH (1820–1892, England): Clough was the founder and president of Newnham College, the first university for women in England. It was at this college that Virginia Woolf delivered her famous lecture on women and fiction, published as *A Room of One's Own.* Clough was secretary and later president of the North of England Council for Promoting the Higher Education of Women. Throughout her life she was engaged in active campaigning aimed at opening all universities to women.

ALBERTINE NECKER DE SAUSSURE (1766–1841, France): De Saussure, daughter of Germaine de Stael, wrote *Progressive Education,* which supported higher learning for women. She was a staunch advocate of physical education for girls, believing it would end the ill health that plagued many middle- and upper-class women, a condition she believed to be the result of their enforced idleness.

ELIZABETH DRUZBACKA (1695–1765, Poland): Druzbacka, one of the finest Polish writers of the eighteenth century, was a poet whose subject matter ranged from religion to feminism.

MARIA EDGEWORTH (1767–1849, Ireland): Edgeworth's nearly fifty books earned her an important place in Irish literature. Her novels and stories depicting Irish customs and heritage are thought to have inspired her friend Sir Walter Scott to write similar books about Scotland. Like Austen, she produced her work amidst the busy goings-on of the family sitting room.

GEORGE ELIOT (1819–1880, England): Born Mary Ann Evans, Eliot—like other women— wrote under a man's name. She established a rep-

utation as a major novelist and in her books frequently dealt with the pain of women who tried to realize their talents in the repressive atmosphere of the Victorian period. In *Daniel Deronda*, for example, the female character laments: "You may try, but you can never imagine what it is to have a man's force of genius in you, and yet to suffer the slavery of being a girl."

MARGARET FULLER *(1810–1850, United States)*: Fuller was one of America's first female journalists and foreign correspondents. Her work helped inspire the women's rights movement in the United States, and her feminist manifesto, *Woman in the Nineteenth Century* (1845), prefigured the Seneca Falls convention. Educated by her father—who had been influenced by Mary Wollstonecraft's arguments—Fuller held a series of parlor lectures for women to discuss art, literature, politics, and philosophy at a time when they were entirely excluded from the academic and intellectual life of New England. As an editor, writer, and critic for the *New York Tribune* and a transcendentalist journal, she played an important role in American intellectual life.

ANNA KARSCH *(d. 1791, Germany)*: Karsch, a peasant woman who was educated by an uncle, started to write poetry at an early age. She was "discovered" by a count who brought her to Berlin, where she was celebrated for a short time, then soon forgotten. She died in poverty and obscurity.

MARY LYON *(1797–1849, United States)*: A pioneer in women's education in the United States, Lyon founded Mt. Holyoke College in 1836. She spent years speaking publicly about her mission of providing college education for women, sometimes raising funds by soliciting door to door. Her methods were often criticized as being appalling for a "proper" woman, but when friends pleaded with her to stop, she would always reply: "I am doing a great work, I cannot come down."

HARRIET MARTINEAU *(1802–1876, England)*: Martineau, a well-known social reformer, wrote on political economy, history, philosophy, and travel. After touring Europe and the Middle East, she visited the United States, where she became an ardent abolitionist. Her economic theories helped shape British fiscal policy.

HEDWIG NORDENFLYCHT *(1718–1763, Sweden)*: The first important Swedish woman poet, Nordenflycht published her poems in the form of "yearbooks," titled *Womanly Thoughts of a Shepherdess of the North*. In 1753, she formed an influential literary society known as the Thought Builders.

BABA PETKOVA *(1826–1894, Bulgaria)*: Petkova, who began teaching in 1869, was committed to the establishment of a complete system of education for young women throughout eastern Europe. Hundreds of girls attended her classes, and though they and their parents supported her efforts to bring education to women, government officials opposed her goal. She was arrested, her home searched for seditious books, and she was forced to stand trial. Released for lack of evidence, she resumed what was a lifelong campaign for female education.

CHRISTINA ROSSETTI *(1830–1894, England)*: Rossetti, one of the greatest English poets of the nineteenth century, has traditionally been characterized as the reclusive, otherworldly, sexually repressed sister of Dante Gabriel Rossetti. Educated by her mother, Rossetti began writing as a child, choosing to live at home in order to entirely devote herself to literature. Though often categorized as a religious poet, there is a range in her work that transcends the limitations of this description.

SUSANNA ROWSON *(1762–1824, United States)*: Rowson opened one of the first girls' schools to offer education above the elementary level. She also wrote the first bestseller in America. In this book, *Charlotte Temple*, she protested the double standard by which women were ostracized for their love affairs while men were not.

GEORGE SAND *(1804–1876, France)*: Sand was the most prolific woman writer in the history of literature. The author of 120 books, she was until recently remembered primarily as Chopin's lover. Born Aurore Dupin, she not only published under a male pseudonym but also adopted male attire and behavior in order to gain greater mobility in Parisian society. Dressed as a man, she could frequent cafes with her male literary friends, sit in the cheapest theater seats (where no women were allowed), and fully participate in a cultural life that was essentially closed to women.

Her feminist views were expressed in her first novel, *Indiana* (1831), which protested the restrictions imposed on married women in a society that regarded them as the property of men. The book, which was an immediate sensation, established Sand's literary reputation. At its best, her later writing style exemplifies the Romantic movement.

HERMINE VERES *(1815–1895, Hungary)*: Veres was responsible for making higher education available to Hungarian women. Frustrated by her own inadequate education, she was determined to open up educational opportunities, and in 1867 she organized a public appeal for more adequate schools for women. She succeeded in founding first the Society for the Education of Women and then, within two years, a women's school.

BETTINA VON ARNIM *(1785–1859, Germany)*: A feminist and writer of the German Romantic movement, von Arnim belonged to a group of writers who actively worked for social reforms. Her work, which sympathetically depicted the lives of poor women, described the tragic conditions of slum life and the deprivations that ultimately forced many women into lives of prostitution.

BERTHA VON SUTTNER *(1843–1914, Austria)*: Von Suttner, who wrote and lectured on pacifism, helped raise European consciousness about the horrors of war through her first book, *Down with Weapons*. With the outbreak of World War II, interest in her work was revived and many of her books were published posthumously.

EMMA WILLARD *(1787–1870, United States)*: In 1821 Willard, the first American woman to take a public stand on the need for women's education, opened the Troy Female Seminary, later known as the Emma Willard School. In addition to teaching subjects considered "suitable" for girls, she also introduced more serious subjects, as she wanted to demonstrate that the students were entirely capable of comprehending mathematics, science, philosophy, and history. She was the first person to provide scholarships for women and one of the first women to write geography, history, and astronomy textbooks. She was also the first female lobbyist in the United States.

Ethel Smyth

(1858–1944)

Smyth was raised in an upper-class English family. By the age of twelve her gifts as a composer had already become evident. In 1877, she traveled to Leipzig in order to immerse herself in its lively musical milieu. By 1889, her compositions were being performed in Germany to glowing reviews, and she returned to England, intent upon establishing herself there. But it soon became clear that few British orchestras were willing to perform her compositions. If she were even able to arrange a concert, something would inevitably go wrong: The musicians would be inadequately prepared, the conductor would—at the last moment—be unable to attend, or the other (male) composers would complain about her inclusion.

Her early work was primarily orchestral and chamber music, but she soon became intent upon expanding her range as a composer, writing the *Mass in D*, one of the most ambitious works ever undertaken by a female composer. Its production was made possible only through the personal support of two influential and wealthy women. The audience response to her *Mass* was wildly enthusiastic, but the work was so bitterly attacked by critics that it was eclipsed for thirty years. In fact, her work was entirely rejected by the musical establishment or, worse, was largely ignored. If she *were* able to garner a positive review, she would inevitably be accused of plagiarizing a male composer's work. Smyth eventually recorded her struggles and frustrations in a series of books that at first brought some attention to her music. But ultimately, not even the publication of her writings brought her the recognition and support that she both craved and deserved.

Not surprisingly, Smyth became actively involved in the British struggle for women's

Ethel Smyth place setting

rights, writing "The March of Women," which was sung by thousands of suffragists during demonstrations, in prison, or whenever their spirits faltered. While visiting the wife of an influential politician in an effort to gain her husband's support, Smyth played some of her music, including this march. Afterward the woman asked: "How can you, with your gift, touch a thing like politics with a pair of tongs?" "I do it *because* of my music," Smyth replied, "for owing to the circumstances of my career as a woman composer, I know more than most people about the dire workings of prejudice."

The Ethel Smyth image takes the shape of a piano whose lid is raised in an effort to escape the confines of the plate while also threatening to compress the form. The notations on the page of music on the stand are based upon one of her operas, *The Boatswain's Mate*, a comic work written from a feminist point of view. The plate rests on a runner that combines several iconographic references: a musical staff and metronome to symbolize her profession; a tailored suit to represent her preferred mode of dress; and a linen tape measure on one side of the tweed jacket, intended as a pun on the word *measure*, which is used in both music and tailoring. The suit has been "taken in" to fit the confines of the runner's dimensions, a metaphor for the tragic containment of Smyth's immense talent.

For many centuries, women were unable to obtain any serious musical education. Only when women's colleges were established did women begin to have the opportunity to be trained. Even then, and despite the fact that a number of women had proven themselves capable of composing and conducting, most, like Smyth, either encountered a solid wall of resistance or remained largely unknown. Grouped around the place setting for Smyth are the names of women whose achievements in music reflect the varied ways women attempted to overcome prejudice and to participate in this, the most closed of the arts.

ELFRIDA ANDRÉE *(1844–1929, Sweden)*: Andrée studied composition at the Stockholm Conservatory from 1858 to 1861, during which time she worked as a cathedral organist, performing over eight hundred peoples' concerts. Her works included solo pieces, a piano quintet and trio, organ sonatas, two organ symphonies, an orchestral symphony, and a Swedish mass. She succeeded in being elected to the Swedish Academy of Music in 1879.

AMY BEACH *(1867–1944, United States)*: Beach was a gifted pianist and composer. She began taking piano lessons at age six and later taught herself theory and composition. In 1883 she began her concert career, often performing her own compositions. She was the first American woman to write a symphony, and her oeuvre included piano concertos, cantatas, string quartets, an opera, religious and patriotic pieces, and over one hundred choral works. She also wrote the composition celebrating the opening of the 1893 Women's Building in Chicago.

ANTONIA BEMBO *(ca. 1700, Italy)*: Bembo was a court musician to the king, one of only three women composers to have ever attained this position. One of her most successful compositions was a trio for women's voices, written to celebrate the birth of her child.

FAUSTINA BORDONI *(1700–1793, Italy)*: Bordoni was one of the great opera singers of the eighteenth century. She performed in all the major musical centers of Europe, earning an international reputation.

LILI BOULANGER *(1893–1918, France)*: A member of a famous musical family, Boulanger showed enormous musical aptitude by the age of three. By the time she was sixteen, she was an accomplished pianist, cellist, violinist, and harpist. In 1913 she became the first woman to win the Grand Prix de Rome for her cantata "Faust et Helene." Although she died at age twenty-five, during her brief career she composed more than fifty works.

NADIA BOULANGER *(b. 1887, France)*: Nadia Boulanger, Lili's sister, has been considered a major force in the shaping of modern music. Although she was a performer, composer, and conductor in her own right, it was as a teacher of composition that her primary impact was acknowledged. Her role as the teacher of some of the major male composers of the twentieth century obscured her own creative accomplishments, which included orchestral pieces, chamber music, and choral works.

ANTONIA BRICO *(b. 1902, United States)*: Brico, though painfully aware of the obstacles barring women from the profession of music, was determined to succeed as a conductor. She graduated with honors from the University of California and studied orchestration and conducting in Berlin. Her conducting debut at the Berlin Philharmonic made headlines throughout Europe and the United States, partly because a female conductor was then considered quite newsworthy. She toured the continent as guest conductor of many major orchestras, making a triumphal New York debut in 1933. To prove the excellence of women musicians and also to create jobs for the many talented but unemployed female musicians, she founded the Women's Symphony Orchestra in New York, which was considered a novelty. This later developed into the "mixed" Brico Symphony Orchestra, formed because Brico was committed to women and men working together. Because this orchestra was not viewed as the same kind of novelty, it was not popular and eventually disbanded. As a consequence, her career suffered a decline. She only became known again as a result of a recent film documenting her life and career.

MARGUERITE-ANTOINETTE COUPERIN *(1676–1728, France)*: Couperin was a member of the famous musical family that dominated French music from the seventeenth through nineteenth centuries. She played the clavichord at the French court and was the principal soprano in the *Musique du Roi*.

MARGUERITE-LOUIS COUPERIN *(1705–1778, France)*: Couperin followed in the musical tradition established by her mother and, like her, became a court musician to the king. She was the first woman to be appointed to the *Ordinaire de la Musique* (in 1723).

ELISABETH DE LA GUERRE *(1664–1729, France)*: De la Guerre, a child prodigy who began composing at an early age, went on to write an opera, a trio sonata, six cantatas, and fourteen harpsichord pieces. She composed and performed for the famous Theatre de la Faire and gave harpsichord recitals that were acclaimed throughout France and England.

MARGARETHE DESSOFF *(1874–1944, Germany)*: In 1912 Dessoff conducted the first public appearance of a women's chorus. From 1925 to 1935, she directed the fifty-woman Adesor Choir in New York City, a group that performed music specifically composed for female voices. Due in part to her efforts, women's choruses began to flourish.

SOPHIE DRINKER *(fl. 1948, United States)*: Drinker spent twenty years researching and writing *Music and Women*, a pivotal book published in 1948 that traced women's role in music from early matriarchal societies to the modern period. She documented the existence of a long and unique tradition of authentic women's music and proved that women's music was directly connected to their social and political authority.

JEANNE LOUIS FARRENC *(1804–1875, France)*: Farrenc entered the prestigious Paris Conservatory of Music at age fifteen, later giving concerts throughout France and composing an ambitious series of piano pieces. One of only two women on the faculty of the French National Conservatory throughout the entire nineteenth century, she composed chamber music, overtures, and symphonies. She was also a musicologist, publish-

ing a twenty-three-volume work that revived interest in such composers as Scarlatti and Couperin.

CARLOTTA FERRARI *(1837–1907, Italy)*: After Ferrari's first opera was performed, she was arrested and forced to stand trial for the crime of being a female composer.

WANDA LANDOWSKA *(1877–1959, Poland)*: Landowska, a musician and musicologist, was responsible for reviving interest in the harpsichord as a concert instrument. While teaching in Paris, she began researching old music. This led her to found a school for the study of this music, supervise the manufacture of authentic replicas of ancient instruments, and to give concerts that reintroduced both the music and the instruments to audiences throughout Europe and the United States. Her theories and techniques became the basis for most contemporary harpsichord playing, influencing almost all modern keyboard composers.

JENNY LIND *(1820–1887, Sweden)*: Known as the Swedish Nightingale, Lind was one of the most celebrated sopranos of all time. She was trained at the Royal Theater of Stockholm, singing her first leading role at age eighteen. By the age of twenty, she had attained the distinction of being a court singer to Sweden's royalty. Her concert tours created a sensation throughout Europe and the United States, netting her vast earnings, most of which she donated to charity.

FANNY MENDELSSOHN *(1805–1847, Germany)*: Mendelssohn, though an exceptional musician and composer, was almost entirely overshadowed by her brother Felix. While he was encouraged in his musical pursuits, Fanny was forbidden by their father to perform publicly. Despite this, she was somehow able to develop into an incredibly accomplished musician. In an effort to be supportive, her brother published some of her compositions in his name. After her father died, she was able to perform in public for the first time, but inexplicably, Felix suddenly announced his opposition to her entry into public life. By then she had married a man who was quite enthusiastic about her work, but her brother insisted that pursuing her music would cause her to neglect her family obligations. Finally, in 1846, a small number of her finest pieces were published in her name. The following year she died, shortly after performing her last composed work.

ROSE MOONEY *(18th c., Ireland)*: Although there were a number of celebrated female harpists in Ireland in the eighteenth century, Mooney was exceptional in that she was blind. An extremely proficient musician, she repeatedly won prizes at competitions in which all the finest harpists performed.

CLARA SCHUMANN *(1819–1896, Germany)*: Schumann, considered the greatest female pianist of the nineteenth century, began to study piano with her father at the age of five. When she was twelve years old a concert tour of Germany and France firmly established her fame, and her first published works appeared at that time. In 1840 she married Robert Schumann and continued to perform during their sixteen years of marriage, bringing public attention to her own work as well as that of her husband, Chopin, and Brahms. After her husband's death, she supported their seven children through her concerts.

MARIA THERESIA VON PARADIS *(1759–1824, Austria)*: Despite becoming blind during her childhood, von Paradis was able to become an active teacher, composer, and musician who performed extensively throughout Europe. In her compositions, she used an innovative notation system involving the use of pegs and a pegboard. In her later years, she devoted herself primarily to teaching, founding a music school for young women.

MARY LOU WILLIAMS *(b. 1910, United States)*: Williams, who was self-taught, was considered one of jazz's finest pianists and composers. She began working as a pianist for one of the big bands by the time she was twenty, at which time she began arranging and composing. In addition to composing numerous works—including religious hymns—she taught at Duke University and established the Bel Canto Foundation to aid down-and-out musicians. Through her radio show, "The Mary Lou Williams Workshop," she influenced an entire generation of musicians.

Margaret Sanger

(1879–1966)

A visionary, feminist theoretician, and pioneer in the struggle for reproductive freedom, Margaret Sanger was convinced that once women were freed of involuntary child-bearing, society would be transformed: "War, famine, poverty, and oppression will continue while woman makes life cheap. When motherhood is a high privilege . . . it will encircle all." When Sanger first began to study nursing, she was confronted with endless pleas from women desperate for some form of birth control, which was entirely prohibited at the time. Sanger resolved to challenge this taboo, renouncing nursing and traveling to Europe and the Orient to investigate the contraceptive research being done there.

Upon her return to America, Sanger defiantly ignored the laws of the time in order to openly disseminate information about contraception. Despite being arrested repeatedly, she would not swerve from her mission. Through her clinic (opened in 1918), her magazine, *The Women Rebel*, and her lectures, she forced the issue of reproductive freedom into the public arena, raising important questions, some of which resound even today: "Who cares whether a woman keeps her Christian name? Who cares whether she wears a wedding ring? Who even cares about her right to vote? For hundreds of thousands of laundresses, clock makers, scrub women, servants, telephone girls, shop workers, without the right to control their own bodies, all other rights were meaningless."

Convinced that the birth-control movement had to be worldwide in order to be truly effective, in 1925 Sanger convened the International Birth Control Congress, the forerunner of Planned Parenthood, of which she became president in 1953. Mar-

Detail of *Margaret Sanger* runner top and back; embroidery by Terry Blecher and L. A. Hassing

garet Sanger's life accomplishments are an inspiring testament to what one woman can do if she is willing to "look the world in the face with a go-to-hell look in the eyes; have an idea; speak and act in defiance of convention," for she almost singlehandedly broke through the curtain of silence that surrounded all matters of sex and reproduction.

The image on her plate, painted in brilliant reds, attempts to reach around the plate edge and lift itself off, a symbol of Sanger's efforts to liberate women and thereby hopefully change the world. The colors of the shaded embroidery on the pink satin runner repeat the intense hues of the plate, the imagery derived from a medical drawing and used here to celebrate the female reproductive system. The outside edges of the runner are shaped to suggest a butterfly, a symbol for the personal freedom achieved by Sanger herself as well as the deliverance that she believed would come to

women once they had acquired reproductive choice.

The capital letter was inspired by Sanger's passionate belief that "this is the miracle of free womanhood, that in its freedom it . . . opens its heart in fruitful affection for humanity. How narrow, how pitifully puny has become motherhood in chains."

Margaret Sanger capital letter

Sanger was not the only woman active in the birth-control movement. Grouped around her place setting are the names of other pioneers in family planning, education, humanitarian work, and the modern revolutionary movements that many women believed would lead to increased freedom for not only women, but everyone.

JANE ADDAMS *(1860–1935, United States)*: Jane Addams was the central figure in the international women's peace movement during World War I and the first woman to win the Nobel Peace Prize. In addition to advocating women's suffrage, she fought for the regulation of child labor and for the legal protection of immigrants, helping immigrant women to regenerate the fine crafts from their countries of origin. In 1889 she opened the first "social service" center in America, which provided education, job training, recreation, and entertainment to many of the people who had emigrated to Chicago at the turn of the century. This center became the model for settlement houses all over the country.

INESSE ARMAND *(1874–1920, Russia)*: Armand was an ardent feminist and an important figure in international socialism and the Bolshevik Revolution. A political associate of Lenin, she is thought to have influenced his ideas on women's position in a communist society.

SYLVIA ASHTON-WARNER *(b. 1908, New Zealand)*: While working with Maori children, Ashton-Warner devised radical new educational techniques. Believing that children's natural talents should be encouraged, she eschewed traditional textbooks, teaching instead from primers that the children wrote themselves. Her methods—called the Creative Teaching Scheme—were initially ridiculed. But Ashton-Warner was eventually acknowledged internationally as a brilliantly progressive educator and visionary theorist.

ANGELICA BALABANOFF *(1878–1965, Russia)*: A social reformer and revolutionary, Balabanoff joined the Socialist party in 1900, working closely with Lenin. But after the Revolution, she rebelled against the authoritarian dogma of the Bolshevik regime. She left the party and, after meeting Emma Goldman, became an anarchist.

CATHERINE BEECHER *(1800–1878, United States)*: Catherine Beecher, the sister of Harriet Beecher Stowe, was committed to restoring value to women's traditional activities. Her approach was in direct opposition to that of the Grimke sisters, who advocated the total eradication of gender roles. These two views typified the fundamentally different arguments of nineteenth-century feminism. In 1843 Beecher published her *Treatise on Domestic Economy*, in which she outlined every aspect of domestic life from the building of a house (including designs for plumbing) to the setting of a table. Intended to help women become self-sufficient and competent, the book marked the beginning of household automation and the servantless home.

RUTH BENEDICT *(1887–1948, United States)*: Benedict, who did her early research on Native American cultures, was one of the world's leading anthropologists. While teaching at Barnard College, she inspired Margaret Mead to pursue anthropology. Benedict's landmark book, *Patterns of Culture*, is a pioneering study of the relationship between culture and the human personality. During World War II she worked on a book about racism, which was distributed in an abbreviated version by the U.S. Army to its troops in an effort to combat racist attitudes. After the war she produced a major study of Japanese culture.

YEKATERINA BRESHKOVSKAYA *(1844–1934, Russia)*: Called the Grandmother of the Russian Revolution, Breshkovskaya became prominent while still a young woman. Although a noblewoman, she agitated for the rights of the serfs, setting up village schools, libraries, and hospitals for them. Repeatedly jailed for her political activism, Breshkovskaya eventually exiled herself to Prague.

RACHEL CARSON *(1907–1964, United States)*: Carson, a marine biologist, naturalist, and environmental writer, used her book *Silent Spring* to focus national attention on the danger of pesticides. Deeply concerned about the future of the human race, she warned: "Along with the possibility of the extinction of mankind by nuclear war, the central problem of our age has become the contamination of man's total environment with substances of incredible potential for harm." Viciously attacked by business interests, she defended her theories at Senate hearings, which led to stricter regulation of the use of toxic chemicals such as DDT. Her work created public awareness of the widespread problem of pollution.

DOROTHEA DIX *(1802–1887, United States)*: Dix, a teacher, writer, nurse, organizer, and philanthropist, dedicated her life to social reform. She founded over one hundred asylums dedicated to the humane treatment of mental patients. Concerned with the treatment of prisoners, she visited prisons, county jails, and poor houses in eighteen states and several European countries. Concluding that most prisoners were in desperate need of rehabilitation, she became a lifelong advocate of such help. When the Civil War broke out, Dix volunteered. Made chief of nurses for the Union Army, she organized the Army Nursing Corps, mobilizing thousands of women and turning hundreds of buildings into hospitals. Her life was a model of selfless service to the common good.

VERA FIGNER *(1852–1943, Russia)*: Despite being from an upper-class, land-owning family, Figner became politically active. She first got involved with leftist student organizations, becoming (progressively) a socialist, a revolutionary, and then a terrorist. For ten years she was a leader, organizer, and propagandist of the People's Will, an underground revolutionary group. She participated in the terrorist activities that led to Czar Alexander's assassination in 1881. Arrested, tried, convicted, and sentenced, Figner served over twenty years in solitary confinement. After the Revolution, she documented her political activities, remaining in the USSR until her death.

ELIZABETH GURLEY FLYNN *(1890–1964, United States)*: Socialist, union organizer, and political activist, Flynn began her political life at age fifteen when she delivered the speech "What Socialism Will Do for Women." She was an organizer for the IWW and the Workers Defense League and a leader of the Lawrence, Massachusetts, textile workers strike

of 1912. Though repeatedly arrested, she continued her labor organizing while also agitating for prison reform and free speech. In 1957 she joined the Communist party and, as a result, spent most of the 1950s in prison. After her release, she became the first woman president of the American Communist party, a position she held until her death at age seventy-six. She was also the founder of the American Civil Liberties Union.

ELIZABETH FRY *(1780–1845, England)*: Fry, a Quaker minister and philanthropist, was the chief promoter of prison reform in England and the first person to suggest that prisons be a place of rehabilitation. In 1921 she appeared before the House of Commons, successfully influencing the passage of a major prison-reform bill. She was also instrumental in achieving reforms in the penal systems of Scotland, Australia, France, Germany, and Holland.

EMMA GOLDMAN *(1869–1940, USSR and United States)*: Goldman, known as the Mother of Anarchy, was a feminist, revolutionary, social reformer, and political organizer and theorist. She was the publisher of the anarchist periodical *Mother Earth* and the writer of numerous essays, books, and over two hundred thousand letters. Goldman was an early and staunch advocate of birth control, urging women "to keep their minds open and their wombs closed." Arrested many times, in 1919 she was deported to Russia. After becoming disillusioned with the Revolution, she left and settled in Europe. On the issue of women's suffrage, she said prophetically: "True emancipation begins neither at the polls nor in courts. It begins in women's soul."

DOLORES IBARRURI *(b. 1895, Spain)*: One of the leading figures in the Spanish Civil War, Ibarruri was entirely dedicated to the ideals of the socialist movement. In 1930 she was elected to the Central Committee of the Spanish Communist party. The following year Ibarruri was sent to Madrid, where she edited the party's newspaper and was put in charge of women's activities. A leading propagandist for the republic, after its collapse in 1939, she went to live in the Soviet Union, where she was awarded the Lenin Peace Prize in 1964.

MARY "MOTHER" JONES *(1830–1930, United States)*: Born to an immigrant working-class family, Mary Jones devoted her life to fighting for the dignity of the worker. After the devastating loss of her husband and four children in a yellow-fever epidemic, Jones started a dressmaking business and began her work in the labor movement. She was a powerful leader, an effective speaker, and a skillful organizer, staging dramatic demonstrations that drew attention to the labor cause. She agitated against child-labor abuse and for improved conditions in coal mines and factories. Though often arrested, Mother Jones was never deterred.

RACHEL KATZNELSON *(b. 1888, Israel)*: Katznelson, who was Russian-born, emigrated to Israel. She helped shape the new state's policies concerning the status of women. She co-founded the Women Workers Council and established and edited the weekly newspaper *Savor Hapocht*.

HELEN KELLER *(1880–1968, United States)*: At nineteen months old, Keller was deprived of sight and hearing by an attack of scarlet fever. At age seven she was put under the devoted care of Anne Sullivan of the Perkins Institute for the Blind in Boston. Slowly and painstakingly, Sullivan taught Keller how to read and write and finally, after enormous effort, how to speak. Keller was able to graduate from Radcliffe with high honors and, despite her disabilities, lead an accomplished life. She published a series of books and mastered several languages. Active in radical politics, she joined the American Socialist party, writing and lecturing on its behalf. During World War I she traveled around the country, courageously inveighing against the military and advocating peace.

ALEKSANDRA KOLLANTAY *(1872–1952, Russia)*: Kollantay, a feminist and leader of the Russian revolutionary movement, was especially notable for her work on behalf of Soviet women. The daughter of a czarist general, she became a successful organizer, writer, and propagandist for the Bolsheviks. In 1917 she was appointed to the post of people's commissar of social welfare, later founding the Central Office for the Care of Mother and Child.

NADEZHDA KRUPSKAYA *(1869–1939, Russia)*: Krupskaya, wife of Lenin, devoted her life to women's rights, educational reform, and the Russian Revolution. From a well-educated and politically oriented family, she first became a teacher, then joined a Marxist group in 1891. Three years later, she met Lenin when both were exiled to Siberia for their involvement in radical political agitation. She and Lenin worked together for the Revolution, with Krupskaya struggling to ensure that women's rights would be an essential part of Communist doctrine. After Lenin's death in 1924, she worked in vain to oppose the repressions of the Stalinist regime.

ROSA LUXEMBURG *(1870–1919, Poland and Germany)*: Because of her radical political activities, Luxemburg had to flee her native Poland at the age of nineteen. For the next twenty years she helped shape socialist theory through her writing and speaking. She then moved to Germany, joined the Socialist party, and was instrumental in the founding of what later became the German Communist party. Luxemburg wrote over seven hundred books, articles, and pamphlets. Because many of these challenged accepted party doctrine, she and her companion, Leo Jogiches, were captured, bludgeoned with rifle butts, and shot to death.

MARGARET MEAD *(1901–1978, United States)*: Mead, a distinguished anthropologist and the author of numerous books on primitive societies, also wrote on many issues central to contemporary life. Her first major work, *Coming of Age in Samoa*—which became a bestseller—brought her to prominence. In her later pioneering studies of six different South Seas societies, she focused on women's roles, childrearing, and other topics through which she illuminated both native cultures and, by implication, aspects of American society. Mead was one of the first people to suggest that the so-called masculine-feminine characteristics were not based on fundamental gender differences but, rather, reflected different forms of cultural conditioning. She argued against the destructive effects of specialized role conditioning and its consequent polarization of the sexes, stating in *Sex and Temperament*: "If we are to achieve a richer culture, rich in contrasting values, we must recognize

the whole gamut of human potentialities, and so weave a less arbitrary social fabric, one in which diverse human gifts will all find a fitting place."

GOLDA MEIR *(1898–1978, Israel)*: Meir was raised in the United States after her Russian parents fled the czar's pogroms. She worked as a teacher until her increasing involvement in socialist and Zionist causes led her to emigrate to Palestine in 1921. A pioneer in the creation of the state of Israel, she was one of the original signers of its Proclamation of Independence. The first woman member of the legislature (Knesset) and a formidable stateswoman, Meir became the president of the state of Israel in 1969.

LOUISE MICHEL *(1830–1905, France)*: Michel, an anarchist, fought in the barricades to establish the Paris Commune, which, though envisioning itself as a permanent world republic, lasted only two months. During that short time, however, it initiated sweeping reforms. The Commune was sacked by government troops, who massacred twenty-five thousand men, women, and children. Michel was arrested and spent nine years in prison.

KATTI MOELER *(20th c., Norway)*: Moeler wrote and spoke on behalf of liberalized abortion laws. She fought for the legal protection of unwed mothers and their children; was involved in the organization of Oslo's first family-planning center (1924); and introduced contraception and improved hygiene practices into maternity and infant wards.

MARIA MONTESSORI *(1870–1952, Italy)*: Montessori, an influential educational theorist, was the first woman to graduate from the University of Rome. In 1907 she attracted considerable attention for her innovative work with slum children, who had previously been considered educationally hopeless. By 1912, after her first book, *The Montessori Method*, was translated into English, she became world-renowned. She believed that "the fundamental problem in education is not an educational problem at all; it is a social one. It consists in the establishment of a new and better relationship between the two great sections of society—children and adults."

FEDERICA MONTSENY *(b. 1905, Spain)*: Montseny, who was active in both the Spanish Civil War and the struggle for women's rights, was brought up by anarchist parents, becoming an important speaker and anarchism's leading theoretician. She was appointed minister of health and public assistance, the first woman to hold such a position in the Spanish government.

EMMA PATERSON *(1848–1886, England)*: An important labor leader, Paterson organized three London unions, fought for protective legislation for women workers, became the first woman inspector of working conditions for women's trades, and founded the Women's Trade Union League. In 1875, by becoming the first female delegate to the Trade Union Congress at Glasgow, Paterson helped overcome the prevailing prejudices of the male delegates against female labor organizers.

FRANCES PERKINS *(1882–1965, United States)*: Perkins became the first woman to hold a cabinet position in the U.S. government when she was appointed secretary of Labor by Roosevelt in 1933. A pioneer in factory and industrial reform, she was instrumental in the formulation of New Deal policies and laws.

SOFIA PEROVSKAYA *(1853–1881, Russia)*: Perovskaya was arrested and exiled to Siberia for advocating social change among the villagers with whom she worked as a health worker and teacher. She escaped in 1881, becoming involved with the revolutionary organization called the People's Will. After taking part in the assassination of Czar Alexander, Perovskaya was executed.

GABRIELLE PETIT *(1893–1916, Belgium)*: Considered a national heroine, Petit served as a secret agent for the Allied armies during World War I, helping many soldiers to cross the border. She also smuggled valuable information to the Allies. In 1916 she was caught and executed.

JEANNETTE RANKIN *(1880–1976, United States)*: Rankin, the first woman elected to the United States Congress, began her long political career as a suffragist. An ardent pacifist, she voted against U.S. entry into World War I in 1917 and then, twenty years later, cast the only dissenting vote when the country declared war on Japan, an act that virtually ended her congressional career. Rankin, who continued to work as a peacemaker and pacifist, led the Jeannette Rankin Brigade of five thousand women in a march on Washington to protest U.S. involvement in Vietnam in 1967.

ELLEN RICHARDS *(1842–1911, United States)*: Over one hundred years ago, Richards launched the science of ecology. Her examination of the effects of toxic chemicals on air, water, and food led to her insistence on the necessity for a better balance between human beings and the environment. She was the first woman admitted to MIT, the first to receive a degree in chemistry, its first female faculty member, and the first to act as a science consultant to industry. Despite these achievements, in 1873 MIT refused her a doctorate because she was a woman. She was allowed to stay on, however, as an unpaid assistant professor in charge of the women's laboratory, which was dedicated to training women scientists. Her work in the field of sanitary chemistry—which involved analyzing air and water for pollutants —laid the foundation for the public health movement in the United States. Her *Food Materials and Their Adulterations* influenced the passage of the Pure Food and Drug Acts.

ELEANOR ROOSEVELT *(1884–1962, United States)*: Eleanor Roosevelt, wife of Franklin Delano Roosevelt and America's most distinguished First Lady, used her position to create a bridge between the presidency and the people. She made frequent speaking tours throughout the country, wrote an ongoing newspaper column, delivered radio broadcasts, and traveled internationally during the war, conferring with world leaders on behalf of the United States. After FDR's death, Roosevelt continued to be an important world figure; from 1945 to 1952, she was a delegate to the U.N. Assembly, chairwoman of UNESCO's Commission on Human Rights, and America's roving ambassador of good will. She was an influential figure in the Democratic party, lending her considerable support to the civil rights movement.

AUGUSTINA SARAGOSSA *(1786–1857, Spain)*: Augustina was a heroine in the defense of

Saragossa against the invading French in 1808. Inspiring others to withstand the French assault, she threw herself into the thick of the fighting, rescuing the wounded and ministering to the sick.

*H*ANNAH *S*ENESH *(1921–1944, Hungary)*: Heroine, spy, and freedom fighter, Senesh gave her life trying to rescue Jews during the Holocaust. Shortly after World War II broke out, she emigrated to Palestine, where she joined a special group of Jewish Palestinian soldiers trained to help Jews escape from the occupied countries. In 1944 the twenty-three-year-old parachuted with her unit into Yugoslavia and, after making her way behind the front lines in Hungary, was captured, imprisoned, tortured, and executed by the Nazis.

*M*ARIE *S*TOPES *(1880–1958, England)*: Stopes, who received excellent training in the field of reproduction, founded England's first family-planning center. She won a scholarship for her research on reproduction and became Manchester University's first female lecturer in science. In an effort to combat the general public ignorance about sexuality, Stopes wrote *Married Love*, an early sex manual. She also developed and perfected the diaphragm, which was not only one of the most effective methods of contraception but one that was essentially controlled by women.

*H*ENRIETTA *S*ZOLD *(1860–1945, United States)*: Szold, the first woman to attend the Jewish Theological Society, was admitted only after she'd promised not to attempt to become a rabbi. Active in both Jewish and Zionist organizations, she encountered constant sexual discrimination. Nonetheless, she continued working for the creation of health and social welfare agencies in Palestine. Although her contributions to the world Zionist movement were considerable, her commitment to equal rights for women prevented her from being elected to leadership positions until she was sixty-seven years old.

*B*EATRICE *W*EBB *(1862–1948, England)*: Webb was among the early members of the Fabian Society, an organization dedicated to social and labor reform. She collaborated with her husband on an important series of books on the history of trade unionism and Soviet Russia.

*V*ERA *Z*ASULICH *(1849–1919, Russia)*: Zasulich was a Russian radical and writer who defied the laws by teaching reading and writing to serfs. She was arrested in 1869, imprisoned, and then exiled. Zasulich returned to Russia an even more dedicated revolutionary and, after moving to St. Petersburg in 1876, heard about the brutal beating of a political prisoner by the chief of police. Walking into his office, she shot him point-blank. Because the chief was widely hated, the jury acquitted Zasulich, but the czar ordered her arrest. She was smuggled out of the country and lived in Switzerland for some years, finally returning to Russia after the 1905 revolution.

*C*LARA *Z*ETKIN *(1857–1933, Germany)*: Zetkin was a political leader, feminist, and writer who formulated the socialist theory of women's emancipation through her publications *The Question of Women Workers* and *Women at the Present Time*. In 1915 she organized the International Women's Conference Against the War. Because it did not have party approval, Zetkin was arrested, then released, but the German Socialist party repeatedly tried to discredit her. Finally, she moved to Moscow, where she spent the remainder of her life.

Natalie Barney

(1876–1972)

From the time she was young, Natalie Barney, who came from a wealthy Ohio family, instinctively rebelled against the social expectations of her gender. When she was seven she was taken on a European tour by her parents. In Belgium she saw a cart being pulled by a woman and a dog, both of whom were in a harness. Barney never forgot this sight, made even worse by seeing the woman's husband walking beside the cart, complacently smoking his pipe. When she was older she frequently spoke of having learned about the implications of being a woman when she observed that "poor woman saddled like a horse."

By the time she was twenty, Barney had made a conscious decision to live as she pleased, which her wealth made possible. She reveled in her lesbianism, wearing it almost as a badge of pride, an unusual and daring attitude at a time when strictures against homosexuality ranged from religious prohibitions to legal injunctions. Settling in Paris, she established a salon, where for almost sixty years women gathered to hear concerts, to read poems and essays, and to affirm both their independence and their sexuality. Her wit and free spirit are reflected in the epitaph that she suggested for herself: "She was the friend of men and the lover of women, which, for people full of ardor and drive, is better than the other way around."

Known as a writer, aphorist, and feminist, Barney was said to be wildly extravagant, once preparing her bed for a night of love by completely covering it with lilies. The lily, traditionally associated with the feminine, was Barney's trademark, as well as a common motif in Art Nouveau, which her place setting emulates. The plate is dark and edged with gold, its iridescent surface achieved by firing multiple layers of different lustres onto

Natalie Barney place setting

the reliefed lily form. The richly beaded and sumptuously colored runner celebrates the life of this "Amazon," as she was frequently called.

The shape of the runner accentuates the butterfly form, its edges almost entirely free from the geometric constraints of the runner shape to suggest the freedom of expression that was offered by Barney's salon and embodied in her life. Constructed with layers of shimmering art deco silk, the undulating contours of the runner are accentuated with glass beads, which are also used in the capital letter, whose lily-like petals repeat the image on the plate.

RIGHT: *Natalie Barney* capital letter; beaded by Connie von Briesen

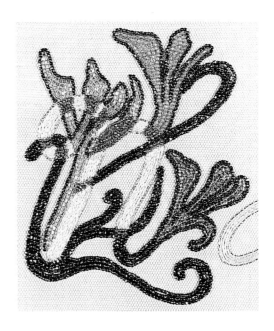

Natalie Barney's salon grew out of a long tradition in which women had been able to exercise power and influence through their positions as saloniéres. Her own salon was unique in that the stature of the women who frequented it was in no way derived from the importance of male visitors, nor were these women expected to "inspire but . . . not write," as their predecessors had been. Nonetheless, revolutionary and feminist ideas had thrived in the early salons, and for that reason numerous saloniéres are honored in relation to the place setting for Barney. This grouping also includes other avowed feminists and lesbians, women who chose women as their companions (with or without a sexual relationship), and women who refused to allow their identities to be submerged by the men with whom they were involved.

DJUNA BARNES *(b. 1892, United States)*: Born and raised in New York and educated at home by her father, Barnes became a novelist, short-story writer, playwright, poetry reporter, theater columnist, illustrator, and painter. Her best-known novel is *Nightwood* (1936), a surreal and poetic book that influenced numerous writers. Her oeuvre also includes a number of less known works. One of her illustrated works, *The Ladies Almanack*, originally printed privately and anonymously and recently reissued, is a highly original and somewhat outrageous satire on the lesbian community that revolved around Barney.

ALICE PIKE BARNEY *(1857–1931, United States)*: Alice Barney, Natalie's mother, was an artist, playwright, patron, and philanthropist. Stifled by her marriage, she took her daughters to live in Paris, where she studied painting and exhibited at the Paris Salon and the London Royal Academy. In 1903 she designed and built Studio House in Washington, D.C., a cultural center that provided studio, performance, and exhibition space for artists. She later established a similar center on the West Coast, as well as organizing a small theater group to perform her own plays.

ANNE BONNEY *(fl. 1700–1720, England)* and MARY READ *(d. 1720, England)*: Bonney and Read were pirates. Bonney joined the ship on which Read was sailing. Read, who was disguised

as a man, revealed her identity only after she and Bonney were suspected of having an affair. The two fought side by side until they were finally captured. Read died in prison, but Bonney, who was sentenced to hang, escaped and was never heard from again.

ROMAINE BROOKS *(1874–1970, United States)*: Brooks, a painter, was the lifelong companion of Natalie Barney and part of the lesbian society that revolved around Barney's salon. Known for her portraits, her work recorded her attachments and relationships with the overlapping worlds of high society, French arts and letters, and the homosexual elite of Paris, where Brooks established herself after inheriting her family's fortune. Except for a one-woman exhibition there in 1910 and an exhibition of drawings in Chicago in 1935, her work was rarely shown. In 1971, one year after her death, a long-overdue retrospective of her work was presented at the National Gallery in Washington, D.C. The exhibition proved her to be a singular figure in the world of art and one of the first painters to deal with lesbian issues, both implicitly and explicitly.

ELEANOR BUTLER *(1745–1829, Ireland)* and SARAH PONSONBY *(1745–1831, Ireland)*: Butler and Ponsonby, both of whom came from titled families, met at a girls' school. They had a close relationship for nearly a decade, before Eleanor's mother tried to end their friendship by insisting that her daughter either marry or enter a convent. Determined not to be separated, the two young women attempted to elope but were apprehended and brought home in disgrace. When Sarah fell gravely ill, Eleanor was forbidden by her family to see her. As soon as Sarah recovered, the women staged a rebellion that finally wore down the resistance of both their families, who gave them a small stipend on condition that they live far away. They settled in Wales, where they attracted many visitors. Butler's journal documented the deep and lasting bond between these two women.

SOPHIE DE CONDORCET *(1765–1822, France)*: De Condorcet was one of the outstanding saloniéres during the period of the French Revolution. Initially devoted entirely to intellectual and cultural pursuits, her salon eventu-

ally became a gathering place for revolutionaries. Outspoken about her radical beliefs, de Condorcet was imprisoned along with her husband. She was released, but her husband committed suicide in prison. After his death she struggled to make a living as a painter but she died in obscurity.

STEPHANIE DE GENLIS *(1766–1841, France)*: Although she was an author, musician, critic, saloniére, and linguist, de Genlis is primarily known for her writings on education. Extremely independent, she was said to have dressed like a man and defied all convention by dancing with servants at balls. She consistently rebelled against the established rules of social behavior, particularly those that stressed class distinctions.

NINON DE L'ENCLOS *(1615–1797, France)*: De l'Enclos's salon was frequented by the most talented and well-educated people of Paris. Determined to remain single, she had numerous relationships and two children, maintaining considerable personal freedom throughout her life and providing a unique example of a woman who lived as she pleased despite social pressure.

JULIE DE LESPINASSE *(1732–1776, France)*: De Lespinasse entered the world of the salons as a companion of Marie du Deffand, one of the major salonists prior to the Revolution. De Lespinasse continued the salon tradition, and her own salon became the social and intellectual center for the Parisian nobility during the reign of Louis XV. Her letters, published in 1809, prove her to have been a strong supporter of democratic ideals.

CATHERINE DE RAMBOUILLET *(1588–1665, France)*: De Rambouillet, who established the first literary salon in France, was disgusted by the coarse, vulgar, and misogynist behavior that she witnessed at the court of Henry IV. She decided to create an environment in which invited guests would be encouraged to share their ideas in an atmosphere of complete equality between the sexes. This resulted in a refinement of manners, the purification of the French language, and the birth of the modern art of conversation. For over thirty years, the Hotel de Rambouillet, a

building that she designed, was the scene of some of France's most enlightened political, social, and literary interactions.

MADELEINE DE SABLE *(1598–1678, France):* The hostess of a literary salon in the de Rambouillet tradition, de Sable was also a gifted writer and influential literary stylist. She introduced and made fashionable the practice of condensing life experiences into maxims and epigrams.

MADELEINE DE SCUDÉRY *(1607–1701, France):* De Scudéry, a salonist and one of the most eminent literary women of the seventeenth century, wrote books that present an unusually complete and vivid picture of the social life of the period.

MARIE DE SÉVIGNÉ *(1626–1696, France):* De Sévigné is famous for a series of letters that she wrote to her daughter over a period of thirty years. These not only present an accurate, lively characterization of the times but serve both as social history and as a compelling model of the literary style of seventeenth-century France.

CLAUDINE DE TENCIN *(1685–1749, France):* De Tencin, who, like many of the salonists, supported the French Revolution, conducted one of the first salons in which the principles of monarchy were denounced in favor of a constitutional government. She encouraged freedom of thought and expression at a time when any criticism of the monarchy could result in arrest.

MARIE DU DEFFAND *(1697–1780, France):* By the age of fifteen, du Deffand realized that she did not want the same kind of life as most of the women she knew. Determined to build a life of personal independence, she left her husband as soon as she could in order to establish herself in Parisian society. The salon she organized provided an important arena for the discussion and development of the political theories and philosophies embodied by the Revolution.

MARIE GEOFFRIN *(1669–1797, France):* Geoffrin added a new dimension to the salon tradition when she brought authors and artists into direct contact with potential distinguished patrons (especially foreign patrons), thereby making a significant contribution to the development of French arts and letters.

RADCLYFFE HALL *(1886–1943, England):* Hall, a writer and member of the Barney circle, lived openly with her lover, Lady Una Troubridge. Her most notable work, *The Well of Loneliness*, was published in 1928 with a foreword by Havelock Ellis. Because it dealt openly with the then-taboo subject of lesbianism, the book became an immediate cause célébre in the literary world. It was judged obscene because of its explicit and sympathetic treatment of homosexuality, and copies of the book were confiscated and burned by Scotland Yard. Eventually the book became widely accepted, but its initial reception shocked and hurt the author. Her later work, which never attracted the same level of attention, is still largely unknown.

MATA HARI *(1876–1917, Holland):* Born in Holland, Gertrude Zelle went to Paris, where she was trained as a dancer. Claiming to be of Japanese descent, she changed her name to Mata Hari. She soon became a celebrated if somewhat notorious exotic dancer, who performed throughout Europe (most notably at Natalie Barney's all-female soirées). Because she knew many government officials and was intelligent and multilingual, she was enlisted by the French government as a spy during World War I. In 1917 she was accused by France of aiding the Germans, but at her trial she claimed to have passed only worthless information to the Central Powers. Although there was no evidence to refute this claim, she was found guilty and executed for treason.

LOUISE LABÉ *(1525–1566, France):* A free-spirited and passionate feminist, Labé was one of the most celebrated poets and cultural leaders of her epoch. At age sixteen, she disguised herself as a man to follow her soldier-lover into battle. She demonstrated such military prowess that the army nicknamed her La Capitaine Louise. She later married a wealthy merchant, and their home in Lyon became one of the centers of the city's cultural life. A singularly independent thinker, she wrote love poems as well as a volume of verse dedicated to another woman poet. In this work,

she appealed to women to not just strive for excellence but to attempt to surpass men in all areas of achievement.

JEANNE RECAMIER *(1777–1850, France):* It was said that the salon of Jeanne Recamier made her almost as influential as Napoleon. The Emperor apparently became enraged by what he viewed as her subversive political gatherings, as well as by her close association with Germaine de Stael, one of his most vocal critics. After de Stael (whom Recamier considered her mentor) was exiled, Recamier insisted upon visiting her, for which she was also exiled. After Napoleon's downfall, she returned to Paris, where she quickly resumed her position as a social and political leader.

MARIE SALLÉ *(1707–1756, France):* A lesbian and pioneer choreographer, Sallé made her stage debut at age nine, later performing with a French touring company, then returning to London in 1727 as an accomplished dancer. Believing that traditional costumes hampered freedom of movement, she instead adopted a simple muslin dress draped in classical Greek style, wore slippers without heels, and let her hair fall free, all of which was considered extremely shocking at the time.

LOU ANDREAS SALOMÉ *(1861–1937, France):* Salomé, one of the first female psychotherapists, struggled all her life to maintain her independence. Known primarily as the inspirer of Nietzche, the confidante of Freud, and the lover of Rilke, Salomé was in her own right an important writer as well as an analyst. Her books on Nietzche and Ibsen and her stories, novels, and essays made her extremely well known during her lifetime. As Anaïs Nin wrote in her preface to Salomé's biography: "She demanded the freedom to change, to evolve, to grow. She asserted her integrity against the sentimentality and hypocritical definitions of loyalties and duties. She is unique in the history of her time."

GERTRUDE STEIN *(1874–1946, United States):* Commenting on her famous phrase "A rose is a rose is a rose," the writer Gertrude Stein stated: "In that line, the rose is red for the first time in English literature in 100 years." In addition to her immense literary influence, she was

one of the first people to recognize the importance of modern painters, building (with her brother) a major contemporary art collection. Her writing was an analog to the avant-garde trends in the visual arts, and several generations of male writers virtually sat at her feet in her Paris apartment. Nonetheless, her own writing was constantly being rejected by publishers, causing her to self-publish many of her early works. It was not until *The Autobiography of Alice B. Toklas* was released in 1933 that she received any significant public acclaim. This memoir—written by Stein in the persona of her lifelong companion, Toklas—became a bestseller, making Stein a celebrity in her American homeland. After touring the United States in the 1930s, speaking, recording, and making radio broadcasts, she returned to France satisfied that she had begun to achieve the recognition she so richly deserved.

CRISTINA TRIVULZIO (1808–1871, Italy):
A political and literary figure, Trivulzio renounced her marriage and refused thereafter to have any relationships whatsoever with men. She went to Paris, where she wrote articles and pamphlets denouncing the political oppression in Italy, arguing in favor of a free press, education for women and the poor, and for the unification of the country under a constitutional monarchy. Returning to Milan, she fought in the Five Days' Revolution of 1848, directing hospital services in Rome when it was under French siege. The founder of several newspapers—through which she agitated for reform—she also wrote fiction, a four-volume work *Essay on the Formation of Catholic Dogma*, and her memoirs.

RENEE VIVIEN (1877–1909, France): Renee Vivien, whose elegant poetry was openly lesbian and feminist, was one of Natalie Barney's lovers, sharing with her a desire to recreate a Sapphic tradition in literature. Vivien produced over twenty volumes of poetry, which dealt with lesbianism, female mythology, Amazons, biblical heroines, and women who either refused to submit to male dominance or chose monsters rather than men as lovers.

Virginia Woolf

(1882–1941)

Born in England, Virginia Woolf was educated primarily at home by her tyrannical father. Delicate from birth, she later commented that, had he not died when he did, she probably would have written no books. It is believed that she was raped by a relative when she was young, which may have permanently affected her sexuality and also contributed to the first of the mental breakdowns that tormented her throughout her life.

In 1904 Woolf moved to Bloomsbury, the center of London's Bohemian intellectual world, where her writing developed against the background of the often-violent English suffrage fight. Although the mere thought of being discriminated against made Woolf physically ill—she often left social gatherings if an antifemale remark were made—she shied away from active social protest. Instead, she addressed feminist issues through her writing, particularly the question of whether a woman's intellectual and creative needs could be satisfied within the framework of married life. Despite her personal conflicts about this, in 1912 she married Leonard Woolf, a writer and intellectual.

When Woolf's first novel was published, she was utterly terrified that her work would be badly reviewed. In fact, whenever she completed a manuscript, she would be threatened by another breakdown.

As her work evolved, she gradually developed a philosophy that posited the subjugation of women as the key to most of the social and psychological disorders of Western civilization. Woolf came to believe that only if the so-called masculine and feminine traits were wedded on all levels—emotional, intellectual, and social—could the world be humanized. Her own struggle to build such an

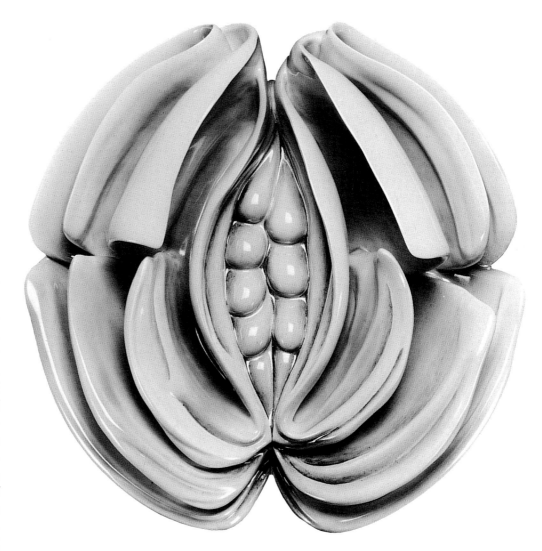

Virginia Woolf plate

integrated literary language must have seemed increasingly hopeless in the rising face of European fascism. Believing that the rise of Nazism was in part a deeply infantile reaction to women's demands for equal rights, she drowned herself in 1941.

Like the beacon emanating from the lighthouse in *To the Lighthouse*, her most famous book, Woolf illuminated a path toward a new, woman-formed literary language. This historical step is symbolized by the plate. This image, almost fully dimensional, is trying to open up and break away from the con-

tainment of the plate form. Its glowing petals reveal a bursting center, a metaphor for Woolf's creative genius and a reference back to the power embodied in the early Goddess plates.

The delicate chiffon of the runner surface emphasizes Woolf's own delicacy. The incredible luminosity of her writing is suggested by the painted and stitched light beam that emanates from beneath the plate. The embroidered waves on the runner front allude to Woolf's book of that title and also to her tragic suicide.

151

Grouped around the place setting for Virginia Woolf are the names of other writers, many of whom believed in a distinctly female point of view. Additionally, the names of writers, philosophers, psychologists, and thinkers who influenced contemporary thought are positioned in relation to their more explicitly feminist sisters.

HANNAH ARENDT *(1906–1975, United States)*: Arendt, a political philosopher, author, and the first woman appointed to a full professorship at Princeton University, was born in Germany. She left for France in 1933 when Hitler came to power, working there in Jewish relief organizations. She later found refuge in the United States, where she served as research director of the Conference on Jewish Relations from 1944 to 1946. Actively concerned with the preservation and transmission of Jewish heritage, Arendt translated and published a number of works by Jewish writers. Her most influential book, *The Origins of Totalitarianism,* was released in 1951. It established her as a major philosopher and political theoretician.

WILLA CATHER *(1873–1947, United States)*: Cather, raised in Nebraska and educated by her grandmothers, created some of the most memorable characterizations of frontier women in American literature. She left a legacy of powerful and independent heroines who were often punished for their strength by loneliness and isolation. As a teenager, Cather called herself William and dressed like a boy, and even though her lesbianism was never explicit, she had a lifelong female companion.

COLETTE *(1873–1954, France)*: Colette's career began when her first husband locked her in her room, forced her to write, then published her work under his own name. Divorced in 1906, she had to sue to regain title to her own work. She went on to become one of France's major writers and an international figure in the literary world. In her work she vividly described the struggles between women and men, focusing primarily on the lives of women, including her mother, of whom she wrote often and fondly.

SIMONE DE BEAUVOIR *(b. 1908, France)*: Beauvoir, a major twentieth-century author and Existentialist philosopher, was born into a bourgeois Parisian family. At the age of fifteen she decided to become a writer. In 1929 she received her degree in philosophy from the Sorbonne, placing second in her graduating class. First place was taken by Jean-Paul Sartre, who became her lifelong friend and companion. After the war Beauvoir emerged as one of the leaders of the Existentialist movement, and her ideas and writings had a profound effect on the intellectual communities of both Europe and the United States. In 1949 she published *The Second Sex*, an examination and indictment of Western civilization's treatment of women. Translated into nineteen languages, its impact was felt around the world. Originally she looked to the socialist system to bring about an alteration of women's status, but later, "discouraged by socialism's failure to create a true social revolution," she become an avowed feminist.

HELEN DINER *(fl. 1929–1940, Germany)*: Diner was the pseudonym of Bertha Eckstein-Diener. She was the author of *Mothers and Amazons*—the first feminine history of culture—as well as a number of other books. Basing her ideas upon the research of the Swiss anthropologist Bachofen and on the theories of Jung, Diner presented the revolutionary argument that most early societies were matriarchal and that the patriarchal family was actually a comparatively recent social development. Her work became an important source for feminist theory.

ISAK DINESEN *(1885–1962, Denmark)*: Dinesen was the pen name of Karen Blixen, a member of the Danish aristocracy who at age nineteen published several short stories and a marionette comedy. But it was to be thirty years before she published anything again. In the interim, she married a distant cousin, the Baron von Blixen, and went to British East Africa, where they managed a coffee plantation. Although the marriage ended after seven years, she continued to operate the plantation alone until a drop in coffee prices in 1931 forced her to give up her land. She then had a long-term friendship and affair with the bush pilot and "white hunter" Denys Finch-Hatton. After his death in an airplane accident,

she returned to Denmark and finally resumed her writing. Her best books, *Out of Africa* and *Shadows on the Grass,* are lyric evocations of her African experience.

LORRAINE HANSBERRY *(1930–1965, United States)*: In 1959 Hansberry wrote *A Raisin in the Sun,* the first play by a black woman to be produced on Broadway. This milestone work in the development of black literature was also the first play by an African American writer to receive the New York Drama Critics Circle Award. Hansberry was then commissioned to write a television play about slavery, but when network officials read it they refused to produce it.

KAREN HORNEY *(1885–1952, United States)*: In the 1920s Horney, a neo–Freudian analyst, offered her theories about female behavior as a direct challenge to the prevailing Freudian point of view. Arguing that social and cultural forces—rather than biology—shaped human personality and sexual identity, she repudiated the noted Freudian theory of penis envy. Horney contended that women only envied men's privileged position in society, even going so far as to suggest that men might actually suffer from womb envy and be jealous of women's reproductive capabilities. In 1941 Horney founded the American Institute for Psychoanalysis, where she served as dean until she died.

MARY ESTHER KARDING *(fl. 1920s, United States)*: Harding, a Jungian psychologist and writer, was a forerunner in the development of a specifically feminist therapy. Her books *Women's Mysteries* and *The Way of All Women* interpret women's history and personal experience from a Jungian and feminist perspective. In *Women's Mysteries,* she discussed the crucial relationship between Goddess worship in early civilizations and the high degree of political and social power that women possessed at that time.

SELMA LAGERLOF *(1858–1940, Sweden)*: Lagerlof, whose work is beloved by the Swedes, was the first woman to become a member of the Swedish Academy and the first to be awarded the Nobel Prize for Literature (in 1909). Her sagas and narratives are considered some of the finest literature from her country.

SUZANNE LANGER (*b. 1895, United States*): One of the few women to achieve recognition in the heavily male-dominated field of philosophy, Langer was primarily interested in aesthetics and the meaning of symbols. Her later works explored the nature of symbolism, poetic creativity, music, language, abstraction, and the issue of emotion in art. In her book *Philosophy in a New Key*, she argued that life was barren without meaningful symbols. Langer sought a synthesis between the objective and the subjective—or, as she put it, between form and feeling.

DORIS LESSING (*b. 1919, England*): Lessing is probably best known for *The Golden Notebook*. Published in 1962, this farsighted book documented the intellectual, political, and personal life of a modern emancipated woman, a theme that has recurred in the work of many other women. Lessing's first novel, *The Grass Is Singing*, examined male-female relationships against the background of the destructive relationship between "the stupid and unimaginative lives" of South African colonizers and the native inhabitants. In the five-volume *Children of Violence*, written and published over a seventeen-year period, Lessing chronicled Martha Quest's search for self-definition in a world that becomes increasingly terrifying and surreal. Her worldview of life has become steadily more pessimistic. She has often stated that she does not believe the human race will survive much longer, which she has expressed in her multivolume science fiction series, *Shikasta*.

EDNA ST. VINCENT MILLAY (*1892–1950, United States*): A celebrated poet and dramatist, Millay began writing verses during her childhood. Her first volume of poetry was published in 1917, and in 1923 she was awarded the Pulitzer Prize for her poem "The Harp Weaver." Millay challenged the traditional image of the genteel lady poet, creating work that was unusually impassioned and often angry.

GABRIELA MISTRAL (*1889–1957, Chile*): Mistral began her varied career as a primary- and secondary-school teacher. Because of her extensive experience within the village schools of Chile, she was asked by the Mexican government to participate in the reorganization of that country's rural school system. She later became Chile's delegate to the United Nations and was appointed to the U.N. Subcommission on the Status of Women. Also a poet, Mistral is considered the founder of the modern poetry movement in Chile. She was awarded the Nobel Prize for Literature in 1945.

ANAÏS NIN (*1903–1977, United States*): Nin, who came to America as a child, was brought up in New York. Bored with high school, she quit at fifteen, burying herself in the public library, where she read from A to Z in the fiction section. In the 1920s she went to France and began traveling back and forth from Europe to the United States. She worked as an artist's model, studied dance, underwent psychoanalysis with Otto Rank, and even became a therapist herself for a while. She came to be known as a "patron of sorts," through helping such struggling writers as Henry Miller and Lawrence Durrell. Nin began writing at an early age, leading a double life both as an author and in life. While writing surrealistic novels and playing multiple roles—wife, lover, protector, enigma—she confided her real self only to her diary. At her death, the diary consisted of over 150 manuscript volumes and was a record of the slow, painstaking process of a woman emerging from a disguised identity into her authentic self. Despite the efforts of many men to tear her diary from her (including Rank, who believed it to be a symbol of her neurosis), Nin had insisted on recording her isolated voyage. But until the 1960s, her journey remained invisible to all but a few close friends. She had limited editions of some of her works printed on a press that she herself purchased, passing them out to authors and critics in the hope of some response. However, the audience seemed so meager that she herself began to doubt the value of her life and work. Finally, Nin's diaries began to be published, primarily because they were thought to be significant in relation to the male writers she had known. When the first diary sold out almost immediately, its publisher was puzzled. Partly as a result of the women's movement, there was a new female audience that recognized in Nin's solo flight the story of their own fledgling independence. Her diaries, her novels, and her letters were finally recognized as the expression of

Virginia Woolf capital letter: embroidery by Susan Brenner

an original and brilliant literary figure who, at the end of her life, was hailed as a unique female creator.

EMILIA PARDO-BAZÁN (*1852–1921, Spain*): Pardo-Bazán is considered by some to be Spain's greatest nineteenth-century novelist. In 1879 she published the first of eighteen naturalistic novels, and in 1906 she became the first woman to chair the literature section of the Athenaeum in Madrid. She was later named advisor to Spain's Ministry of Education and appointed professor of romance literature at the Central University of Madrid. However, the all-male university faculty protested her appointment, while the male students boycotted her classes.

DOROTHY RICHARDSON (*1872–1957, England*): The author of a thirteen-volume semi-autobiographical novel, Richardson was an innovator in modern fiction. The term "stream of consciousness" was first applied to her book *Pilgrimage*, which took her twenty years to write. Attempting to create "a feminine equivalent of the current masculine realism," this epic work is an account of a woman's search for self-discovery, freedom, and independence in a world dominated by men.

NELLY SACHS (1891–1970, Germany): Sachs, who is often called the Poet of the Holocaust, created a body of work that was a profound lamentation for the terrible tragedy that befell the Jews. Born in Berlin to a family of prosperous Jewish industrialists, she received training in the arts as well as literature. Reading Selma Lagerlof's books shaped her future as a writer, and she began a correspondence with Lagerlof that lasted for years. In 1940 Sachs and her mother were brought to Sweden by Lagerlof, who presented a personal petition to the government to obtain the family's escape from Germany. In 1966 Sachs received the Nobel Prize for her writing.

VITA SACKVILLE WEST (1892–1962, England): Sackville West, a writer and entirely unique woman, was the inspiration for Virginia Woolf's spoof *Orlando*. She married Harold Nicholson, a prominent member of the Foreign Service. Their unconventional relationship was chronicled by their son in *Portrait of a Marriage*, which was based upon her unpublished memoirs. Both she and Harold had numerous affairs with members of their own sex. Despite this and also Vita's intense and well-chronicled involvement with Virginia Woolf, she and her husband maintained a close relationship for fifty years, producing two sons and writing daily love letters to one another. Unfortunately, the notoriety about their relationship has obscured the fact that Vita was a highly gifted and successful writer of poems, novels, short stories, biographies, and literary criticism.

OLIVE SCHREINER (1855–1920, South Africa): An avowed socialist, feminist, and suffragist, Schreiner created a body of work dealing with the position of women in society along with women's relationship to work, the family, and the class structure. In her books, short stories, allegories, and essays, she developed a powerful feminine symbology that influenced Woolf, Richardson, and Lessing. Her *Women and Labor* became a textbook for the early women's movement, and from 1885 until her death she worked on *From Man to Man*, a novel about sisterhood and motherhood that was published posthumously in 1926.

EDITH SITWELL (1887–1964, England): Dame Edith Sitwell hated the dull and ordinary, preferring to devote herself to "the avant-garde in literature and the eccentric in lifestyle." Sitwell was intensely interested in the sound of words, once delivering a reading from behind a screen to ensure that her personality would not impinge upon the audience's concentration on her voice. To further emphasize this, she experimented with reading through a megaphone and reciting her poetry to music. In addition to being an innovative writer, Sitwell was also an astute critic, prolific prose writer, and the author of several biographies.

AGNES SMEDLEY (1894–1950, United States): Smedley, a writer, radical journalist, and lecturer, grew up in poverty and hardship in rural Missouri, then lived in a series of small Colorado mining towns. She became deeply involved in left-wing politics. After writing sympathetically about the Chinese Revolution, she was exiled from America and accused of being a spy. Summing up her philosophy, Smedley said: "I have had but one loyalty and one faith, and that was to the liberation of the poor and oppressed."

ALFONSINA STORNI (1892–1938, Argentina): With the publication of her first volume of poems in 1916, Storni emerged as an important modern Argentinean writer. She wrote over a dozen poetic works and is considered the first poet in her country to write from a woman's point of view.

SIGRID UNDSET (1882–1949, Norway): A novelist and the recipient of the Nobel Prize in 1928, Undset is best known for her books depicting Scandinavian life during the Middle Ages.

SIMONE WEIL (1909–1943, France): Weil was a scholar, philosopher, mystical writer, and revolutionary who identified so closely with the oppressed peoples of the world that "existence was continual agony to her." During World War II, when she became involved in the French Resistance, she permitted herself to eat no more than the rations allowed her countrymen in the occupied territories. Her later decision to die of voluntary starvation became a symbol for many European intellectuals of her moral integrity.

REBECCA WEST (b. 1892, Ireland and England): A renowned journalist, novelist, and social critic, West was respected in both the United States and Great Britain. Her critical work was published regularly in the *New Yorker*, while her feminist views appeared in many political periodicals of the left-wing press. Her astute reportage of the Nuremberg trials was published as *A Train of Power* in 1955.

EDITH WHARTON (1862–1937, United States): One of America's most distinguished writers, Wharton was born into a New York family of merchants, bankers, and lawyers whose biases against both women and artists helped drive her abroad. She spent most of her life writing stories and novels that expressed her discontent with the constrained role of women, graphically describing the limited society from which she had fled. In *House of Mirth*, the heroine Lily Bart commits suicide rather than face the "disgrace" of not having acquired a suitable husband. In *Age of Innocence*, for which Wharton won the Pulitzer Prize, the male characters are vigorous only in their domination of women. Discussing her personal isolation in one of her letters, she wrote: "I believe I know the only cure, which is to make one's center of life inside one's self . . . to decorate one's inner house so richly that one is content there."

ADELA ZAMUDIA-RIBERO (1854–1928, Bolivia): Zamudia-Ribero, feminist, poet, and educator, spoke out against the oppression of women in Bolivia, arguing passionately for better education, more job opportunities, and the right to vote. In one of her most famous satirical poems, she protested the fact that even the most ignorant and illiterate man could then vote, while intelligent, educated women could not.

Georgia O'Keeffe

1887–1986

Originally from Wisconsin, O'Keeffe studied at the Chicago Art Institute and the Art Student's League in New York. Frustrated when her painting seemed to come to a standstill, she returned to her family's home intending to give up her art career. She then took a teaching position in Texas and there—among the "terrible winds and wonderful emptiness"—she began painting again.

One day O'Keeffe assembled all her work and, recognizing that it seemed derivative of other artists, destroyed it all. She started an entirely new and startling series of drawings, which, when finished, she sent to a friend in New York. Although O'Keeffe had insisted that her work not be shown to anyone, her friend disobeyed her, taking it to the small but famous Gallery 291. When Alfred Steiglitz, the photographer and owner of the gallery, looked at the work, he was struck by the fact that the drawings gave "something of a 'woman' feeling; and a woman isn't a man," saying: "Finally, a woman on paper."

In 1924 O'Keeffe and Steiglitz were married. But she kept her own name, inquiring: "Why should I take on someone else's famous name?" O'Keeffe began to visit New Mexico, drawn there by the landscape, which she painted again and again. After Steiglitz died, she moved there permanently, refusing to allow anything to distract her from what became a well-ordered pattern of existence and a life increasingly centered on art. For several decades there was little interest in her work. Then in the late 1960s—although her style had not dramatically changed—there was renewed focus on her painting as well as intense curiosity about her independent lifestyle,

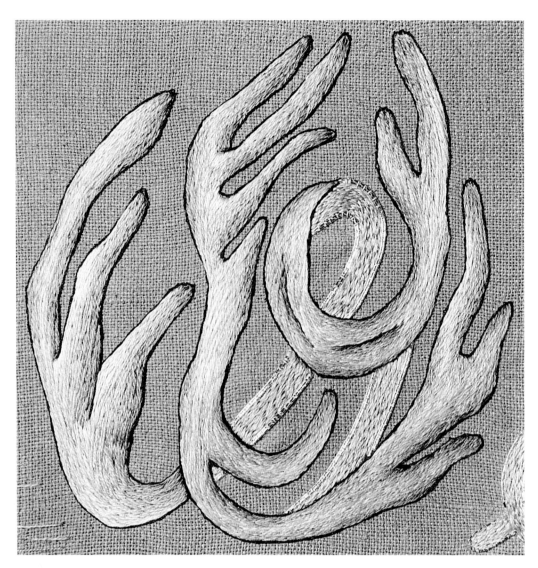

Georgia O'Keeffe capital letter; embroidery by Terry Blecher

probably fueled by the women's movement and its search for female heroes. O'Keeffe met this with an unwillingness to acknowledge that her work might reflect a feminine sensibility, along with a typically taciturn response: "It is just that what I do seems to move people today in a way that I don't understand at all."

The plate honoring O'Keeffe is a sculptural translation of one of her paintings, *Black Iris.* It is also an acknowledgment of my own aesthetic debt to her, for despite her disclaimer, I consider her work to be pivotal in the development of an authentically female iconography.

The runner is made of Belgian linen, the painter's canvas, and stretcher bars define its edges. The sides are cut, raw, and unstretched, a metaphor for the unusual degree of aesthetic freedom that O'Keeffe attained. The capital letter is embroidered to suggest the reaching antler forms typical of many of her paintings. Its gesture, like that of the plates, embodies the yearning for liberation to which so many of the women represented in *The Dinner Party* aspired.

155

"Why have there been no great women artists?" is a question that is still too often asked. The question itself reveals a profound lack of knowledge about the many obstacles faced by women in their centuries-long struggle to fully participate in the arts. Surrounding the place setting for O'Keeffe are the names of a number of other heroic women who broke through the many formidable barriers to women's full creative expression.

DOROTHY ARZNER (*b. 1900, United States*): One of the few women to become a major director in Hollywood, Arzner began as a typist at Paramount. She became an editor, then wrote and helped to film and edit *Old Ironsides* in 1925. She directed seventeen feature films in all. Working with the major female stars of the day, she directed them in roles that explored many facets of the female personality, thereby challenging some of the stereotypes about women perpetuated by most other Hollywood films.

MARIE BASHKIRTSEV (*1860–1884, Russia*): In 1877 Bashkirtsev enrolled in the women's art class at the Academie Julien in Paris. In her journals, published ten years later, she described the many injustices faced by her and other women artists, outlining the lack of opportunities available to them. She inveighed against the poor quality of art instruction available to women and discussed the devastating effect on women's art produced by the lack of adequate training, combined with restricted opportunities. Bashkirtsev then explained how these factors had contributed to her growing commitment to feminism.

SARAH BERNHARDT (*1844–1923, France*): Bernhardt, the most celebrated actress in French history, became a legend throughout the world during her sixty-year career. Along with her many other roles, she starred in *Queen Elizabeth*, the first full-length American feature film. Though she was quite tall and weighed over 190 pounds, the Divine Sarah was considered one of the loveliest women in the world.

ROSA BONHEUR (*1822–1899, France*): Bonheur, known primarily for her large-scale animal paintings, was one of the most celebrated and successful woman artists of the nineteenth century. Unable to study the nude because she was a woman, she dressed in men's clothing and went every day to the slaughterhouses and horse fairs in order to learn anatomy. She worked constantly, making extensive preparations and sketches and sometimes waiting two years for the oils to dry before applying another layer of paint. Internationally acclaimed, Bonheur was able to earn enough to buy a large estate, which she filled with exotic animals. In this private paradise, she lived and worked, first with Natalie Micas as her companion and then, until the end of her life, with Anna Klumpke, who was also an artist.

JULIA CAMERON (*1815–1879, England*): Cameron, who was Virginia Woolf's aunt, picked up a camera for the first time when she was forty-eight years old. She created some of the most expressive documents of the Victorian period, eventually producing over three thousand pictures. Her work included portraits, along with religious, symbolic, and allegorical photographs.

EMILY CARR (*1871–1945, Canada*): Although little known outside of Canada, Carr was an unheralded genius who, like O'Keeffe, began to open up visual forms to a female perspective. Accompanied only by her companion animals, she journeyed into the forests of northwest Canada to record the rituals, lives, and totems of the Northwest Coast Indians. Her later paintings depict the raw Canadian wilderness, anthropomorphized in feminine terms. Her final paintings were deeply spiritual: the forest transformed into a cathedral-like space, the images rich in symbolism. Carr, who only exhibited five times in her lifetime, did not have a one-woman exhibition until she was sixty-three. Often discouraged, she wrote in one of her books: "How completely alone I've had to face the world; no booster, no artistic backing, no relatives interested, no bother taken by papers to advertise, just me and an empty flat and the pictures."

MARY CASSATT (*1844–1926, United States*): Cassatt, a major figure in art history, was the most important woman artist of the nineteenth century and perhaps the best American artist of her generation. She settled in Paris in the early 1870s and exhibited there with the Impressionists. Fascinated by the Japanese prints that were then popular, she made a series of aquatints that are considered among the finest colored prints ever created. Her later work concentrated increasingly on the subject of mother and child; her approach to the theme was unique, generally unsentimental, yet always expressive of a wide range of human interaction. She was commissioned to create a monumental mural for the 1893 women's building at the 1893 Chicago World's Fair, which she titled *Modern Woman*. It consisted of three panels with feminist themes, including "Young Women Plucking the Fruits of Knowledge and Science," "Young Girls Pursuing Fame," and a third devoted to women involved in music and dance. Sadly, this incredible and wholly original work was lost.

IMOGEN CUNNINGHAM (*1883–1976, United States*): When Cunningham died at the age of ninety-three, she had just completed her last collection of photographs, *After Ninety*, which included portraits of "survivors" like herself. Influenced by the work of Gertrude Kasebier, she took her first photograph in 1901. Her early work was typified by a soft-focus pictorial style that was both allegorical and romantic. At this same time, she photographed her husband naked on Mt. Ranier, probably the first time a woman ever photographed a male nude. The pictures were censored for years. After moving to the San Francisco Bay area, Cunningham found herself forced to spend more time at home raising her children. She solved this problem by concentrating on subject matter in her own backyard, doing some of her finest work in sharp-focus closeups of flower and plant forms.

SONIA DELAUNAY (*b. 1885, France*): A pioneer abstract painter and a co-founder (with her husband, Robert) of Orphism, Delaunay had a long and productive career in the arts. She brought a personal vision and great energy to the decorative and applied arts. Her work was motivated by her belief in the many ways that art and design could benefit a democratic society. In addition to painting, she designed costumes, fabric, furniture and tapestries, illustrated books, and also did interior decoration.

MAYA DEREN (*1922–1961, United States*): Deren, a major figure in avant-garde film, was a

pioneer in distributing her own films and championing the cause of independent filmmakers. Her images were often heavily symbolic, offering striking examples of the possibilities of experimental film and revealing a unique and obviously feminine sensibility.

ISADORA DUNCAN (1878–1927, United States): Barefoot and dressed only in a flowing white tunic, Duncan introduced a form of movement that revolutionized the dance world. Challenging the basic tenets of ballet, she searched for a spiritual rather than physical center of motion, which, once felt, she stated, made motion effortless. She believed that young children easily grasped this idea but that "materialist society quickly robbed them of their innate spiritual power and grace." Although enthusiastically accepted in Paris and Russia, Duncan's dancing was less well received in America, partly because she moved with an unconstrained freedom considered shocking at the time.

ELEANORA DUSE (1858–1924, Italy): Duse, one of the greatest actresses of her time, was known for her naturalistic style. Her most famous role was as Ibsen's Hedda Gabler; her interpretation was so powerful it was said to have overwhelmed the playwright.

EDITH EVANS (1888–1976, England): One of England's foremost Shakespearean performers, Evans made her debut as Beatrice in *Much Ado About Nothing* in 1912. In 1931 she first appeared on Broadway as Florence Nightingale in *The Lady with the Lamp*, and in the 1940s she began to appear in films. On November 20, 1950, as England's first lady of the stage, Evans spoke the prologue at the joyous reopening of the Old Vic Theater, which had been destroyed during the German blitz. She received numerous acting awards, along with honorary doctorates from Cambridge and Oxford.

NATALIA GONCHAROVA (1881–1962, Russia): The innovative painter Goncharova (with her companion Mikhail Larionov) was the leader of an avant-garde movement that advanced Russian art in the early twentieth century. She also worked with Diaghilev on decor and costumes for the Ballet Russe.

MARTHA GRAHAM (b. 1894, United States): Graham created an entirely new style of dance through which she explored and expressed "the emotions and the inner being." Her most forceful and vivid creations were her portrayals of heroic women, both real and legendary. Her performing career spanned fifty years, and by the time she retired from the stage in 1970, she had created 150 works and had taught and influenced generations of dancers all over the world.

EILEEN GRAY (1879–1976, Ireland): Gray was a forerunner of many of the modern movements in design. She built several houses that expanded upon the nineteenth-century concern with the efficient employment of space. She also developed a number of interior spaces and pieces of furniture that were unusually rich, sensual, and personal. While interred as an "enemy alien" in France during World War II, her house was looted and much of her work destroyed. Devastated by these events, along with the almost total lack of recognition of her innovative designs, she lived in seclusion for the remainder of her life.

SOPHIA HAYDN (1868–1953, United States): Haydn—the first female graduate in architecture from MIT—won the competition to design the Woman's Building at the Columbian Exposition in 1893 in Chicago. In an effort to draw attention to women's progress in entering previously all-male professions, the Board of Lady Managers (in charge of the building) had established a $1,000 prize for a woman architect. Haydn was only twenty-two years old and just out of school when her proposal was chosen. She went to Chicago to supervise the construction, where she was confronted with constant interference. Then, when the building opened, it was bitterly attacked by critics as a "student's creation and a woman's work." Disheartened and depressed, Haydn never designed another building.

KATHARINE HEPBURN (b. 1909, United States): Hepburn, the only woman to win an Oscar for best actress three times, created some of the screen's most memorable female characters. The spirit and individuality that infused her life and work were fostered in part by her feminist mother, who was active in both the suffrage and birth-control movements.

BARBARA HEPWORTH (1903–1975, England): By the time she was sixteen, Hepworth had decided to become a sculptor, soon becoming a fellow student of Henry Moore. In 1931, a year before Moore, Hepworth made the historic step of piercing her sculptures, taking "the most intense pleasure" in modifying their form in accordance with her own biology. She consistently described her abstract shapes as related to the earth, to the human figure in the landscape, and to her own experience as a woman, asserting that "there is a whole range of formal perception belonging to the feminine experience."

HANNAH HOCH (1889–1971, Germany): Hoch, along with a male colleague, invented photomontage, the medium that she employed all her life. In her collages, she utilized objects traditionally associated with women, including lace, buttons, and bits of fabric, often making strong and ironic images of female experience.

HARRIET HOSMER (1830–1908, United States): In the midnineteenth century, Hosmer went to Rome to study art. She soon achieved considerable renown, not only for her remarkable Neoclassical sculptures but for her masculine attire, her midnight rides through the city, and her taste for ambitious projects requiring as many as thirty assistants in her large studio. She was the leader of and inspiration to a group of women artists who gathered around her in Rome.

FRIDA KAHLO (1910–1954, Mexico): Because of her unique artistic vision and enormous personal courage, Kahlo became a heroine in both the feminist art movement and to Hispanic and Mexican artists. Badly injured when she was fifteen, she faced her physical infirmity and agonizing pain with grace and dignity, transforming the difficulties of her circumstances into haunting self-portraits. Her images, which are vividly infused with the warmth of native Mexican art, transform joy and pain, tragedy and humor, into a complex vision of one woman's universe.

IDA KAMINSKA (b. 1899, Poland): A major force in Yiddish theater, Kaminska founded the Warsaw Jewish Art Theatre and then the Ida Kaminska Theatre, where she not only performed but worked as producer and director as well.

When antisemitism forced her to emigrate to New York, she re-created the Yiddish theater there. In 1965 she gave one of her most moving performances in the Polish film *The Shop on Main Street.*

GERTRUDE KASEBIER *(1852–1934, United States)*:
Kasebier had to wait until her three children were grown to begin expressing her lifelong desire to "make likenesses that are biographies." In 1897 she opened a portrait studio in New York, doing a series of portraits that were remarkable in that she used only available light and natural settings, both departures from formal Victorian studio-portrait techniques. She also created a series of allegorical photos exploring many aspects of the concept of motherhood.

KATHE KOLLWITZ *(1867–1945, Germany)*:
Kollwitz, a major sculptor and prolific graphic artist, felt a strong identification with working-class people, stating: "When I really got to know about the want and misery of the working classes . . . I felt I had a duty to serve them through my art." Her work sustained her through the many tragedies of her life: the death of her son Peter in World War I, the ban placed on her work by the Nazis, her forced evacuation from her home during the war, and the death of her husband. She left a powerful record of a woman whose vision was heroic and whose art was drawn from the deepest well-springs of feminine compassion.

DOROTHEA LANGE *(1895–1965, United States)*:
Lange is best remembered for her powerful photographs of migrant agricultural workers, pictures so eloquent that they served to arouse national sympathy for their plight. She began as a portrait photographer in San Francisco, but during the Depression she took her camera out of the studio and into the streets. After being sent by the Department of Agriculture to document the miserable conditions of agricultural workers, she went on to photograph the tragic dislocation of Japanese-Americans, who were being interred in concentration camps in California. In her last series, *The American Country Woman*, she attempted to depict American womanhood in ways that departed from the media image of "our well-advertised women of beauty and fashion." In-

stead, she wanted to present "women of the American soil. They are a hardy stock. They are the roots of our country."

MARIE LAURENCIN *(1885–1956, France)*:
Laurencin was a painter and a member of the circle around Picasso in Paris during the early twentieth century. Behind the artifice and perfumed sweetness of the women in Laurencin's paintings, there is an aura of sadness that speaks of containment and stifled rage. She also designed sets and costumes for the ballet and theater, illustrated a number of books, and produced lithographs, etchings, and woodcuts. Her early work was critically acclaimed, though in later years her art was generally ignored.

MARY LOUISE McLAUGHLIN *(1847–1939, United States)*:
McLaughlin, a pioneer American ceramicist, was fascinated by the unique European underglaze slip decoration that she saw at the 1876 Centennial Exhibition. In 1879 she organized a group of women in Cincinnati to experiment in ceramics and china-painting and to try to duplicate the quality of the European ware. Her innovative work in the use of colored slip and underglaze painting became the basis for the Rookwood pottery techniques. Established by Marie Longworth Nichols, this was one of the first important art potteries in America. McLaughlin's later experiments with porcelain resulted in innovative and exquisite art nouveau pieces. A consummate craftswoman, she worked in wood-carving, stained-glass, metalwork, jewelry-making, etching, needlework, sculpture, and painting. She also wrote two manuals on pottery decoration and one on oil-painting.

PAULA MODERSOHN-BECKER *(1876–1907, Germany)*:
The talented painter Modersohn-Becker was convinced by her husband to resume their marriage after she had separated from him in order to pursue her work. She soon became pregnant and, three weeks after the birth of her daughter, died of heart failure. By the time of her death at the age of thirty-one, Modersohn-Becker had already produced almost four hundred paintings and studies and almost a thousand drawings. Her images of women are earthy, sensual, and celebratory. In describing her vivid self-portraits, she wrote: "And finally you saw your-

self as fruit, lifted yourself out of your clothes and carried that self before the mirror, let it in up to your gaze."

JULIA MORGAN *(1872–1957, United States)*:
When Morgan received her degree in 1894, she was the only female student at the University of California School of Engineering. She became the first woman to study at the École des Beaux Arts in Paris and the first to obtain a degree there. The first licensed female architect in California, she opened her own office in San Francisco in 1904. Morgan's buildings—whether brown shingle residences or Renaissance-style edifices—reflected her elegant sense of design, her concern with interior and exterior space, and her respect for materials and the principles of construction. Although her most famous building is Hearst's Castle at San Simeon, she designed over a thousand others in a career that spanned fifty years.

BERTHE MORISOT *(1840–1895, France)*:
Morisot, from an upper-middle-class French family, was fortunate in that she was able to obtain art training. She continued to paint even after she married Eugene Manet, the younger brother of the artist Edouard. Because the content of her work was primarily women and children and also as a result of its intimacy, her art has often been derisively labeled as "excessively feminine." However, its gentle charm, combined with its vigorous brushwork, would be better described as successfully blending both strength and tenderness.

GABRIELE MÜNTER *(1877–1962, Germany)*:
Münter was closely associated with Wassily Kandinsky and the Blue Rider Group in Munich. After their personal relationship ended, her work changed. Instead of the earlier brilliantly colored landscapes and portraits of friends, Münter painted somewhat melancholy studies of women. Her last works, though markedly introspective, are typified by an authentic and rich personal style.

LOUISE NEVELSON *(b. 1899, United States)*:
Nevelson studied at the Art Student's League in New York. After becoming dissatisfied with traditional materials and forms, she started to work in wood. Gluing and nailing disparate objects

that she first collected, she assembled them in milk crates, which she painted in one tone in order to create an overall unity of form. In the 1950s, after several decades of struggle and obscurity, Nevelson finally began to receive recognition for the unique and innovative sculptures, wall reliefs, and environments that she had created.

ELIZABETH NEY (1833–1907, Germany): Ney was the first woman to attend the Munich Art Academy. At first she was refused admittance on the basis that "there would be little work done by the male students with her to distract them." After vowing that she would leave the class if the male students' work suffered, she was finally admitted. She went on to achieve a successful career as a sculptor, doing portraits of many notable people. She later married and, with her husband, emigrated to America, where she bore a son. For twenty years she did little work. Finally she was commissioned to do a statue for the Columbian Exposition in Chicago. She resumed her career, spending the rest of her life in Austin, Texas, where her home and studio became a museum dedicated to her work.

ANNA PAVLOVA (1885–1931, Russia): One of the century's greatest ballerinas, Pavlova began her career with the Russian Imperial Ballet Company in 1899, becoming the dazzling prima ballerina of the troupe and bringing new life to many of the classics.

AUGUSTA SAVAGE (1900–1962, United States): Savage, one of America's most important African American artists, attended Cooper Union in New York, then applied to art schools in Paris. She was rejected without an explanation, only to later discover that it was because of her race. From then on she worked on behalf of black artists, teaching art to black children, serving as president of the Harlem Artists Guild, and creating strong images of African Americans in all her sculptures. Because she lacked the money to have them cast in bronze, many of Savage's works have been damaged or destroyed. Most tragically, this was the fate of her largest and most important work, *Lift Every Voice and Sing!* which was commissioned for the New York World's Fair in 1939–1940. Her

monumental representation of black contributions to music—cast in plaster—was bulldozed at the closing of the fair.

SOPHIE TAEUBER-ARP (1889–1943, Switzerland): Originally a weaver, embroiderer, and dancer, Taeuber-Arp began to paint in 1916. Her early innovative work in the decorative arts contributed to her later painted geometric abstractions. Married to the famous artist Jean Arp, like many women artists of her generation she worked in secret and her achievements were overshadowed by his.

SUZANNE VALADON (1865–1938, France): Valadon had no formal training as an artist. In 1893, while working as an artist's model, she began to draw. Her bold and intuitive work developed rapidly and was strong, earthy, and unrelentingly honest. She brought an uncompromising vision to her art, particularly to the self-portraits that documented her own aging. Some of her most interesting work was done when she used her husband as a model to create images of the male nude from a distinctly feminine point of view. For a long time, Valadon was known only as the mother of the painter Utrillo, whom she trained.

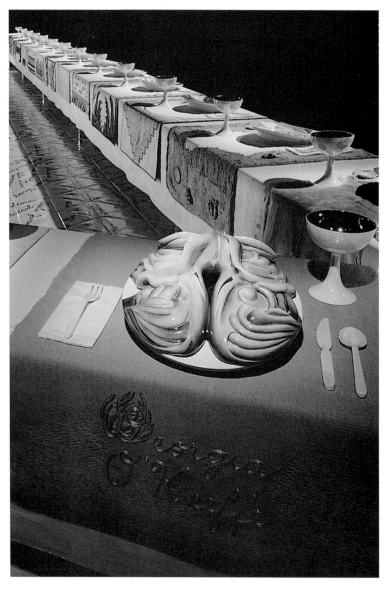

Georgia O'Keeffe place setting with view of runner backs, Wing One

159

PART THREE

A Tour of
The Dinner Party

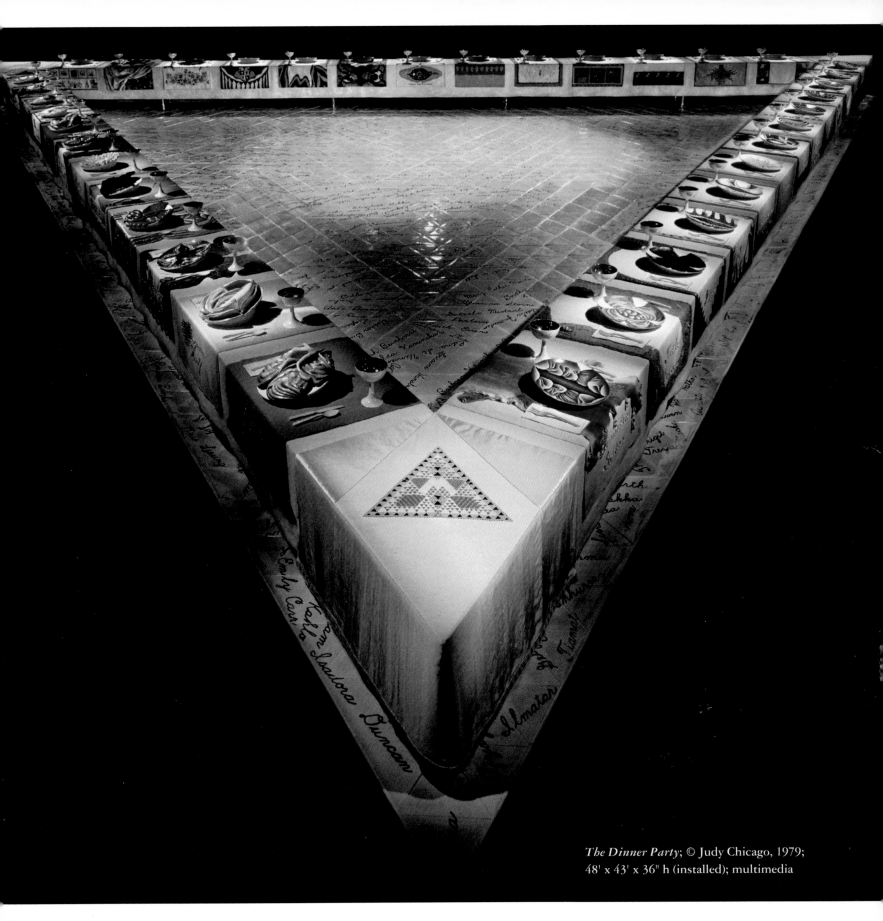

The Dinner Party; © Judy Chicago, 1979;
48' x 43' x 36" h (installed); multimedia

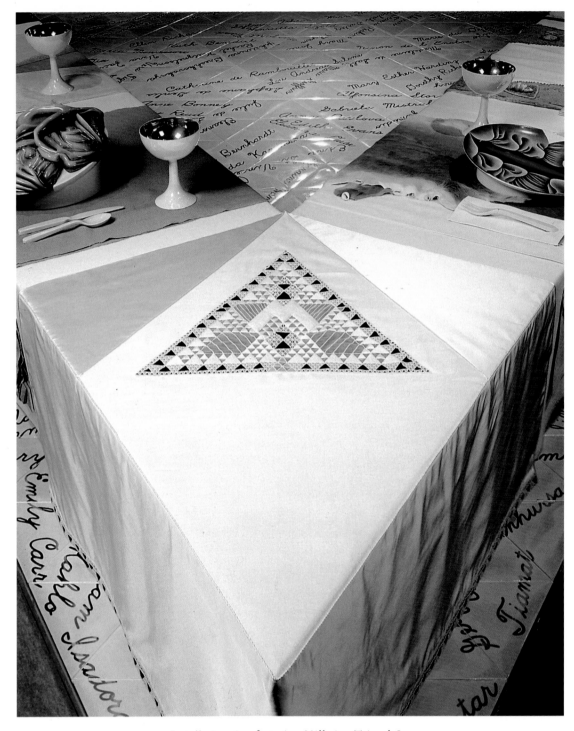

Installation view featuring *Millenium Triangle I*

FACING PAGE: Installation view featuring *Primordial Goddess* and *Fertile Goddess* place settings
with view of runner backs, Wings Two and Three

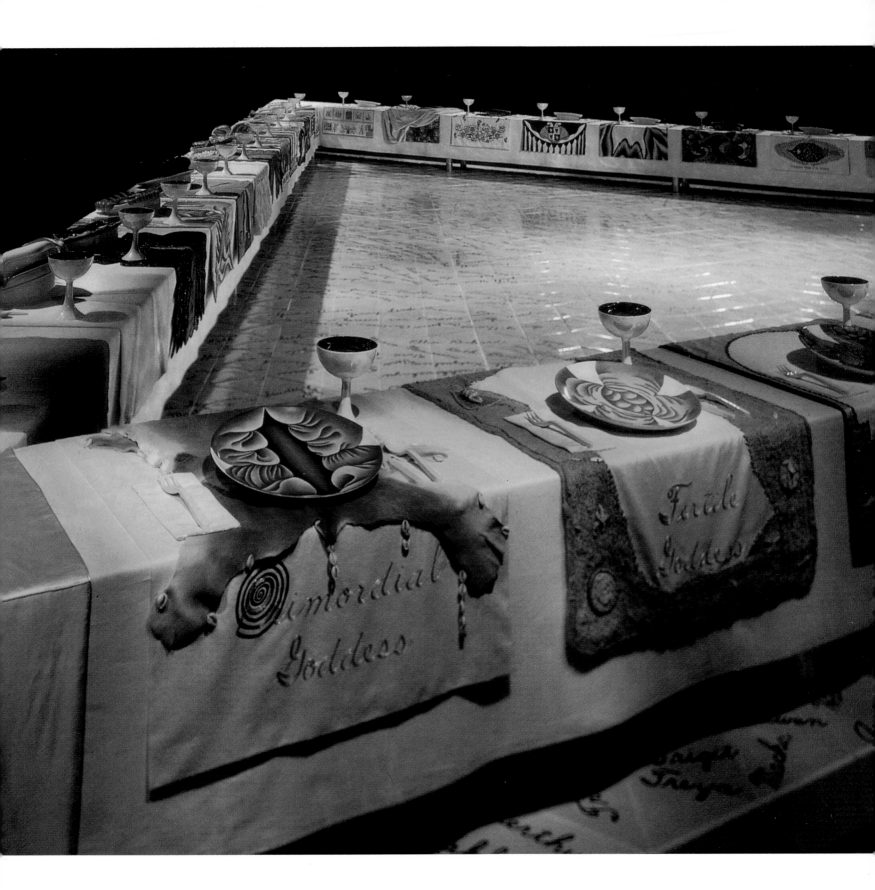

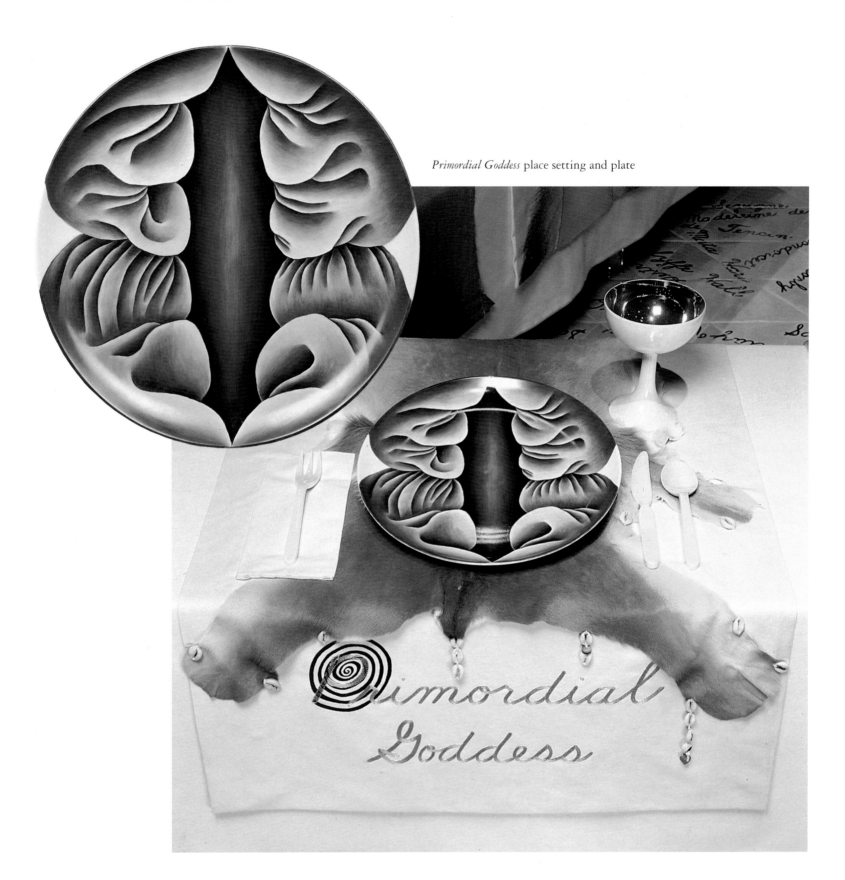

Primordial Goddess place setting and plate

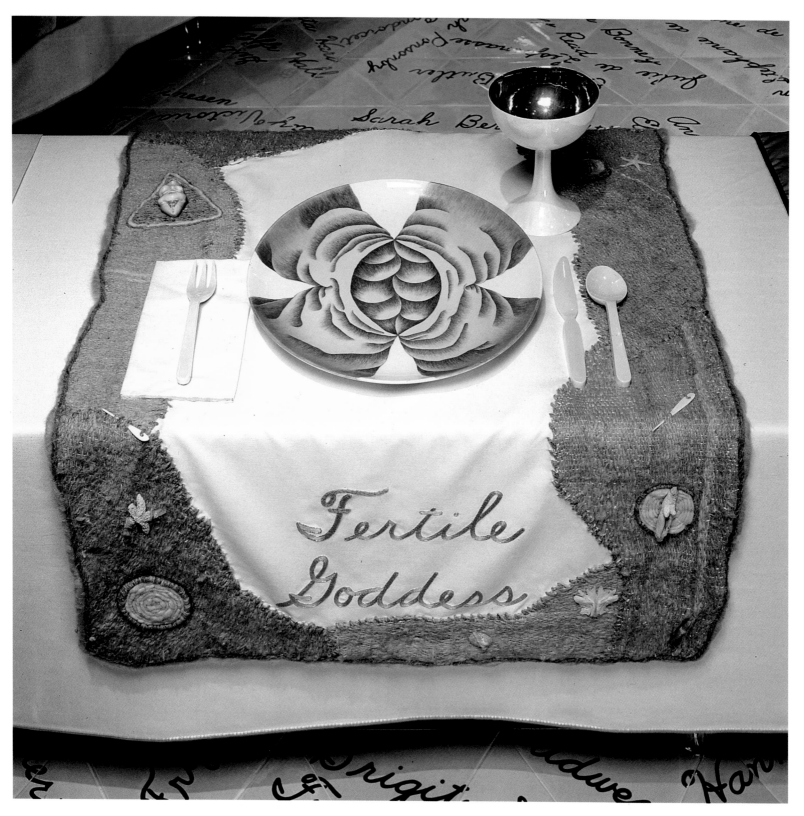

Fertile Goddess place setting

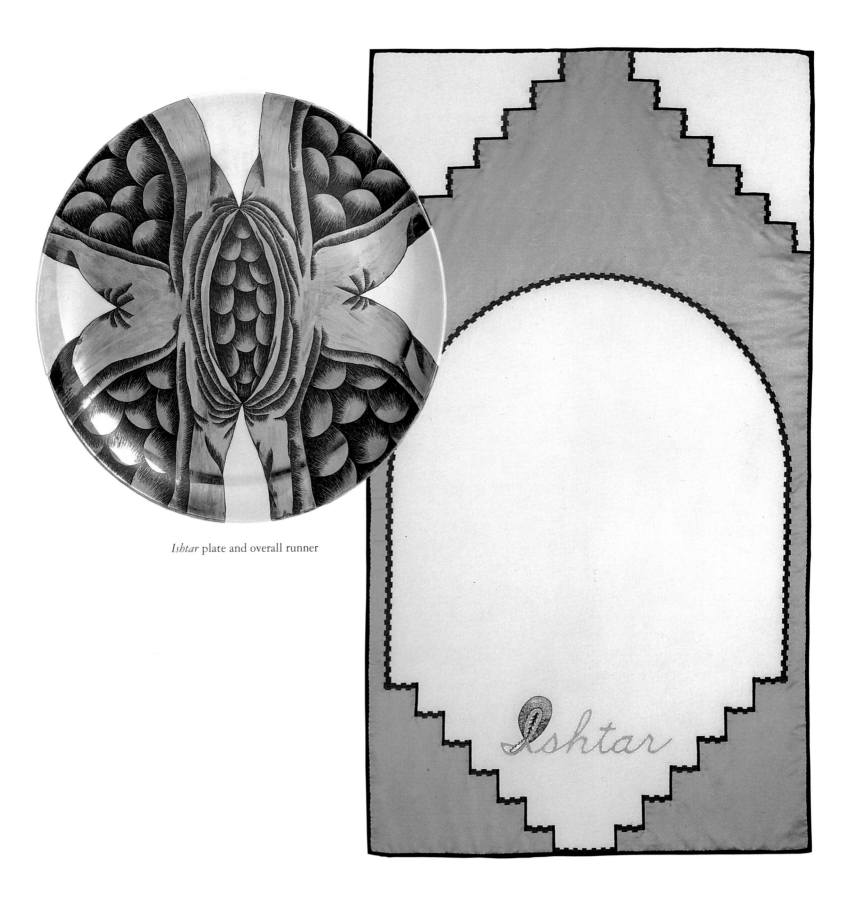

Ishtar plate and overall runner

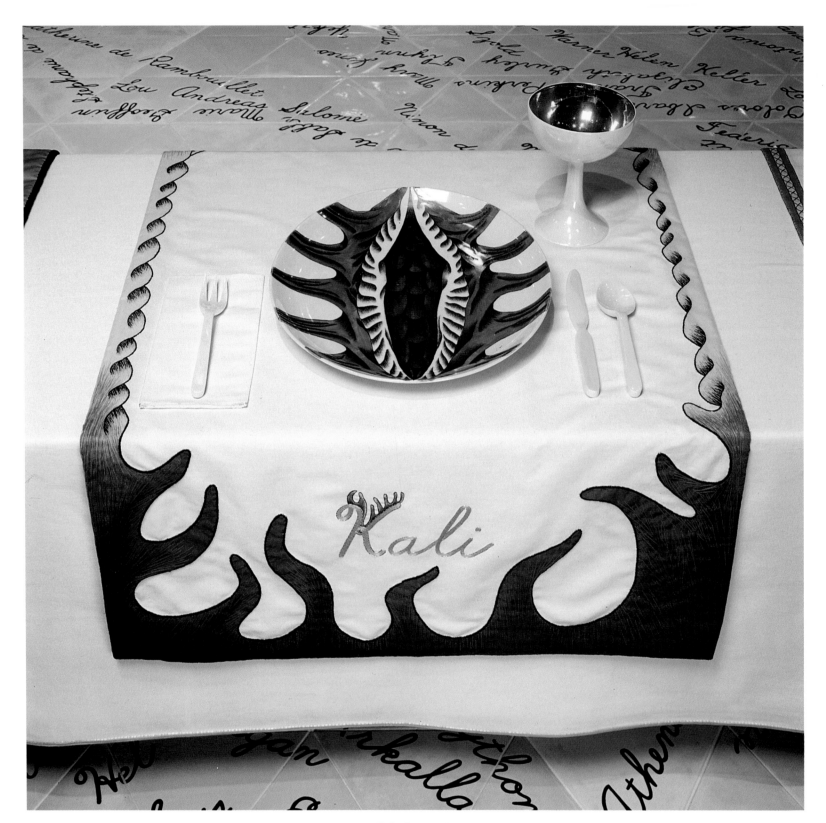

Kali place setting

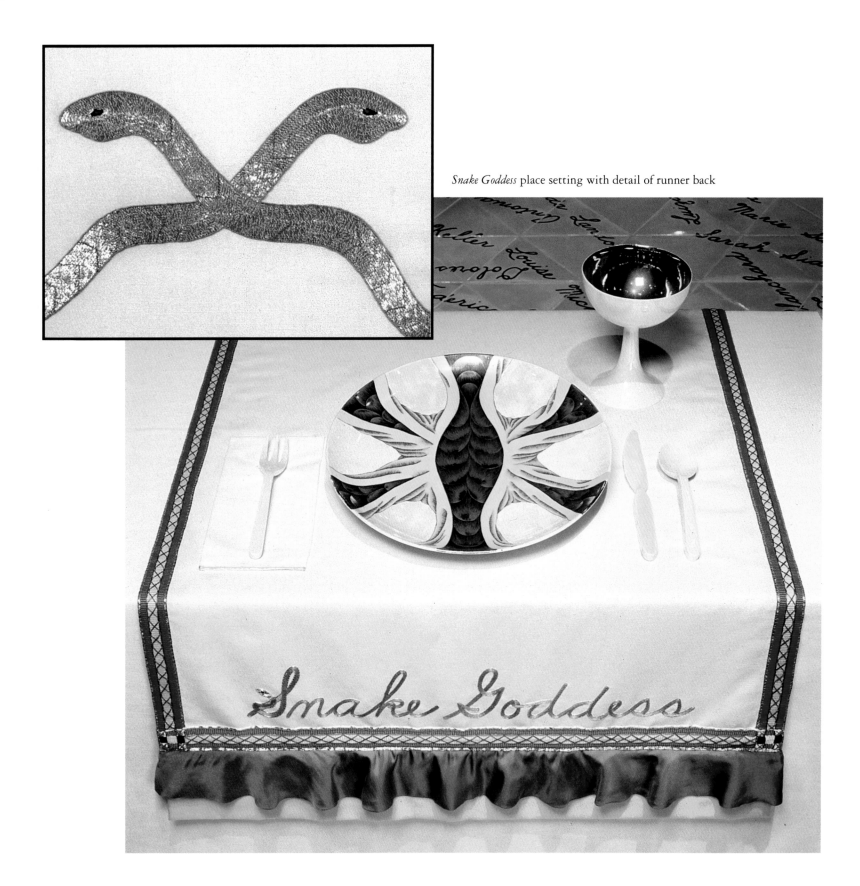

Snake Goddess place setting with detail of runner back

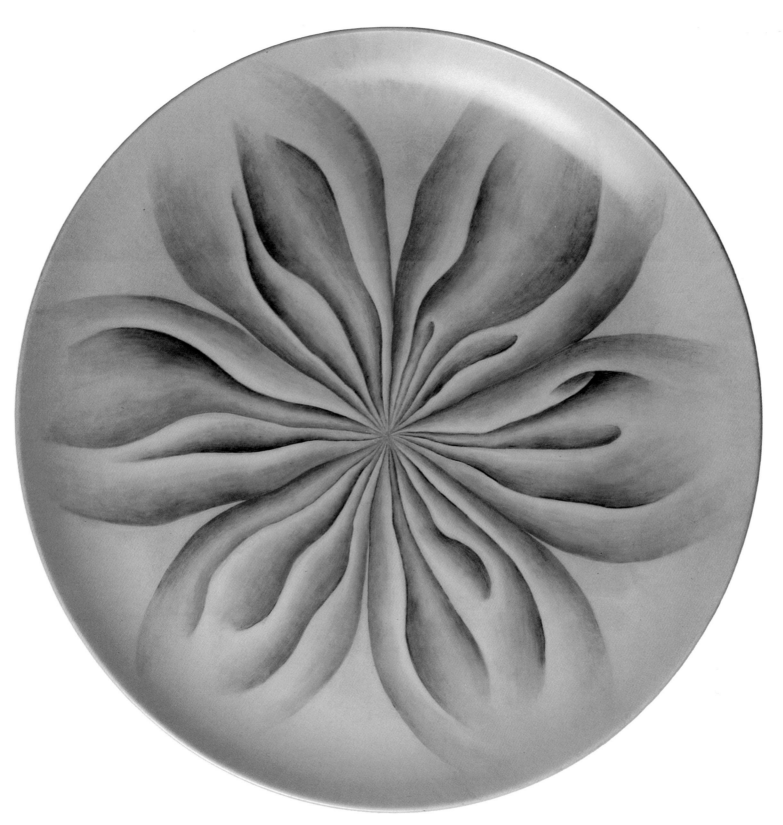

Sophia plate

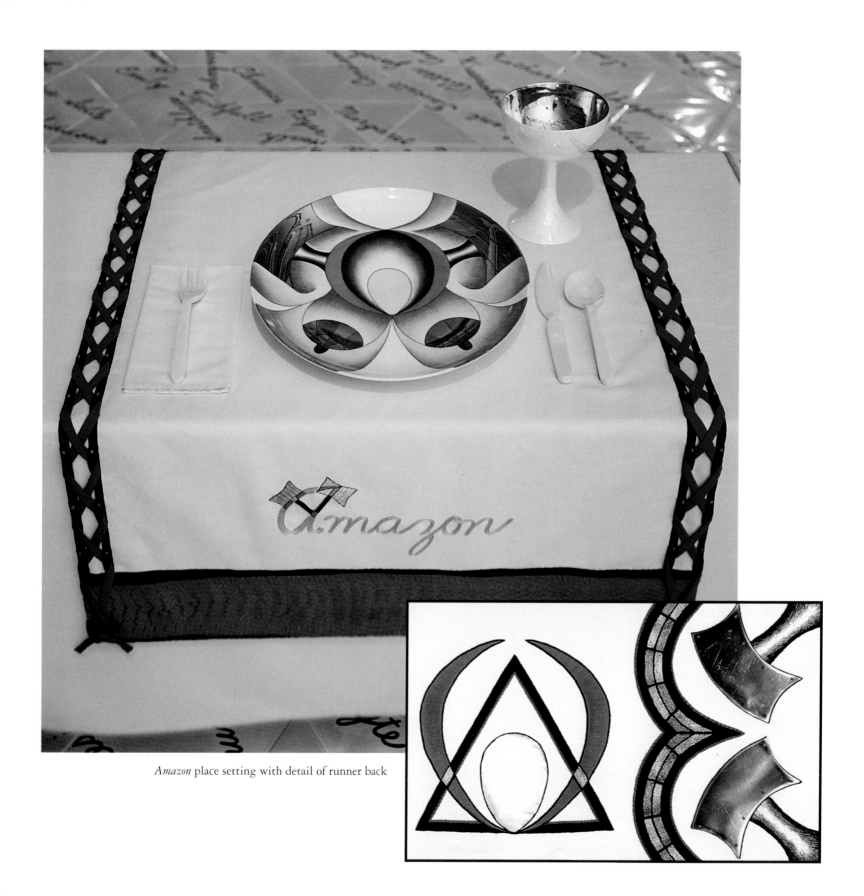

Amazon place setting with detail of runner back

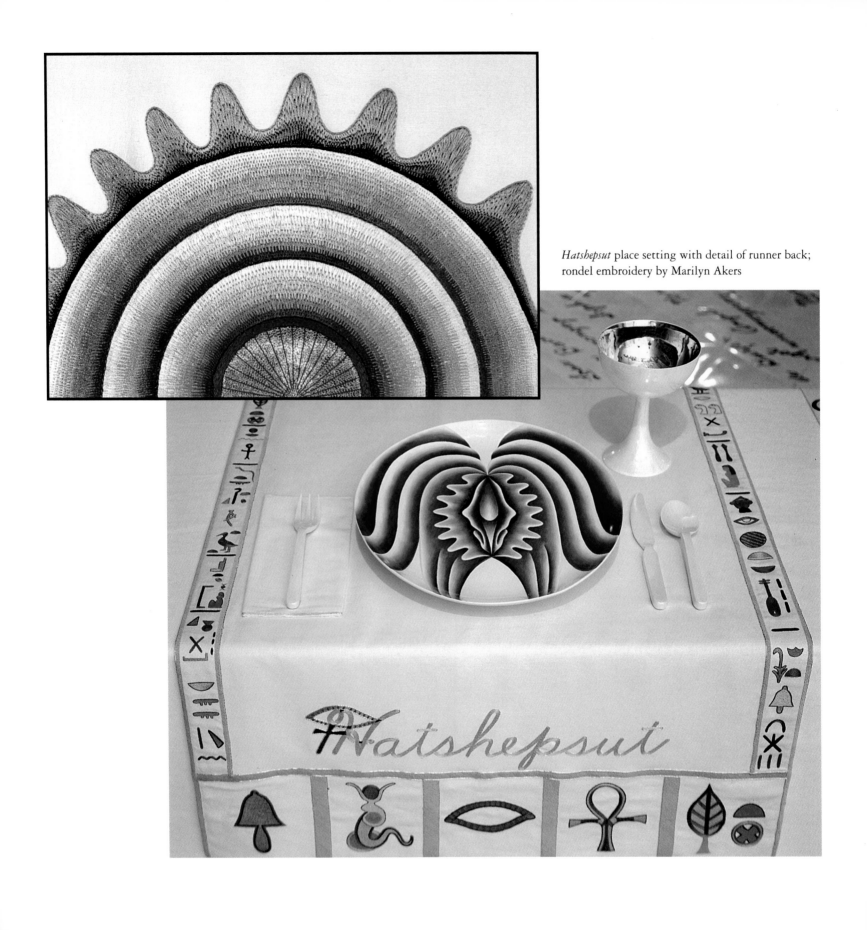

Hatshepsut place setting with detail of runner back;
rondel embroidery by Marilyn Akers

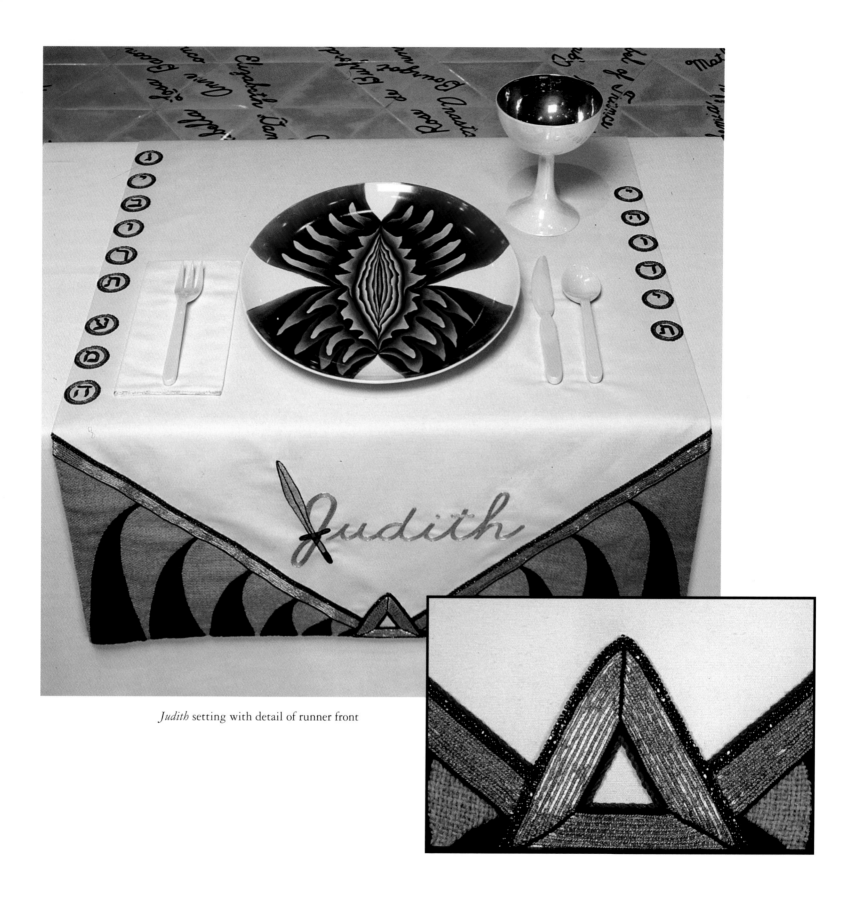

Judith setting with detail of runner front

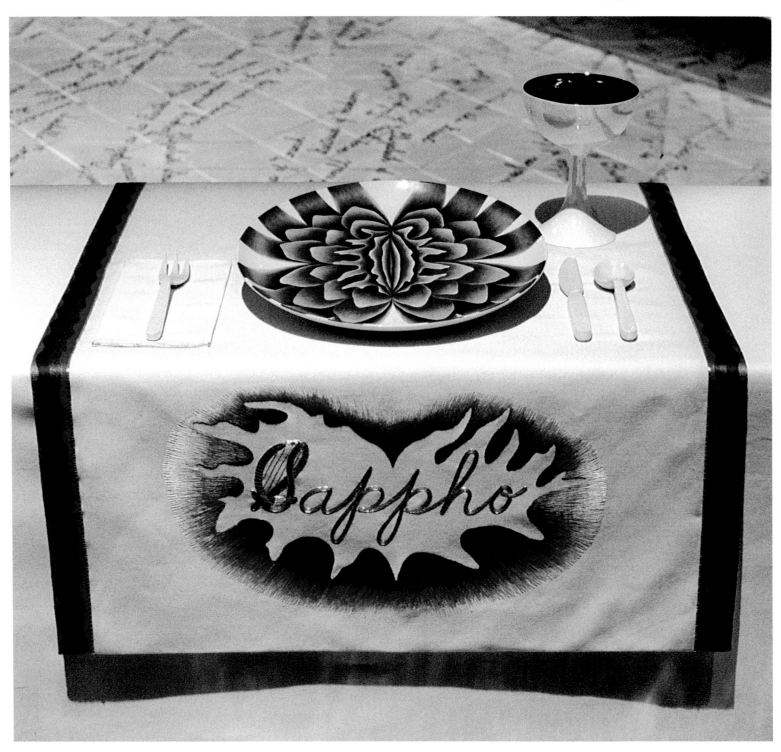

Sappho place setting

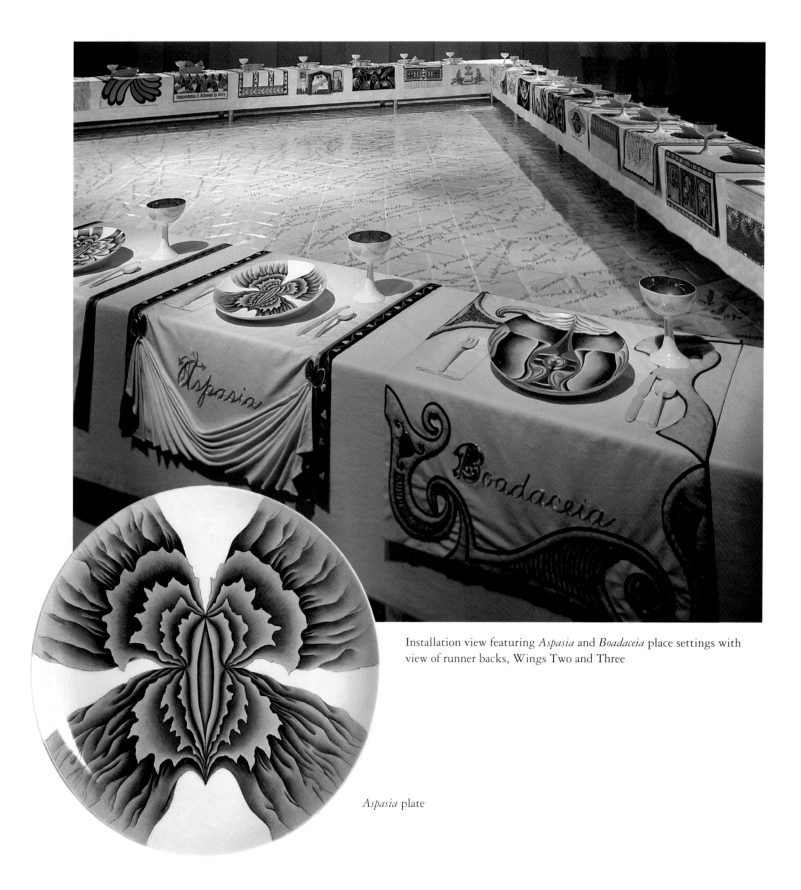

Installation view featuring *Aspasia* and *Boadaceia* place settings with view of runner backs, Wings Two and Three

Aspasia plate

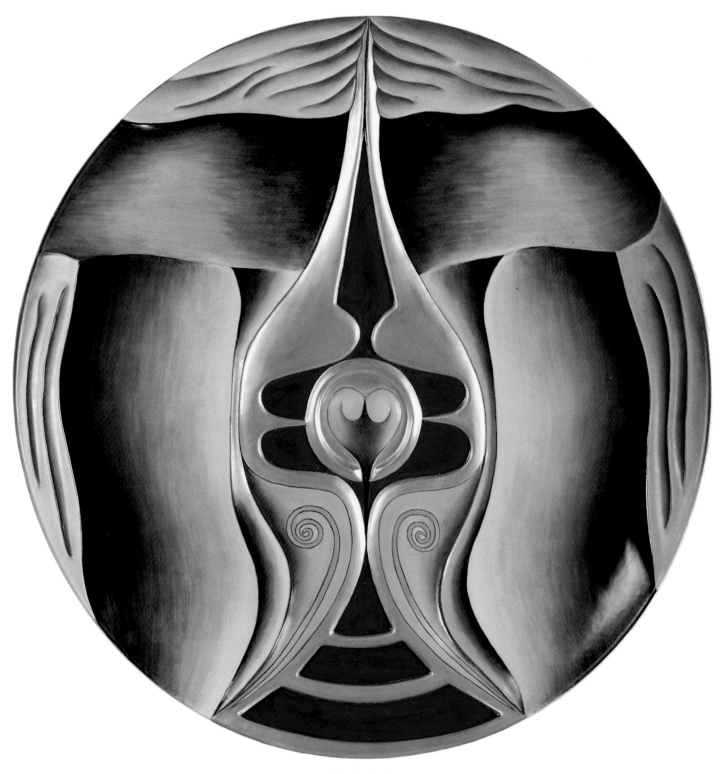

Boadaceia plate

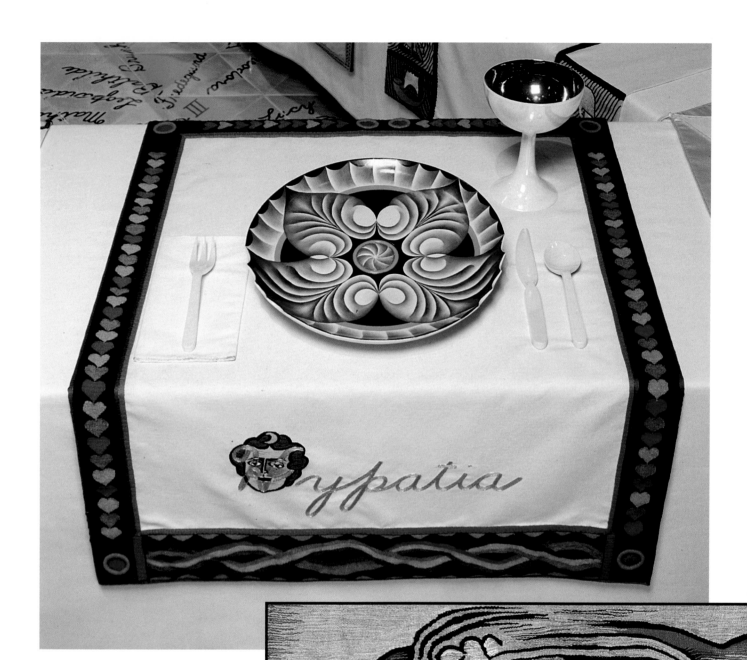

Hypatia place setting, with detail of
runner back; woven by Jan Marie du Bois

FACING PAGE: *Marcella* place setting
with view of back of *Hypatia* runner

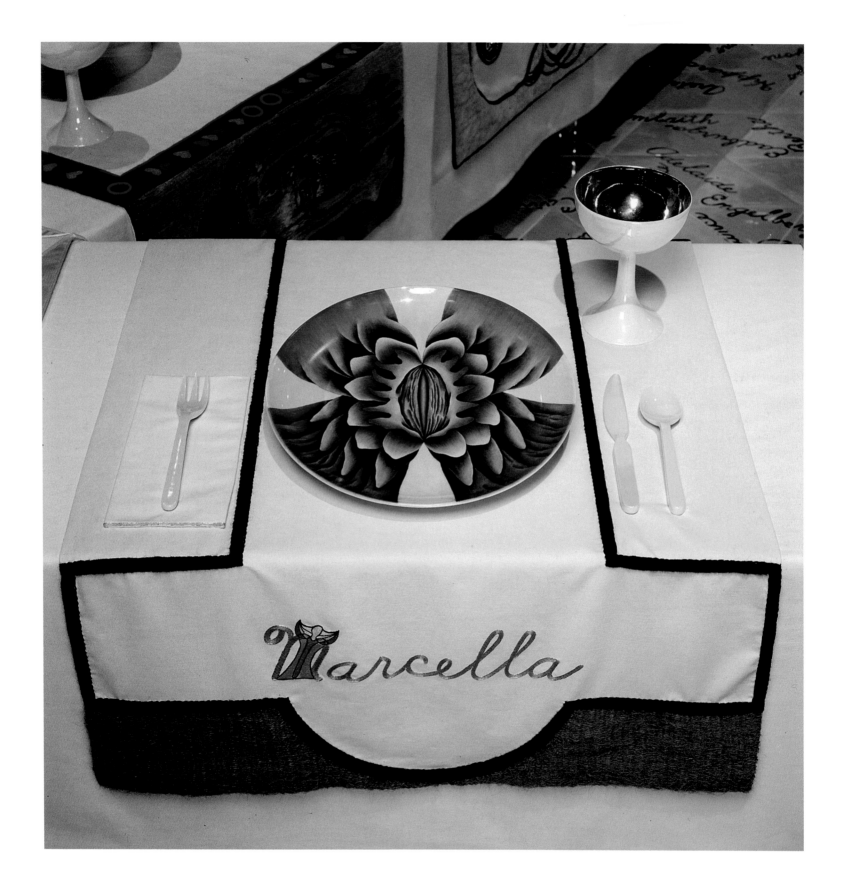

St. Bridget plate and capital letter

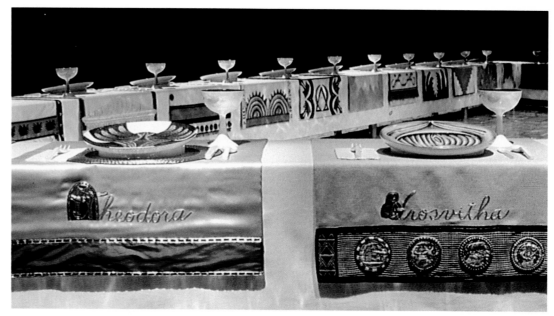

Detail of *Theodora* runner back; embroidery by Marjorie Biggs

Installation view featuring *Theodora* and *Hrosvitha* place settings

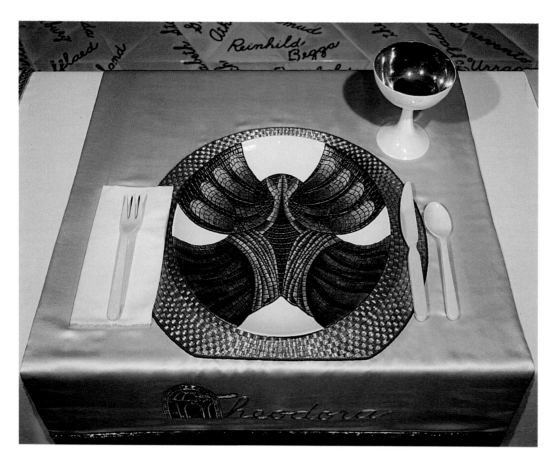

Theodora place setting

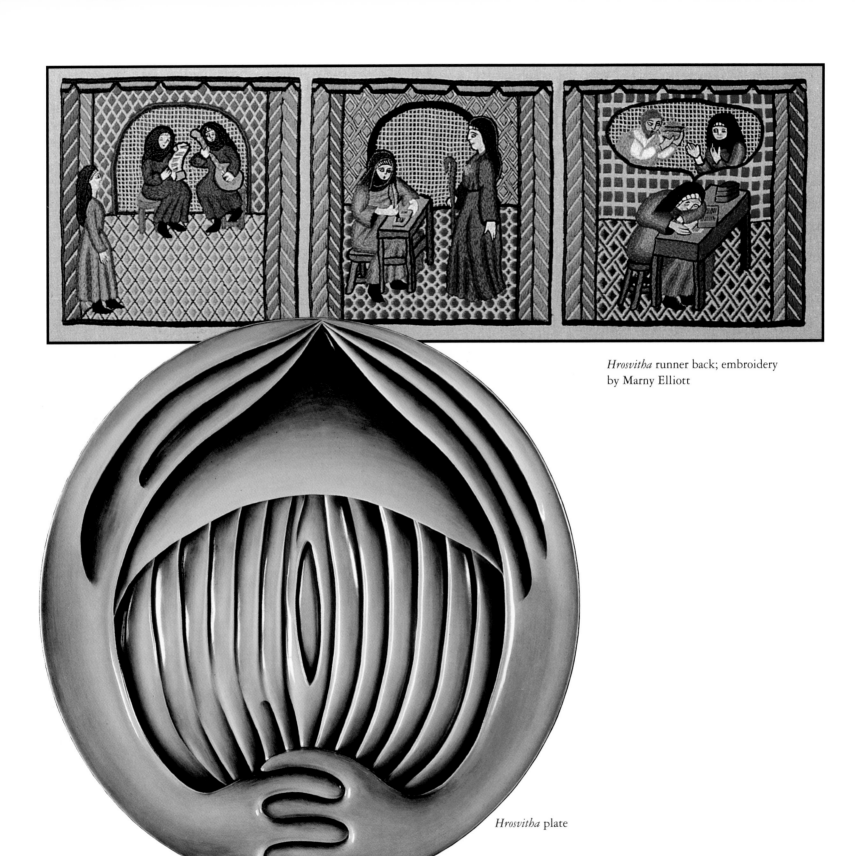

Hrosvitha runner back; embroidery
by Marny Elliott

Hrosvitha plate

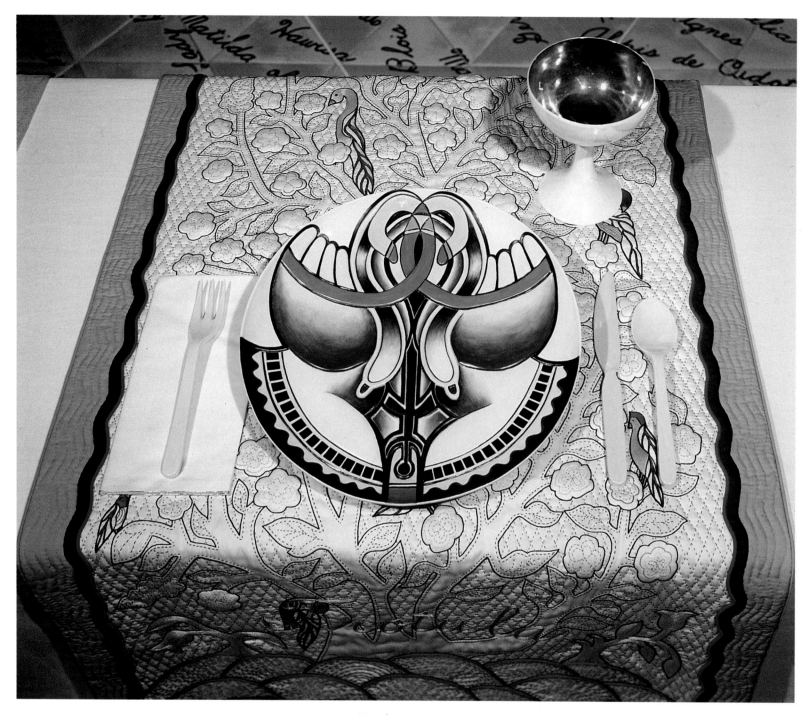

Trotula place setting

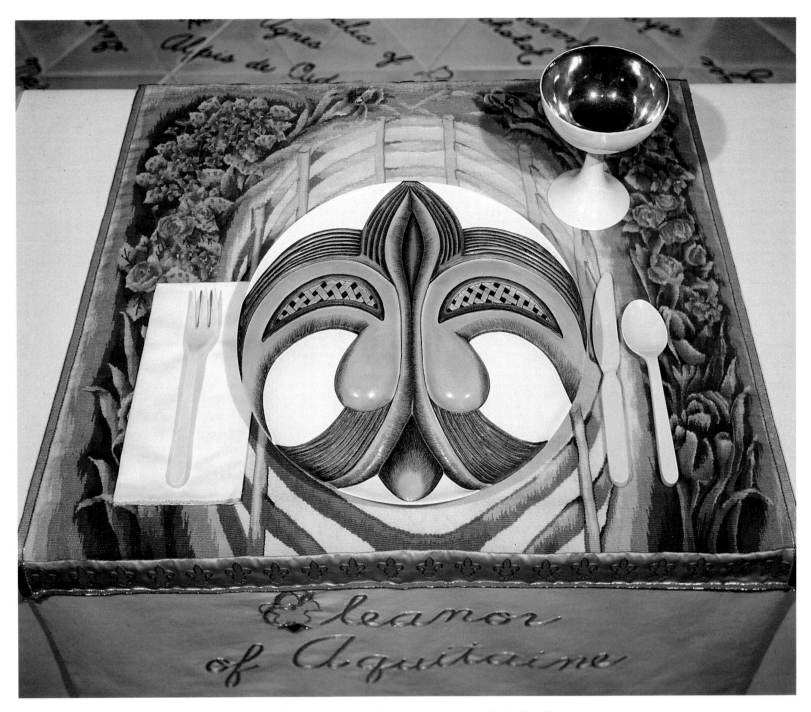

Eleanor of Aquitaine place setting; runner top woven by Audrey Cowan

Hildegarde's Vision of the Universe

Hildegarde runner back;
embroidery by Marilyn Akers

Hildegarde plate

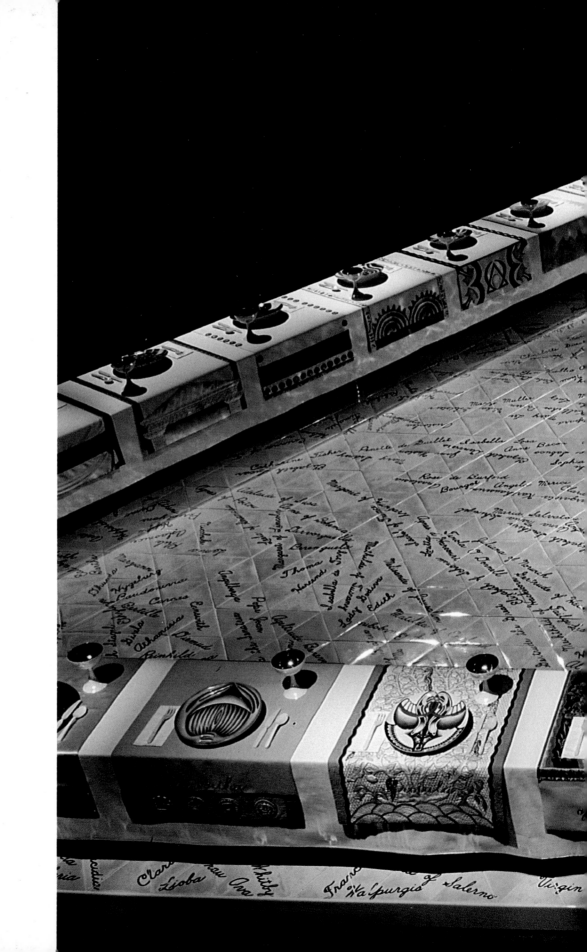

Installation view showing streams of names
on the *Heritage Floor*

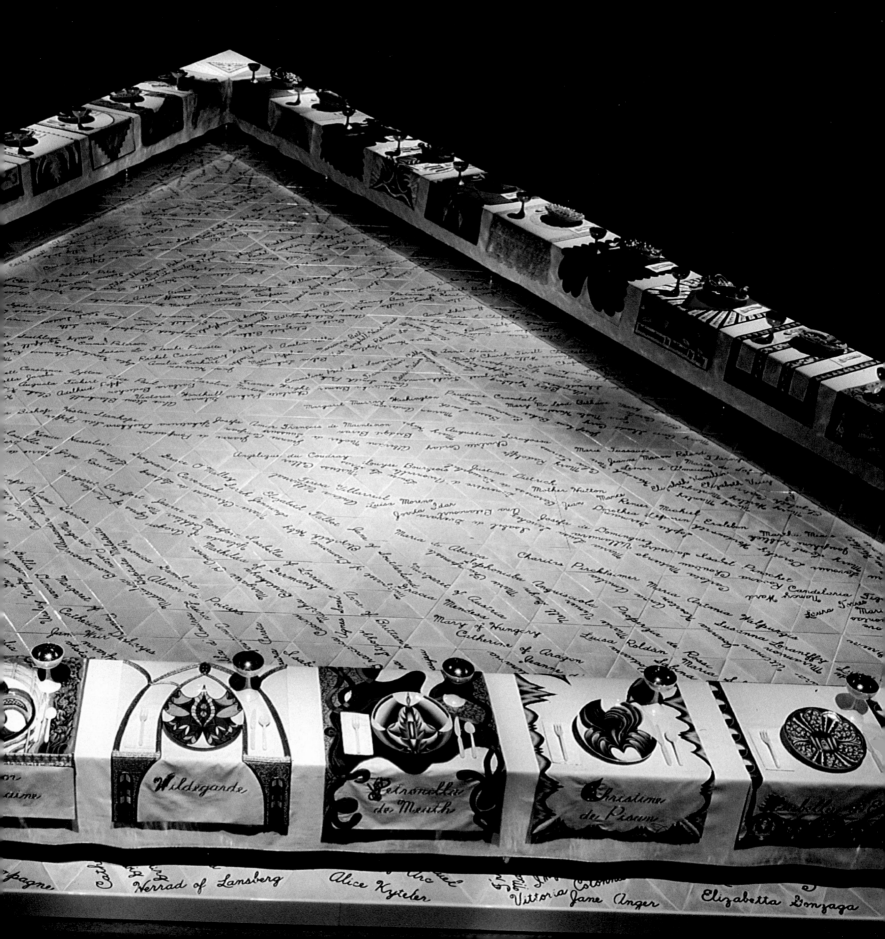

Hildegarde

Petronella
de Meath

Christine
de Pisan

Herrad of Landsberg Alice Kyteler

Vittoria Jane Anger

Elizabetta Gonzaga

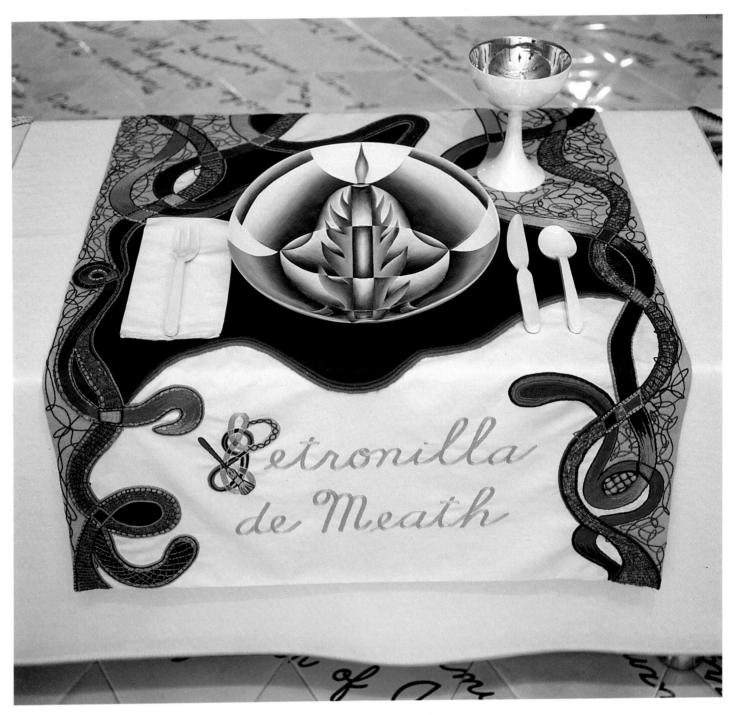

Petronilla de Meath place setting

Christine de Pisan

Christine de Pisan overall runner;
bargello by Connie von Briesen

Detail, *Christine de Pisan* capital letter;
embroidery by L. A. Hassing

Christine de Pisan plate

Isabella d'Este plate

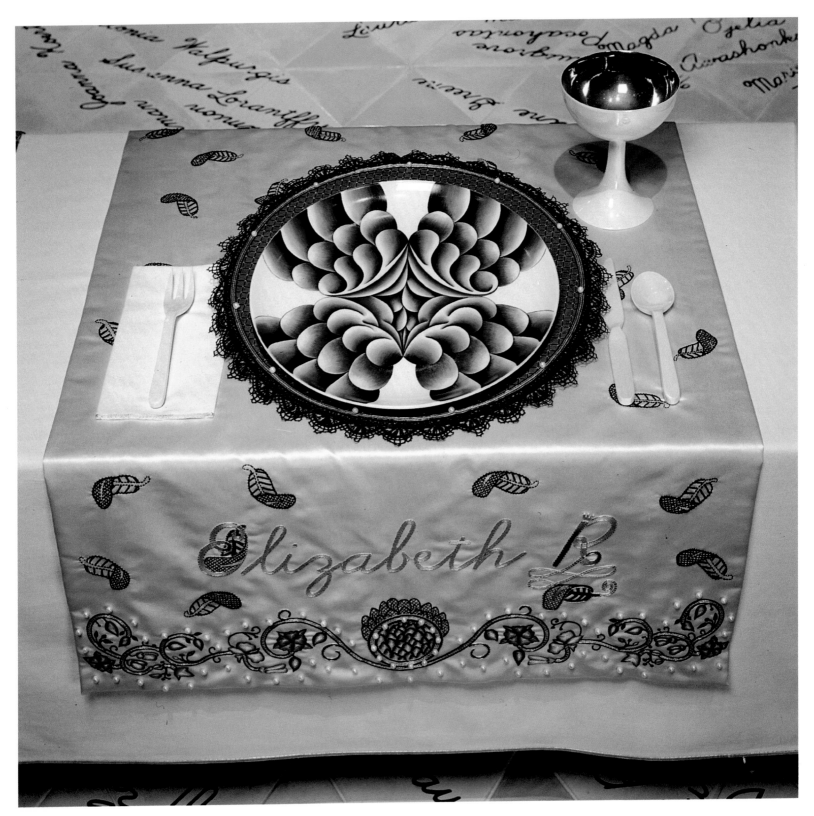

Elizabeth I place setting

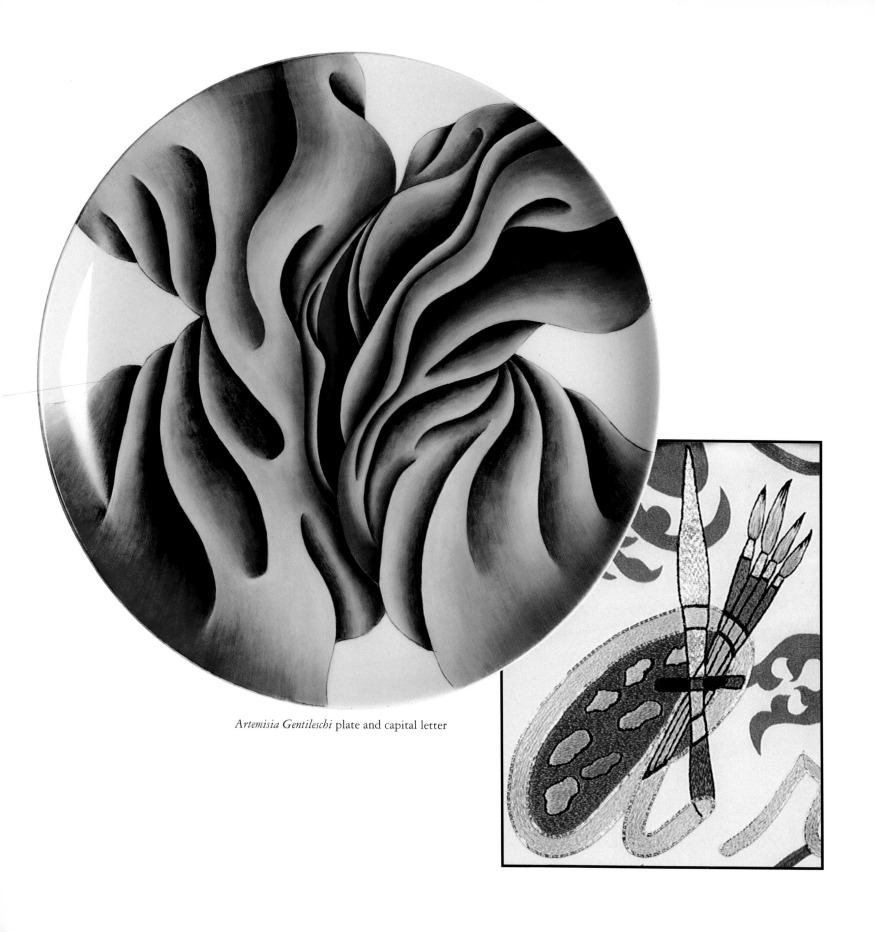

Artemisia Gentileschi plate and capital letter

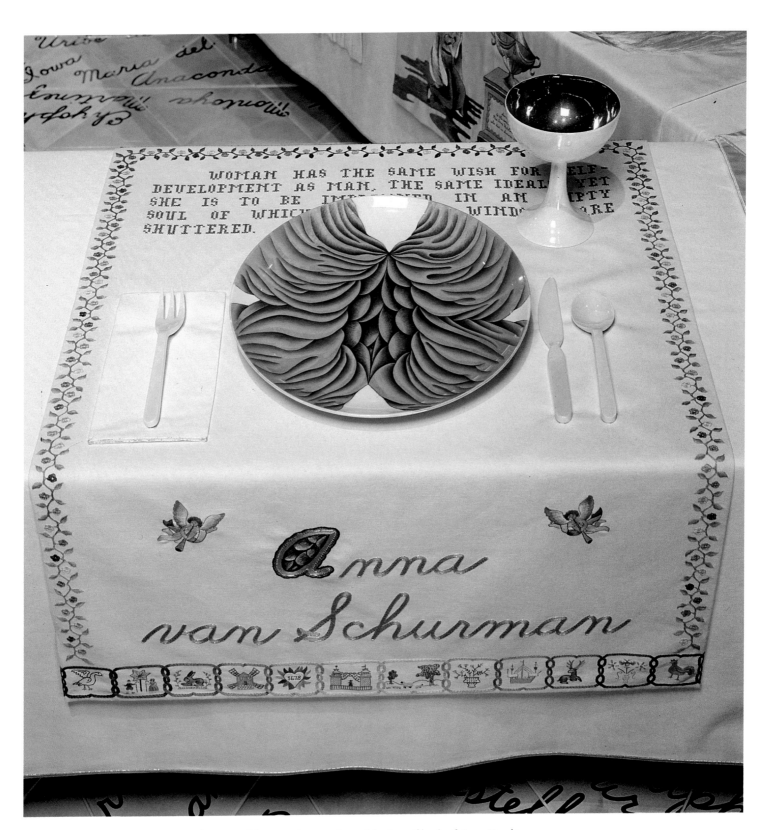

Anna van Schurman place setting with view of back of *Anne Hutchinson* runner

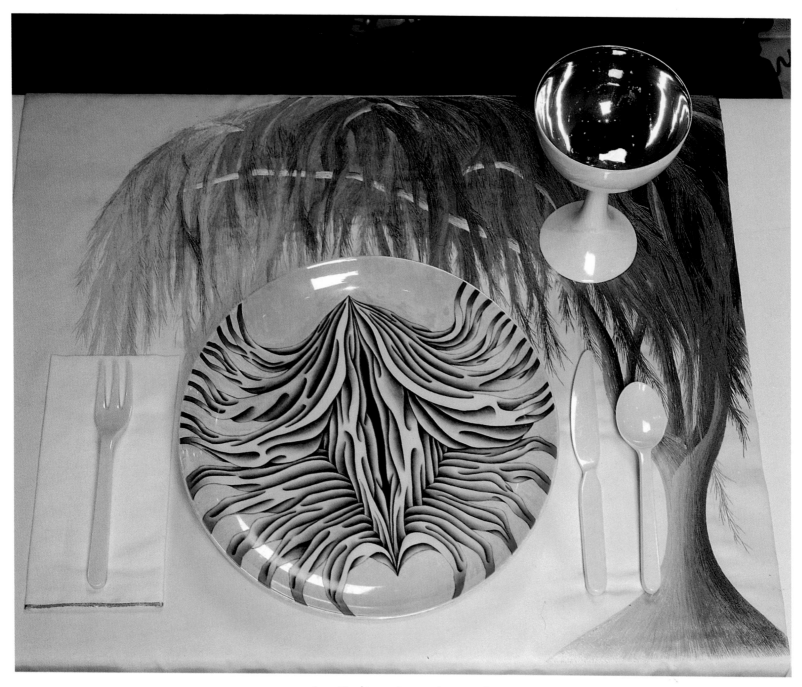

Anne Hutchinson place setting, top view

Sacajawea capital letter

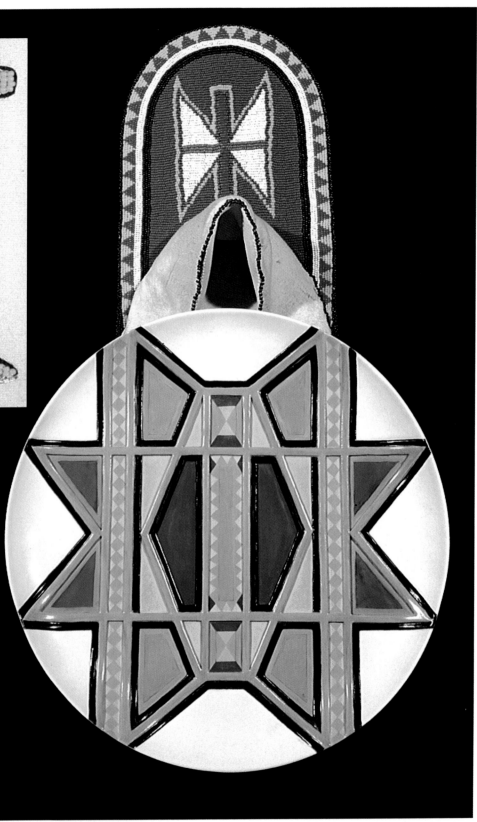

Sacajawea plate with cradle board;
beading by Cherie Frainé

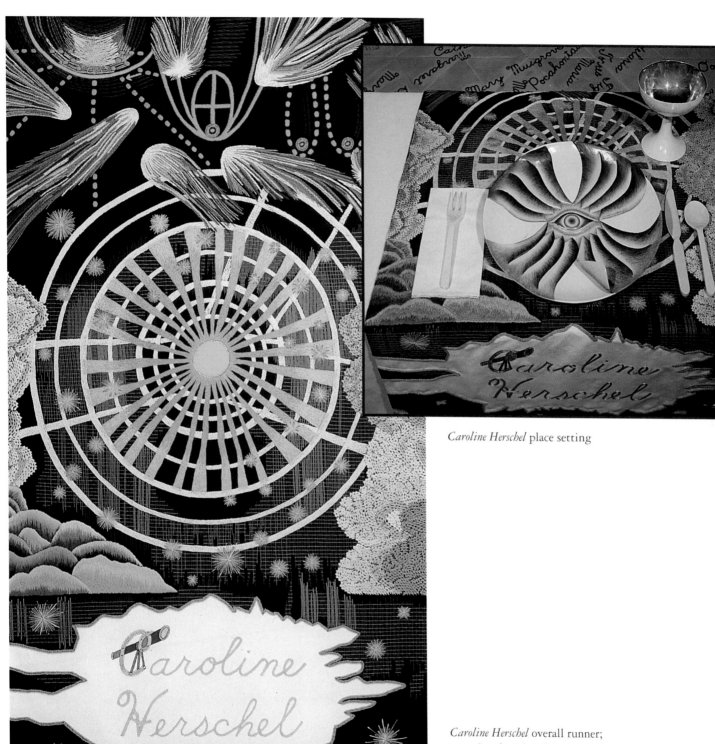

Caroline Herschel place setting

Caroline Herschel overall runner;
crewel embroidery by Marjorie Biggs

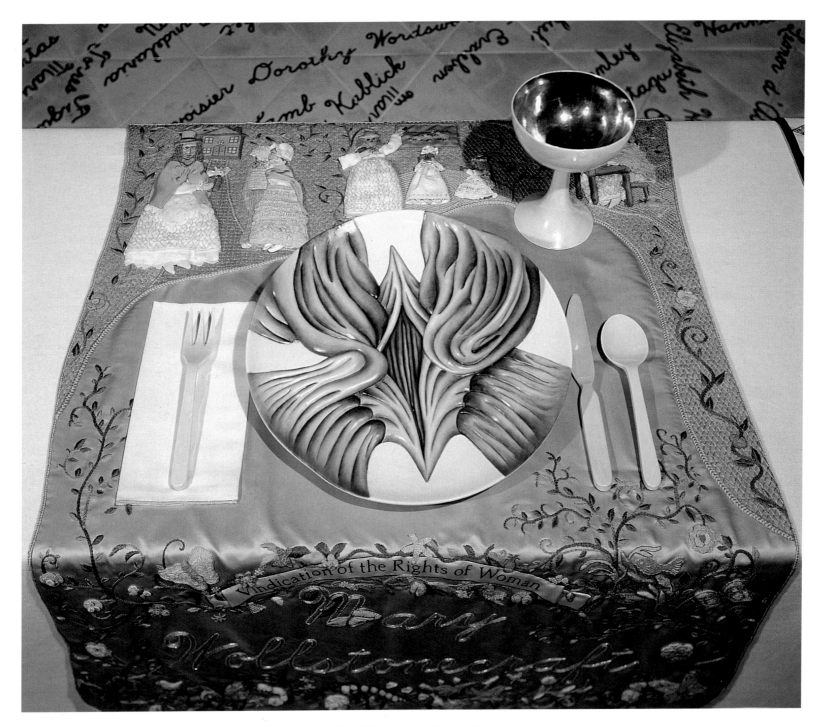

Mary Wollstonecraft place setting

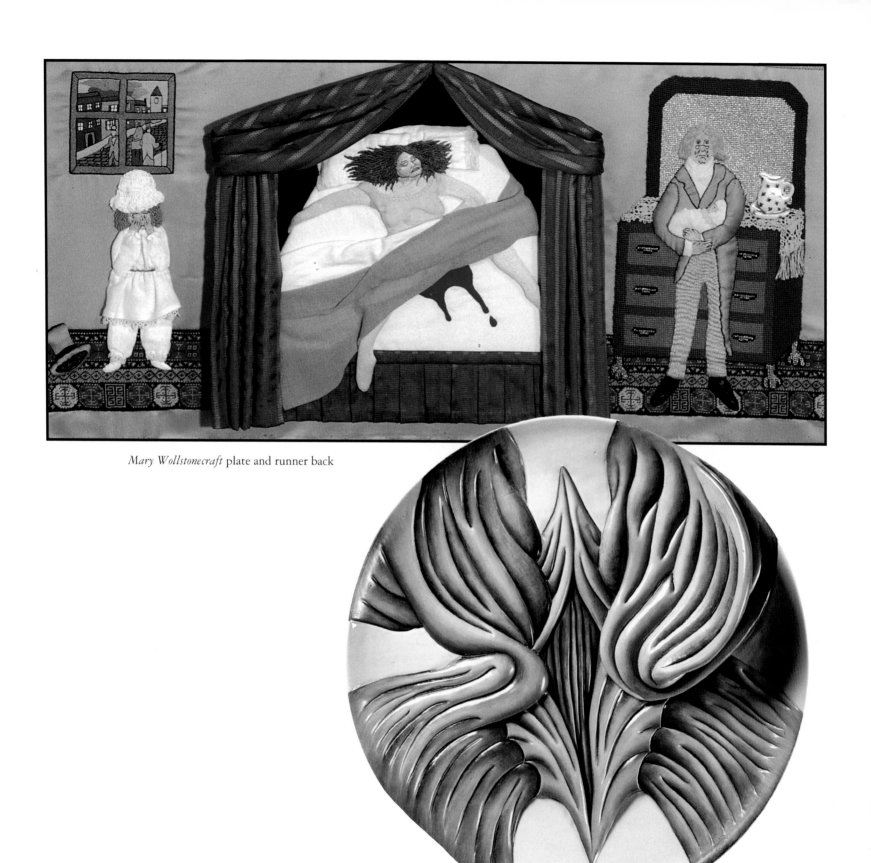

Mary Wollstonecraft plate and runner back

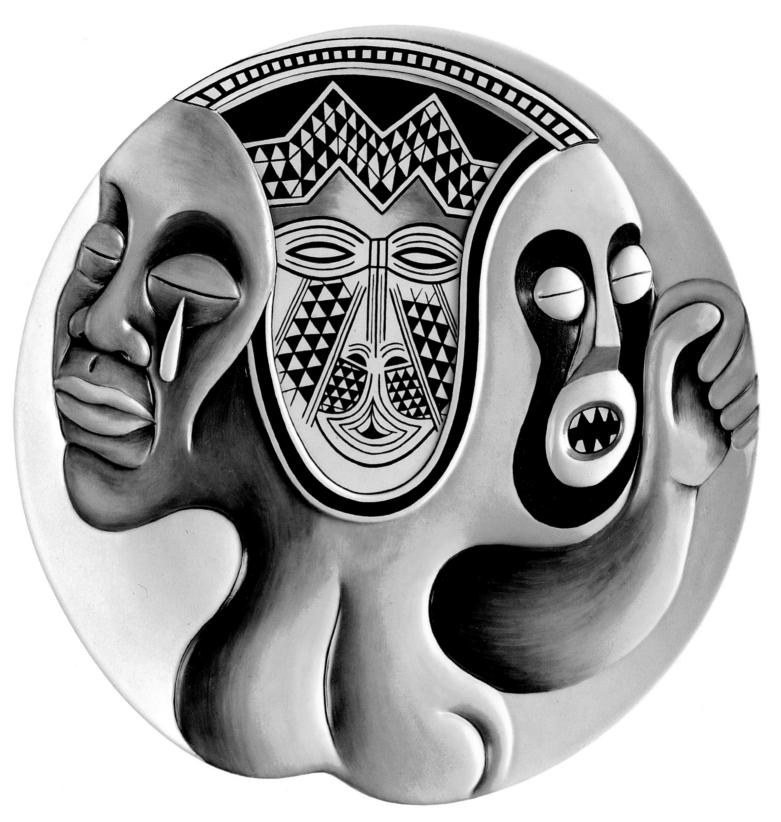

Sojourner Truth plate

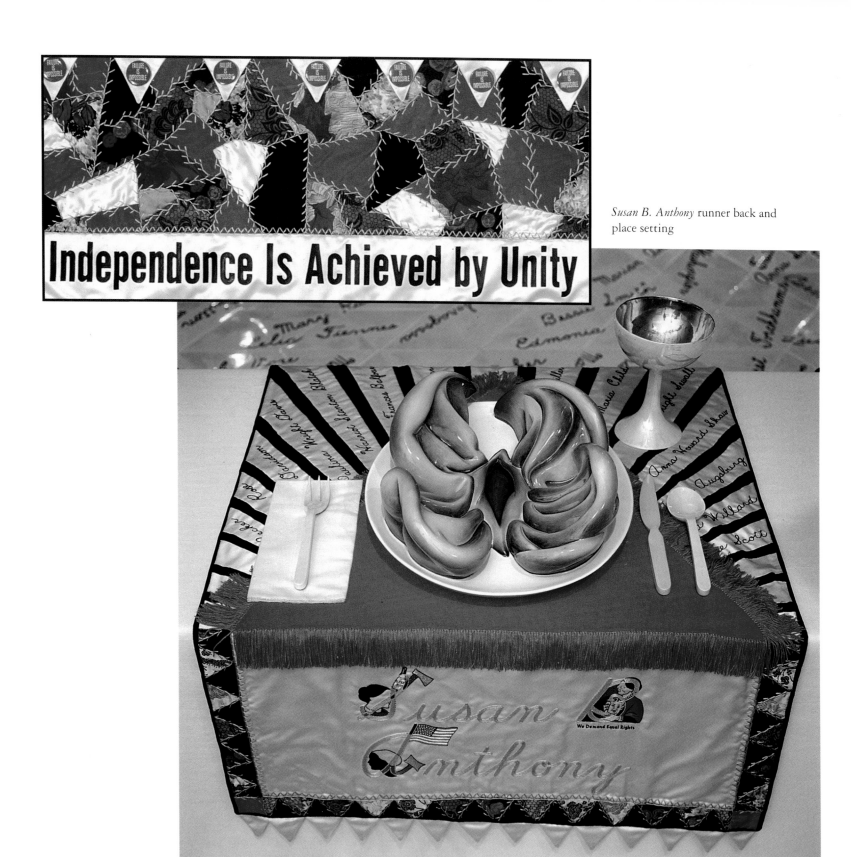

Susan B. Anthony runner back and place setting

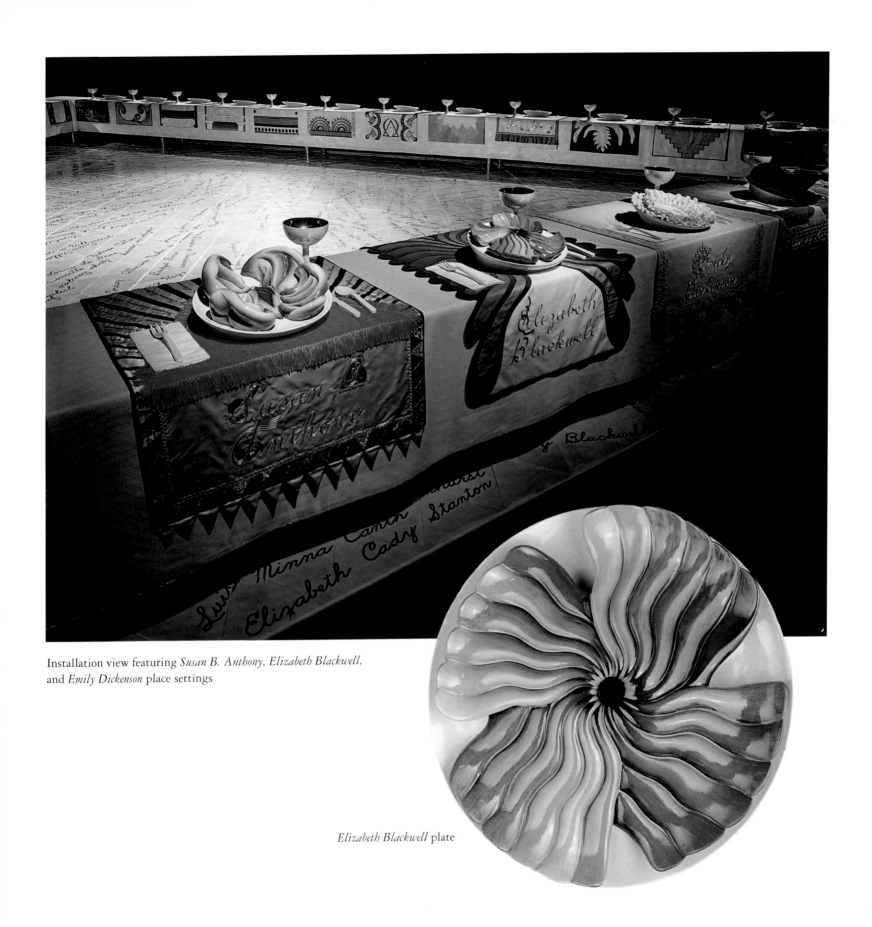

Installation view featuring *Susan B. Anthony, Elizabeth Blackwell,* and *Emily Dickenson* place settings

Elizabeth Blackwell plate

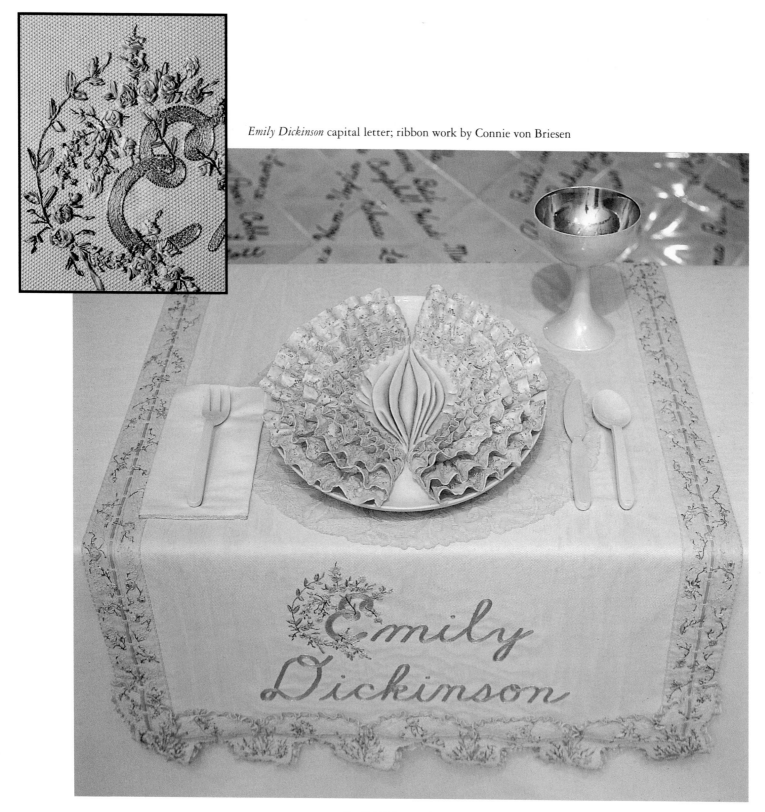

Emily Dickinson capital letter; ribbon work by Connie von Briesen

Emily Dickinson place setting

Ethel Smyth plate and overall runner

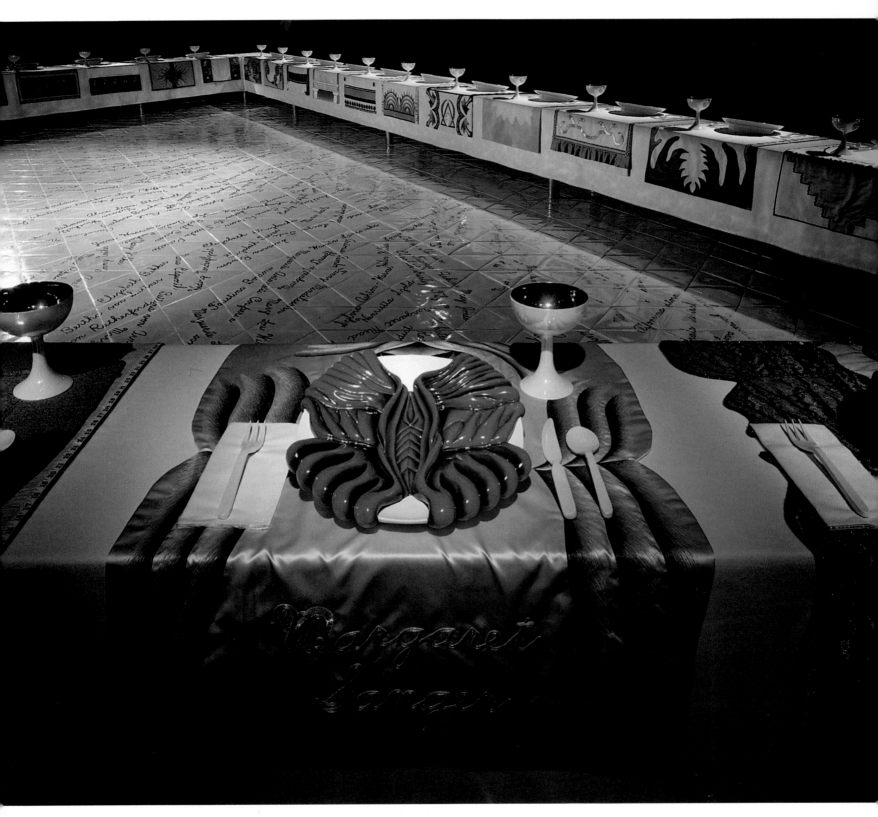

Installation view featuring *Margaret Sanger* place setting with view of runner backs, Wings One and Two

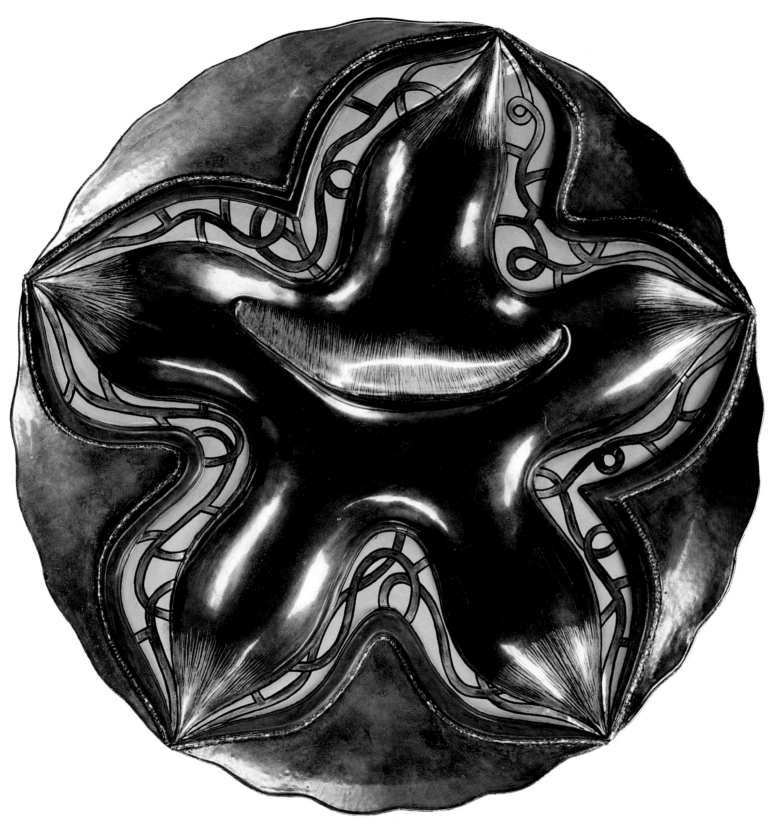

Natalie Barney plate

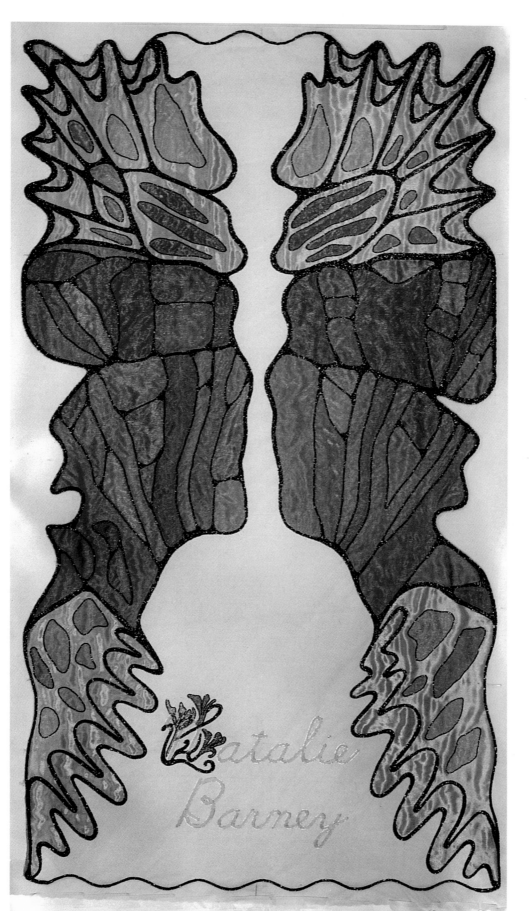

Natalie Barney overall runner

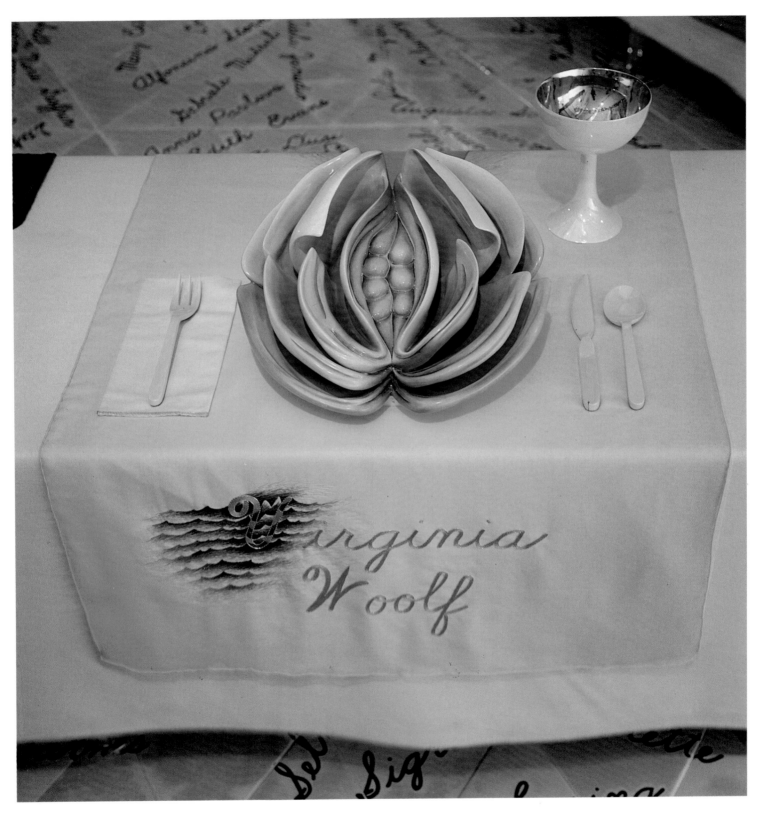

Virginia Woolf place setting

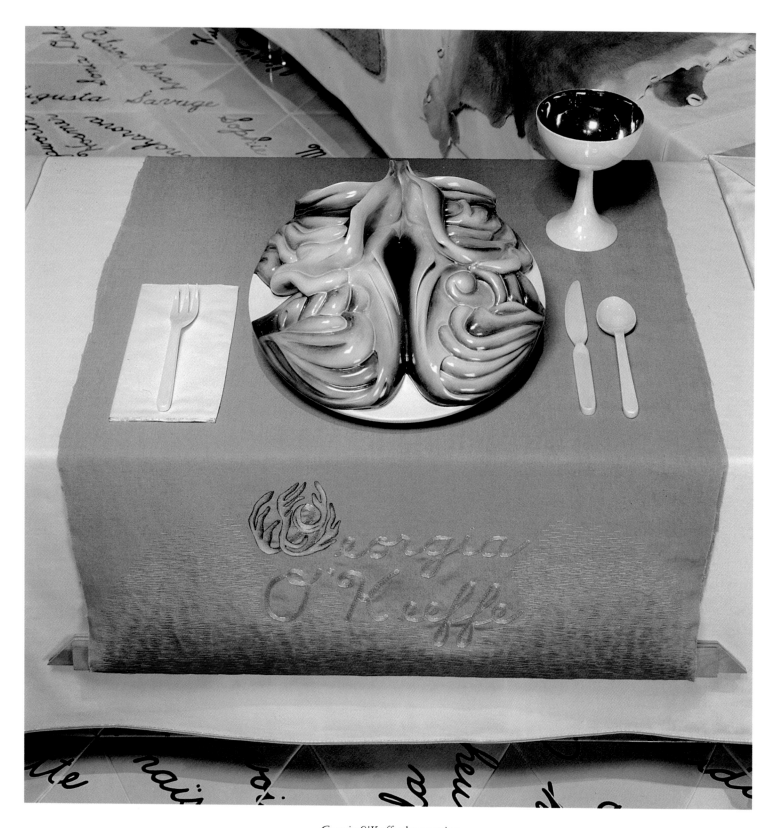

Georgia O'Keeffe place setting

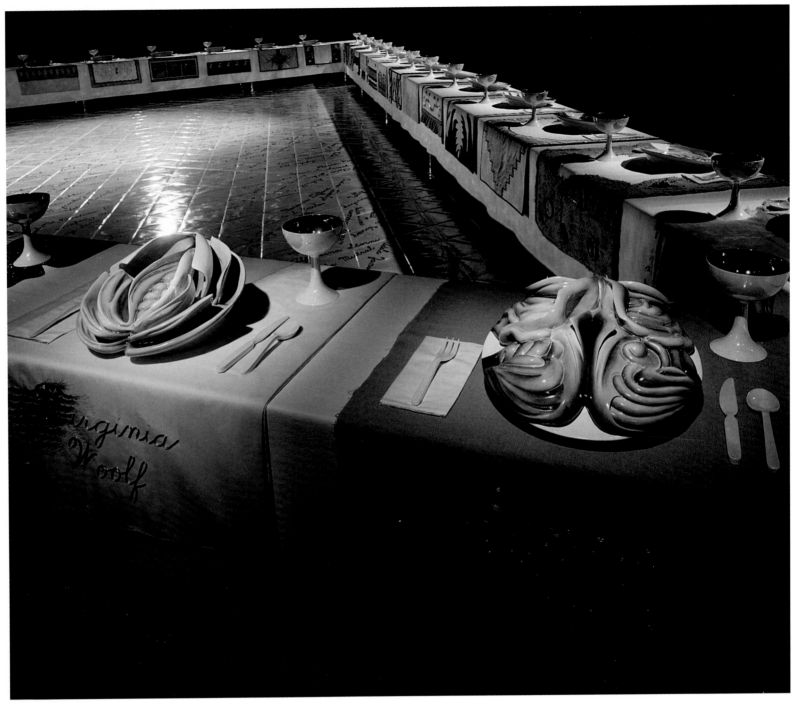

Installation view featuring *Virginia Woolf* and *Georgia O'Keeffe* place settings with view of runner backs, Wings One and Two

PART FOUR

The Dinner Party
as Symbol

BY THE TIME that *The Dinner Party* exhibition closed in San Francisco, I had retreated to a small town in northern California and was trying to understand how it had happened that, despite the show's enormous popularity, the two other museums scheduled to exhibit it had canceled and no other institutions had come forward to express interest in the work. Meanwhile, the Santa Monica studio, which was being run by some of the remaining members of the core staff, was being besieged with phone calls from people around the country. They all wanted to know when they would be able to see *The Dinner Party* in their local museums, finding it impossible to believe that there was no exhibition tour.

Over the years, many people have asked me why the museums refused to show *The Dinner Party*. I have tried to explain that neither financial nor popular success necessarily guarantee museum support. Moreover, the negative institutional response to *The Dinner Party* seemed to be part of a larger pattern of discrimination against women and women's art. As I mentioned earlier, I had deliberately set out to test the art system—to see if it would respond to art with female subject matter—but I had firmly (though naively) believed that there would be a positive outcome. I was devastated by the art-institutional rejection and was therefore hardly in a position to explain what was going on, and my staff was not in much better shape. In fact, we were *all* in a state of shock.

It would be years before we would even be able to discuss this demoralizing period. I moved to the Bay area, the remainder of the staff closed down the once-bustling Santa Monica space, and everyone went their separate ways. Only Gelon seemed able to overcome the intense disappointment, spending much of the next few years meeting with groups of people in various cities who were interested in exploring ways of exhibiting the work in the face of demonstrated museum resistance.

Gelon was apparently determined that *The Dinner Party* would not stay in storage, even if that meant showing it only in alternative spaces. With this goal in mind, she traveled all over the country. When this or that community group realized that the art institutions in their region weren't interested, she would go with a group member to look at warehouses, community centers, old theaters, and railroad stations—any place, in fact, that had a clear span of sixty feet. The first such successful grassroots effort was in Houston, where in March 1980, *The Dinner Party* reopened in a black-box theater space at the University of Houston in Clear Lake City. It was brought there by a broadbase coalition, organized and spearheaded by Mary Ross Taylor, the owner of a feminist bookstore, and Calvin Cannon, one of the deans of the university.

Despite the gas rationing of the early 1980s and the fact that the school was thirty miles outside of Houston, the exhibition drew eighty thousand people and was considered a huge success. Moreover, the many discussions, classes, and workshops stimulated by *The Dinner Party* demonstrated to Mary Ross that my work seemed able to stimulate a level of dialogue that she had long been trying to achieve through events at her bookstore. Eventually she came to work with me, becoming the executive director of Through the Flower for nearly a decade, handling the organization and exhibition of my next undertaking, the *Birth Project*. Although the Houston action was organized under the auspices of Mary Ross's own nonprofit organization, TACO (the Texas Art and Cultural Organization), other communities turned to Through the Flower for guidance and support. Our small corporation struggled to handle what was first a national, then an international, tour, as other groups developed, often modeling themselves on this first effort.

In Houston, to celebrate the re-opening of *The Dinner Party* and to emphasize the *inclusive* intentions of my art, I inaugurated the International Quilting Bee. In this ever-expanding ancillary exhibition, people were invited to create small, triangular quilts, two feet on a side, honoring other women whose achievements they admired. As *The Dinner Party* traveled, more

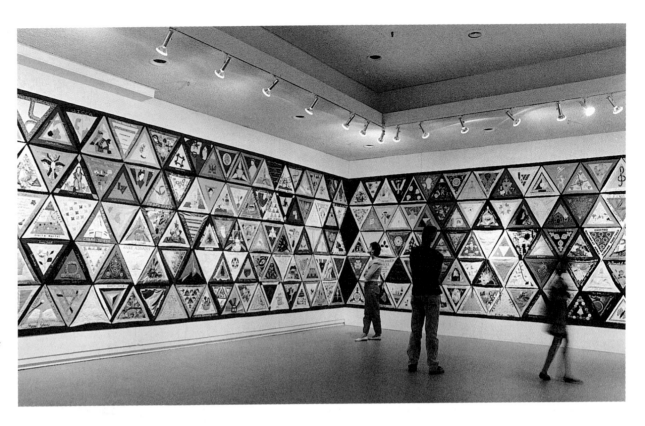

International Quilting Bee
(Installed)

and more quilts were put up at each exhibition site or sent for later display to Through the Flower's headquarters, which relocated to Benicia, where by then both Mary Ross and I were living. We were operating out of a large industrial building that we had rented to accommodate the burgeoning *Birth Project*, in which I had become deeply engrossed. My goal was to break what was a surprising iconographic void on the subject of birth in Western art and to extend the participatory nature of *The Dinner Party* in that people worked on my images but in their own homes. Many of the needleworkers who came to work with me were inspired to volunteer after seeing *The Dinner Party* in San Francisco, then Houston, Boston, New York, Cleveland, Chicago, or Atlanta, the cities to which it traveled between 1980 and 1982.

In Boston, *The Dinner Party* exhibition was held in a converted cyclorama, which later became the Boston Center for the Arts. The building was located in a run-down part of town, which has since been gentrified. Although I was extremely gratified to have the work on view again, the spaces in which the

shows were held in Houston and Boston were a far cry from both the professionalism and prestige of the San Francisco Museum of Modern Art.

It seems important to explain that there are considerable risks involved in entrusting a fragile work of art to volunteers unversed in museum practices and to spaces unprotected by temperature and humidity controls. The fact that *The Dinner Party* managed to escape major damage is a testament to the dedication of Gelon and our installation team, along with the scores of volunteers who came forward to help them. Nonetheless, there would be numerous times when the piece would be endangered. I was therefore quite relieved when Gelon informed me that a group of influential New Yorkers had managed to interest Michael Botwinick, then director of the Brooklyn Museum, in showing the work. In addition to appreciating the secure and handsome galleries in the museum, I hoped that New York, which had never evidenced all that much enthusiasm for my work, might change its stance.

As in San Francisco, Houston, and Boston, tens of thou-

sands of viewers flocked to see *The Dinner Party* at the Brooklyn Museum, which only seemed to provoke even greater art-world antagonism. With the exception of Lucy Lippard, writing in *Art in America,* and John Perrault, in the now-defunct *Soho News,* the New York art establishment rained down a barrage of hostile criticisms and virulent misrepresentations of the piece in such publications as *The New York Times*, *Time* magazine, and *The New York Review of Books.* One influential reviewer deemed it grotesque "kitsch," but a more destructive remark, which set the tone for a considerable amount of subsequent writing, was that *The Dinner Party* could be best described as little more than vaginas on plates.

Although I was crushed by the hostile reception of the New York art establishment, the criticisms didn't seem to even faze the audience. The more the (mostly male) critics foamed at the mouth about the work, the more the (mostly female) popular audience seemed to organize in order to ensure its exhibition. However, one result of the negative New York art press was that, after the Brooklyn Museum showing and no matter how much pressure was brought to bear in other cities, no other American museum was willing to exhibit *The Dinner Party.*

In Cleveland, the piece was shown at the converted Temple on the Heights, and the profit enjoyed by the ad hoc committee (after recouping its initial $250,000) was used to create the Women's Community Foundation, which has supported local women's causes since then. In Chicago, the Rosalind Group for Arts and Letters mounted a huge community-based effort to build support and find a suitable space, finally obtaining the cooperation of a local developer who offered the Franklin Building, a wonderful old building in the South Dearborn district, another shabby area that later became gentrified, stimulated in part by the thousands of people who ventured into the area to see the show. In Atlanta, the show was held at the old Fox Theatre, the only venue that was not entirely successful. A rainstorm caused the ceiling of the sponsoring agency's office to collapse, thereby ruining their planned mass mailing of 60,000 promotional brochures, a disaster that was complicated by the fact that the organization

Memorabilia from around the world

went bankrupt even before the show opened (through no fault of the planned exhibition).

Some of the problems that developed in what became an alternative exhibition tour were more a result of what happens outside of the established system for the distribution of art than any failings on the part of the community groups. The main reason that institutional venues are so desirable is that museums are in the business of exhibiting and caring for art. For no matter how good the intentions of the people involved, going out-

side that art-world system introduces innumerable difficulties, not the least of which is people's lack of experience in dealing with artists.

I had a number of unfortunate misunderstandings with some of the women in the various community groups, many of whom felt that I did not sufficiently appreciate their efforts. Art institutions do not expect artists to be grateful for exhibitions, as their commitment is primarily to the *art*. It was very confusing to me when people expressed the idea that by helping to exhibit *The Dinner Party*, they were doing something "for me."

Moreover, many of the women failed to appreciate how painful it was to have one's work so publicly rejected by the art world. An artist who is attacked the way I was by the most prominent New York art critics is usually expected to quietly disappear. But I was becoming ever more visible, a result of the growing controversy about the nature and quality of *The Dinner Party*—which escalated after its New York viewing and the release of Johanna Demetrakas's documentary film, *Right Out of History: The Making of Judy Chicago's* Dinner Party, which was to be seen by millions of people around the world.

Because many people do not understand that artists are not paid for the exhibition of their work, it was probably not surprising that some folks, particularly those outside of the art community, assumed that because so many thousands of people were viewing *The Dinner Party*, I was making money. This was not at all the case. After taking on the responsibility for the exhibition tour, Through the Flower received some monies from rental fees, but these funds went to cover the costs of our installation crew and for storage of the work between shows. I received no revenues whatsoever from *The Dinner Party* exhibitions, which made it especially hurtful when some women began to accuse me of having exploited the people with whom I had worked, as if there had been even the most remote possibility that *The Dinner Party* could have been accomplished without massive volunteer labor, theirs or mine.

Even before the show initially opened, I knew from years of lecturing about my work that there was a large audience hungry for images that affirmed women's experience. But what happened with *The Dinner Party* exceeded my wildest expectations.

It was certainly true that the ongoing, often virulent criticism continued to upset me (as it still does), but I learned that the potential power of art was even greater than I had ever dreamed. For *The Dinner Party* stimulated a seemingly unprecedented, international grass-roots movement that managed to exhibit the work in the face of multiple obstacles, including continued institutional resistance, along with an ongoing lack of traditional support, such as large grants and/or corporate funding.

This community network and eager audience was steadily extended by the expansion of the exhibition tour, first to Canada, then to Scotland, England, Germany, and Australia. Eventually, the show was presented in fourteen venues in six countries to a total viewing audience of nearly one million people. Everywhere it went, it inspired massive media attention, along with controversy.

Each city was somewhat unique in its organizational methods, space, and educational programming. In 1982, between its exhibition in Chicago and Atlanta, *The Dinner Party* was exhibited in Montreal. This exhibition, like the other two held in Canada, was at a museum and was one of the few times that a grass-roots group was not involved. A female director and her woman curator cooperated to do what no other art institution but the San Francisco Museum had done, which was simply to exhibit the piece without community pressure, external funding, or a populist movement.

As a result of the success of the Montreal show, a group of women in Toronto approached the Art Gallery of Ontario about showing *The Dinner Party*. Although I do not know whether they encountered resistance, I do know that they had to raise the funds for the exhibition themselves. But the institution made all the profit. The same thing held true at the Glenbow Museum in Calgary, where the museum insisted that the women post a bond, then went on to enjoy all the revenues *after* the bond was repaid. What was frustrating in every city was that museum officials were always convinced that what had happened in previous cities would not happen in theirs—i.e., that there would be such a large and enthusiastic audience. This was just another indication of the refusal of mainstream institutions to respond to women's desire to see images that relate to their experience.

In 1984 *The Dinner Party* was exhibited in Scotland as part of the Edinburgh Festival Fringe, again in an alternative space. By then Gelon was in law school in New York but still handling all of the exhibition logistics and administrative details. From there, the work traveled to a renovated warehouse in London, where Germaine Greer presented the opening address. In the spring of 1986, a year after the London showing, Gelon and I, along with my new husband, photographer Donald Woodman (whom I had married on the previous New Year's Eve), flew to Frankfurt for something called the Festival of One Thousand Women, which was held at the city's reconstructed opera house.

Over the years of its tour, *The Dinner Party* had prompted many satires, parodies, programs, events, and spin-off activities, but this German celebration was to be one of the most elaborate. As part of their efforts to build interest in a German exhibition of *The Dinner Party*, a group of women had organized this rather splendid event. Hundreds of women from all over Europe gathered at the Frankfurt Opera House, which had been rented for the day, all costumed as the various figures represented on the table or named on the *Heritage Floor*. One woman, who was dressed as Fanny Mendelsohn, conducted an all-female orchestra in the premiere of a piece by the composer that had never even been played before.

A year later, *The Dinner Party* was shown at the Schirn Kunstalle in Frankfurt, which proved to be the museum's most successful exhibition to date. I, of course, enjoyed having the work seen in an important European museum, though I later discovered that the German art-world reaction was even worse than it had been in New York. I was completely unaware of this at the time, again because of its popular success and the fact that even before it opened, there had been over three hundred articles in the European mainstream press. This was a near repeat of what had happened in the States, particularly in New York— the mass media was extremely positive while most of the art reviews were hostile.

The last stop on *The Dinner Party*'s worldwide exhibition tour was Melbourne, Australia. It was brought there after years of work by a grass-roots group that succeeded in making the

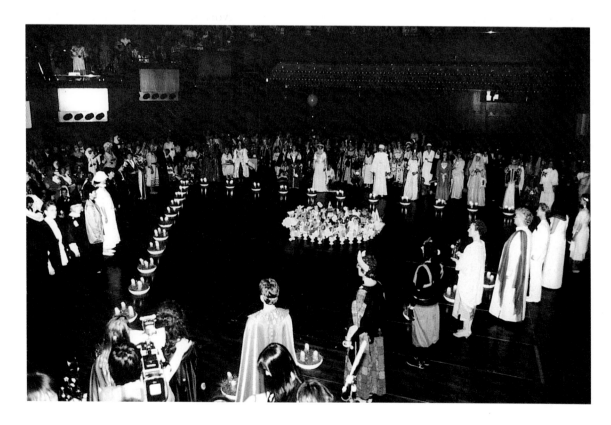

Festival of 1000 Women;
Frankfurt Opera House, 1987
(organized by Dagmar von Garnier
and Anna-Marie Gesse

show part of the Australian bicentennial celebration. *The Dinner Party* was presented at the Royal Exhibition Center, where it was co-sponsored by the Victoria and Albert Museum.

On the weekend of the opening, there was the boisterous Banquet for One Thousand Women, which mimicked an all-male event held one hundred years earlier as part of the Australian Centennial celebration. The exhibition itself again proved quite successful, and even before the show had closed, a museum in Western Australia asked to exhibit the piece there. But I was becoming anxious about the work's physical condition because it had been subject to considerable wear and tear, particularly some of the fabric runner, which had sustained damage when the roof of the London venue had leaked.

Moreover, it seemed that *The Dinner Party* had overcome the resistance initially evidenced by the art world. For by that time (1988), it was being featured in many art-history books and being taught in both art and women's studies classes all over the world. The board of Through the Flower had been expanded, many of the women—like Mary Ross—having been attracted to my work and vision through their involvement with their particular community's exhibition effort. We all thought that the piece had best come back to America where, we assumed, it might finally find a permanent home. After its demonstrated appeal, it seemed as though any number of institutions would be interested in housing it.

Shortly before the many crates containing *The Dinner Party* returned from Australia and were placed in storage, the National Museum for Women in the Arts had opened in Washington, D.C., founded by Wilhemina Holladay and her husband, Wallace. Since then, many people have asked both Mrs. Holladay and myself why *The Dinner Party* is not on display there. The simple answer is that it does not fit into the existing space. The more complex issue relates to the whole problem of the preservation of women's art, history, and culture.

It is instructive to examine the major museums to see what percentage of their exhibitions or collections include art by women. The fact that the work of even those women artists cited in *The Dinner Party* are rarely or never to be seen leads to one of two conclusions: that their work is unworthy of inclusion (as

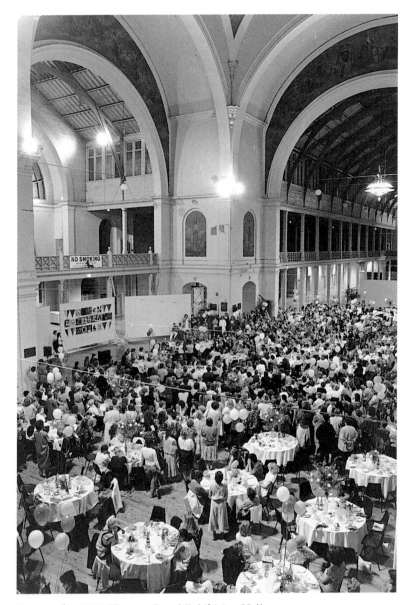

Banquet for 1000 Women; Royal Exhibition Hall, Melbourne, Australia, 1988

some people still argue) or that the mainstream institutions are just not interested in preserving women's work. I hope that after having carefully perused this book, most readers will have realized—as I did—that numerous women, the artists named in this book among them, are eminently worthy of commemoration. If this is the case, what can be done? In the case of visual artists, we women could petition the museums to change their policies, but it would seem that the story of *The Dinner Party*

suggests that this is easier said than done. For if a revenue-pro-ducing work with a broad audience (which had already begun to enter the art historical canon) cannot be enthusiastically em-braced by the museums, what chance is there for much of the other art created by women through these many centuries?

Given this sad reality, it would seem that what the Holla-days have done makes considerable sense. The problem is that there is a frequently held assumption that this one institution can singlehandedly accomplish what is actually an enormous task. This raises the possibility that the National Museum for Women in the Arts needs to be seen as an important step in the long-term and crucial project of preserving the immense range of women's heritage, a range that is only hinted at by *The Dinner Party*. The degree to which preservation of our own precious his-tory is still a significant challenge will, I hope, become evident as I continue this saga.

Early in 1990, Patricia Mathis, a Washington business-woman, a former assistant at the Treasury Department under President Carter, and a supporter of Through the Flower, ap-proached me and my board with an exciting proposal. The pri-marily African-American University of the District of Columbia (UDC), of which she was a trustee, was interested in creating a new and ground-breaking, multicultural art center and archive to house the work and papers of a coalition of artists of color, feminists, and others whose life and work was devoted to the struggle for freedom and dignity.

The university already owned a group of works by a num-ber of prominent African-American artists, along with pieces by numerous local white artists, some of whom were faculty mem-bers at the school. Pat's vision was that by linking these to *The Dinner Party*, UDC could establish an important core collection, one that might attract numerous visitors and private donations, along with much-needed revenues for the university.

This plan was enthusiastically endorsed by the trustees, who decided that, if I were willing to gift *The Dinner Party* (then valued at two million dollars), they would make it the center-piece of this assemblage. All of the art was to be housed in the old Carnegie Library, a handsome and historical though deterio-rating building located on UDC's Mount Vernon Square campus in Washington's downtown arts district. Because the roof of the library leaked and the paintings already hanging there were nei-ther properly protected nor often visited, the D.C. city council had allocated funds for the library's restoration as early as 1986, funds which the university had not yet touched.

The intention of the trustees was to not only fix the roof but to transform the building into a proper and altogether unique museum. The fact that the library was in close proximity to the Women's Museum and that Mrs. Holladay supported this idea and, moreover, hoped to do shared educational program-ming with UDC only made the plan more appealing.

On June 19, 1990, the UDC trustees voted to accept my gift of *The Dinner Party*. In early July, the D.C. city council ap-proved a bond bill from the university's own capital budget to re-store the library, and later that month, Donald and I, along with a number of Through the Flower board members and supporters, flew to Washington for the formal gifting ceremony, which was, fittingly enough, to take place on my birthday, July 20.

I arrived a few days early and spent the morning of July 18 at a local health club. While walking home, I happened to glance at a kiosk displaying the *Washington Times,* a local right-wing paper. There on the front page, in full color, was a photo-graph of me and *The Dinner Party*, along with the ghastly headline, "UDC's $1.6 million 'Dinner'; Feminist artwork causes . . . indigestion." As I had no change with me, I could not even purchase the newspaper and had to wait until I got back to where I was staying to find out what had happened.

Apparently, rumors had begun to circulate on the UDC campus during the month of June concerning an underground sabotage campaign being mounted by some conservative mem-bers of the faculty senate. Moreover, there were some people in both the university and the local art community who felt that no art by white artists should be included in the school's collec-tions, despite the fact that it had included such work for years. There were also many unresolved problems within the univer-sity itself, which the museum plan would bring to a head, though what these were, exactly, were never clear to me, nor to anyone on the board of Through the Flower.

Over the next few days, the *Washington Times* continued to

Susan Grode, Nira Long (then president of UDC Board of Trustees) and Judy Chicago at gifting ceremony, 1990

pump out erroneous information implying financial impropriety on the part of a trustee and even outright wrongdoing by some of the university officials. They also trotted out the old cant about "vaginas on plates" that had dogged *The Dinner Party* ever since its New York showing. In an effort to counter some of the untruths being promulgated about the art, the financial terms of the gift, and the planned museum, UDC held a press conference the day after the gifting ceremony. I presented a slide talk, university officials explained their vision, and we all answered questions. This press conference, which included reporters from *The Washington Post* and *The New York Times*, seemed to turn the tide. We all felt confident that we had succeeded in communicating the real story, especially about some of the many anticipated benefits to the university. Donald and I, along with the rest of those who'd traveled to Washington for this propitious occasion, went home.

Unfortunately, over the next few months, the hopeful plan of a visionary multicultural institution would go up in smoke. On July 26, while recuperating at home from a minor surgical procedure, I received a phone call from Cheryl Swannack, a former student of mine and a lobbyist at that time. She happened to be attending a debate on the future of Representative Barney

Frank—who faced disciplinary action following his confessed involvement with a male prostitute—when she became apprised of the fact that *The Dinner Party* was about to be discussed on the floor of Congress. For the next hour and twenty-seven minutes, Donald and I sat stupefied in front of the televised proceedings on C-Span.

The Dinner Party was discussed as part of the debate on UDC's budget, which Congress controls. Then-representative Stan Parris from Virginia introduced an amendment that would delete $1.6 million from the school's operating budget, "in direct response to . . . [the] offensiveness to the sensitivities and moral values of our various related communities." He went on to ask, "What kinds of art . . . what value system are we, the Federal lawmakers, responsible for promoting in this, the nation's Capital, by being asked to give our imprimatur of approval to this particular work?"

Parris argued for his amendment on the grounds of fiscal impropriety, which was entirely inaccurate. Nonetheless, he managed to convince a number of liberal congressmen—including my own representative, the usually astute Bill Richardson—to support his measure. But there was another and ultimately more distressing accusation about *The Dinner Party*, first put forth by Robert Dornan of California and then amplified by his colleague Dana Rohrbacher, who came right out and said that *The Dinner Party* was "pornographic," which is what Parris's comments about "offensiveness" probably implied.

"We now have this pornographic art," railed Dornan, "I mean, three-dimensional ceramic art of 39 women's vaginal areas, their genitalia, served up on plates." After introducing the *Washington Times*'s distorted reports directly into the Congressional Record, the congressman went on to make the entirely fictional statement that the piece had been "banned in art galleries around the country . . . and characterized as obscene."

Several congressmen (no women participated in the debate) attempted to counter these charges, notably Ron Dellums (also of California) and Pat Williams of Montana, but to no avail. The Parris Amendment was passed by a large majority and the university was left to deal with this reduced budget.

During the summer of 1990, the Christian Television Net-

work picked up on the UDC/*Dinner Party* controversy, with the Reverend Pat Robertson apparently blasting the art on his *700 Club* show. It was reported to me that the black religious right had actually circulated rumors that the reason *The Dinner Party* was in storage was that the crates contained the Devil and that I was the Antichrist. Even the normally liberal columnist Mary McGrory got into the act. With a seeming lack of journalistic responsibility, she wrote about *The Dinner Party*, reportedly without having ever seen it, repeating the nonsense that it was "obscene." Nonetheless, throughout that summer, in the face of financial punishment, the lies being circulated and all of the many problems that had erupted, the trustees of UDC and the board of Through the Flower continued to stand firmly behind the agreed-upon museum plan.

Thanks to a massive organizing effort, educational packets about *The Dinner Party* were sent to all of the members of the Senate, which was scheduled to take up the UDC budget in committee. After being exposed to information about the art and its history, the committee voted to restore the money that they deemed unjustly cut by the Parris Amendment. When the House and Senate disagree, their differences are hashed out in conference, and every indication was that a conference committee would confirm the Senate committee's decision some time that fall. In the meantime, letters of support and offers of other works of art for the proposed museum were arriving at UDC from all over the country.

Unfortunately, the events in Congress, coupled with the ongoing activities of the right wing, created a breakdown of confidence in the trustees' judgment among the faculty and student body, which resulted in a student strike. Instead of seeing *The Dinner Party* as a positive addition to the struggle for human rights for which the university presumably stood, it came to be seen as something that was being foisted upon the students, something that they didn't want. One of the sad things about the UDC debacle was the degree to which the students were successfully manipulated into viewing me and my work as the "enemy," while (seemingly) unknowingly participating in a "divide and conquer" strategy that is as old as the hills.

Nevertheless, I supported the students' right to a voice in

the institution's decisions and therefore felt it best to withdraw *The Dinner Party*, as I certainly didn't want to force something unwelcome upon them. In a press release, I said that the vicious misinformation campaign had "managed to create a division of values where there was none—i.e., between the concept of *The Dinner Party* and the issues that are important to the students." I went on to say that, "as my life's work has been dedicated to the [right] of self-determination of all people," I believed I had no choice but to rescind the gift.

Sometime later, after studying an article in *Art in America* by Lucy Lippard analyzing the convoluted events that had taken place, Congressman Richardson recognized his mistake in supporting the Parris Amendment. He read Lippard's piece into the Congressional Record in the hopes of at least setting the historical record straight, but by then it was too late—for both the permanent housing of *The Dinner Party* and the establishment of the museum. To this day, the Carnegie Library remains unused and, until recently, in a steadily deteriorating state of disrepair.

Lippard concluded her piece by saying: "Had the student strike not happened, *The Dinner Party*/UDC partnership probably would have survived. But the prospect of such an alliance may have set off subliminal alarm systems among those for whom multiculturalism is . . . threatening. . . . The proposed center . . . could have inspired not only exhibitions and art-world attention, but also a much needed historical analysis of the connections between feminism and the civil rights movement."

Perhaps, as Lippard suggested in her article, "it was fool-hardy to have introduced *The Dinner Party* into the boiling pot of Washington politics at that particular moment in the city's history," but doing so was to eventually teach both me and the board of Through the Flower an extremely important lesson. Although it was to be some time before I was able to reach any real understanding of the events in Washington, gradually I began to perceive connections between what had been said in Congress and the language of much of the art-critical discussion of *The Dinner Party*, particularly in New York. In both instances, the focus was primarily on the plates, which were decontextualized

from the larger intent and scope of the work. In fact, it seemed as though *The Dinner Party* had been deliberately misrepresented in both the art community and in Congress, promulgating an image of it that bore little resemblance to the piece's goal of teaching women's history through art and honoring our aesthetic, intellectual, and philosophical achievements.

The negative art-world attitude toward the work did not ultimately prevent its exhibition, nor did it stop it from entering the written art historical record. It did, however, impact on where the work was shown and also seemed to greatly affect my own career. (Despite this, I was able to create opportunities to continue to work and show, which was what was most important to me.) But at the point at which *The Dinner Party* would have moved from the printed pages of the many books in which it is now featured into a permanent installation, the misrepresentation campaign became not only more intense but more successful, in that *The Dinner Party*'s housing was blocked.

Some people have dismissed what happened to *The Dinner Party* in Washington as just another installment in the ongoing assault on the NEA. I do not agree with that, although the whole UDC museum project was certainly caught up in the larger struggle surrounding arts funding. But the lesson that the congressional hearing and the events of that summer finally taught me was that *The Dinner Party* seemed to be a much more dangerous symbol than I had ever imagined. The right wing, for all its foolishness, has the uncanny ability to discern that the opening up of the symbol system—particularly visual art—to the voices and experiences of women, people of color, gays and lesbians, and other marginalized groups challenges the control of representation upon which the prevailing value system rests.

Many people do not realize the symbolic importance of art in that it embodies a perspective that either enhances or challenges the prevailing values. Nor is it widely understood that the art that is preserved in our museums attests to a particular world view, one that basically reflects the male-dominated society in which we live. Housing *The Dinner Party* would mean the preservation of a visual symbol that asserts the importance of women's lives, experiences, contributions, and achievements, thereby calling into question the generally assumed primacy of

male experience along with the underlying presumption that *what men do is important while what women do does not count.*

But few people today—and certainly not the members of an art community that presents itself as avant garde—would be so bold as to admit their belief in the inherent inferiority of women. Nor is this bias conscious; rather, it is the internalization of a value system that we are all taught both explicitly and implicitly through the constant *presence* of images that assert male experience, history, and importance and the *absence* of comparable images honoring women. *The Dinner Party* challenges this imbalance at its core.

In both the art world and Congress, the plates were described in terms of female sexuality, as if there was something inherently evil about images that alluded to women's sexual power. As I've stated before, although the imagery is rooted in a vulval form, the plates are actually transmuted and layered images. However, I have become convinced that no matter *how* I describe the plates, this perception of the images *as vaginas* will continue, so I must ask: What is wrong with that? If I wished to be simplistic, I could describe skyscrapers, church steeples, missiles, guns, and, in fact, all thrusting forms as penises, but I cannot imagine a comparable furor over any artist's use of such shapes.

It appears extremely curious that in regard to *The Dinner Party*, there seems to have been such a strange congruence between the language of the art world and that of the right wing. In both instances, the plates were not described in the context of the huge tables on which they are displayed, nor was the imagery of the runners, the place settings, the streams of names on the floor, the entryway banners, or the ancillary exhibition materials even discussed. Instead, the plates were lifted out of the context of the work and examined as if with a speculum by a gynecologist doing a Pap smear.

Why this obsession with the plates? Perhaps because they suggest that female sexuality can be assertive, powerful, and transformative. What I believe is being revealed in this assertion that the plate images are somehow pornographic or obscene is something very real about our culture's view of women and women's sexuality: that it is, at its base, detestable or at the very least shameful and not to be publicly revealed.

Of course, it is not that images of female sexuality are not omnipresent; they surround us in art, advertising, popular entertainment, and, of course, in pornography. But what do these images teach us? That female sexuality is something to be manipulated, controlled, or dominated; that it is basically passive or, if active, it is to be subdued, often by violence. The reclining nude, the posed model, the "fatal" attractor, and the dominatrix have little to do with the concept of sexuality that the plates imply. In contrast, the plate images exist entirely independent of men, bravely struggling to assert their own identities in their own context, their own history, and their own long effort toward liberation.

Years ago, when I set out to make art that was truthful to my sense of myself as a woman, I had no idea that it would generate the controversy that it has. In the early days of the women's movement, the question was often posed: What would happen if women told the truth about their feelings and experiences? The answer—cited in the title of one book—that the world would split open, seems confirmed by the level of fury that *The Dinner Party* has provoked.

But one might well ask: Why should I be surprised? Doesn't the story recounted by *The Dinner Party* tell us that throughout history, women have been misunderstood, misrepresented, and maligned, their contributions ignored and their achievements obscured? And, unfortunately, women have been some of the worst culprits in disowning, attacking, and undercutting other women, which just goes to prove that women can be just as unthinking as anyone else in not being able to differentiate between their enemies and their friends.

While I was engaged in the research for *The Dinner Party*, I was both overwhelmed and inspired by my ongoing discoveries about women's rich heritage. I earnestly hoped that others would find the information—as expressed in the art—equally meaningful. I am now convinced that one of the most significant insights embodied in the work is about the cycle of repetition that has locked women into what has been an endless and fruitless reinventing of the same wheel. This process, which continues to thwart our growth, needs to be first understood, then interrupted, if we are ever to escape the (symbolic) confines of

The Dinner Party table, which, with all its beauty, is too small a space for the fullness of the female spirit.

As I have stated repeatedly, one of my primary goals was to break this terrible cycle. I must admit, with both embarrassment and chagrin, that I never contemplated the possibility that *The Dinner Party* could become just one more example of this cycle of repetition. I can only explain this by admitting that *even though I had learned that so many other women's important achievements had been excised from history, I did not believe that the same thing could happen to me.* It was not only that this was unthinkable—else why would I have even attempted such an ambitious project?—but that I had learned to disregard the evidence of other women's lives, preferring to look to male models for guidance.

I had learned in art history that there is a traditional path that leads from creation to exhibition to the preservation of art. Because *The Dinner Party* was becoming a part of the canon of art history—even in the face of all of the controversy it had generated—I firmly believed that its future was ensured. So did Through the Flower's board, as well as a number of people in the art world, including Wilhemina Holladay and Henry Hopkins, both of whom wrote letters of congratulations and support when I first gifted the work to UDC. Holladay wrote:

> The National Museum of Women in the Arts welcomes Judy Chicago's important work to our community. *The Dinner Party*, widely recognized as a major monument of feminist art . . . has become a popular icon, a part of our modern world.

And Hopkins summed up:

> *The Dinner Party* had its first public presentation at the San Francisco Museum of Modern Art on March 14, 1979. . . . The rest is history and women's history. During the following decade, *The Dinner Party* was seen in fourteen institutions in six different countries. Now, happily, this ambassador without portfolio returns as an icon triumphant to the nation's capital.

Permanent Storage?

What we all overlooked was one of the most important lessons of *The Dinner Party*: that women cannot count on "history" to verify, much less preserve, the reality of our experiences, achievements, or point of view. This realization was brought home as I ruminated over the congressional hearing. Intense criticism of my art did not deter me from continuing to create. Institutional rejection did not stop the exhibition of my work. It required the United States Congress to bring me to my knees,

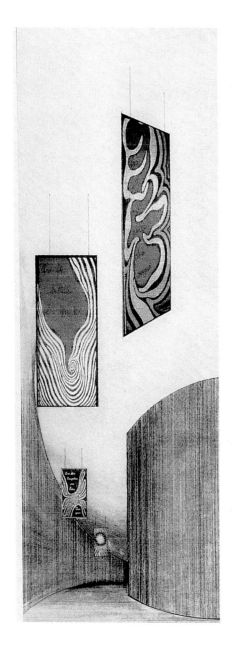

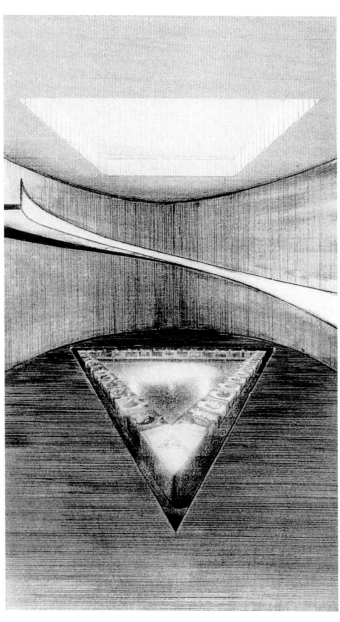

The architects Susan Narduli and Elyse Grinstein of Los Angeles recently developed a conceptual design for the permanent housing of *The Dinner Party*. "It is the spirit of *The Dinner Party* that we have invoked in the process of comprehending an architecture which continues its principles," they wrote in the proposal they created describing their concepts. The design expresses an idea that could be developed for any number of sites and would seem eminently suitable to the values embodied by the art. Drawings by Yasi Vafai for Narduli/Grinstein Architects.

Permanent Housing?

forcing me to ask the anguished question: What is the point of so much effort if the art is to be lost?

But Judy, I am constantly told, your work has changed so many people's lives. This is usually followed by the question, Isn't that enough? My answer is, *No, it is not!* One of the most important reasons for transforming ideas into tangible form is so that the work can outlast both the creator and the viewer, thus preserving the concepts for future generations. It is crucial

for women to understand Gerda Lerner's point, cited in the Introduction, that "men develop ideas and systems by absorbing past knowledge and critiquing and superseding it [while] women . . . struggle *for insights others already had before them*" (author's emphasis).

If *The Dinner Party* is not permanently housed, then it will have failed in its most significant mission: helping to break the cycle of repetition that, as Lerner suggests, "is not only a symp-

tom of women's oppression but its very manifestation." Its loss would mean not just the destruction of a precious aesthetic object but, more tragically, it would allow the historical information that the art embodies to slip back into the murky darkness from which I and my co-workers all labored so hard to wrest it. The art and the history it represents would thereby be condemned to becoming mildewed, then moldy, then ultimately destroyed.

Mildew has already attacked the delicate Millennium runners, which required thousands of dollars in conservation and is a harbinger of what lies in store for the art if it is *not* preserved. The eventual disintegration, in particular, of the meticulously needleworked fabrics will be a physical demonstration of a terrible fact: that nothing whatsoever has changed in that *women's work is still not valued, not even by women themselves.*

The fact that it cannot be housed within the limits of the space of the National Museum for Women in the Arts should be neither a disappointment nor a deterrent but, rather, an incentive to create a variety of institutions to house women's rich and multifaceted heritage. What prevents us from bringing our attention, our skills, and our resources to the honoring of our own foremothers? Why is there not a single museum honoring artists of the stature of Mary Cassatt, Kathe Kollwitz, Georgia O'Keeffe, or Frida Kahlo, while there are numerous institutions devoted to the likes of Picasso, Miro, Dali, or, more recently, Andy Warhol? The underlying vision of *The Dinner Party* proclaims that the Millennium will be marked by an increased respect for women. What better way to move into this future than by taking up the cause of preserving this work?

But how can this be accomplished? People are constantly asking me if *I* am going to house *The Dinner Party*—as if, with my paintbrush, I could conjure up a site, a building, and the funds. Or they expect that the board of Through the Flower

will somehow be able to raise the millions of dollars it would take to build a museum to house the work. The board members have been trying to determine if permanent housing in some form is even within the realm of possibility for us to achieve. At the moment, it is all we can do to sustain our small organization; creating such housing seems a somewhat overwhelming task. Moreover, despite the best of intentions, this goal could not be realized without the committed help of countless others, including some people willing to make substantial donations.

Artists usually work with existing institutions to preserve their work; rarely are they expected to handle the entire gamut from creation to exhibition to preservation, which is what I am faced with. I cannot bear the thought of *The Dinner Party* being lost or moldering in storage, and I sometimes wonder if I should break it up in the hope that individual place settings might make their way into museums. To tell the truth, I really do not know what to do. The unhoused state of *The Dinner Party* seems to perfectly exemplify the problem to which I referred before: the *absence* in this case of institutional support for women's point of view.

Members of the United States Congress seem to have understood how potent a symbol *The Dinner Party* would be in a permanent installation. The question is whether there are enough dedicated people to take this symbol and use it as a wedge to move into a future in which women's history becomes a foundation to build upon, rather than a memory that has to be retrieved again and again. Have we reached the historic moment where we can begin to break the terrible cycle of history that condemns each generation to grow up ignorant of women's contributions? The future of *The Dinner Party* hinges on the unknown answer to this challenging and troubling question.

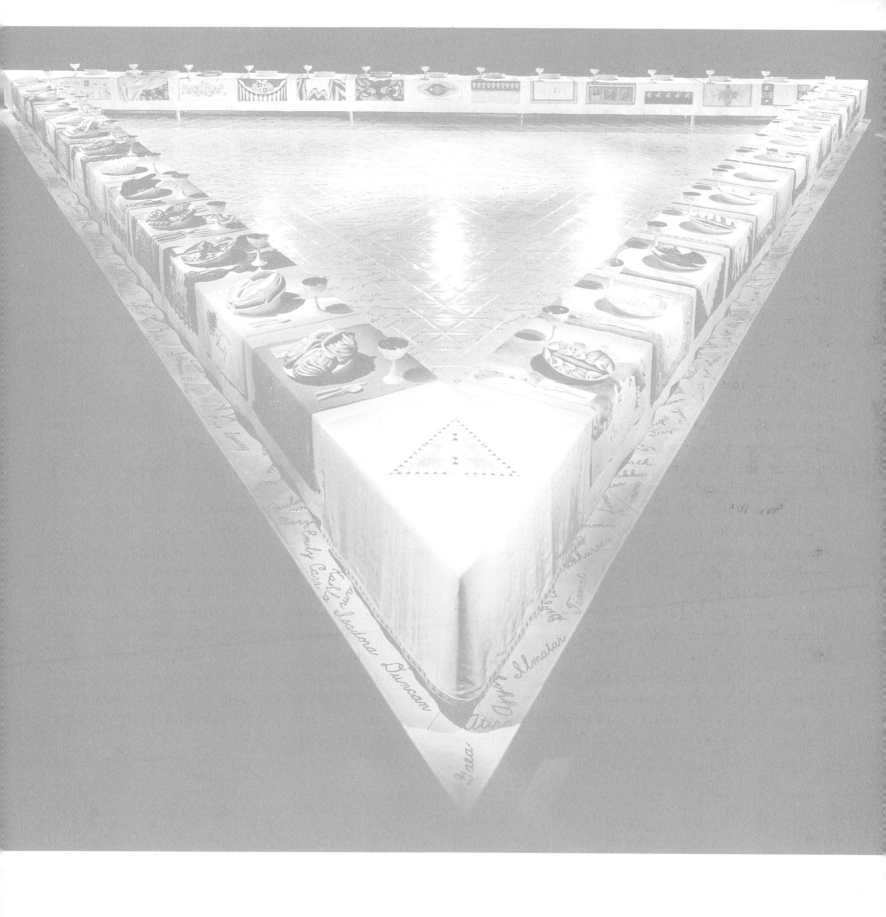

ACKNOWLEDGMENTS

The Dinner Party was created in my studio in Santa Monica, California, between 1974 and 1979. Over those years, many people participated in the work necessary to complete the piece. Along with countless others whose help was appreciated, I wish to thank the following people for their dedication and commitment:

Daphne Ahlenius
Marilyn Akers
Pat Akers
Katie Amend
Marilyn Anderson
Evelyn and Stan Appelt of the
 China Boutique
Ruth Askey
Cynthia Betty
Marjorie Biggs
Terry Blecher
Sharon Bonnell
Susan Brenner
Thelma Brenner (*In Memoriam*)
Julie Brown
Frances Budden
Susan Chaires
Pamela Checkie
Adelth Spence Christy
Marguerite Clair
My mother, May Cohen
 (*In Memoriam*)
Audrey Cowan
Joyce Cowan
Ruth Crane
Laura Dahlkamp
Meredith Daiglish
Lynn Dale
Holly Davis
Michele Davis
Sandi Dawson
Ellen Dinerman
Jan Marie DuBois

Elizabeth Eakins
Laura Elkins
Marny Elliot
Kathy Erteman
Faye Evans
Peter Fieweger
Marianne Fowler
Cherié Frainé
Libby Frost
JoAnn Garcia
Diane Gelon
Sally Gilbert
Ken Gilliam
Dorothy Goodwill
Winifred Grant
Estelle Greenblatt
Amanda Haas
Judy Hartle
L. A. Hassing
Arla Hesterman
Robin Hill
Susan Hill
Shannon Hogan
A. Springer Hunt
Elaine Ireland
Ann Isolde
Anita Johnson
Lyn Jones
Nancy Jones
Sharon Kagan
Bonnie Keller
Cathryn Keller
David Kessenich

Judye Keyes
Mary Helen Krehbiel
Jean Pierre Larochette and Staff
 of San Francisco Tapestry
 Workshop
Sherri Lederman
Julie Leigh
Ruth Leverton
Virginia Levie
Thea Litsios
Shelly Mark
Mary Markovski
Stephanie G. Martin
Sandra Marvel
Judith Mathieson
C. Alec MacLean
Laurie McKinnon
Marie McMahon
Mary McNally
Susan McTigue
Amy Meadow
Chelsea Miller
Don Miller
Kathy Miller
Judy Mulford
Juliet Myers
Natalie Neith
Laura Nelson
Logan Palmer
Anne Marie Pois
My aunt, Dorothy Polin
 (*In Memoriam*)
Linda Preuss

Betsy Quayle
Rosemarie Radmaker
Charlotte Ranke
Rudi Richardson
Martie Rotchford
Roberta Rothman
Bergin Ruse
Karen Schmidt
Kathleen Schneider
Mary Lee Schoenbrun
Elfi Schwitkis
Manya Shapiro
Linda Shelp
Dee Shkolnick
Helene Simich
Louise Simpson
Leonard Skuro
Sarah Starr
Millie Stein (*In Memoriam*)
Catherine Stifter
Leslie Stone
Gent Sturgeon
Beth Thielen
Margaret Thomas
Sally Torrance
Kacy Treadway
Sally Turner
Karen Valentine
Betty Van Atta (*In Memoriam*)
Constance von Briesen
Audrey Wallace
Adrienne Weiss
Judith Wilson

Both I and *The Dinner Party* itself are extremely fortunate to have had so many people over the years who have been committed to the art and to the precious historical information that it embodies. For without them, this work, like the history it represents, would be but a shadowy presence in a few art-history books. There are so many people I wish to thank—most notably Diane Gelon, Susan Hill, Peter Bunzick (and, more recently, my husband, Donald Woodman)—for the excellence with which they have installed, de-installed, and cared for the work. Many people tell me that the fact that the art is still in relatively good shape is a tribute to their dedication and good work.

In recent years, *The Dinner Party*'s safety has been in the hands of Through the Flower, its board, and, for a long time, its former executive director, Mary Ross Taylor. She and the board members have made sure that the piece was safely stored, demonstrating a level of devotion that has known no bounds. There is no adequate way to ever express my deep gratitude, except to say, Thank you, for without you, *The Dinner Party* would surely have been lost. Let me say to the board members, to the board president, Judith Sherman Asher, and to Mary Ross, along with and especially to my dearest allies—Susan Grode, Elyse Grinstein, Audrey Cowan, and the now-deceased Holly Harp—that your staunch support has sustained me for many decades. Without you, not only the art but the artist would have been lost. (I am desolate beyond words that Holly died before the publication of this book and the opening of the Los Angeles show that would have meant so much to her.)

It was Ruth Lambert, one of Through the Flower's former board members, who transferred the 999 biographical listings chronicling the *Heritage Floor* onto computer disks. This arduous mechanical process made it possible for me to revise and update these listings for this book, and I am extremely grateful. The process of preparing the manuscript fell to my (former) devoted assistant, Jessica Buege, and my new and extremely competent typist, Phyllis Sullivan. (I confess that, although I no longer write by hand, I am still not ready to struggle with the many "crashings" of the computers that I observe in the offices of Through the Flower, not to mention all the teeth-gnashing.) Thanks to both Jess and Phyllis for doing such a good job and for sparing me so much frustration.

When I married my husband, Donald Woodman, he told me that I would never be without good photographs of my work (which is not *why* I married him, but it is definitely a side benefit). It is Donald who contact-printed the hundreds of unsorted black-and-white negatives from which we chose, and he printed, these fine reproductions. He also helped me select and assemble the color section, and I am grateful to him for his support, his expertise, and his talent. But without a number of dedicated and generous photographers over the years, there would have been no photo archive from which to choose, nor would it be in any order without those who spent many hours organizing the photo files.

Thanks are in order to the following photographers in addition to Donald: Mary McNally, Beth Thielen, Don Miller, Michael Alexander, and Michelle Maier, all of whom helped make it possible to assemble the forty-eight pages of color that, for the first time, accurately convey the scope of *The Dinner Party*. And to Georgia Smith, Pamella Quinn, and Jessica Buege, I express my appreciation for the archival work you did on getting the photographs into usable form. The reproduction of many of the pictures has been made possible by the archives of Through the Flower and its staff, for which I am grateful.

It is difficult to believe that this is my sixth book, as I never imagined that I would be a writer as well as an artist. I am fortunate to be in the hands of a wonderful literary team: Loretta Barrett, my agent, friend, and Through the Flower board member; and my fabulous editor, Mindy Werner, who allows me to call her at all times of the day and night for advice, which I

always try to dutifully follow. Thanks also to my conscientious copyeditor, Bob Castillo, who had the formidable task of turning the *Heritage Floor* listings into a consistent manuscript. The Viking Penguin production people, including Kate Nichols, Dolores Reilly, and Susan VanOmmeren, are simply without peer. And then there is Marcia Burch, Maureen Donnelly, and my personal publicist, Ron Longe, in publicity and marketing. To all of them I wish to say that in Penguin I feel as if I have found a home.

I am very fortunate to have been given a grant by the Thanks Be to Grandmother Winifred Foundation. Though it was awarded to support the preparation of *Beyond the Flower*, the sequel to my autobiography, *Through the Flower*, it has served to support this book as well.

Before I close, let me extend my deep appreciation to the "daddy" of *The Dinner Party*, Henry Hopkins, who launched its exhibition tour and who, hopefully, has given it yet another start in the world. Thanks also to the 1995 exhibition project director, Elizabeth Shepherd, and to the exhibition curator, Dr. Amelia Jones. And last but not least, I wish to mention those people who have been long-time friends of *The Dinner Party*: Stanley Grinstein, Bob Cowan, Joan Palevsky, Joy Picus, Michael Botwinick . . . the list could go on and on. And a special thanks is due to Marilee Schmit Nason, who has been cataloging the International Quilting Bee, bringing to bear her prodigious professional skills on this colorful, ever-growing tribute to women from all over the world.

If I have not mentioned someone's name through the fault of my failing memory or the lack of space, be assured that I have not altogether forgotten that *The Dinner Party* grew out of the profound commitment of many people and that it has been sustained by those who hold in their hearts the vision of a better world.

Index

The Women of the *Dinner Party*

Page numbers in *italic* indicate an illustration

231